Hellenistic Art

FROM ALEXANDER THE GREAT TO AUGUSTUS

Hellenistic Art

FROM ALEXANDER THE GREAT TO AUGUSTUS

LUCILLA BURN

The J. Paul Getty Museum
Los Angeles

To all my friends and colleagues, past and present, in the Department of Greek and Roman Antiquities at the British Museum, with sincere admiration for your work as curators, scholars and interpreters of the past.

© 2004 The Trustees of The British Museum

Lucilla Burn has asserted her moral right to be identified as the author of this work

First published in the United Kingdom in 2004
by The British Museum Press
A division of The British Museum Company Ltd
46 Bloomsbury Street, London WC1B 3QQ

First published in the United States of America in 2004
by Getty Publications
1200 Getty Center Drive, Suite 500
Los Angeles, California 90049-1682
www.getty.edu

Christopher Hudson, *Publisher*
Mark Greenberg, *Editor in Chief*

ISBN 0-89236-776-8

Library of Congress Control Number 2004110574

Designed and typeset in Adobe Garamond by Andrew Shoolbred
Printed and bound in China by C&C Offset Printing Co., Ltd.

Contents

Acknowledgements	6
Key dates	7
Map	8
Introduction	10
1 Intimations of Opulence: Macedon and the fourth century BC	26
2 Ancient Faces	50
3 Public Life: Hellenistic cities and sanctuaries	79
4 Private Life: the Hellenistic house and tomb	100
5 Themes in Hellenistic Art	131
6 Artists, Patrons and Collectors, and the Hellenistic Legacy to Rome	155
Bibliography and Abbreviations	179
Notes	181
Photographic Acknowledgements	187
Index	189

Acknowledgements

Without the help of large numbers of my friends and colleagues this book would never have been completed. I would like first to thank all my former colleagues in the Greek and Roman Department at the British Museum for their support and encouragement, and for their willingness to allow me access to the departmental library, photographs and archives. For their generous help with photographs, advice and information I am also indebted to Violaine Jeammet in the Musée du Louvre, Christopher Lightfoot and Joan Mertens at the Metropolitan Museum of Art, New York, Andrew Morris and Andrew Norman at the Fitzwilliam Museum, Cambridge, Clare Pickersgill at the British School at Athens, Maria Pipili at the Academy of Ancient Athens, and Bonna Wescoat at the New York Institute of Fine Arts. I am also very grateful to all my 'new' colleagues at the Fitzwilliam Museum, Cambridge, for not merely tolerating but positively encouraging me to keep working on this publication. My family, too, especially my daughter Eleanor, has become remarkably tolerant of neglect and has not (greatly) objected to growing in self-sufficiency over the long duration of this project. My greatest debts, however, are owed to various members of the British Museum Press. Nina Shandloff originally commissioned the book, and encouraged me not to forget about it when I left the Museum in 2001. Beatriz Waters has been a wonderfully energetic, helpful and enthusiastic picture researcher. In the end, however, it has been wholly thanks to the editorial and organizational skills, the diplomatic persistence and the confidence of my editor, Laura Brockbank, that this book has appeared at all, and I am extremely grateful to her.

Key dates

359 BC	Philip II becomes king of Macedon
357 BC	Start of wars between Philip II and Athens
356 BC	Birth of Alexander the Great
338 BC	Philip II defeats Athens and Thebes for the last time at the battle of Chaeronea
336 BC	Death of Philip II and succession of Alexander the Great
334–323 BC	Campaigns of Alexander in Asia Minor, Egypt, Mesopotamia, Parthia and India
334–264 BC	Rome expands to control all of Italy south of the River Po
331 BC	Foundation of the city of Alexandria
323 BC	Death of Alexander
323–c. 277 BC	Struggles of Alexander's successors for political and military supremacy
310 BC	Murder of Alexander the Great's son Alexander IV: end of the dynasty
307 BC	Demetrios Poliorketes assumes power in Athens
305–304 BC	Demetrios Poliorketes lays siege (unsuccessfully) to Rhodes
300 BC	Foundation of Antioch
285–283 BC	Demetrios Poliorketes captured by Seleucus, dies of drink
279 BC	Gauls invade Macedon and Greece
276 BC	Antigonos Gonatas defeats the Gauls and founds new Macedonian dynasty
276 BC	Macedon (Antigonids), Egypt (Ptolemies) and the Seleucid Empire (Seleucids) emerge as the three great powers of the Hellenistic world
274–217 BC	Repeated wars between the great powers over disputed territory, successions and supremacy
270–215 BC	Hieron king of Syracuse; prosperity and cultural flowering in Sicily
263–241 BC	Eumenes of Pergamon starts great building programme
238–227 BC	War of Attalos I of Pergamon against the Gauls
214–146 BC	Main period of Roman conquest of Greece
146 BC	Romans sack Corinth
133 BC	Attalos III of Pergamon bequeaths his kingdom to Rome (province of Asia)
86 BC	Roman general Sulla captures Athens and Greece (province of Achaea)
31–30 BC	Antony and Cleopatra defeated by Octavian at the battle of Actium; Egypt becomes Roman province
27 BC	Octavian takes the title of 'Augustus'

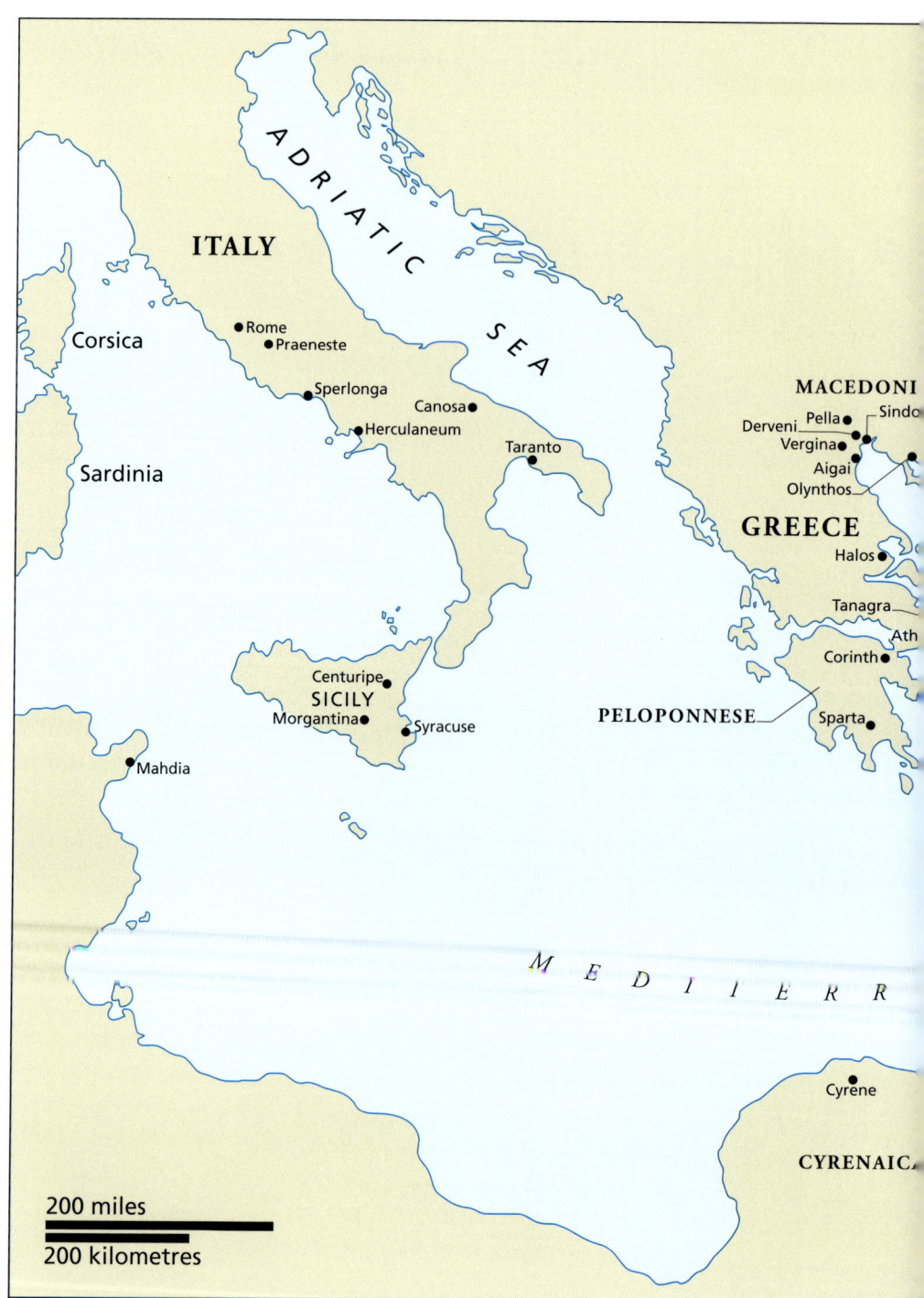

Map of the western part of the Hellenistic world, showing major cities, regions and findspots.

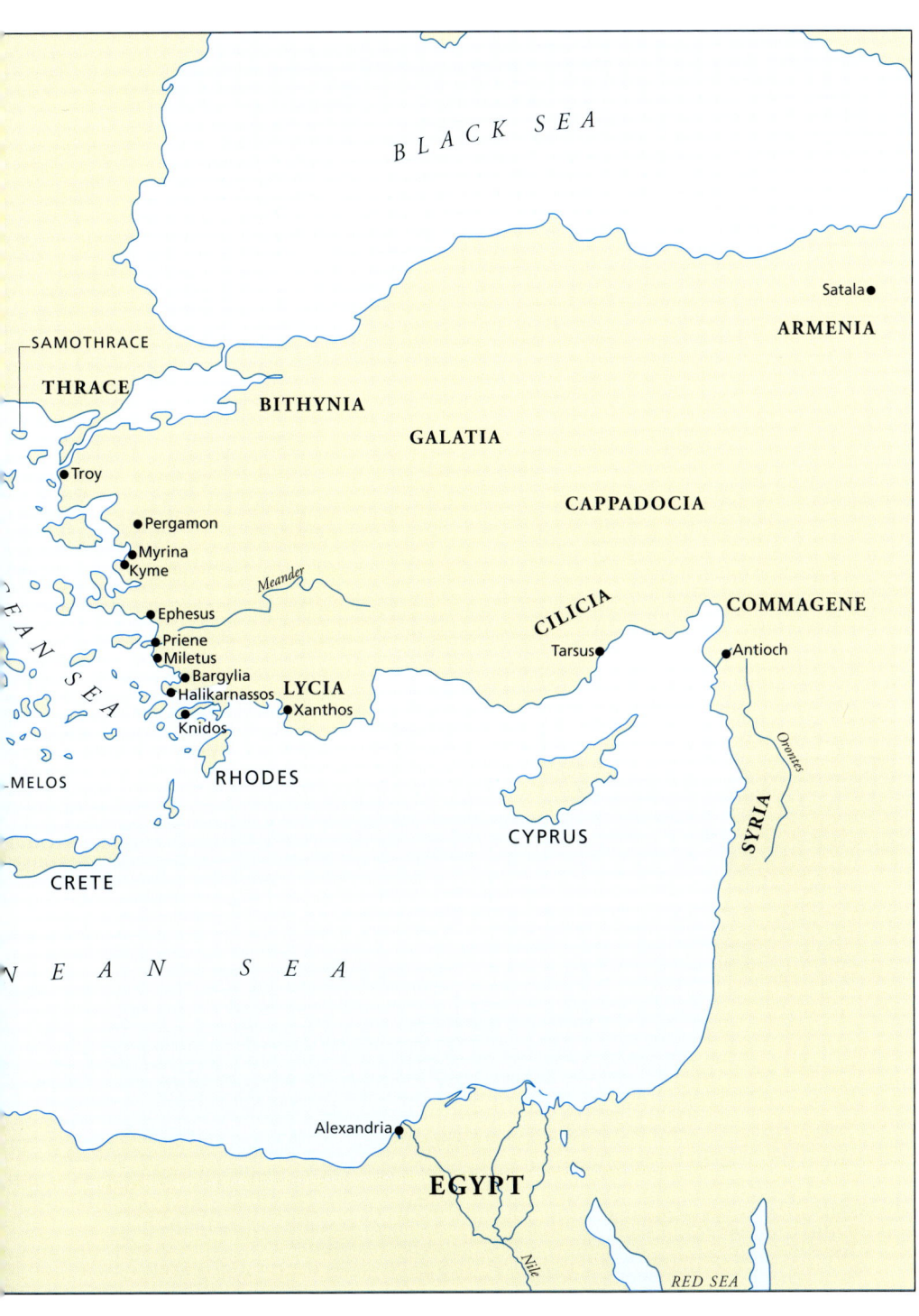

Introduction

'Alexander ... brought men from everywhere into a unified body, mixing together, as if in a loving cup, their lives and characters and marriages and social customs....' (Plutarch, *On the Fortune versus the Virtue of Alexander the Great*, 329C)

An inscription in the British Museum, finely carved in beautifully legible Greek letters on a large block of marble, brings Alexander the Great very squarely before us: 'King Alexander dedicated [this temple] to Athena Polias' (fig. 1). The inscription comes from Priene (fig. 2), a city not far from Miletus in Asia Minor, several thousand miles from Alexander's native Macedon, and provides us with very direct and tangible evidence of his widespread presence and influence. According to legend or history, Alexander wished to have his name associated with the temple of Artemis at Ephesus, the greatest temple of the

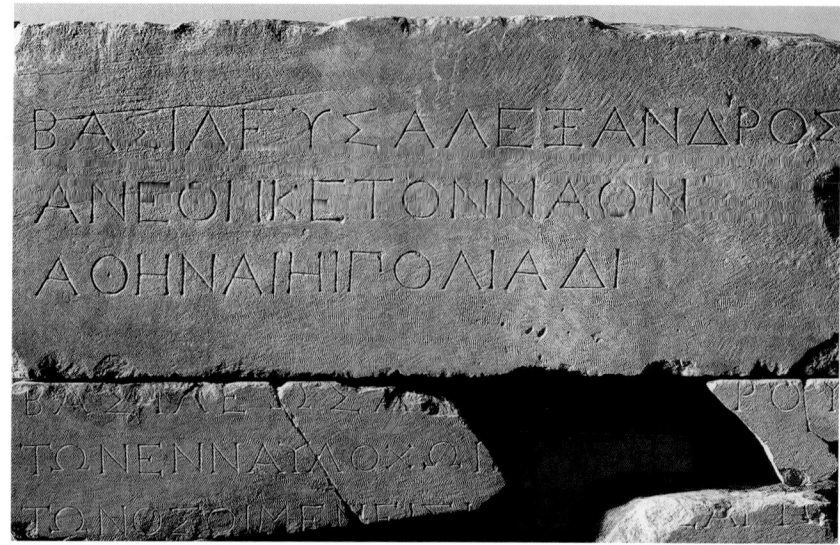

1 'King Alexander dedicated [this temple] to Athena Polias': dedicatory inscription from the temple of Athena Polias at Priene, c. 334 BC. Height 48.7 cm.

INTRODUCTION

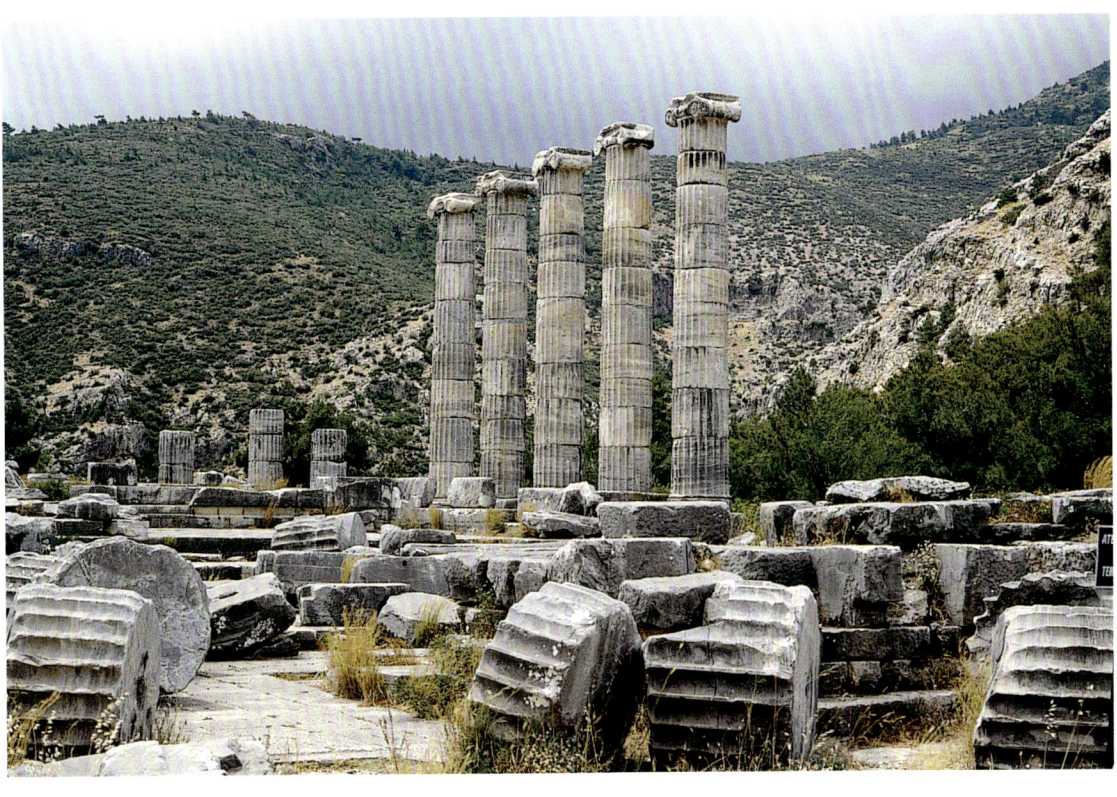

2 General view of the remains of the Ionic temple of Athena Polias at Priene in Asia Minor. The temple dates to the late fourth century BC. Its architect, Pytheos, was also the architect of the Mausoleum of Halikarnassos.

Hellenistic world. The independent-minded Ephesians demurred, tactfully but cleverly pointing out to Alexander, many of whose subjects worshipped him as a god, that it was not fitting for one deity to provide a temple for another. At Priene, however, it seems he met with a more favourable response. This inscription is solid evidence for one minor episode in Alexander's life and career: although we know little about his connection with Priene from any other source, we can infer from it that when he visited Priene he was allowed to make this dedication. In the Hellenistic period of Greek history and culture, traditionally the period between Alexander's death in 323 BC and the defeat of Egypt's last queen, Cleopatra VII, at the battle of Actium in 31 BC, very little is as certain as this.

In fact the uncertainty sets in earlier, in Alexander's own reign. It is believed that the historical record provides a reasonably accurate picture of his military campaigns. But what did Alexander really look like? The question of Alexander's true appearance, as opposed, perhaps, to the visual image that he liked to popularize, is constantly being subjected to review and adjustment.

A considerable number of 'portrait' heads of Alexander have survived – including two examples in the British Museum (see fig. 28). But how do we know whether either of these – or indeed any of the others – provides us with a realistic image of the youthful king? Are they, rather, purely idealized constructs? Or do they combine the real and the ideal? How can we tell which, if any, date to Alexander's lifetime and which were carved after his death? Which are copies of earlier work and which 'original'? Actually, we cannot be certain at all; all we can do is review the evidence, suggest 'reasonable'-seeming developments, but remain aware of the limitations of our knowledge and accept the inevitably provisional nature of any conclusions we may come to draw.

Choosing an approach

Problems such as this, which recur in virtually all areas of Hellenistic art or visual culture, can make it hard to know how to approach the subject. In their recent book on Hellenistic and early Roman art, *Classical Art: from Greece to Rome*, Mary Beard and John Henderson have vividly demonstrated how difficult or even impossible it can be to define or identify an 'original' cultural context for many of the most famous surviving monuments of Hellenistic art. Their response is to suggest that actually this is not a worthwhile pursuit and that rather than worrying about the place or moment of production we should be looking 'stereoscopically' at these monuments, in other words reconstructing the successive phases of their cultural lives from antiquity to the present day. As their book so richly demonstrates, such an approach can be made to yield stimulating insights into the works in question. But if it offers a convincing model for appreciating the major surviving monuments of the Hellenistic age, largely as we view them in the museums of the twenty-first-century world, it has perhaps rather less to offer those who start from the position of wanting to visualize, colour and furnish the Hellenistic age itself. Perhaps this is partly because of Beard and Henderson's concentration on large-scale sculpture[1] – for as they amply demonstrate, it is sculpture that has always been most subject to plundering, looting, copying, restoring, criticizing and admiring through the centuries. It is not the intention here to ignore the famous sculptural monuments of the age. But as the main aim of this book is to try to suggest what areas and periods of the Hellenistic world really looked like, at least as much attention will also be paid to the so-called 'minor arts', which can sometimes be more securely re-contextualized.

In the following chapters we shall be looking both at individual works of Hellenistic art and, where possible, at general artistic characteristics or trends. An attempt will be made to assess what impulses – artistic, political or social – determined both styles and individual creations, and also to enquire what effect these had in their original context. Where possible art will be seen from the point of view of both the producer and the consumer, and, where appropriate, the commissioner. But first we must set the scene, with a brief account of the historical events that led up to and determined the new political geography of the Hellenistic world.

Historical outline

When does the Hellenistic period start? For most people the death of Alexander the Great of Macedon in 323 BC conveniently marks the end of the Classical period of Greek history and the dawn of a new 'Hellenistic' age. This lasted for roughly three centuries, until another critical event, the battle of Actium in 31 BC, where Octavian defeated the last independent Hellenistic monarch, Cleopatra VII of Egypt, signalling the end of one era and marking a crucial point of progress in Rome's campaign for political dominance in the Mediterranean world, Egypt and the Near East. Various scholars, however, have questioned whether it is appropriate to start a 'new age' with Alexander's death. They have argued that it was rather the events of his lifetime and indeed that of his father, Philip II (fig. 3), that had brought about profound changes in the physical, political, economic and cultural configuration of the Classical Greek world. Thus if we are to think of a new era at all – and there are those who claim the practice of dividing history into periods is in any case arbitrary and unhelpful – it would perhaps be more legitimate to start it either with Alexander's succession to the throne of Macedon in 336 BC or even earlier, with his father's transformation of Macedon from a relatively isolated northern kingdom into

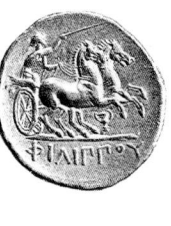

3 Gold *stater* of Philip II of Macedon (359–336 BC), showing on the reverse a racing chariot. The head of Apollo on the obverse emphasizes Philip's aspirations as leader of the Hellenic world.

the dominant state of Greece. Surely events in and controlled by fourth-century Macedon must be seen to form a prelude to the Hellenistic age itself: though separate from it, they contain many of the seeds that germinate in the centuries that follow.

When Philip himself came to the throne in 359 BC, Macedon, weakened by forty years of civil war and foreign invasion, was on the verge of disintegration. Philip lost no time both in restoring control in Macedon and in making the rest of Greece accept that Macedon was from now on to be recognized as a major power. In his ultimate assumption of leadership over the whole of Greece he took full advantage of the way in which the individual city-states were unable to resolve their own internal disputes and jealousies in the face of the ever-growing threat of Persia. But at the same time he was careful to forge significant social and cultural links with the Greek city-states. It is almost certain, for example, that he reasserted the Macedonian royal family's claim to Greek descent, first put forward by Alexander I in about 476 BC: had Philip not done so he would not have been allowed to compete in – and win – the chariot race at the pan-Hellenic Olympic Games of 356 BC. Still more significant was Philip's selection of Aristotle, the leading Greek philosopher of the day, as tutor for his young son, Alexander: this choice no doubt impressed the Greeks, while at the same time it ensured that Alexander's education would embrace Greek culture alongside that of Macedon.

In 337 BC Philip had vowed to free the Greek cities in Asia Minor from the tyranny of Persian rule. As he was assassinated before he could fulfil his promise, the liberation of these cities became the first goal in what was to be, for Alexander and his army, a decade of gruelling and relentless route marches, of savage and merciless suppression of resistance, and of almost invariable conquest and assimilation. Before his death Alexander had pushed the boundaries of the Macedonian Empire southwards and eastwards to absorb Egypt, Syria, Cilicia, Mesopotamia, Bactria and parts of north-west India. This tremendous physical expansion of the Greek world had an enormous impact on the Greek way of life in the centuries to come: this alone would justify the claim that Alexander's career laid the foundations for a new period of Greek history.

The historical and political events of the Hellenistic period itself were complex and turbulent. After Alexander's death his former generals, many of whom he had appointed as satraps (the Persian name for client rulers or governors) in the areas he had conquered, began to divide his enormous empire up between them. Initially they were acting as regents for Alexander's half-brother, Philip Arrhidaios (said to be mentally disabled), and Alexander's posthumous

son, Alexander IV. But before the end of the third century BC the Macedonian royal line was extinct, while some of the generals had assumed royal titles and were struggling amongst themselves, at first in a vain attempt to determine which of them should assume the supreme authority wielded by their former leader, and subsequently to establish their own individual hereditary monarchies. By the early third century, three main Macedonian dynasties had emerged. The first and most successful was that of the Ptolemies in Egypt, closely followed by that of the Seleucids, centred in Syria and Mesopotamia. The third major player in the early Hellenistic period was still Macedon, whose Antigonid kings retained control over the rest of Greece with greater or lesser success from one period to the next. During the third century, several smaller kingdoms were formed, including Cappadocia, Bithynia and Pontos in Asia Minor; many of the Greek cities in the same area and some of the islands, notably Rhodes, remained nominally independent, though in practical terms they were controlled at least intermittently by one or another of the major powers. For much of the third century BC the larger Hellenistic kingdoms were at war with one another, and the balance of power shifted with the territorial ambitions of successive monarchs; they also had to deal with incursions of Gauls from northern Europe. The Ptolemaic kingdom of Egypt remained intact until 31 BC, but the vaster and less cohesive Seleucid Empire split up earlier, with separate kingdoms breaking away first in Bactria and India, then in Asia Minor. The early second century BC, when the two most powerful Hellenistic monarchs were Philip V of Macedon and Antiochos III of Syria, saw the emergence of Rome as a major player on the eastern stage. Gradually a combination of military force and political diplomacy brought both Macedon and Syria into the Roman sphere of influence and ultimately into the Roman Empire. In 133 BC Attalos III, the last of the Attalid dynasty, which, centred on Pergamon, had finally expanded to take over much of Asia Minor, bequeathed his kingdom to Rome. In 31 BC Egypt's submission after the battle of Actium left Rome in overall control of Alexander's former empire. Many aspects of Hellenistic life continued little changed into the Roman period, but the new political and social conditions did bring with them elements of cultural development.

What does 'Hellenistic' mean?

The word 'Hellenistic' has become a convenient short-hand term for denoting both the period of time and the prevailing culture of the period from Alexander

to Augustus. It is, however, a relatively recently coined term, certainly not one that would have been recognized in antiquity. In its German form, 'Hellenismus', the word is first used in 1833[2] in a history of the period by J.G. Droysen, the first to discuss the period as a cultural and historical unit. In etymological terms 'Hellenistic' derives from the verb ἑλληνίζειν ('hellenizein'), which means 'to Hellenize' or 'to make Greek'.[3] But Droysen seems to have used it more neutrally, to express the fusion of western (that is Greek) and eastern cultures, and traditions that he saw resulting from the campaigns and conquests of Alexander: it was this fusion, he believed, that eventually gave Christianity the chance to flourish.

The degree to which the new areas brought inside the Greek world by Alexander were 'made Greek' is certainly debatable. It was true that a simplified form of the Classical Greek language, the *koine* (common language), became the official language of all the newly conquered regions. Greeks and Macedonians formed the ruling class in the new Hellenistic kingdoms, and so it was also inevitable that Greek modes of thought, political and social institutions (such as the notion of the city itself), and elements of art and architecture, were adopted, imposed or insinuated over a wider area of the known world than ever before. The extent to which Greek and non-Greek cultures mingled or fused, as Droysen suggested, is a perennial subject of debate. In some areas, such as architecture, for example, it can be relatively straightforward to identify, say, Persian or Mesopotamian influence. But in other aspects of culture, most notably religion, it can be extremely difficult to establish whether Greek and non-Greek cults were being practised in the same place at the same time, or to what extent Greek and indigenous deities were synthesized or assimilated. This balance between Greek and non-Greek is an issue to which we shall return. If we try, for the time being, to use 'Hellenistic' simply as a convenient, non-prescriptive label for a chronological period, clearly we have to evolve our own description of the character or key features of the age – or at least of its art and culture.

What is special about Hellenistic art?

Until the relatively recent past, the art of the Hellenistic period, along with its history and literature, had been relatively neglected. The tendency to view the period as culturally inferior to the Classical had already set in in the Hellenistic period itself – Pliny's dismissal of much of Hellenistic sculpture was borrowed from a Hellenistic critic. In educated Roman circles the view became further

entrenched: the work of the Classical sculptors Pheidias and Polykleitos was seen as the apex of the Greek achievement, while subsequent centuries were periods of decay and degeneration. The same primacy was given to most aspects of the Classical period by modern Classical (*sic*) scholarship from the eighteenth century onwards. In terms of the study of ancient art it was the influential 'father of art history' J.J. Winckelmann, with his theory of the growth, decline and fall of periods of art, who first voiced the theory that progress towards the Classical peak of artistic excellence was followed by an inevitable decline into decadence and degeneracy. In Victorian England the critic John Ruskin went so far as to work out a precise pattern for the rise and decline of Greek art in the nine centuries before Christ: the ninth to seventh centuries he classed as 'Archaic', the sixth to fourth as 'Best' and the third to first as 'Corrupt'. As late as 1896 C.H. Smith could, in all seriousness and without anticipation of any kind of criticism or ridicule, name the volume of the British Museum's *Catalogue of Vases* which deals with the red-figure vases of fifth-century Athens *Vases of the Finest Period*. The sequel to this volume (by A.B. Walters), devoted to fourth-century and Hellenistic wares, was rather flatly and dismissively entitled *Vases of the Latest Period*. Although Hellenistic history and literature became respectable fields of study at least from the mid-nineteenth century, as did the major scientific advances of the age, it took longer for Hellenistic art to gain appropriate recognition. Only really in the last thirty or forty years of the twentieth century, partly because of new archaeological discoveries of Hellenistic sculpture and partly through the questioning of received opinions and a natural desire to explore new fields of study, has Hellenistic art become a legitimate and indeed popular area of research. As a result, instead of being seen as a degenerate let-down after the art of the Classical period, great progress has been made in understanding later Greek art in its own right, in seeing it as different from, rather than inferior to, that of the Classical period. Nowadays, while the debt of Hellenistic artists to their Classical predecessors can still be recognized, the innovations of the period, along with its great influence on Roman art, can also be appreciated and assessed.

In recent years many distinguished scholars have tried to characterize the principal features of Hellenistic art. The reasoned subtleties of their theories are lost in selective précis and quotation, yet even this can give some idea of the complexity of the subject, and of the almost universal scholarly agreement as to its close dependency on contemporary political, social and intellectual conditions. C. Havelock, the first twentieth-century scholar to devote a whole book to the subject, declares that 'Variety and diversity are the keynotes of Hellenistic

art'.[4] For J. Onians,[5] it overwhelmingly reflects current philosophical and scientific theories, especially the Hellenistic desire to explain and categorize all aspects of experience. J.J. Pollitt,[6] in what remains the single most helpful, comprehensive and authoritative book on the subject, isolates five attitudes of mind that he feels constitute the spirit of the Hellenistic age and inform its art: an obsession with fortune, the theatrical mentality, individualism, the cosmopolitan outlook, and the scholarly mentality. E.D. Reeder[7] stresses the widened range of subject matter, and like Pollitt sees many of the preoccupations of the age reflected in its art: she emphasizes the influence of the courts and notes the new market for luxury goods in court circles. R.R.R. Smith believes the Hellenistic period was 'a time of major innovation' and picks out variety, subtlety and complexity as the 'foremost qualities of Hellenistic sculpture'.[8] A. Stewart sees Hellenistic art as 'protean and unstable largely because the society that sustained it is insecure, shifting and divided'.[9] C.M. Robertson, on the other hand, has characteristically chosen to make a stand against the general desire to stress the new, exotic, revolutionary, socially and politically determined nature of Hellenistic art, and has ventured the opinion that many of the essential characteristics of Hellenistic art would have happened regardless of the historical events of the era – 'Much of what happened in art in the Hellenistic period is development inherent in the art itself …'[10] – and this, too, is a point of view that must be heard.

As it is perfectly easy to embrace most, if not all, of these definitions and opinions, it would clearly be both rash and premature to offer others at this point. Instead, however, a few preliminary generalizations may help to set the scene for the chapters that follow. And the first point to be reinforced is that many of the characteristics of Hellenistic art have no clearly defined starting point, with several of them incipient in the early and mid-fourth century BC. On the fringes of the Greek world at this time, for example, most notably in Lycia and Caria, there are several examples of architectural self-aggrandizement on the part of local rulers that clearly anticipate the self-glorifying tendencies of the Hellenistic kings. The Nereid Monument at Xanthos, for example – the tomb of a Lycian ruler dated to the early decades of the fourth century BC – takes the form of an Ionic Greek temple on a high, Lycian form of podium, decorated with Greek-style sculpture that combines both Greek and oriental iconography (fig. 4). Already, then, Greek and oriental elements are blended and Greeks are working overseas, beyond the traditional confines of the 'proper' Greek world, in the service of rich foreign patrons. The mid-fourth-century Mausoleum at Halikarnassos, again, in its vain-glorious concept and its position,

OPPOSITE:
4 The Nereid Monument at Xanthos is the tomb of a local Lycian ruler, probably built c. 400 BC. The façade resembles that of a contemporary Greek temple and the Nereids are also very Greek in style. The high podium, however, like the style and subjects of some of the friezes, reflects purely Lycian traditions.

INTRODUCTION

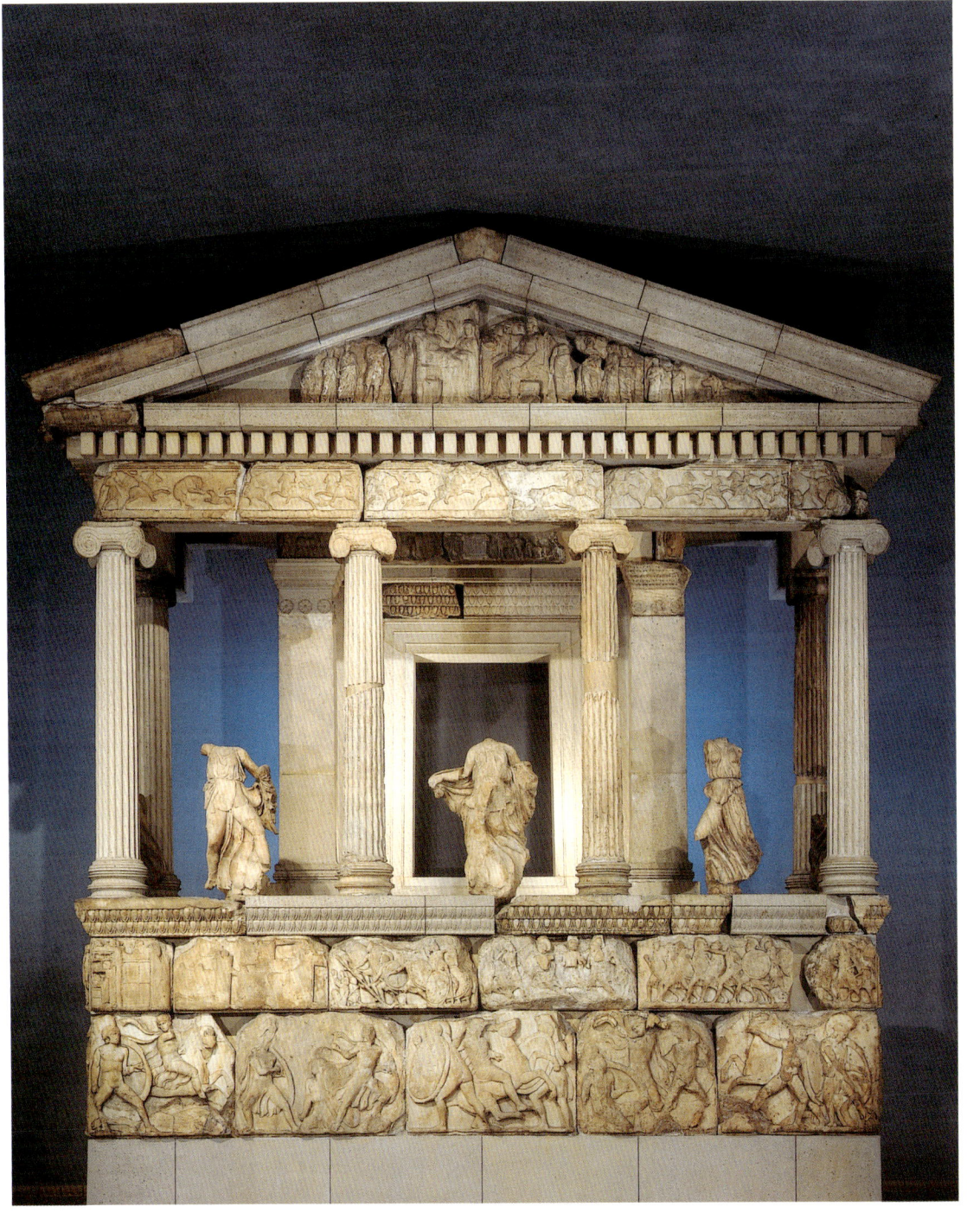

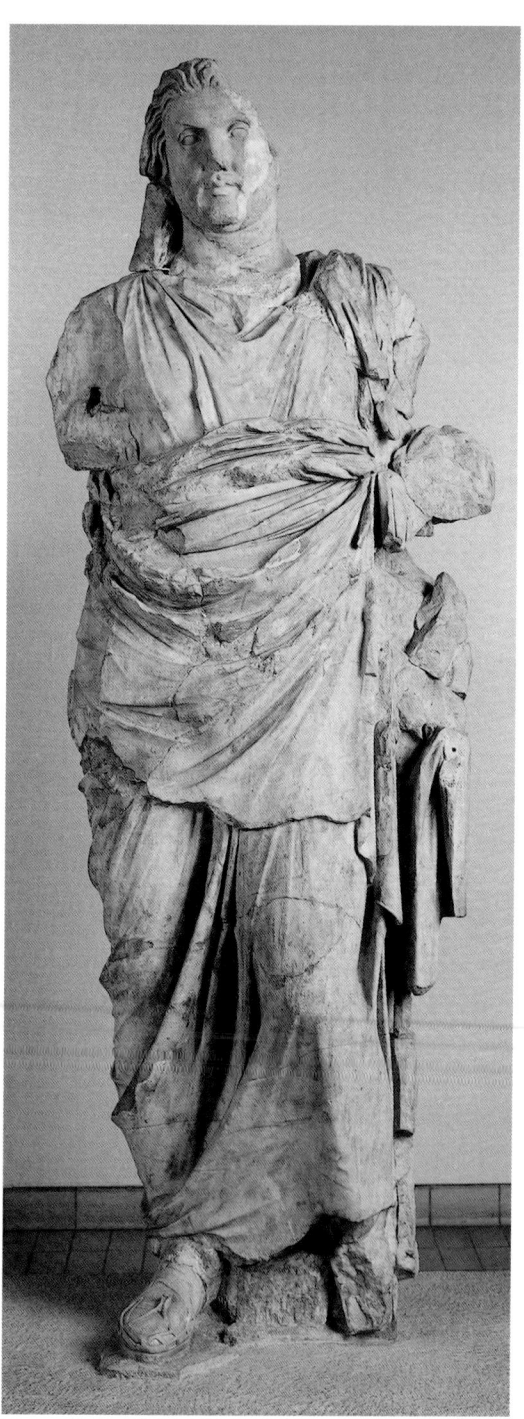

dominating the natural theatre of Mausolos's new capital, anticipates both the aims of personal self-promotion and the careful staging of later Hellenistic rulers' cityscapes (fig. 5). The way the Mausoleum combines Greek, Near Eastern, and Egyptian elements also prefigures the blending of Greek and 'foreign' elements typical of some Hellenistic monuments. At the same time, in their geographical position, both the Nereid Monument and the Mausoleum anticipate the eastward shift of the cultural and political power centres of the Hellenistic Greek world.

Secondly no-one could deny the sheer variety inherent in Hellenistic art: contributing to and feeding from this are both its internationalism and its eclectic blend of the traditional and the new. Both these characteristics are mirrored in Hellenistic literature. Where Classical literature is dominated by Athens – in the fifth century by the three great tragedians, in the fourth by Plato, Aristotle and the orators – the great poets and writers of the Hellenistic world came from far and wide. Although many of the best known ended up living and working in Alexandria, where the Library and the patronage of the Ptolemies ensured exceptionally congenial conditions, Callimachus was a native of Cyrene in North Africa, Theocritus came from the Sicilian city of Syracuse, and Apollonios from the East Greek island of Rhodes. Much the same contrast can be observed with the known artists and craftsmen of the Classical and Hellenistic periods. Most Classical sculptors came from mainland Greece and many trained or worked in Athens; but in the Hellenistic period they were just as likely to come from Alexandria, Rhodes or further east. The continuity in tradition was also a feature of both literature and art. At Alexandria transcribing and establishing authoritative texts of the great Classical authors was a major industry. The equivalent in

the visual arts was the copying of famous works of Classical sculpture: both activities surely offered a means, in an expanding and changing world, of affirming Greek identity and of marking continuity with a great tradition.

The subjects of Hellenistic poetry, as of Hellenistic art, were a combination of the old and the new. Just as sculptors might revisit many of the same subjects that their predecessors had treated, while at the same time creating truly innovative work, so many poets still found inspiration in the Homeric poems, and many wrote epic verse alongside new forms of poetry. Traditional epic themes such as the story of the Argonauts were recycled by some poets, while others experimented with new subjects, many of them rare and recherché, bizarre, shocking or ambivalent: at the same time 'ordinary' people, especially country-dwellers, shepherds, goatherds and fishermen, became for the first time principal subjects of literature. The choice of this sort of subject was very characteristic of Theocritus, but avoidance of the beaten track was most self-consciously claimed by Callimachus:

'… don't seek from me the thumping song:
thunder is not my part, that is for Zeus.
The very first time I put my tablet on my knee
Apollo said to me, the Lupine god,
"Poet, make your sacrifice as fat as you can,
but keep your Muse slim.
I say this too: where the wagon does not trample
there you should tread, not by others' common tracks
nor on the broad highway, but on unworn paths.…"'
(*Aitia*, Fr. 1, 21–8)

Callimachus was criticized in his own lifetime for the superficial and trivial nature of his poetry; but his work has survived to the present day, while almost all the heavier-weight 'epic' writers of the age are practically unknown. In artistic terms, the continuity between the Classical and Hellenistic periods in social and religious practice meant that many of the traditional subjects of Classical art were still an important part of the Hellenistic repertoire, with continuing demand for many of the same sorts of product. In sculpture, for example, the need for cult statues of the traditional gods, images of victorious athletes, or Victory herself, remained constant; and just as in fifth-century Athens, so too in second-century Pergamon heroic scenes of the battle of gods and giants might still be chosen to express the triumph of civilization over the

OPPOSITE:
5 Formerly believed to represent Mausolos himself, this rugged and powerful-looking individual is now believed to represent an unknown member of the ruling dynasty of Caria: large numbers of these monumental figures ringed the podium of the Mausoleum, emphasizing Mausolos's power and importance. Height 3 m.

barbarian. But alongside these age-old subjects new themes were introduced, some corresponding once again to the new interests of Hellenistic poetry. New gods such as the Egyptian Serapis entered the repertoire; the female nude, found only occasionally in the Archaic and Classical periods, now became firmly established alongside her male counterpart (fig. 6); relatively obscure episodes of mythology, such as the legend of Telephos, appeared alongside the better-known stories. New sorts of characters, from people of different races to nursemaids, fishermen, drunken old women and hunchbacks, appeared for

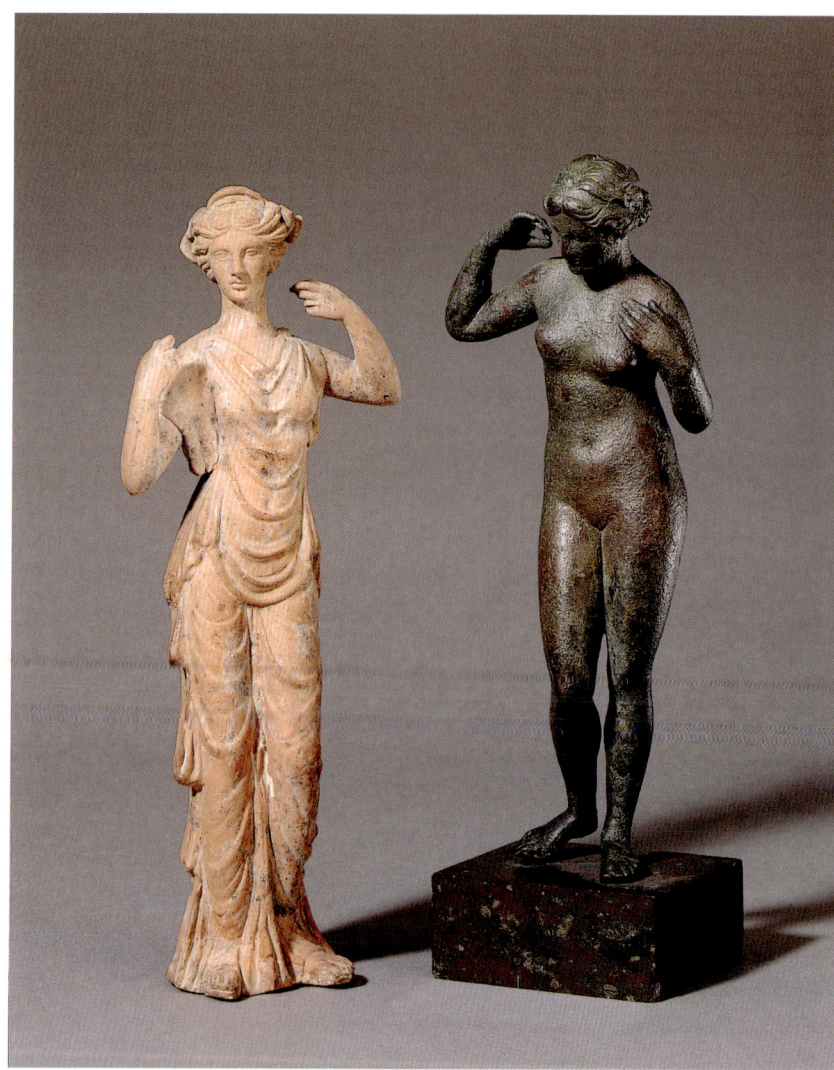

6 Aphrodite, goddess of love, was reproduced in many types, sizes and materials in the Hellenistic period. Both these versions, one naked and the other clothed, show her with hands raised to tie up her hair. The place of manufacture and findspot of the bronze figure are unknown. The rather elongated terracotta version with its distinctively looped and swagged drapery was made at Myrina in Asia Minor in the late first century BC or the first century AD. On the back is the signature of the coroplast (terracotta-maker) Menophilos. Height of terracotta 28.4 cm.

practically the first time in art, as did the embodiments of such literary conceits as Kairos (Chance or Opportunity). Even surprising new *sizes* of art works began to sprout. At one extreme were created individual extravaganzas on a larger scale than ever before – the colossal statue of Apollo erected beside the harbour of Rhodes to celebrate the city's success against the siege of Demetrios Poliorketes in 305 BC, one of the Seven Wonders of the Ancient World, is the most famous example of work on a gigantic scale (though typically unclear in its specifications). But at the same time, pocket-sized versions of some popular works – some of the Lysippan Herakles figures (fig. 7), for example – were also available to serve as decorations for the table, dedications in sanctuaries, or offerings for the grave.

In terms of architecture it had been common enough for many of the Classical city-states to erect fine public buildings on as grand and lavish a scale as their treasuries could afford. But the existence in the Hellenistic period of competitive monarchies, the establishment of new centres of power, and the struggles of the rival monarchs to assert their wealth, power and cultural superiority, encouraged a new proliferation of elaborate and carefully integrated city developments; and the scale and cohesion of such planned developments as that of Pergamon was a novel phenomenon for the ancient Greek world.

Naturally, the traditional materials of the Classical world – bronze and precious metals, clay and marble – remained in common use. It does seem, however, that there was much more colour, and more variety of colour, in the Hellenistic world. Multicoloured mosaics, the finest made up of tiny squares of various materials, developed from the monochrome pebble pavements of earlier times; gold jewellery was enhanced with multicoloured precious stones. Occasional pieces of cream or vivid

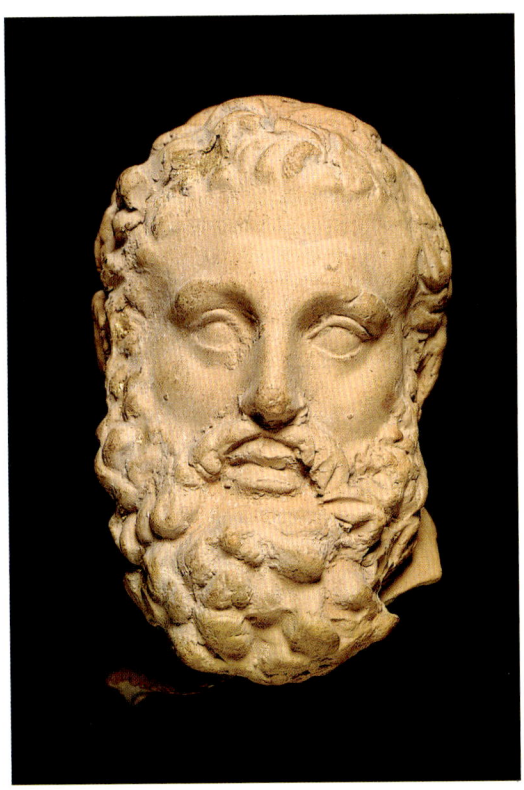

7 Terracotta head of Herakles, probably from a full-length miniature version of one of Lyisppos's famous Herakles figures. Made at Smyrna in Asia Minor in the first century BC or AD. Height 6.4 cm.

turquoise faience, worked principally in Egypt, contrasted with the standard black or clay-coloured pottery, while a major innovation in tablewares was the development of new techniques for the production of glass, wrought in a variety of colours and ever more complex patterns. It is particularly in small-scale work such as pottery, glass, jewellery or terracotta figures that technical virtuosity and innovations are most readily to be seen (fig. 8). The rulers of the Hellenistic kingdoms took the lead in commissioning luxury articles that would demonstrate their wealth and taste, and their example was followed by their subjects.

Stylistically the expanded boundaries of the Hellenistic world and the greater mobility of artists and craftsmen from one area to another in search of work led on the one hand to increased regional diversity and the admission of exotic foreign influences to native Greek styles, and on the other to the establishment of a common voice, an artistic equivalent of the linguistic *koine*, in which strikingly similar images and styles could be seen and practised in as far-flung corners of the world as Athens, Pergamon and Alexandria. Traditional Classical styles never completely disappeared. But alongside them were experiments in more novel approaches, most notably and especially in sculpture with the development of an elaborate, highly wrought and emotional style, sometimes described as 'Hellenistic baroque'.

In this general introduction, the hope is that newcomers to the subject will be equipped both to recognize the role played by an individual object in the overall kaleidoscopic patterns of the Hellenistic world and to gain an impression, however fragmentary, of the patterns themselves and the factors by which they were influenced and formed. It is not easy to present Hellenistic art in a manner both logical and meaningful, one that will order without

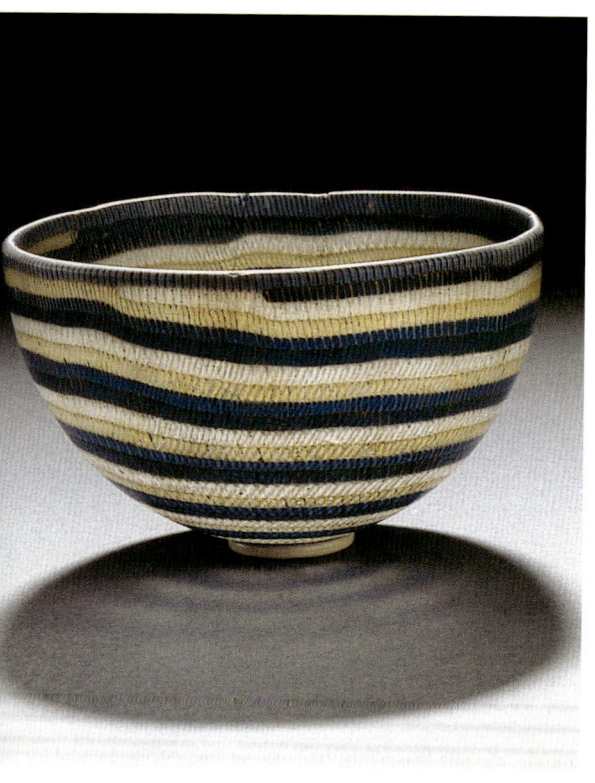

8 Mosaic glass bowl made up from canes of spirally twisted threads of different colours laid in concentric circles. Made in the eastern Mediterranean in the second century BC; said to be from Crete. Height 6 cm.

repressing its variety and exuberance. A strictly chronological approach would clearly be impractical, and while a regional study might have certain advantages, given the transfer of some forms or styles of art across the Hellenistic world, it would inevitably prove repetitious. To divide the art up by material or category, such as sculpture, jewellery or architecture, would obscure the detection of links between materials, or the relation between the product and its geographical or social context and purpose. For all these reasons a flexibly thematic approach seems preferable. The following chapters will take as their principal areas of investigation the representation of the individual; the visual appearance of the public areas of a Hellenistic city or sanctuary; the decoration and equipment of the private space in a Hellenistic house or tomb; aspects of Hellenistic iconography, especially in the decorative arts; evidence for the lives and working practices of Hellenistic artists and craftsmen; and the influence of Rome on Hellenistic art – and of Hellenistic art on Rome. Wherever possible, examples will be drawn from the rich collections of the British Museum so that this book may serve to introduce these collections as well as the wider subject; however, in order to provide a representative overview of Hellenistic art it will be necessary also to refer to sites and objects in other countries and museums. Throughout the book the emphasis will be on trying to see the art and artefacts from the point of view of the people who commissioned, made, and above all used and experienced them. We shall start the exploration, however, by setting the scene in fourth-century Macedon, source and cradle of the Hellenistic world.

Chapter 1

Intimations of Opulence: Macedon and the fourth century BC

'Do you think that the Persians, or the king of the Persians, or the Macedonians, or the king of the Macedonians, even if one of the gods had prophesied the future for them, would ever have believed that the very name of the Persians would have vanished utterly – they who were masters of the whole world – and that the Macedonians, whose name was scarcely known earlier, would now rule over all?' (Polybios 29.21.3–6)

In several areas of the Greek world, cultural and artistic developments in the fourth century BC appear, in retrospect, to be preparing the way for what are frequently regarded as the achievements of the Hellenistic period. In the production of gold jewellery, for example, many of the hallmarks of the Hellenistic age – including ornateness of design and technical virtuosity – were actually the achievements of the mid-fourth century, a time of considerable wealth for many parts of the Greek world. In the north Pontic cities on the shores of the Black Sea some of the vast wealth of the kings and nobility of the corn-rich Bosporan Kingdom was deployed – probably indeed quite literally melted down – to produce some of the finest jewellery ever made, brought to light in the excavation of rich tombs at Kul Oba and elsewhere. These masterpieces, some of which are thought likely to be the work of Athenian emigrants, include large circular disc earrings, from which hang boat-shaped elements loaded with festoons of chains, and seed- and amphora-pendants, each assemblage richly adorned with intricate filigree and granulation work, and incorporating beautifully twisted and

'knitted' chains of fine gold wire. This workmanship was equalled elsewhere: in southern Italy tombs not only in wealthy Greek cities such as Taranto but also in more remote parts of Calabria have produced assemblages of gold jewellery of superlative quality and style. The same is true of the Greek cities of the eastern Mediterranean, released from the exacting tyranny of Athens by its defeat in the late fifth century to enter a new period of greater wealth and prosperity; here, too, in Rhodes, Caria, Aeolia or Ionia, gold diadems and intricate personal jewellery have been found in considerable quantities (fig. 9).

Macedon is another area that was entering a period of increased prosperity in the fourth century BC, one of several reasons why it makes sense to start this survey of Hellenistic art here. Macedon's two great mid-fourth-century kings, Philip II and Alexander III, were jointly responsible for the chain of events that led to the creation of the new social and political order of the Hellenistic world. Furthermore, Macedon, hitherto on the fringes of the Greek world, provides the earliest example of the Hellenistic tendency for political dominance to be accompanied by a wave of cultural, especially artistic, expansion. Above all, Macedon is the first area in which many of the themes and motifs that come eventually to characterize the art of the developed Hellenistic period may be detected – among them personal opulence and its display, linked

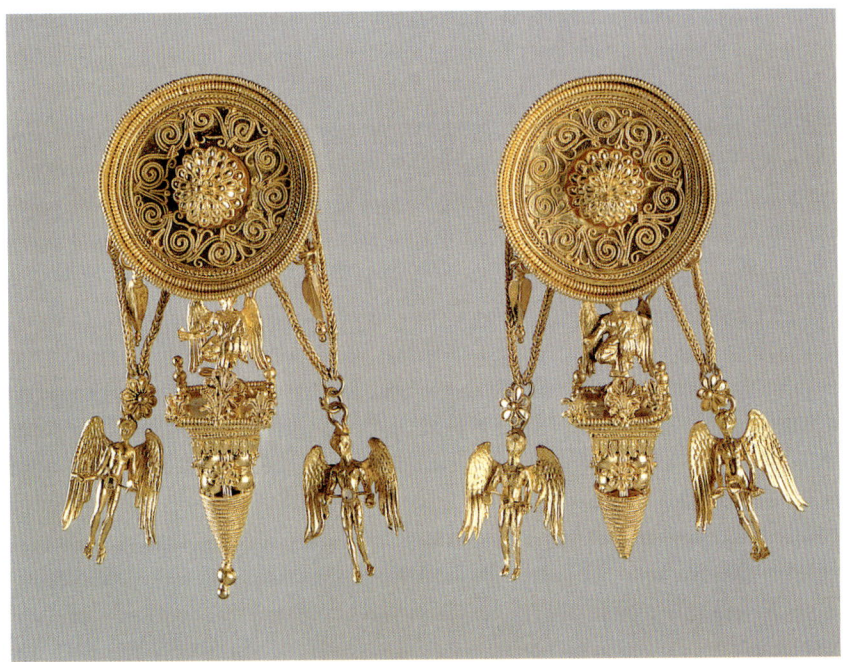

9 Pair of elaborate gold earrings in the form of large and ornately decorated discs. Below each disc is suspended an inverted pyramid on top of which crouches the figure of Nike (Victory), flanked on either side by figures of Eros playing with a magic wheel, a *iynx*. Made in Asia Minor, c. 340–300 BC. Diam. of disc 2.4 cm.

to the deliberate development of a royal style, selective blending of styles, and the admission of eastern influences into local traditions.

The geographical position of Macedon, far to the north of the dominant Greek states of the Archaic and Classical Greek world, had led not exactly to the country's isolation from mainstream Greek culture and affairs, but perhaps to a rather marginal status as regarded participation in common Greek endeavours and traditions. Through both choice and necessity the Macedonians had as much contact with the Thracians and other northern and further eastern neighbours as with the southern Greeks. It is by now impossible to say whether the ancient Macedonians were ethnically different from the Greeks. The language spoken by ordinary Macedonians, as opposed to the ruling family, seems at most times to have been a dialect form of Greek; the élite communicated both with itself and with other élites in standard, probably Attic Greek. Their common language notwithstanding, it certainly seems that the other Greeks regarded the Macedonians as separate or different, even before Philip's plans to unite the rest of Greece under Macedonian control had aroused the vituperative hatred of such enemies as the Athenian statesman and orator Demosthenes.[1] We know that several Macedonian kings made efforts to assert their Greek ancestry and deliberately to foster Greek culture in Macedon, and this too suggests that at times they felt their difference and took steps to minimize it. The first king known to have acted decisively in this way, according to the Greek historian Herodotos, was Alexander I, who claimed admission as a Greek to the Olympic Games, probably in 476 BC, presenting a genealogy that traced his descent from the Temenids of Argos. His claim was successful and he was allowed to compete, but many of the other competitors were outraged. Although several of Alexander I's successors both established diplomatic relationships with individual Greek city-states and participated in the wider international scene of the fifth century BC, we do not hear of other Macedonian competitors in successive Olympics. The fact that King Archelaos, in the late fifth or early fourth century BC, established an alternative Olympic Games at Dion rather suggests that Macedonians were not made welcome at the grand Peloponnesian festival. It was, perhaps, the extremely phil-Hellenic Archelaos who prepared the ground for the astounding blossoming of Macedonian-Greek culture that seems to have taken place under Philip and Alexander. Establishing a new royal capital at Pella, he is said to have commissioned Zeuxis, one of the leading Greek painters of the day, to decorate his new palace; he also invited prominent Athenian poets and playwrights, among them the tragedians Agathon and Euripides, to live and work there. After the death (by assassination)

of Archelaos, the first half of the fourth century in Macedon was largely taken up by civil war, foreign invasion and anarchy. Yet we still hear of the fondness for Greek culture of Philip II's brother and predecessor, Perdikkas III, as shown, for example, by his appointment of a court philosopher chosen from the Academy in Athens. Philip himself, therefore, did not assume the throne of a country entirely devoid of social or cultural links with the rest of Greece.

In recent years rapid progress has been made in revealing and interpreting the material culture of Macedon before the mid-fourth century BC. There is still very little trace of monumental architecture, apart from some fine architectural fragments believed to have belonged to an Archaic Ionic temple at Therme, the city that preceded Thessaloniki at the mouth of the Saronic Gulf. Otherwise, no great temples or sanctuaries have been found in Macedon comparable with those elsewhere in the Greek world. It is clear, however, from the graves excavated in the early 1980s at Sindos in the Chalkidiki peninsula, that some of the Archaic and early Classical inhabitants of Macedon enjoyed a very high standard of living, and that there was a firmly rooted tradition of craftsmanship, especially of metal-working, from the Archaic period onwards. In these graves imported material includes painted Athenian vases and terracotta figures from Rhodes and the east, but alongside these are many locally made artefacts. Particularly remarkable are the metal objects, which range from items of gold jewellery of superlative quality, such as pins or earrings covered in intricate designs executed in granulation and filigree, to gold death-masks, finely worked bronze helmets (sometimes edged with gold sheet) and vessels, and, in iron, model carts, chairs, tables and spits for roasting meat. These tombs contain far more costly and elaborate items than anything found in contemporary southern Greek cemeteries. They testify not just to the wealth of the inhabitants of Sindos, to their contacts with the wider Greek world and to their own skills, but also to their strong belief that the dead would require gold jewellery, banqueting equipment and furniture in the afterlife.[2] The excavations in the 1970s of the Great Mound at Vergina, culminating in the momentous discovery of several royal tombs (see below, pp. 33–42), were also important for their revelation of numerous fragments of fine, mostly painted grave *stelai* (markers) of the fifth and earlier fourth centuries BC, very comparable in terms of style and quality with contemporary sculpted examples from Athens. Thus the great finds of mid-fourth- and early third-century Macedon, both the many wealthy burials, and the traces of fine palaces and private houses, should not be seen as a new and totally unexpected phenomenon, but rather as the opportunistic development of pre-existing traditions, technical and artistic skills.

Late Classical to early Hellenistic tombs

Macedonian tombs of the late fourth and early third century BC are astonishing in their profusion, their architectural elaboration and the richness of their furnishing. In all these respects they present a great contrast with the comparatively restrained burials known from most parts of the Greek world in the earlier Classical period. It has been argued that the apparently sudden and dramatic proliferation of rich burials in Macedon from about 330 BC onwards reflects the wealth and new ideas of veterans returning from Alexander the Great's campaigns in the east. While there may be some truth in this, as suggested above the tendency towards extravagant display can already be detected earlier in Macedon. It is difficult to say exactly how many rich tombs of the late Classical period have so far been found, as discoveries continue to be made at a rapid pace, but already they number in their hundreds. They are found throughout Macedon, placed singly or in small clusters, generally near to known centres of population and often set alongside ancient roads.

The earlier and simplest types are the so-called 'cist' tombs – rectangular stone boxes constructed as graves for either inhumations or cremations in many parts of the Greek world. The Macedonian examples vary in size and in the elaboration of their decoration and equipment: many but not all have plastered and sometimes painted walls and floors. A rich cluster of tombs was found in 1962 at Derveni in the territory of the ancient Macedonian city of Lete, on a strategically important pass beside the modern (and ancient) road between Thessaloniki and Langadas.[3] Here four cist tombs were discovered intact, and two of them contained exceptionally rich burials. Tomb A, the walls of which were plastered and painted with decorative floral and coloured bands, was crowded with numerous pots of clay and bronze, jewellery and other objects, including a fragmentary papyrus bearing an Orphic inscription. The cremated remains of the dead person were contained in a bronze volute *krater* (wine bowl), along with parts of a gold oak wreath and also a wooden wreath stem with gilded bronze leaves and berries of gilded clay; a cloth had been wrapped around the neck and shoulders of the vessel.

Tomb B contained a similar but even richer array of objects, the most remarkable among which was a large and ornately decorated bronze volute *krater* containing the burnt bones of a man and woman, wrapped together in a cloth. This, the so-called 'Derveni *krater*', is 91 cm high and, like many of the bronze vessels in these tombs, at first sight looks like gold, an illusion deriving from the unusually high tin content of the bronze (fig. 10). Some details of the

INTIMATIONS OF OPULENCE

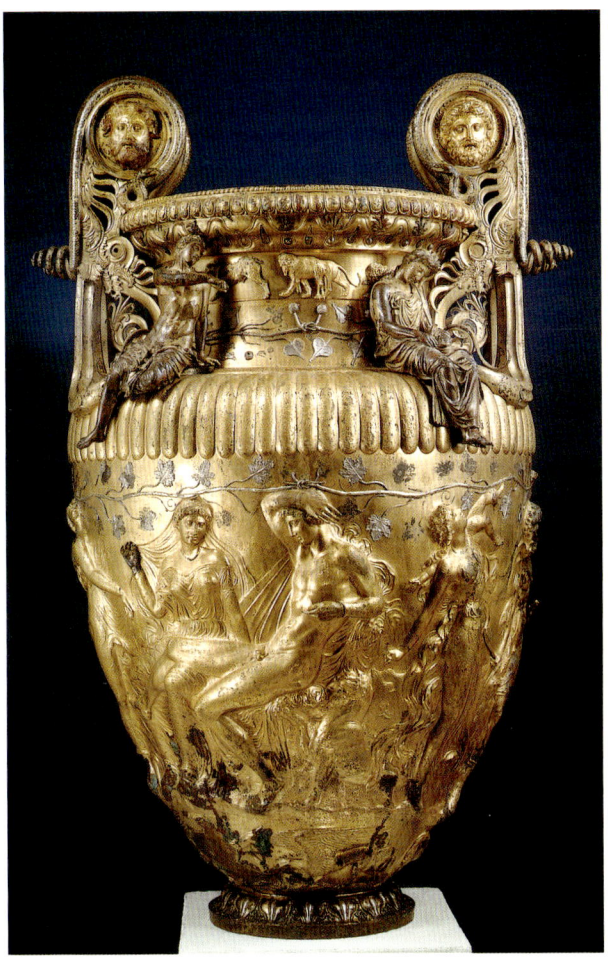

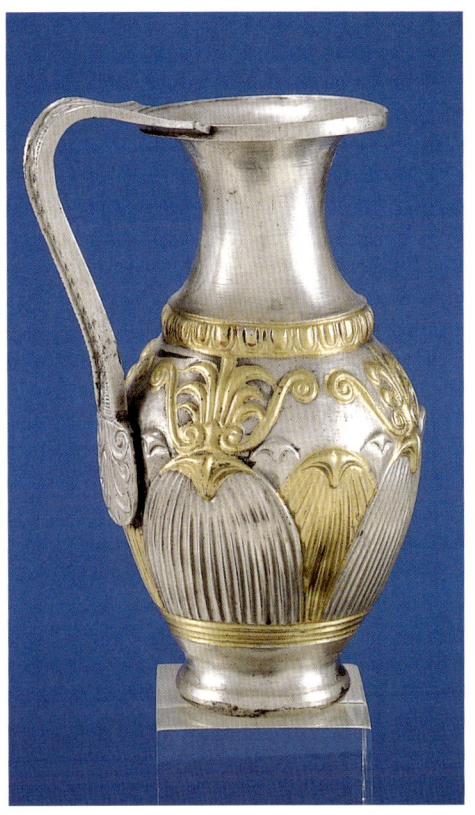

10 The 'Derveni *krater*', a large bronze wine bowl decorated with a Dionysian frieze raised in low relief and with separately cast figures attached to the shoulder. In the tomb this bowl was used to hold the ashes of the deceased person. From Derveni, Macedon, c. 340 BC. Height 91 cm.

11 Silver-gilt jug from Derveni, one of many beautiful vessels found in the same tomb as the *krater*. c. 340 BC. Height 13.6 cm.

krater's design, such as the ivy leaf and berry garland on the neck, or the vine wreath above the main figure scene on the body of the vase, are added in silver. Silver is also used for the (Greek) inscription at the rim, which may be translated 'Astion, son of Anaxagoras, native of Larisa' – but whether Astion was the maker or the owner of the vase is quite unknown. Thessaly, where the city of Larisa lay, was controlled by Macedon for much of the fourth century BC, and in 344 BC Philip II took hostages from one of the aristocratic families of Larisa which had taken part in a bid for independence; it is therefore just possible that the presence of this vase in a Macedonian tomb might in one way or another be associated with this event. The body of the vessel bears a scene executed in repoussé technique – that is, hammered through from the back so that it

appears in relief on the front – of Dionysos seated with Ariadne, accompanied by satyrs and maenads in various attitudes. Subsidiary animal friezes run below the main scene and the rim: the volute handles are masked with four bearded heads; and four seated figures, Dionysos, two maenads and a satyr, cast separately and fully in the round, sit or recline on the shoulder of the vase at each side of each handle. The mouth of the vase was fitted with a strainer to catch wine dregs and prevent them from entering the vessel, though a thin layer of wax on the inner walls, left over from the manufacturing process, shows that it was never used other than as a funerary vessel and was brand new when laid in the tomb. While any Dionysiac theme is suitable for the decoration of a vessel whose primary function was to hold wine, the sacred wedding of the wine god and Ariadne made a particularly appropriate subject for a funerary urn, connected as it was in Greek thought with views of life after death. Some scholars have suggested that the *krater* was made in Athens, or even in southern Italy, but careful examination of the ever-increasing number of metal vases found in Macedonian tombs and the tentative identification of various workshops suggests it is much more likely to have been made locally.

Other items in the tomb included bronze greaves, spear-heads and a leather breast-plate covered in bronze scales. The silver vessels are particularly fine, including a beautiful *oinochoe* (jug) with lotus leaves rising from its base (fig. 11) and an elegantly fluted silver *phiale* (libation bowl): both these items suggest the influence of eastern, probably Achaemenid, workmanship. While the majority of the grave goods seem more suitable for the male than the female occupant of the tomb, there were also three small bronze vessels containing coloured pigment and two bronze spatulas for its application, perhaps placed there for the (symbolic) use of the woman.

A very distinctive picture emerges from the grave offerings at Derveni where some objects, notably the pottery, were imported from major artistic centres in southern Greece, especially Athens, while the majority were locally made under the mingled influence of mainland Greek and further eastern styles and prototypes. In noting this, the publishers of the Derveni tombs suggested that this eclecticism is a 'recognisable diagnostic element of an art occurring within the geographical boundaries of the Macedonian Kingdom; it may be called "Macedonian"'.[4] It is also an early example of trends and characteristics that may properly be called 'Hellenistic'.

Also found at Derveni was an example of the so-called 'Macedonian' type of tomb, characteristic of which is a more or less elaborate architectural façade, with one or two barrel-vaulted chambers built on behind. 'Macedonian' tombs

became increasingly common for wealthier burials in the later fourth and third centuries both in Macedon itself and in other areas of Macedonian influence. Like their contents, the imposing frontages of these tombs would only have been visible before and during the funeral rites, for the area leading up to them, like the *dromos* of the earlier Mycenaean *tholos* (beehive) tombs, would have been filled with earth once the tombs had received their occupants. A mound would then have been raised over the top, with the vaulted roof or roofs supporting the weight of the soil and minimizing the chances of collapse into the funerary chamber. No less than the contents of such tombs as those at Derveni, the architectural style of these Macedonian tombs can best be described as eclectic.[5] The combination of a Classical columned façade with a barrel-vaulted chamber illustrates the Macedonians' readiness to blend styles from completely different parts of the world. While barrel-vaulting seems to have been adopted from Persia or Mesopotamia, much of the architectural detail of the façades derives from contemporary architecture in Athens and the Peloponnese. With apparently very little in the way of a formal architectural tradition behind them, the Macedonian architects – or builders – felt free to use, in a purely decorative fashion, elements of Classical Greek architecture that elsewhere were employed in a conventional and canonical order. Moreover, the Macedonian builders had a blatant disregard for the traditional links between form and function which anticipated aspects of Hellenistic architecture. Thus the tomb façades themselves had no formal connection with the vaulted chambers behind them; the columns were generally engaged (built into the wall of the façade) rather than functioning as supports for the architrave; their spacing, like that of the triglyphs and metopes above the architrave, was arbitrary, nor did the arrangement of the frieze elements bear any relationship to the positioning of the columns. The normal Classical conventions regarding proportions were disregarded, and the façades as a whole gave only a very superficial illusion of Classical Greek architecture. In some cases the illusion was carried to a logical conclusion by painting on the architectural features rather than building them in three dimensions. In fact, painting was often an important feature of both the façades and the interiors of these tombs. The traditional pediment might be replaced by a painted frieze, or painted figures might be set between the real or painted columns of the façade. Inside many tombs the spatial illusions might be continued: there are several examples where the walls of vaulted chambers bear painted architectural details or a painted altar; even the solid fronts of the marble funerary couches might be decorated with a painted footstool.

In 1977 Professor Manolis Andronikos's painstaking examination of the

Great Mound at the modern village of Vergina finally revealed the remains of four monumental and spectacular tombs: one cist and three of 'Macedonian' type, along with a probable *heroon* (hero shrine).[6] His discovery, and his identification of the largest, intact tomb as that of Philip II, gave dramatic and highly colourful reality to the legends of Macedonian wealth and opulence. Vergina lies on the site of ancient Aigai, the capital of the Macedonian kings from the seventh to the late fifth century BC. When in the late fifth century the Macedonian capital was transferred to Pella, Aigai retained its status as the burial place of the Macedonian royal family, who continued to visit both for state funerals and for other occasions: it was in the theatre at Aigai, during an elaborate ceremony marking the marriage of his daughter Cleopatra to the king of Epirus, that Philip II was assassinated. The royal tombs lay deep beneath a great mound of earth, probably erected in about 270 BC by Antigonos Gonatas to prevent further damage after the cemetery had been ravaged by Gallic mercenaries in 274–273 BC.

The contents of the first tomb to be discovered – a large, rectangular cist or box tomb – had been plundered before the Great Mound was raised. Scraps of pottery date it to around 350 BC, and fragments of bone found in it have been identified as those of a man, a woman and a child. The walls and floor of the tomb were plastered. The lower part of each wall was painted a rich shade of red, and above it on three sides was set a narrow frieze of heraldically posed griffins alternating with lotus buds, flower calyces and palmettes: the griffins and the floral decorations are white with brown and red interior markings, while the background is a still vivid blue. The fourth, undecorated, wall is thought originally to have carried a shelf. Above the griffin dado on the other three walls were painted scenes relating to the myth of Persephone. One of the long walls bears the most detailed and best preserved of the scenes: it represents the rape of Persephone by Hades, god of the Underworld. On the other long wall are painted three seated female figures, perhaps the three Fates, and on the painted short wall is a female figure seated on a rock in an attitude of mourning, surely Persephone's mother Demeter.

The scene of the rape of Persephone is undoubtedly the finest example of monumental Greek painting so far known to have survived (fig. 12). The chariot of Hades, drawn by four plunging, galloping horses, moves rapidly to the left. At its head runs the messenger god Hermes, his distinctive staff held upright in his hand, his forehead shaded by a broad-brimmed hat beneath which he turns to look back at the chariot: his short cloak billows back towards the leading horse. Streaking down towards him from the upper left-hand corner

OPPOSITE:
12 Hades snatches Persephone up from the meadow where she has been picking flowers: detail of the painting on one wall of the so-called 'Tomb of Persephone' at Vergina, Macedon, c. 340 BC.

INTIMATIONS OF OPULENCE

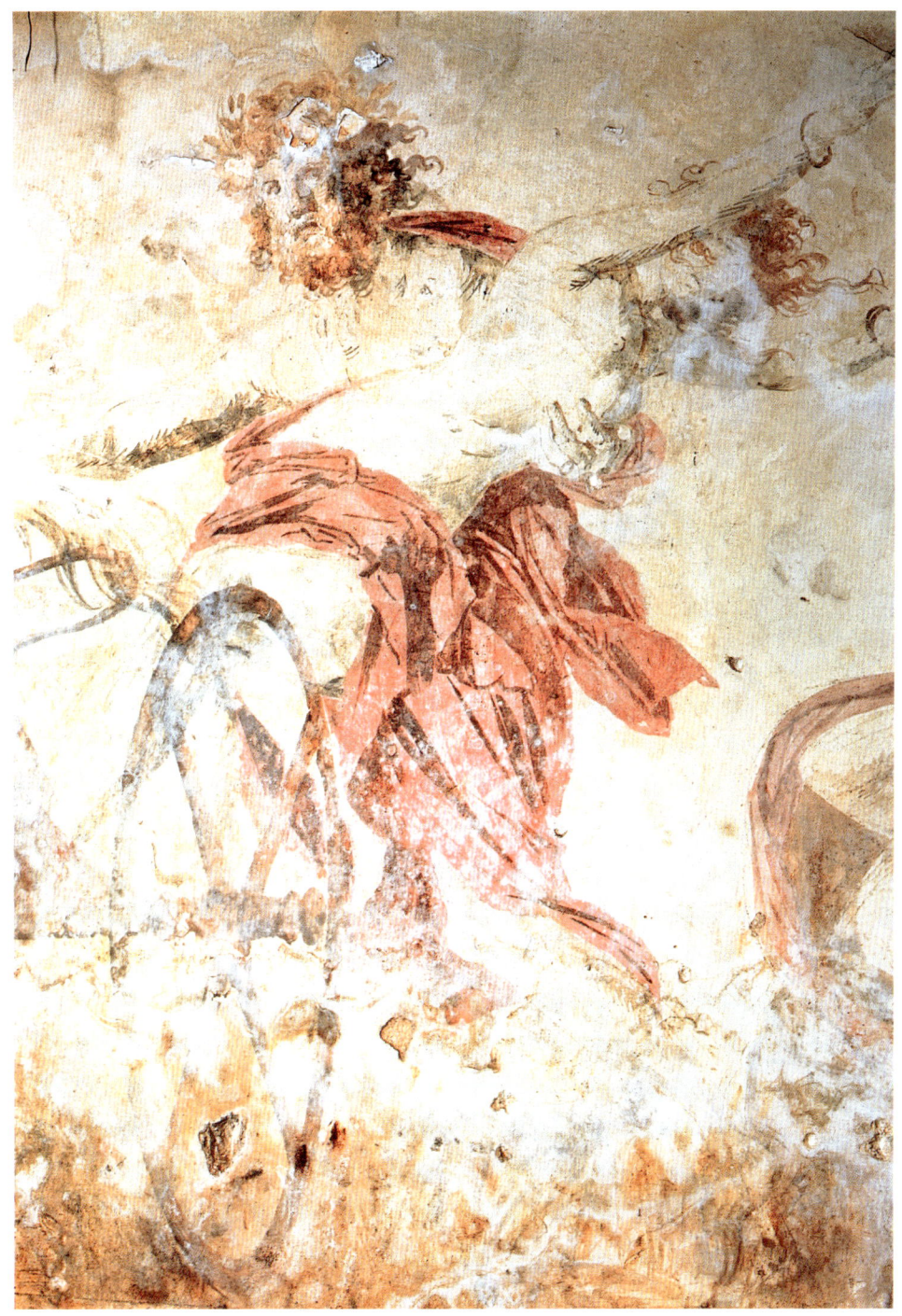

of the scene comes a thunderbolt, rendered like strands of waving hair. The chariot is shown in three-quarter view, with every detail of its wheels and box meticulously rendered. Much of the detail of the four white horses is now lost, but the mêlée of plunging legs and hooves is still powerfully visible, along with the tossing heads and tails, and the criss-crossing lines of the bridles and traces. The main focus of the scene, however, is on the two magnificently drawn figures of Hades and Persephone. Hades, his serious, grim expression framed by a mass of wildly curling hair and beard, stands in his chariot and manages with his right hand to retain his sceptre, hold on to the rail and control the horses; his left arm supports the wildly flailing naked body of Persephone, his hand clamped firmly on her left breast. She, desperate to escape but powerless in his grip, seems at once to struggle and collapse: she flings herself back perilously into space behind the chariot, her arms reaching out in a hopeless appeal for help. The swathe of wind-blown drapery wrapping itself across the lower part of her body belongs to Hades's cloak; another swathe passes round the god's shoulders while the bulk of it swirls off behind the chariot wheels. Their sharing of this garment locks their destinies together: it underlines the tightness of Hades' grip and the impossibility of his victim's escape. Persephone's expression is set rather than anguished; and the waving locks of her hair, flying out uncontrollably behind her head or streaked across her face, seem to emphasize her extreme helplessness. Crouching on the ground behind Persephone is another young girl, presumably one of her companions. She turns to look up at the abduction, sheltering or shading her face and expressing her horror by the gesture of her raised right hand.

Like the technique used to decorate Athenian white-ground *lekythoi* (tall, cylindrical oil flasks) of the late fifth century BC, the painting here relies largely on the use of line, with added washes of colour for some areas. Much of the scene is left in the natural white-ground of the plaster background, against which the brown outlines of the figures show up well. The preserved colours, used mainly for garments or parts of the chariot, are rich shades of red, brown, yellow and purple. Although they are now less vivid than they would once have been, they stand out well against the white background and set off the reserved areas of the scene. The artist was skilled at suggesting, through deepening or lightening the areas of colour or adding deft strokes of shading, the effects of light and shade.

Everything about this painting is of superlative quality – the design, the execution, the impression of rapid movement, the feeling of terror. One especially rare and interesting feature is the survival of detailed preliminary sketch

lines roughing out the whole scene. Rather like the preliminary lines observable on some black- and red-figure vase paintings, these have survived as indentations in the plaster, showing that they were carried out with a sharp incising tool while the plaster was still damp. Professor Andronikos has argued that these sketch lines show the work is the original composition of a talented artist, rather than a mechanical copy. He suggests the artist could be Nikomachos, named by Pliny as the painter of a version of the rape of Persephone which once hung in the Shrine of Minerva on the Capitoline at Rome, and which may be reflected in a mosaic of the second century AD, found near the Porta Portuensis in Rome. However, the association of the Vergina painting with Nikomachos cannot be proven; and while the attempt to link the painting with a 'name' and to trace the influence of its painter or subject in Roman art again anticipates aspects of the study of many monuments of Hellenistic art, perhaps it is more profitable to appreciate the painting in its own right as an indubitably original work of the mid-fourth century BC.

Although we are unlikely ever to establish the identities of the occupants of this first tomb, its proximity to the other lavishly appointed tombs in the Great Mound at Vergina makes it very probable that they were members of the Macedonian royal family. The form of the tomb is simple, but the brilliance of its painted decoration raises it high above the norm. To us it may well seem remarkable that so beautiful a painting was almost certainly designed to be seen only for a very short time: its superlative quality must surely reflect both the high status of the occupants of the tomb and the significance placed by the Macedonians on the environment of the tomb and on the quality of funerary display. It also bears eloquent testimony to the high standards and abilities of artists working in – and perhaps attracted to – Macedonia in the mid-fourth century BC.

The largest and grandest tomb in the Vergina group, this time of 'Macedonian' type, was discovered by its excavators to be intact. Its importance was immediately suggested by its grand façade, in which a great, double-leaved marble door is flanked by a pair of engaged Doric columns, below a Doric architrave and triglyph frieze. The whole is crowned not by a pediment but by a much broader frieze, painted with the once-vividly coloured scene of a hunt for a lion and other animals. Although the triglyphs are still a brilliant blue, standing out against the white of the architrave and the metopes, and further set off by narrow horizontal fillets of red above and below, the colours and outlines of the main painting, sadly, are now very faintly preserved: this is the more regrettable as the subject of the painting may well contain clues as to the

identity of the occupants of the tomb. The tomb structure behind the façade consists of a pair of vaulted chambers connected by a double marble door. The principal burial was in the further and larger chamber, where a richly decorated gold chest (fig. 13), placed in a marble sarcophagus, contained the cremated bones of a man and a gold oak wreath, which also shows signs of damage on a funeral pyre. Near it were the remains of a wooden couch, inlaid and decorated with gold, glass and ivory, including fourteen small ivory portrait-like heads; on this some of the dead man's possessions had been laid – his iron helmet, his cuirass, his sword and his diadem, symbols of military prowess and royal power. Elsewhere in the chamber lay other pieces of armour including a parade shield of gold and ivory, a bronze shield and greaves, and large numbers of beautiful silver vessels, some decorated with gold. There were silver cups, jugs, buckets, strainers, spoons – all for serving or drinking wine – and bronze vessels mainly of types used for transporting or pouring water for washing; there was also a perforated bronze lantern containing a small clay lamp. Thus all that the dead man might need for his banquets was supplied – a couch to recline on, vessels from which to drink and wash, even a source of light. The antechamber

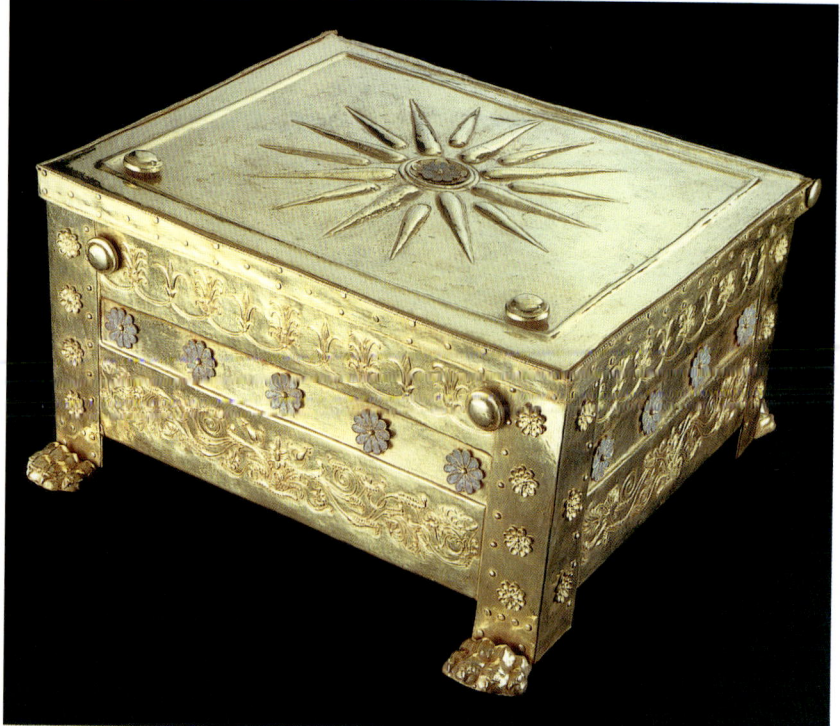

13 Gold chest from the so-called 'Philip tomb' at Vergina, Macedon. This chest contained the bones of the male occupant of the tomb, wrapped in purple cloth. The star on the lid is a very characteristic Macedonian symbol. Height 20.5 cm.

contained a smaller gold chest; inside, wrapped in a gold and purple textile, were the bones of a young woman, along with a beautiful and intricately worked gold diadem. Again, there were numerous finely made vessels of silver and bronze, and more weapons, including the remains of a wooden bow and seventy-four arrows; these were originally placed inside a leather quiver, of which only the magnificent gold cover, adorned with scenes showing the capture of a city, has survived.

The now faded painting on the façade was certainly once as spectacular as the contents of the tomb (fig. 14). A greater range of colours was used for this painting than for those in the first tomb – warm oranges, reds, browns, yellow, violet and deeper purple, along with cooler greens and blues. The composition, too, is more complex than that of the rape of Persephone scene. Ten huntsmen can be made out, three of them on horseback, accompanied by large numbers of dogs and vigorously pursuing various sorts of wild animal, among them a lion, a bear, a boar and a stag. The hunt takes place in a rural landscape. In the foreground are loose rocks, and at the right a rocky outcrop provides a retreat for a bear; trees, both live and dramatically dead, serve to punctuate and articulate the various parts of the action. In the background are indications of mountainous territory and a tall pillar, topped by three small figures or perhaps a tripod, and suggesting the location of a rural shrine. The foreground is filled with people, horses, dogs and hunted animals, some in their death throes, most at bay. Most of the hunters are naked, but two of those engaged with the grandest

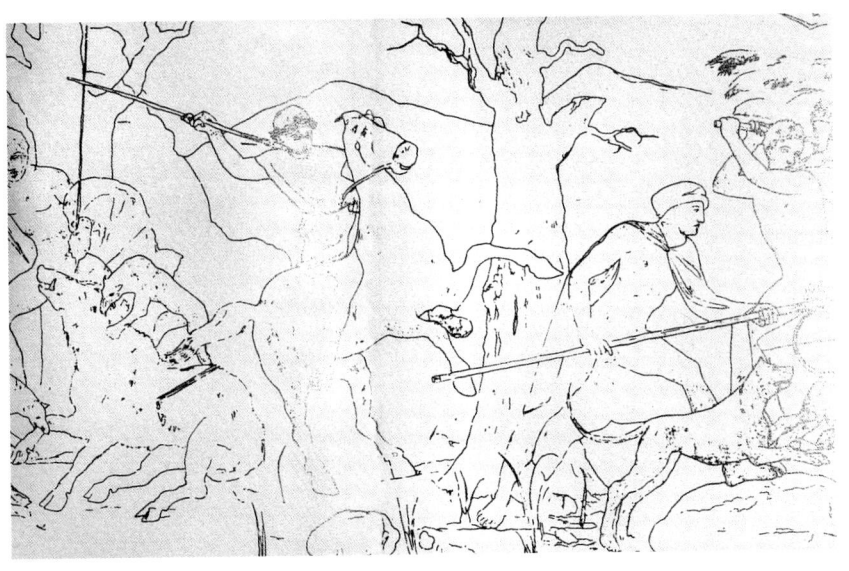

14 Detail from a drawing of the 'hunt' painting from the top frieze of the façade of the 'Philip tomb' at Vergina. Several hunters pursue their quarry in a rocky landscape: the figure on a rearing horse may be Alexander himself. Late fourth century BC.

beast, the lion, wear short purple tunics; one of these two is the only bearded figure in the scene.

There are several points of resemblance between this painting and the so-called 'Alexander Mosaic' from the House of the Faun at Pompeii (fig. 15). This mosaic, which depicts Alexander defeating the Persian king Darius, perhaps at the battle of the Issus in 333 BC or that of Gaugamela in 331 BC, has long been considered (like numerous Pompeian paintings or mosaics) to be a second-century BC copy of a late fourth-century Greek painting, perhaps that reported by Pliny to have been commissioned by Alexander's stepbrother-in-law and eventual successor, Kassander. Obviously the subjects of the tomb painting and the mosaic are quite different, and in any case the composition of the scene on the mosaic is far more complex than that of the painting, and also more internally cohesive: the painting, partly because of its frieze-like dimensions and setting, is split into a series of individual vignettes or episodes. However, the painting and the mosaic have in common various motifs, such as dead trees, broken and twisted spears, the attitude of the youthful riders who, tentatively on the painting and certainly on the mosaic can be identified as Alexander; and, most convincingly, the ambitiously foreshortened back view of a horse. Such details, if they scarcely offer proof of common authorship, must at least offer support to the general consensus that the Alexander Mosaic is in some way connected with iconography current in late fourth-century Macedon. The two scenes seem to belong to the same artistic milieu and jointly suggest the high standards of artistry current at the Macedonian court in the late fourth century BC. A second, much smaller mosaic, from a villa in Palermo, shows a lion hunt, which also has affinities with the Vergina hunt painting. Although clearly not an exact copy of the Vergina hunt – and how could it be, given that the Vergina painting was unlikely to have been visible for very long – its style and subject suggest that it too may reflect an earlier Macedonian painting.[7] Thus here again, perhaps, we can already in fourth-century Macedon anticipate the sort of influence that Hellenistic art was to have on that of Rome.

The identity of the occupants of the tomb at Vergina is still disputed. The date cannot be very precisely determined by the contents. The forms of the metal vessels demonstrate very clearly that the tomb must date to the second half of the fourth century BC; the few black-glazed or red-figured vessels in the tomb cannot be dated more closely than to before 295 BC. That the burials are royal is suggested not merely by their location, in an area where the royal cemetery is known to have been sited, but also by the richness of the funerary paraphernalia and by the iconography of the lion-hunt painting on the façade.

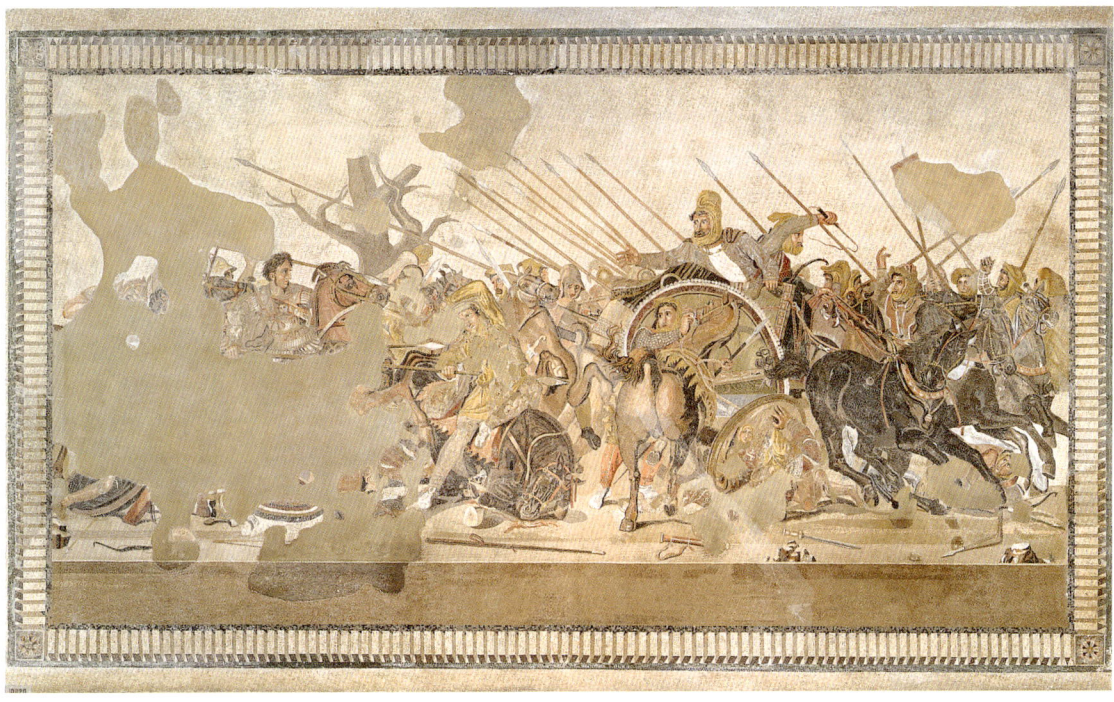

Professor Andronikos and others rapidly became convinced that the chief occupant of the tomb was Philip II. This view seemed initially to be supported by forensic work on the skull found in the gold chest in the principal chamber, which showed signs of considerable damage to the right eye and cheek: this corresponded with the historical sources according to which Philip lost an eye at the siege of Methone in 354 BC. If Philip were buried in the principal chamber of the tomb, the occupant of the antechamber could be his last wife Cleopatra, murdered by Alexander the Great's mother Olympias in 335 BC. But this view has not won universal agreement, and another possibility is that the tomb was built and equipped in 316 BC by the then regent of Macedon, Kassander, for Alexander's half-brother Philip Arrhidaios and his wife Eurydice, respectively murdered and forced to commit suicide by Olympias. There are several advantages in this second hypothesis, but the strongest arguments in its favour derive from the close analysis of the painting on the façade. Hunting wild animals on horseback was not traditionally a popular Greek pursuit. Hunting lions in particular was the sport of eastern rulers: the hunt, and still more the image of the hunt, was enthusiastically taken up by Alexander, and his successors used images of their own participation in his lion hunts as a means of establishing

15 The 'Alexander Mosaic' from the House of the Faun at Pompeii. In this dramatic scene Alexander the Great is shown vanquishing the Persian king Darius. It is likely that the mosaic reflects an earlier painting, but in any case the fact that it was thought suitable for the decoration of an affluent Roman house around 100 BC demonstrates the enduring appeal of the Alexander legend. Height 3.42 m.

and enhancing their own legitimacy. The iconographic programme of the sculpture that decorates the so-called 'Alexander Sarcophagus' (fig. 16), for example, found in the royal cemetery at Sidon and believed to have been made for Abdalonymos, the last Phoenician king of Sidon, appointed by Alexander after the battle of the Issus, includes a scene which is likely to show Abdalonymos on horseback and being attacked by a ferocious lion; behind him rides Alexander himself, recognizable by his diadem.[8]

The poor state of preservation of the Vergina tomb painting makes identification of the individual figures in the scene extremely difficult. There is, however, general agreement that unless we are determined at all costs to see the tomb as that of Philip II, the natural identification of the youthful hunter on the rearing horse to the left of the lion should be as Alexander himself. If we

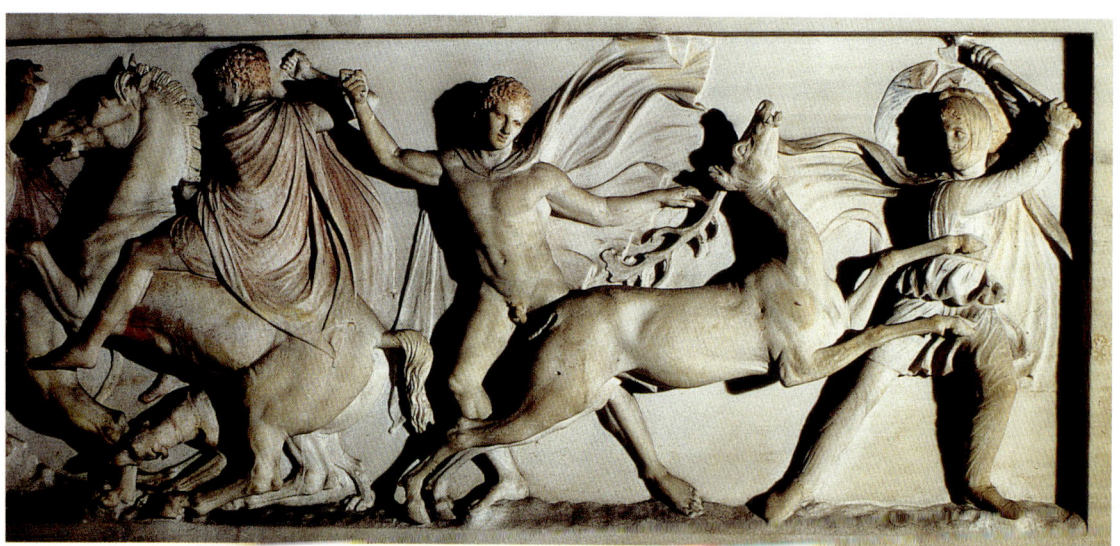

16 Detail of one side of the so-called 'Alexander Sarcophagus', showing Macedonians and men in eastern, probably Phoenician, dress, bringing down a finely antlered stag. This sarcophagus was made for Abdalonymos, king of Sidon, c. 320–300 BC.

agree to this proposition, and also to the probability that the tomb would have been completed not too long after the death of its occupants, then the tomb is surely less likely to be that of Philip, for whom a scene that glorified the lion-hunting exploits of his son would have been fairly irrelevant. Olga Palagia, who subscribes to the Philip Arrhidaios theory, has recently suggested that the bearded rider on the other side of the lion could be Philip Arrhidaios himself, while the builder of the tomb, Kassander, can be recognized as the prominent figure between Alexander and the lion.[9] Although Alexander and Kassander had never been on good terms, Kassander would have been fully aware of the value

of honouring the image of Alexander as a means of strengthening his own grasp on the Macedonian throne. If Palagia is right, the Vergina hunt painting would thus afford an early example of Alexander's successors' well-attested technique of seeking to legitimize and popularize themselves by reference to their illustrious leader. This process, by which a particular iconographic theme or themes is first appropriated by the ruler and then gradually imitated by his supporters and successors, who thus take on something of the royal aura by association, is very characteristic of Hellenistic art.

Royal palaces

As houses of the dead, architecturally elaborate and furnished with the sorts of objects that their occupants would have used in life, it may be legitimate to use such royal tombs imaginatively to reconstruct the less well-preserved domestic surroundings of everyday royal life. In the development of royal palaces, too, the Macedonians led the way in modelling and refining a type of building that was to become increasingly important in the Hellenistic period.[10] Although the kings of Macedon must always have had some sort of palace, the main function of which was to serve as a place for the feasts and banquets for which Macedonian courts were famed, it was not until the fourth century BC that their palaces seem to have become important focuses for the display of wealth and taste. Here, the lead seems to have been taken by Archelaos in the early fourth century when he built a new palace at Pella and commissioned the well-known painter Zeuxis to decorate it. Presumably this building, of which no traces now survive, would have been essentially Greek in style, a large-scale version of the sorts of private houses known, for example, at Olynthus. But in the course of Alexander's eastern campaigns, he and his generals became familiar with several of the great palaces of the east, including those of Memphis in Egypt, Babylon, or Susa, Persepolis, and Pasargadae in the Achaemenid Empire. In some of these palaces they lived for considerable periods of time; some were indeed taken over for the permanent residences of those whom Alexander left in command when his expedition moved on. It is not, therefore, surprising that when new palaces came to be built or existing ones extended in late fourth-century Macedon, elements of their design appear to reflect aspects of eastern royal architecture. A new palace was built at Aigai, for example, in the late fourth or early third century BC. Set on a terrace on the northern slope of the acropolis hill, it was provided with a monumental approach in the form of a 10 m-wide gateway or

propylon, reached via a ramp. The façade of the *propylon* was two storeys high, the lower storey made up of Doric columns, the upper of engaged Ionic half-columns with blind stone windows between them, an arrangement recalling the design of various 'Macedonian' tombs, most notably that at Lefkadhia. It is in fact entirely probable that the façades of the tombs were built in imitation of those of the palaces, as was the case with Achaemenid architecture. The *propylon* at Aigai was flanked on either side by colonnades or stoas, probably just one storey high. The main part of the palace behind the *propylon* consisted of a large peristyle court surrounded by rooms on all four sides; in front of the north wing was a large terrace provided with balustrades and commanding wide and magnificent views over the town and surrounding countryside. The courtyard arrangement recalls that of earlier Greek private houses and the public dining areas found, for example, at Epidauros. But the grand, two-tiered façade and the imposing approach may derive rather from eastern models such as those mentioned above. Probably on a grander scale than Aigai was the contemporary palace at Pella, though its plan is difficult to disentangle from the later monumental structure built by Philip V in the early second century BC.

Fine pebble mosaic[11] floors survive from the palace at Vergina, the most impressive and intricate, though fragmentary in its state of preservation, being an elaborate circular floral design with a central rosette from which spring interlocking branching, twining and converging stems, leaves and spiralling tendrils. Similarly intricate floral borders frame the figured mosaics found in several contemporary palatial houses excavated in the town of Pella, perhaps the homes of Alexander's closest comrades, the so-called 'Companions of the King'. These houses, which, like contemporary tombs, demonstrate the conspicuous wealth of the Macedonian aristocracy, are arranged in the same way as the palaces, as a series of rooms set around an inner courtyard. The finest of the figured mosaics are found in two houses. In House 1.1, the so-called 'House of Dionysos', the ground plan of which covers more than 3,000 m^2 and which was partly two storeys in height, two mosaic floors show Dionysos riding on a panther and two youthful hunters, possibly Alexander and one of his Companions, converging on a lion. This 'royal' motif, found outside a specifically royal context, may be another example, like the iconography of the sarcophagus of Abdalonymos, of the adoption of 'royal' iconography by the king's associates and followers. It has been suggested that House 1.1 may have belonged to the family of Krateros, the Companion who once saved Alexander's life during a lion hunt in Syria in 332 BC. This episode was certainly commemorated in a large-scale bronze group set up at Delphi, commissioned by Krateros himself but not completed and erected

INTIMATIONS OF OPULENCE

until after his death. In a second grand house at Pella, House 1.5, the vividly executed hunt of a finely antlered stag by two youthful hunters, accompanied by their dog, is signed in the manner of Athenian vase paintings by one Gnosis (fig. 17). Another mosaic in the same house shows the rape of Helen by the hero Theseus, the four white horses of the chariot team reminiscent of those of Hades in the 'Tomb of Persephone' at Vergina. The technique employed for these floors, with smooth, natural pebbles set in a layer of fine mortar, may have developed originally elsewhere in Greece, possibly in the Peloponnese. Sikyon has been suggested as a possible place of origin, partly because similarly fine floors have been discovered there and partly because the literary sources record a contemporary Sikyonian school of flower painting. But many of the best, and best preserved, examples have been found in Macedon, earlier in the fourth century at Olynthos and later on at Pella and Vergina. The later mosaics, of which the stag hunt is the best example, represent considerable technical and stylistic

17 Stag hunt mosaic from one of the aristocratic houses at Pella, Macedon, c. 300 BC: it shows both the developing skill of mosaicists at this time and the importance of hunting as an aristocratic pursuit. The inscription gives the name of the mosaicist, Gnosis.

advances on the earlier. The poses of the stag hunters are more complex and cleverly interlocked, and have ambitious management of foreshortening and shading to give an impression of three-dimensionality and movement. The pebbles are carefully graded for colour and size, with a denser packing of smaller stones used to set the figures off against a background of larger, more loosely placed ones. Another device used at Pella was the skilful creation and insertion of strips of fired clay or lead to outline the figures or emphasize inner details, rather in the manner of the relief line used in earlier red-figured vase paintings.

The great houses at Pella look as though they were intended to impress visitors with the wealth and taste of their owners. Many of the rooms both in these palatial houses and in the palaces themselves were designed for dining and feasting. We know this because they are supplied with drains to carry off dregs of wine and water, and with asymmetrically positioned doorways, allowing the optimum number of couches to be fitted in on which the participants might recline. Most conclusively, several mosaic floors have short decorative strips near the walls, often of a wave pattern, marking the position of the couches (so-called '*kline* [couch] bands'). Although no symposium couches have survived *in situ* in the houses, their appearance, translated into wood and bronze, is likely to have been not unlike that of the numerous chiefly marble examples found in contemporary Macedonian tombs. Good examples survive, for instance, from an otherwise largely plundered tomb at Potidaea, where the vertical surfaces of the couches are covered with a fine clay slip on which finely drawn and coloured

18 Detail of a marble couch and throne from a tomb at Potidaea. The two long cross-beams of the couch and the panel between them are painted with a selection of real and mythical animals, and a scene set in an open-air sanctuary. Late fourth century BC.

INTIMATIONS OF OPULENCE

scenes of griffins and other animals, gods and goddesses are painted; the most opulent couches might of course have resembled that found in the great tomb at Vergina with its ivory figure attachments (figs 18 and 19).

The royal style

Banquets had always been an important, even notorious, feature of Macedonian society, but after Alexander they became larger in scale and expanded in significance. Impressive as visible displays of wealth and patronage, lavish banquets were frequently used by Alexander for the announcement of major policy decisions. With these occasions there is a sense in which he started the process, carried further by later Hellenistic monarchs, of adopting elements of Classical religious ceremonies (the traditional occasions for great feasts and banquets)

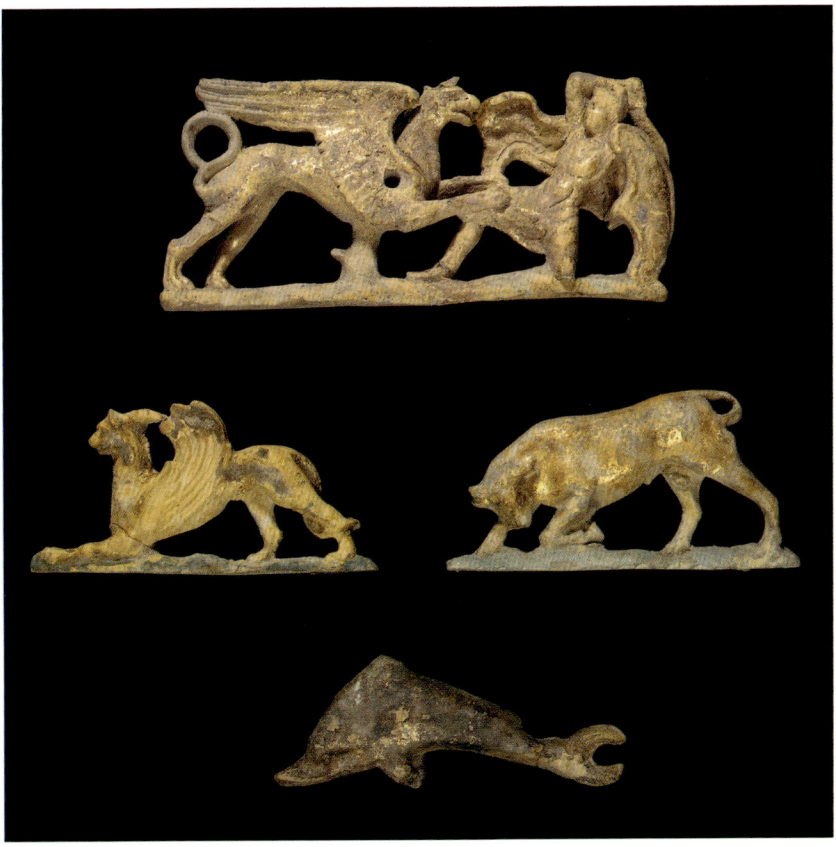

19 Gilded terracotta plaques in the form of an Arimasp fighting a griffin, a griffin, a bull and a dolphin. Plaques of this type could have been used to decorate a variety of items from small chests to full-sized thrones and couches. These examples were made at Taranto, probably in the late fourth or third century BC. Height of Arimasp group 7 cm.

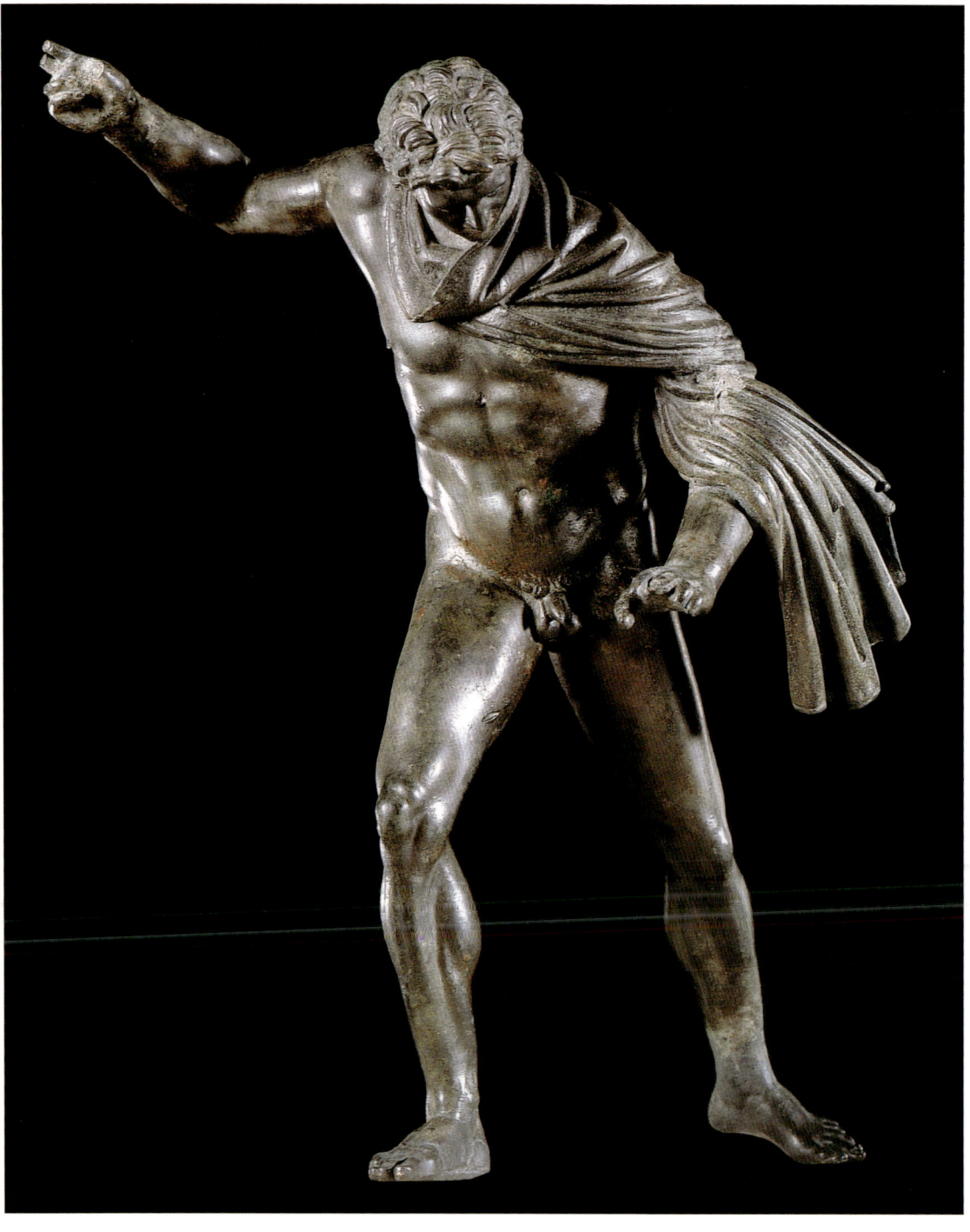

INTIMATIONS OF OPULENCE

that he could blend with displays of royal might and wealth derived from eastern models. As in the other developments of Macedonian culture at which we have been looking, the process represents a harnessing of old with new, west with east, to create a distinctive new Hellenistic style. It was also from the east that Alexander borrowed both some of his ideas of divine kingship, and the methods of conveying it, which had a major impact on artistic style. As an absolute monarch he naturally had no normal Greek models on which to form himself but plenty of Near Eastern examples to follow, not least the Egyptian pharaohs or the Great King of Persia himself. He was perhaps the first Macedonian – or Greek – deliberately to set out to control the way his own image was used, in terms not just of what his official portrait looked like and who might produce it (a subject we shall be considering in the next chapter), but also of the public appearances that he made or the contexts in which his surrogates – whether they were of marble, bronze or some more exotic material – should appear. Like King Ashurbanipal on the great Assyrian palace reliefs, Alexander preferred to be shown in the thick of a lion hunt (as demonstrated perhaps by the Pella mosaics or the Delphi Krateros group) or as a warrior, leading his armies into battle (as seen on the 'Alexander sarcophagus' or the 'Granikos monument', a large-scale equestrian bronze group commemorating his first great victory over the Persians at the River Granikos in 334 BC) (fig. 20). As the literary sources recognize and make clear, Alexander firmly believed that in order to maintain his authority over so extended a territory the image, whether visual or spiritual, that he presented to the world was of critical importance. Even after his death, control was scarcely relaxed, with the accounts of the imagery that adorned his funeral cortège making it clear that wherever the body passed on its final journey the same powerful legends of his character and achievements should be made manifest. This concept of a royal style, its development, control and maintenance, was one of Alexander's most significant legacies to the Hellenistic period.

OPPOSITE:
20 Bronze figure of a huntsman preparing to drive his spear into his prey. The figure may echo one or more larger-scale sculptural groups depicting the young Alexander and his Companions hunting a lion. c. 100 BC. Height 47.5 cm.

Chapter 2

Ancient Faces

'For this reason Alexander decreed that only Lysippos should make his portrait. For only Lysippos, it seems, brought out his real character in the bronze and gave form to his essential excellence....' (Plutarch, *De Alexandri Magni Fortuna aut Virtute*, 2.2.3)

How did people want to be seen in the Hellenistic world? What sorts of image of themselves or others did they want to project, and is it possible to determine how these images related to what they really looked like? In answering such questions we need to look not just at recognizable 'portraits', but also at artistic representations of people in general. We must ask what was new about people's appearance in Hellenistic art, and we shall want to bear in mind the many contrasts Hellenistic art offers in the imaging of different-looking types of people, whether individuals or generic types, 'real' or mythical figures, the beautiful or the ugly.

There is no simple answer to the question 'what is a portrait?'[1] It might seem natural to us to think first in terms of a photograph or a 'realistic' painting, drawing or three-dimensional model of an individual, one instantly recognizable to those who know the subject and offering those who do not an accurate impression of his or her physical likeness. Yet through the ages there have been radically different interpretations of what constitutes a portrait. Some portraits are indeed the physical twins of their subject, but in many cases artists have adopted completely different principles, either of their own volition or because of the demands of their subjects (not infrequently their patrons) to be portrayed in a particular way. In addition, the wider conventions of culture and society have always played their part. Thus while it is sometimes claimed that so far as the Greek world is concerned, portraits only really developed in the Hellenistic period, it is probably more accurate to suggest that portraiture

developed in new directions at this time. For in some senses of the word many of the earliest surviving human images of ancient Greece are portraits. The stiffly posed *kouroi* of the sixth century BC, for example – free-standing figures of naked youths who stood as markers over graves or as lasting, silent worshippers in sanctuaries – may lack individual-seeming differentiation. Yet they still embody – or portray – characteristic qualities of those individuals named in their inscriptions, namely youth and strength. Similarly the Classical athlete statues (generally surviving only in Roman copies), while offering idealized images of physical beauty, athletic strength and prowess, are at the same time portraits of the significant qualities and achievements of those whom they commemorated.

Portraits of civic worthies

From the fourth century BC, but growing in popularity in the Hellenistic period proper, new categories of people started to be portrayed in statue form, notably philosophers, statesmen and poets; as these proliferated, they generated new formulae and conventions that incorporated, if not more individualism, at least a greater realism. Almost without exception such portraits were posthumous, and the originals were designed to be set up in some public space of the city where their subjects had lived and made their names. Many of the heads of these statues now survive in the form of Roman copies because collections or sets of the heads, usually placed on top of the long, rectangular shafts of herms, were to become fashionable and tasteful ornaments in the houses of affluent and well-educated Romans. The most extensive collection so far discovered is that of the 'Villa of the Papyri' at Herculaneum where portraits of philosophers, poets and statesmen were found along with those of ten Hellenistic kings and queens.[2] Although the original location of the portraits in this collection is not absolutely certain, it is very probable that they were carefully grouped and placed either in particular rooms, or else around the courtyard colonnades in the villa of a notable scholar and connoisseur.

How do we know whom such 'portraits' represent? The short answer is that we can rarely be certain. In the case of some very popular figures, fifty or sixty closely comparable examples of what is clearly the same portrait may be located and recognized, and if just one of these is inscribed with a name, some scholars feel confident that the whole set can be identified; but this may be assuming greater knowledge and consistency in antiquity than is really justified!

The clear similarity of so many copies makes it likely that they do give a reasonably good impression of what the original heads were like; but we do need to remember that these once belonged to full-length seated or standing statues (fig. 21), and their pose and dress would also have contributed to the overall effect. It is also important to consider that however 'realistic' they may seem, it is improbable that any of these portraits are true likenesses of the individuals they portray: this was never their intention. Although some of the portraits were created sufficiently soon after the death of the individual concerned for some people to remember what he (almost all were male) had looked like, their main purpose was to suggest to future generations not so much the physical likeness as the moral qualities that had distinguished this person in his lifetime. In the sense that they were portraying character and quality rather than external likeness they were not so very different from the athlete statues of the Classical period, but while these had stressed the potential for physical prowess and improbable physical perfection, the later portraits were generally far less beautiful, and far more realistic-seeming than the athletes. Many of the characters shown are considerably past their prime, with lined and wrinkled faces (and if preserved in full-length form, with sagging stomachs or heavily veined legs). In most cases the aim seems to have been to portray such suitable combinations of powerful character as deep intellectual purpose and sheer cleverness for the philosophers, intelligence mingled with creativity for the poets, and brains plus moral responsibility for the statesmen. In all three categories an impression of age, sometimes venerableness, was generally *de rigeur*: almost all were bearded, with faces lined or even ravaged by experience; expressions were severe and pensive.

This is not to suggest that no distinctions were drawn between the different categories or the individuals within them. The philosophers, for example, were often shown in a reflective, seated, pose; they would generally be very simply dressed in just a cloak (*himation*), marking their lack of interest in material comforts. The Classical philosophers Socrates, Plato and Aristotle were all popular subjects, as were the founders and members of the separate schools of philosophy that became important in the Hellenistic period. The distinctive tenets of the schools were reflected in the appearance of their adherents. A number of philosophers are included in a group of portraits, found near the Via Appia, in the British Museum. The representatives of the Epicurean and Stoic schools are very characteristically portrayed. The Epicureans, Epicurus himself and his disciple Metrodoros have short, neatly curling hair and well-combed beards framing their long, narrow faces; Epicurus has the more deeply furrowed

OPPOSITE:
21 Bronze figure of a philosopher, seated in a pensive attitude with his chin resting on his hand, either an original Hellenistic work or a Roman version of the first century AD. Height 51 cm.

brow, a mark of his superior intellectual ability, but both project the air of studied calm and tranquillity advocated by their philosophy, with its doctrine (misinterpreted by many today) of the avoidance of pleasure or pain. The appearance of the Stoic Chrysippos is completely different – a burning intellect within a ruined, aged frame. The members of the third main school, the Cynics, were famous for the scruffiness of their appearance and the British Museum's Antisthenes (not from the Via Appia group), with his shaggy, unkempt hair and beard, is a good example of the type (fig. 22).[3]

The statesmen (often referred to as 'orators' after their Greek title, which in its normal translation stresses their speech-making role at the expense of the other civic activities in which they played leading roles) would generally stand in attitudes suggesting greater dynamism than the philosophers, in order to show that they were men of action as well as words: the two great fourth-century figures of Aischines and Demosthenes were the most revered by the Romans, and so their portraits survive in greater numbers than do those of any later statesmen or civic figures (fig. 23). As these two Athenians had occupied opposing political positions in early fourth-century Athens, so their portraits reveal elements of their different characters: where Aischines comes across as powerful, controlled and rather urbane, Demosthenes, with

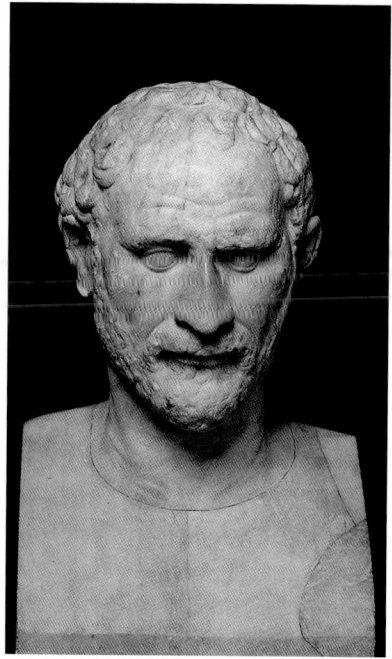

22 Marble head of the philosopher Antisthenes, founder of the Cynic school. Roman version of an original Greek work of c. 300 BC. Height 39.25 cm.

23 Marble head of the orator Demosthenes, the dogged Athenian adversary of Philip II of Macedon. Demosthenes died c. 320 BC; this statue was erected c. 280 BC during a short-lived resurgence of Athenian independence from Macedon. Height 45 cm.

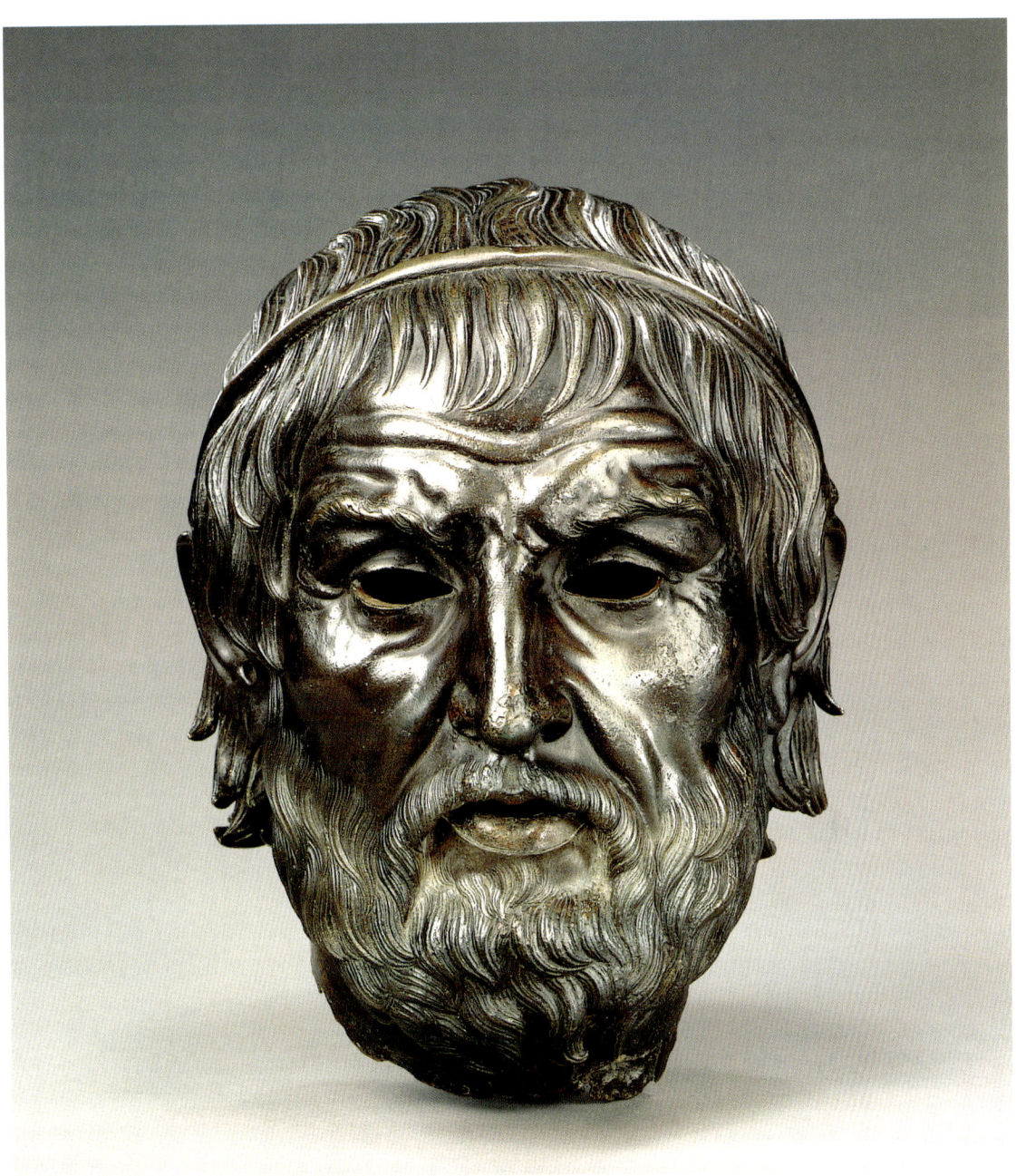

24 Bronze head from a full-length portrait statue, probably a portrait of the Athenian tragic poet Sophocles. Made in the second century BC; acquired in Constantinople and presented to the British Museum in 1760. Height 29.5 cm.

his more stressed and anguished expression, has more in common with some of the philosophers.[4]

As the theatre remained a major civic institution from the Classical period into the Hellenistic, so successful dramatic poets might enjoy considerable civic status and be honoured with statues after their death. One of the first to be so honoured was the tragedian Sophocles who may be the character represented in a magnificent bronze portrait head that has been in the British Museum since 1760 (fig. 24). The man shown is in late middle age, with a worn, deeply lined face framed by shaggy hair and beard, and a severe expression conveyed by his down-turned mouth and furrowed brow. Although his face resembles others believed to represent the poet, the rolled band around his head is similar to the diadems worn by Hellenistic rulers, so his identity is not perfectly secure. We are on slightly firmer ground with images of Menander, the founder of the so-called 'New Comedy', full-length portraits of whom are said to have been erected in the theatres of Athens and Eretria shortly after his death in the early

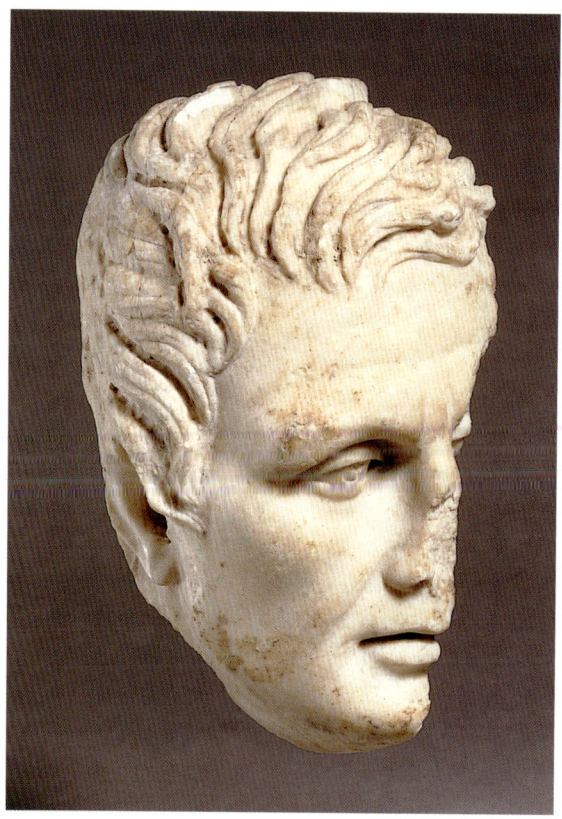

25 Fragment of a marble head of the Athenian comic poet Menander, the founder of New Comedy. The deep-set eyes and side-flicked hair are characteristic of Menander portraits. This is a Roman copy of an original Greek work of c. 280 BC. Height 16.9 cm.

third century BC. Menander's success and fame was largely posthumous: he won very few dramatic victories in his lifetime, but many Roman intellectuals considered him the greatest of all the comic poets, and judging by the numbers that still survive, many copies of his portrait must have been in circulation. His portrait type has been identified only relatively recently; for some time it had been thought that the type, of which more than fifty examples are known, portrayed the Roman poet Vergil, but in 1971 a bronze version was acquired by the Getty Museum, on which Menander's name is clearly inscribed; subsequently two other inscribed versions of the type have turned up.[5] A fragmentary marble version recently acquired by the British Museum shows the poet as a handsome man in early middle age (fig. 25). His squarish face is clean-shaven, with eyes sunk deep beneath a furrowed brow and deep lines leading from the nose to the corners of the mouth. His hair is rough and curly with a distinctive wave that falls across his forehead. While his intellectual expression is not unlike that of several philosophers or statesmen, his lack of beard – a fashion that, as we shall see, he may have adopted from Alexander and his successors – may perhaps signal the fact that he is very much a man of the world, someone who is fully abreast of contemporary style. This stylishness suited both his reputation as an innovator and the nature of the drama that he initiated, with its focus on real-life, modern-day people and their mishaps, as opposed to characters from mythology.

Portraits of ordinary people

Few truly 'ordinary' people would have found themselves in a position where they would have been able to commission a portrait, for the fees of artists, and especially sculptors, would have been beyond the reach of most; nor would there have been places or occasions for the erection of such items. The greatest number – and closest to 'ordinary' of 'ordinary people' portraits – has been found on Delos and dates to the later Hellenistic period. Delos from 166 BC onwards, when Rome presented it to Athens as a free port, was a great commercial centre, probably the most important market in the Mediterranean, and because of this the cosmopolitan home of numerous wealthy merchants and traders of several nationalities.[6] The atmosphere of competitive opulence promoted a huge demand for sculpture of all kinds, for sanctuaries, public buildings and private houses, and the many sculptors' signatures that survive on Delian works suggest that artists came from throughout the Mediterranean to

work in so lively and lucrative an environment. The Italian community was particularly influential from the late second century onwards, as is demonstrated by the Agora they built about 120 BC, and it seems to have been they, rather than the Greeks, who demanded innovative forms of sculpture. The great courtyard of the Agora was probably both a commercial and a social centre, and soon it was richly decorated with sculpture of varied types. In the central space were historical groups, of Celts defeated by Romans; but standing in niches in the surrounding colonnades were portraits of prominent benefactors of the community, including some of those who had sponsored the construction of the Agora itself. Unlike the more traditional Greek 'civic notables' discussed above, the Italians on Delos generally chose to be portrayed on horseback, in armour, or heroically naked. Examples only of the last variety survive sufficiently intact for us to appreciate their overall effect: one such is an unfinished statue from the 'House of Diadoumenos', in which the combination of a classically muscular and athletic body and a frequently all-too-realistic head, with sticking-out ears, short-cropped hair, sagging jaw-line and furrowed brow, appears cruelly incongruous or even comical to modern eyes.[7] But presumably to the contemporary viewers such schemes seemed to offer a suitable blend of traditional and modern values, satisfying feelings of what was appropriate for the location by mingling traditional forms with respect for the real-life personalities of the individuals concerned. Certainly, however, when the heads of such figures survive in isolation from the bodies they can provide some of the most evocative portraits of the time.

A different, much more 'Greek' portrait is preserved from Delos in the form of the bronze portrait head sometimes known as the 'Worried Man', an almost incredibly modern-looking individual, whose face is a type you might see in any crowded street today (fig. 26). Lined and creased, the rugged surface of his face suggests a lifetime of physical and emotional experience; perhaps because, unusually, his original inlaid eyes survive, his peering, preoccupied expression and furrowed brow seem extraordinarily realistic. This effect is partly the result of the material and technique employed, as it is generally possible to achieve far more surface detail in bronze, which is cast from a model in clay or wax, than it is in marble.

If we wish to digress briefly from people's faces to consider other aspects of their appearance such as dress, large- and small-scale sculptures or figurines, not necessarily portraits, in various materials can offer invaluable information. It would appear that many women wore two main garments, a sleeveless *chiton* (tunic), belted just beneath the breast, and a *himation* (cloak) on top: both were

draped and twisted so as to fall in numerous folds, and sometimes the folds of the *chiton* were visible through the over-garment, suggesting the fineness of its material. Though silk and cotton were known in the Hellenistic period, wool, spun and woven in the house, was the most common material for all garments and could be spun to an extremely fine quality. All Greek garments were essentially rectangular pieces of cloth, woven to suitable dimensions on the loom, and then in the case of the *chiton* folded, sewn down where necessary and tied with a girdle. There was no need to cut the cloth and so no material was wasted. Where terracotta figures have the advantage over marble statues is in their ability to suggest something of the colours of the garments worn. The wool might be left its natural cream colour or else dyed before weaving in a wide variety of shades from blue to pink, green and yellow; contrasting border stripes are commonly found on terracottas and these would be woven into the material

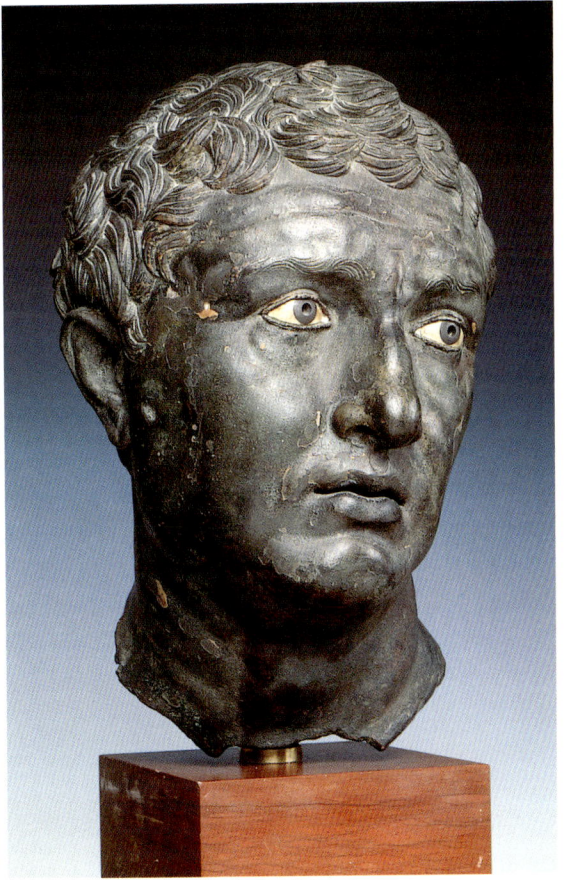

26 Bronze portrait head of a man from Delos, c. 100 BC. The rare survival of the inlaid eyes give this head a wonderfully lifelike appearance, and while the hair lies in rather formal patterns, the anxious-looking face is actually quite modern-seeming. Height 32.5 cm.

on the loom. If they so wished, women could draw a fold of the outer garment up over their heads and faces for privacy and modesty; in the sun the figurines suggest that women in the Greek mainland at least might wear a broad-brimmed, high, conical sun-hat. For cooling purposes women might carry a leaf-shaped fan. Terracotta figures of adult men are relatively rare, but young boys do appear, often fully draped in long, enveloping mantles. More information about male dress is derived from East Greek grave reliefs. These suggest that for formal outdoor wear men, like women, would wear two garments – an inner tunic and an outer mantle sometimes so draped that one arm was comfortably muffled as though in a sling; indoors, however, when reclining at a banquet, most male figures seemed to wear just a mantle, leaving one arm and their chest naked, and a wreath.

Both men and women might also wear jewellery to enhance their appearance. The orator Demosthenes describes an order he himself had placed with an Athenian goldsmith for gold wreaths and a mantle decorated with gold thread for a procession in honour of the god Dionysos:[8] presumably the wreaths would have been something like the beautiful examples occasionally found in tombs in southern Italy, northern Greece, the Black Sea or the cities of Asia Minor from the late fourth century BC onwards (fig. 27). Terracotta figures of women and boys are often equipped with leafy wreaths, sometimes gilded: these offer a

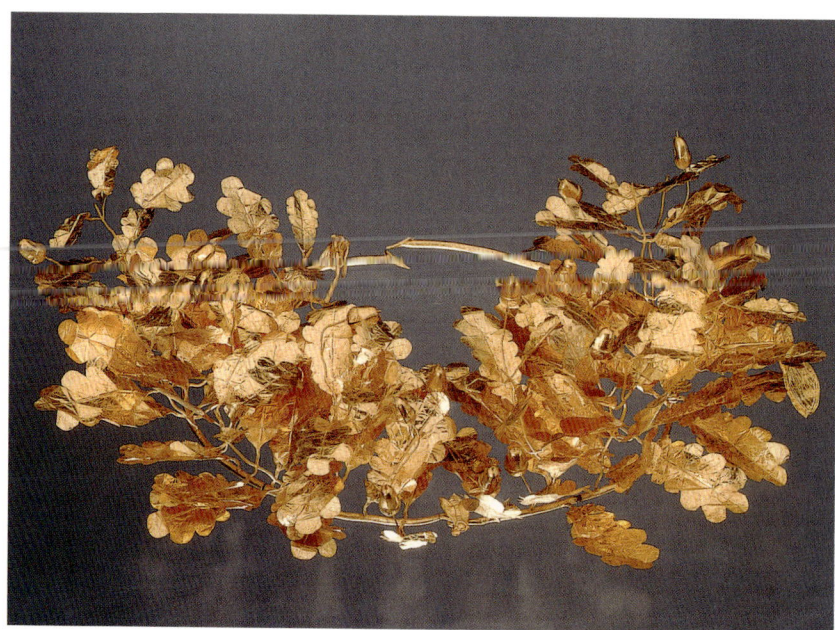

27 Gold oak wreath with acorns, a bee and two cicadas. The leaves are so thin that they move and rustle in the smallest breeze. Said to be from a tomb in the Dardanelles. Diam. (as restored) 23.3 cm.

vivid impression of how such items would have appeared when in use. Gold earrings – both hoops with human- or animal-head terminals, and large discs with dangling pendants, richly adorned with filigree and granulation – survive from this time, as do gold bracelets of many designs, including examples with snakes'-head terminals or hoops of rock crystal carved to create an illusion that the material has been twisted into shape. Some gold finger-rings have intricately worked 'box bezels'; others have flat bezels, oval or circular, engraved with designs in intaglio that could be used as seals to mark personal property. Many thousands of stone intaglios also survive from the period: those that were not set into rings could have been attached to the owner's wrist or neck with a cord or leather thong, or just held loose in a purse. A wide variety of materials was used for sealstones in the Hellenistic period (fig. 28): in addition to various types of quartz, new stones such as garnets became popular; glass was also used. The most popular shape of stone in the Hellenistic period was the ring-stone, generally in the form of an elongated oval but sometimes circular, with a flat back and a slightly domed or convex upper surface on which the design was engraved. Some of the surviving intaglios are masterpieces of small-scale carving; but many others are undistinguished. The subjects include portraits of individuals, gods and goddesses, likenesses of contemporary sculpture, animals and dramatic masks.[9]

28 Hellenistic sealstones, both set in rings. On the left, a cornelian intaglio showing the profile head of a young man whose large eye and curly hair recall various images of Alexander. Third to second centuries BC. Height 1.5 cm.
On the right, a sard intaglio engraved with a young male figure holding a sceptre and a purse; around his head is a diadem with a lotus-like projection at the front. This figure seems to combine elements of the god Hermes with royal attributes. Second to first centuries BC. Height 2.6 cm.

In the course of the Hellenistic period coloured stones, including amethysts, garnets, rubies and emeralds, were increasingly used to decorate earrings, diadems and other articles; tiny sections of coloured glass might also be fused onto gold, typically in the form of individual scales separated by beaded wire, to achieve a rich, polychromatic effect. Silver jewellery is also found, especially in northern Greece and Illyria; bronze rings and bracelets are more widespread, sometimes plated with gold or silver.[10] For those with less money to spare terracotta jewellery, coloured red or gilded, might form a cheap alternative to gold.[11]

Portraits of Alexander and his successors

Returning now to portraiture proper, like many Hellenistic developments several new ideas and uses of portraiture originated with Alexander the Great, and resulted from the unprecedented position of power and authority to which he climbed in the course of his brief career. The basic political unit of the Archaic or Classical Greek world had been the city-state or *polis*: as none of these was large it would have been perfectly possible for all citizens to know, without being specially informed, what those in charge actually looked like, whether they were kings or magistrates or demagogues. Alexander's empire, on the other hand, was by any standards almost unbelievably vast; it also differed from any of the *poleis* in that he ruled it as an absolute monarch. These two factors, and the need to justify them to his now subject peoples, combined to make it imperative for him to develop and broadcast a new and extremely authoritative image of himself; this he set about doing in a variety of innovative ways.[12]

From an early age it seems that Alexander had felt – and encouraged others to believe – that there was something special about himself, that he was the possessor of peculiar abilities and character that marked him out for greatness. His rule – the example of which his successors closely followed – was a very personal one and it very much depended on others' acceptance of his charisma and authority. The development of a particular kind of visual image that expressed this special character – in other words, a portrait – was one important way of broadcasting and securing this acceptance. No certain contemporary portraits of Alexander have survived so our picture derives, of necessity, from posthumous, Hellenistic or Roman copies, combined with the evidence of the literary sources. These last are not always easy to interpret, but they certainly suggest that, whether or not he was successful, Alexander made energetic attempts to control the images of himself that appeared. Many of the

cities that came under his sway would have set up at least one full-length statue of their king in the city centre; in addition, there would have been private or civic dedications of similar statues in sanctuaries. After his death, as the cult of the deified Alexander proliferated, so did the need for suitable cult statues. But even in his lifetime, besides the traditional, honorific forms of image, there would have been others, ranging from large-scale, publicly positioned paintings depicting and celebrating major triumphs of the reign, to small-scale engraved gems that could be used to reward close associates who might both keep them as jewels and use them as seals. Reaching even beyond the boundaries of the empire was the superb silver coinage on which the features of the hero Herakles became gradually indistinguishable from those of Alexander himself. Given the number of Alexander images that proliferated during his lifetime, the much-repeated quotation from Plutarch that heads this chapter, explaining why Alexander wished only Lysippos to portray him in sculpture – combined with Pliny's claim that Pyrgoteles enjoyed a monopoly in the production of gem-engravings of Alexander, and Apelles of Kos in the medium of paintings – can hardly be taken at face value. It is perhaps more likely that such statements can refer only to portraits commissioned by Alexander himself, the type or style of which would doubtless have had an influence on others produced elsewhere.

The literary sources seem to suggest that, through these multiple images of himself that sprang up and spread across his empire, Alexander wished to convey his special, superhuman status – essentially that of a hero who has finally become a god (although in many regions his subjects were quite happy to accept him as a god, among the more sceptical Greeks his divine status was officially proclaimed only shortly before his death). To promote this end Alexander fostered his association not just with the hero Herakles – his own 'leonine' hair surely imitated the hero's lion-mask – but also with various gods. One famous painting by Apelles, set up in the temple of Artemis at Ephesus, showed him in the form of Zeus, wielding a thunderbolt, while another associated him with Nike and the Dioskouroi. After his death his divine status was made still clearer by the bestowal on his image of such attributes as the ram's horn of Zeus Ammon, or even the aegis of Athena. But in addition to his divinity Alexander also wanted to stress (with equal, and quite extraordinary self-confidence) his overwhelming 'excellence', or virtue (*arete* in Greek), and this was felt to be the quality that gave him the authority to reign. Are these qualities – divinity and excellence – apparent in the surviving portraits?

The British Museum's Alexander head may be an original, posthumous portrait dating to the third century BC (fig. 29). It differs from the known copies

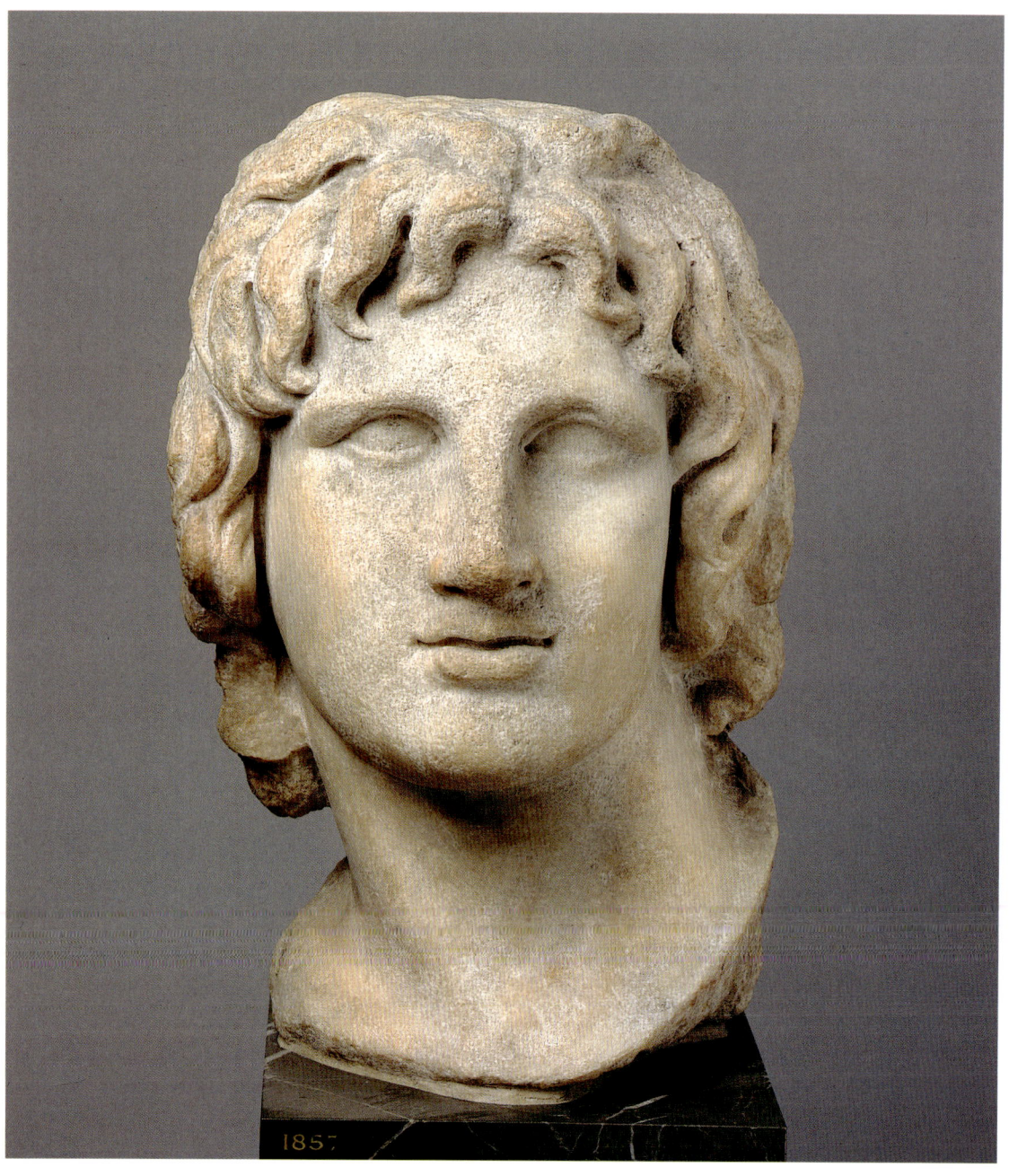

29 Marble head of Alexander, acquired in Alexandria, Egypt. The tilt of the head, the wildly curling hair and the far-seeing gaze are all very characteristic of posthumous Alexander portraits. Third or second century BC. Height 37 cm.

of contemporary portraits, in which Alexander's age ranges from extreme youth to early middle age, in that it shows the king as an idealized, god-like blend of youthful strength, beauty and aspiration, combined with maturity, experience and hard-won power. Some elements are characteristic of all Alexander portraits – the clean-shaven cheeks and chin, the curly hair with its distinctive, off-centre parting, the tilt of the head and the slight upward turn of the gaze. But here the curls that frame the parting are less upswept than on the earlier versions; the tilt of the head is very pronounced, and combines with the deep-set eyes to produce a far-seeing, rather visionary expression. It is virtually impossible for us to look at a head like this without reading into it the literary sources; but trying hard to leave these to one side, it is clear that it represents a quite new portrait type – not, perhaps, a realistic image of an individual but a carefully judged construct. Does it convey divinity and excellence? Certainly the visionary expression could be read as slightly superhuman; but probably the portraits need to be read with foreknowledge of the Alexander legend to be appreciated to the full.

Alexander's portrait remained a crucially important political tool even after his death, because his successors at first used their close association with their former leader to justify their own assumption of power. This is why, in many areas of his empire, the cult of the deified Alexander was assiduously promoted, with a consequent proliferation of cult images, and at first the majority of the coins issued in the various kingdoms bore Alexander's image too (fig. 30). Gradually, however, as the Alexander legend became of less immediate relevance to both rulers and their subjects, members of the individual dynasties began to supplant his portrait with their own. Like Alexander, each ruler would have ensured that his or her own portrait statues along with those of the immediate family were prominently displayed in the public spaces of the kingdom. As the Romans, however, were much less interested in portraits of Hellenistic rulers than in those of philosophers and poets, far fewer ruler portraits have survived even in the form of copies: the owner of the 'Villa of the Papyri', in whose eclectic collection a fine assortment of Hellenistic rulers rubbed shoulders with the more usual types of famous Greeks, must have been a man of unusual and notable erudition. Those sculptured portraits that do survive, however, form a stylistic class that shares common features across the boundaries, both geographical and chronological, of the Hellenistic age: broadly speaking the portraits combined elements of Alexander iconography, touches of divinity and individual characterization. Within the

30 The head of Alexander with the ram's horn of the composite Egyptian deity Zeus Ammon, on a silver tetradrachm struck by Lysimachos of Thrace at Alexandria Troas c. 283 BC.

overall class, individual dynasties developed their own 'house style', with the Ptolemies, for example (fig. 31), favouring calm, generally rather more dignified representations, in keeping perhaps with the traditional ruler portrait style of Pharaonic Egypt; the Seleucids and Antigonids of Asia Minor preferring a wilder, more impassioned type of image; and the Bactrians an older, more military style of appearance.[13]

The relatively short supply of surviving bronze and marble portraits of the Hellenistic rulers is partly compensated for by the abundance of portraits on their often magnificent coins. Particularly fine, largely because of their enormous wealth but also because their access to sources of gold enabled and encouraged them to mint in gold as well as silver and bronze, were the coins of the Ptolemaic dynasty (fig. 32), whose founder, Ptolemy I, started to issue coins bearing his own portrait on the obverse when he took the title of king in 305 BC. In these first portraits only the wildly curling hair and perhaps something in the steadfast gaze recalls Alexander: the new king has made no attempt

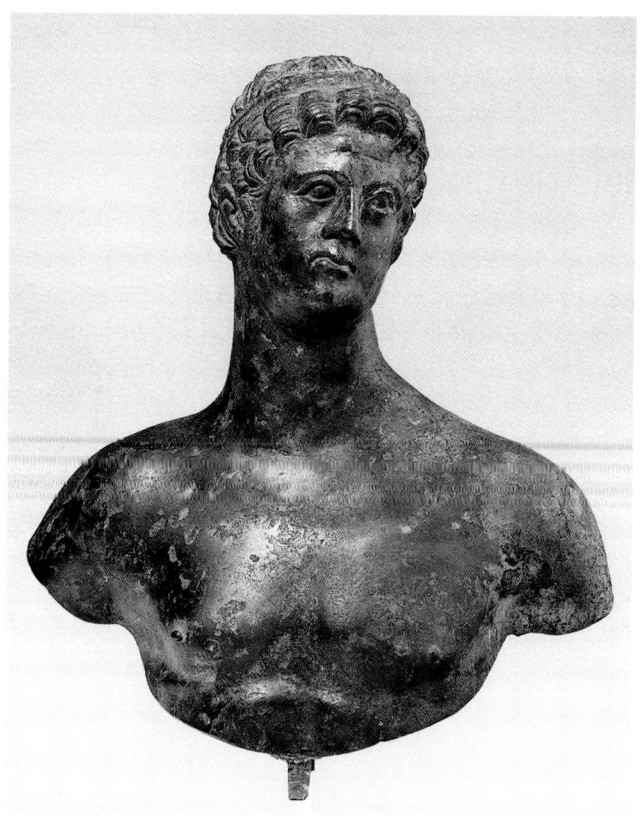

31 Bronze bust representing a member of the Ptolemaic dynasty: the thick curls and sideburns, pointed nose and small, rounded chin suggest it may be Ptolemy IV Philopator (222–205 BC). This may be either an original Hellenistic work or a Roman copy. Height 25 cm.

to conceal either his greater age or his prominently hooked nose and sharply jutting chin. Portraits of Ptolemy I remained the standard obverse design for silver issues until the end of the dynasty, but from time to time various rulers did place their own or other members of their families' portraits on coins: often this was on the gold issues, many of which are likely to have been struck for particular occasions such as festivals. The largest group of portrait coins are those in the name of Arsinoe II Philadelphus, queen and sister of Ptolemy II, most of which were issued after her death in 268 BC. One fine gold octadrachm shows the queen as an elegant and youthful woman, with her hair arranged in the so-called 'melon' coiffure, partly concealed beneath a diadem and veil. Behind her head appears the top of a sceptre, perhaps a local Egyptian symbol; the small horn below her ear may be designed to associate her with either Zeus Amun or Khnum, the Egyptian ram-headed deity. On the reverse of this issue is a double cornucopia, containing the fruits of Egypt and referring to the queen's role as provider. The double form may allude to Arsinoe's close association with her brother, consort and co-ruler, or again it may be a more traditionally Egyptian reference to the unification of upper and lower Egypt: the same combination of types is found on a massive silver coin, a ten-drachma piece or decadrachm.[14]

Another series of Ptolemaic images that provides glimpses of the queens and an indication of their status is the group of full-length relief figures placed on the faience, trefoil-mouthed jugs (*oinochoai*) thought likely to have been used in the cult of the queens themselves.[15] The modelling of the faces is not usually of sufficiently high quality to appear very individual, but hairstyles and dress are carefully shown; of interest in their own right, these figures can also be taken as evidence for the general appearance of many full-length statues that no

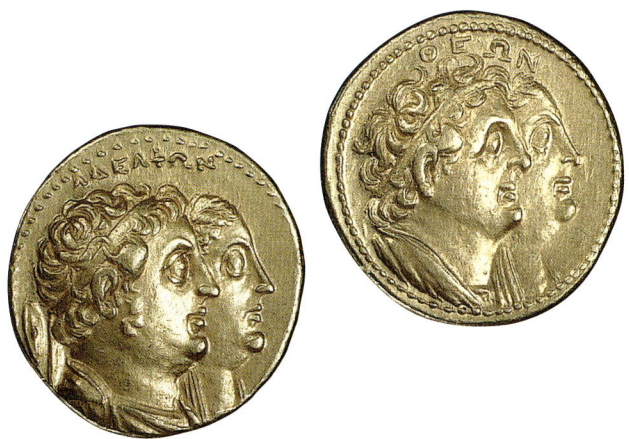

32 Gold octadrachm of Ptolemy II Philadelphus (284–246 BC). The obverse shows the founder of the dynasty, Ptolemy I, with his queen Berenike I; the reverse, Ptolemy II with his wife and sister Arsinoe II.

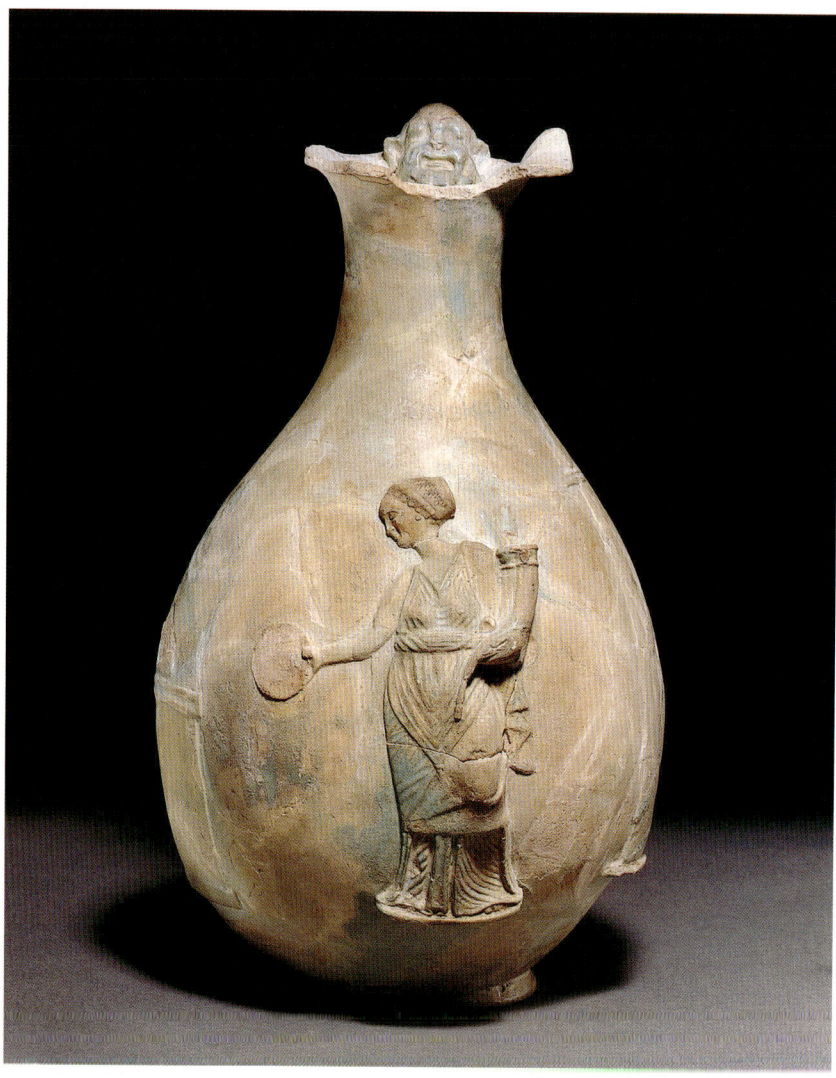

33 Faience jug showing Queen Arsinoe II of Egypt holding a cornucopia (horn of plenty) and a *phiale* (libation bowl). An inscription wishes great good fortune to the queen. Made in Alexandria c. 280–270 BC. Height 32.4 cm.

longer survive. Each queen supports a double cornucopia overflowing with the fruits of Egypt, and pours a libation from the shallow bowl (*phiale*) in her hand. On one example in the British Museum the queen is Arsinoe II, standing between an altar and a garlanded cylindrical pillar (*baitulos*) – indications of a sanctuary (fig. 33). The inscription takes the form of a dedication wishing the queen herself good fortune; Arsinoe was the first Ptolemaic ruler to be deified and worshipped during her own lifetime, but her cult continued and indeed expanded after her death. A yearly festival in her honour, the Arsinoeia, was

established in 267 BC and jugs like this may well have been used and offered to her on such occasions.

So far we have been looking at purely Greek images of the Ptolemies, but in parallel to these, many statues were produced which represented them either completely in the traditional Egyptian style, or in a style that is essentially Egyptian but which includes Greek-style portrait features and/or Greek attributes.[16] It was obviously politically important for the Egyptian acceptance of their foreign rulers that they should be seen to promote and continue many of the traditions of their native Egyptian predecessors, and the Ptolemies themselves appear to have been genuinely keen to show themselves in every respect as Egyptians and respecters of Egyptian tradition. The production and public visibility of Pharaonic-style statues would in any case have helped to legitimize their assumption of power. The purely Egyptian-style Ptolemaic portraits show the rulers in traditional Egyptian costume and pose; their features, too, are not easily distinguishable from those of the last native Egyptian pharaohs of the thirtieth dynasty. Of greater interest, perhaps, are the so-called 'mixed' statues. It is rare for Greek-style statues to incorporate Egyptian elements, although there are a number of generally small-scale Greek-style heads carved in Egyptian stone. Most of the traffic was in the other direction, with portraits carved in Egyptian workshops, in traditional Egyptian forms and materials, incorporating Greek-style portrait features. One example of this tendency is a female head in the British Museum, carved in the traditional Egyptian material of greywacke stone rather than the marble preferred by Greek sculptors (fig. 34): like most Egyptian statues it seems originally to have been provided with a back-pillar (on which names and titles might be inscribed) and to have worn an Egyptian crown; facial features and hair, however, are carved in

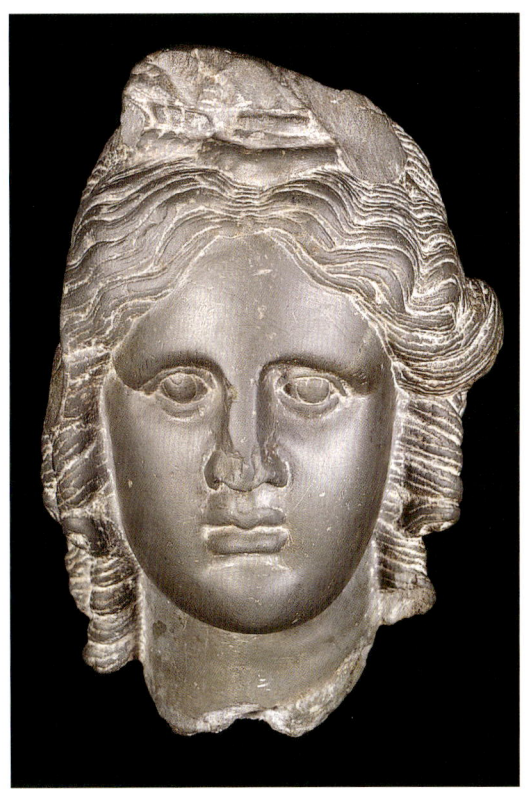

34 Greywacke stone head of a Ptolemaic princess, made in Egypt c. 200–150 BC. Height 17.5 cm.

the Greek style and the head is likely to represent Cleopatra I or II. Pieces like this, with their deliberately 'bilingual' or cosmopolitan approach, may well have served a specific function in the royal cults.

'Type' portraits: the dramatic mask

Despite the apparent realism of some examples, all the ancient faces we have so far looked at have in a sense been 'type' portraits rather than what we might today think of as true likenesses of individuals. It is almost as though the individuals or their artists wished above all to make clear their role or status in life. Thus the philosophers and poets projected one kind of image, the merchants another, the kings and queens a third: and the members of each group almost certainly resemble each other far more than their ostensible individual subjects. This conformity to 'type' is most obviously, even exaggeratedly, shown in quite a different form of portrait: the series of dramatic masks portraying certain set types of character that were used in the Hellenistic theatre and that also appear either in the form of independent mask models or worn by individual figurines in Hellenistic art. The fact that in most cases of portraiture 'proper' we are dealing just with disembodied heads in itself recalls the shape of the dramatic masks; the analogy goes furthest with the coins for, like the dramatic mask visible at the back of the theatre, the portrait-head was the part of the ruler seen by most people in his kingdom or beyond. But philosophically, too, there seems to be a sense in which the coin portraits broadcast the message 'royal type', just as the dramatic masks could be read 'wavy-haired young man' or 'brothel-keeper'. There may also in this typecasting of rulers have been an element of the philosophical conception that 'rulers' were in a sense just acting a part – the dramatically changeable nature of the Hellenistic 'stage of life' was such that anyone might find himself called upon to play the part of king, if only for a while.[17]

Although masks had been worn by actors for various types of dramatic performance from the fifth century onwards, the use of specific masks for particular types – reflecting as it does the philosophical idea that human nature or character is itself divisible into types – seems to be a new feature of the Hellenistic stage. Our knowledge of the appearance and function of dramatic masks in the Hellenistic period derives partly from later literary sources, especially the much-quoted and disputed list of mask types provided by Iulius Pollux in the second century AD, and partly from the evidence of the artefacts

themselves. Pollux listed, for example, forty-four New Comedy masks, and some of the types he named, such as the 'young man with blond wavy hair' have been reasonably convincingly identified among the surviving artefacts.[18] While the majority of 'dramatic' artefacts of the late fifth and fourth centuries are complete figurines, or scenes on South Italian Greek vases involving more than one actor in a 'dramatic' situation, isolated masks are rare. But from the late fourth century onwards terracotta model masks start to proliferate, and although full-length actor figurines remain popular, for these too the mask is now very often the most prominent and seemingly significant element of their appearance (fig. 35). These masks are often quite repulsive in effect, their features hideously exaggerated and distorted, their brows puckered, their mouths gaping. Although male and female types can usually be distinguished, it is not always easy to recognize individual characters: there is a sort of code or language to be deciphered. However, since examples of the same or similar types have been found – and presumably were recognized – right across the Hellenistic world, it seems that in its own day the visual language of drama, like the Greek language itself, was widely understood. The increasing importance of masks from the early Hellenistic period onwards reflects, it seems, changes in the types of popular drama: similar characters peopled many plays so that audiences would grow

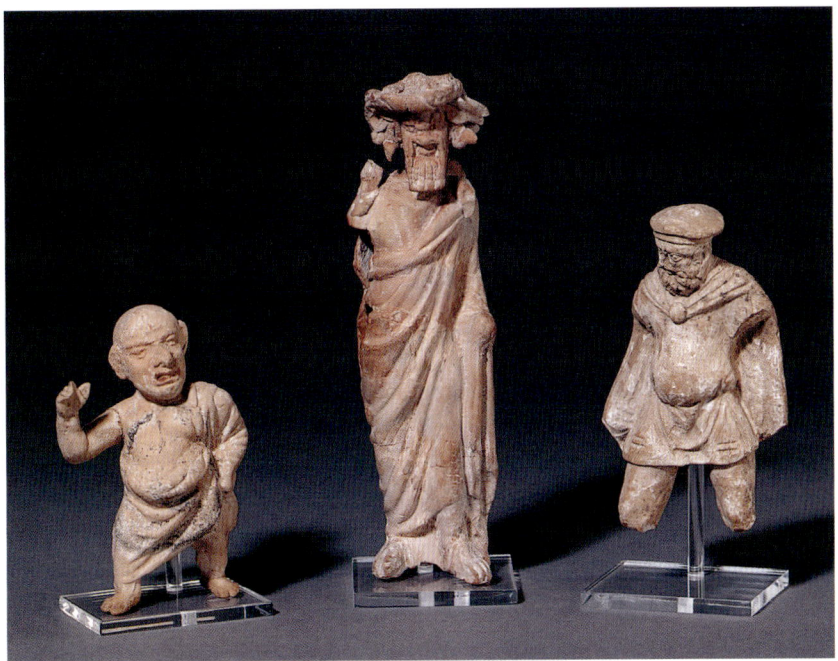

35 Group of terracotta actors. Made at Tanagra in Boeotia and Myrina, Asia Minor, in the third to first centuries BC. These small-scale figures provide a vivid impression of the appearance of the masks, costume, and in some cases poses, of the real-life actors of New Comedy. Height of actor with wreath 19 cm.

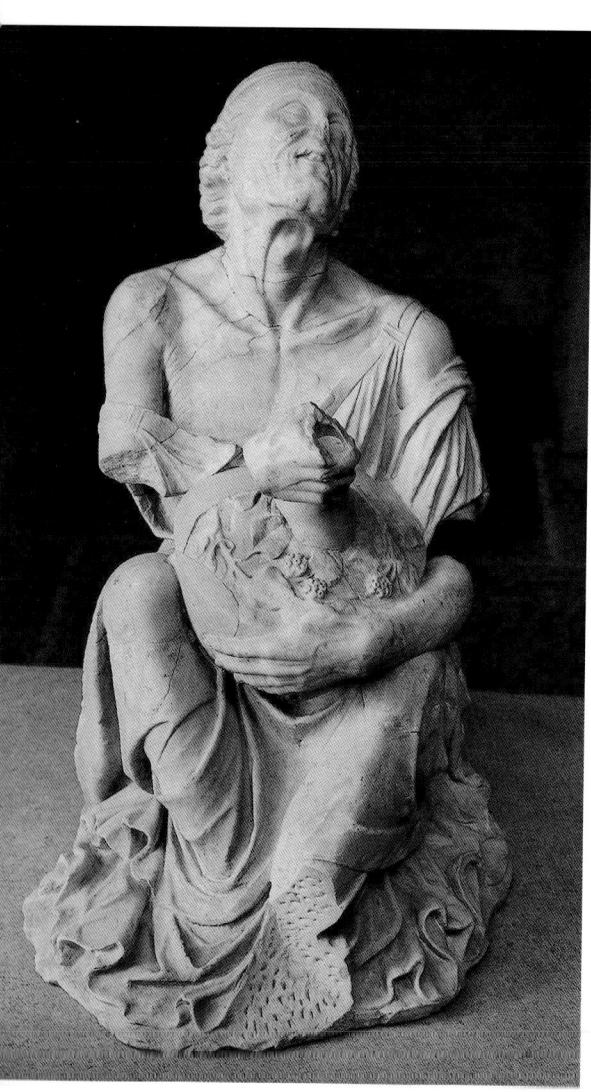

36 Marble figure of an emaciated old woman in ragged garments clutching an ivy-wreathed wine flagon. Probably Roman in date, though the Hellenistic shape of the flagon suggests the statue reflects an original Greek work of the third or second century BC. Height 92 cm.

familiar with what to expect in terms of age, social status and psychology from someone wearing a particular type of mask. A subtle dramatist like Menander might take the opportunity to play about with the mask types and defy expectations by deliberately making their wearers act 'out of character', thus raising thought-provoking questions about character or destiny.

'Genre figures' and 'grotesques'

Dramatic masks can seem quite startling because of their deliberate ugliness, but in this they are not unique among Hellenistic faces. Despite the multiplicity of their types and functions, the great majority of the faces of the Hellenistic age that have come down to us are in one way or another ideal, tending to emphasize or even exaggerate the good parts or character of their subject. But the discussion of masks leads us on to other images that portray a very different type of character, as exemplified by one of the most memorable survivals from the Hellenistic era: a marble figure, now in Munich, that shows an evidently drunken old woman, gazing upwards, her garments slipping from her scrawny shoulders as she cradles in her lap an ivy-wreathed wine flagon (fig. 36). Over the centuries that have passed since her discovery she has been variously reviled and admired, interpreted and reinterpreted as a rapturous devotee of the wine god, a participant in a Ptolemaic festival, a visual metaphor for old age, a *memento mori*, a parody of an Aphrodite, and most recently a clever visual riddle based on the ancient maxim that aligned life and wine, their loss and people's shifting estimate of their value.[19] While this figure is not a portrait in any normal sense of the word, her face is a very striking and vivid piece of

carving that could equally well represent either a specific individual or a totally artificial construct, an amalgam of traits observed in more than one person. What is most striking about the figure is its concentration, almost its overload, of ugliness. It seems that it deliberately sets out to shock and repulse, to evoke conflicting emotions of horror and pity through its cruelly exaggerated delineation of what old age can mean. Age and decrepitude are expressed in the thinned receding hair, the eyes sunk deep into their sockets, the deep furrows and jowls running between nose and mouth, the missing teeth, the hollow, bony upper chest and arm – and yet at the same time we have to admire the skill and ingenuity of the sculptor, the beauty inherent in the triumphant success of the workmanship.

Difficult as it may be to determine what such a figure as this might have meant in her original time and setting, were she a 'one-off' she could perhaps be accepted as a rich man's whim, a talking point for the visitors to a wealthy mansion, a counterpoint, perhaps, to a smoothly elongated and reassuringly perfect Aphrodite. But in fact she is instead probably just the most prominent – because large, marble and very high quality – member of a huge group of 'non-ideal' images that have come down to us from the Hellenistic world and still stand in considerable need of explanation. Although there are a few other large-scale examples in marble or bronze, the greatest numbers of such figures are small-scale bronzes or terracottas (fig. 37). In the case of the terracottas,

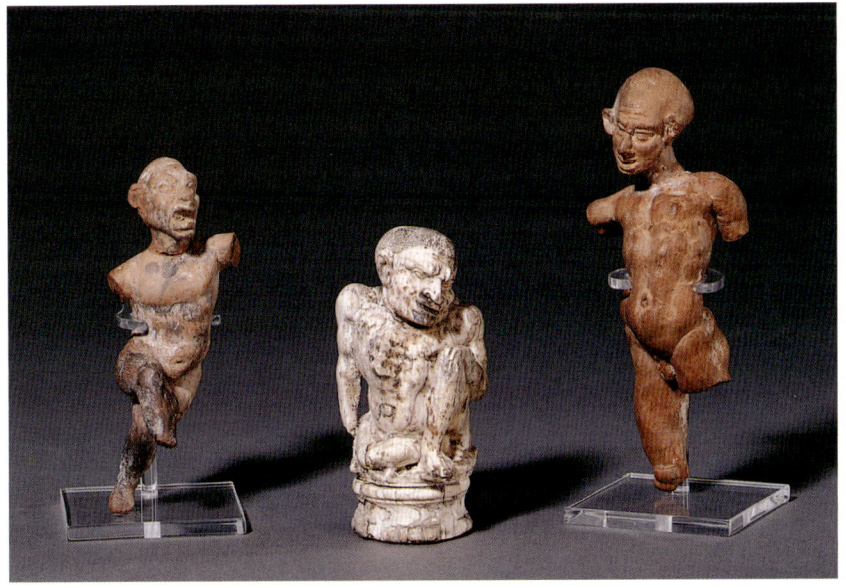

37 One ivory and two terracotta figures with distorted limbs and features: the poses and gestures of the terracotta versions suggest they are performers, acting to an audience. The place of manufacture of the ivory figure is unknown; the terracottas were made at Smyrna, Asia Minor, in the first century BC or AD. Height of the taller terracotta 12.4 cm.

generally it is just the heads that survive, but occasionally complete figures are found, and the construction techniques used for the heads show that they were designed originally to be fitted into figures. It is common for scholars to group all such 'ugly' heads together and describe them as 'grotesques', but this term is both limited and inaccurate as in fact a number of sometimes overlapping categories of significance appear to have been involved. These include comic and other types of actors; images of mentally and physically disabled people, varying from reasonably sympathetic likenesses to what can seem to us at least cruel mockery of undeserved misfortune; and representations of non-Greek, principally African, racial types, ranging again from the more or less realistic to crude caricatures.

It can at times be difficult to decide in which of the three broad categories an individual image should be placed. In the case of comic actors, some may readily be identified by the stylized, formulaic nature of their masks; these correspond with what we know about the masks of the stock figures from the New Comedy of Menander and his contemporaries. Others, though, who do not wear obvious masks or costumes, can also look like actors because everything about them is unnaturally exaggerated, from their over-large heads and features, mouths opened wide in speech, to their ungainly bodies, spindly legs and extravagantly clumsy gestures and movements, apparent parodies of more graceful dances. No-one, however, is very sure from what genre of drama such figures have stepped out. It is possible that, like the figures on some 'dramatic' scenes on Athenian or South Italian vase painting, they represent the actual characters of comic drama – the slaves and other typically 'low-life' characters – rather than the actors playing the parts, so that instead of masks they wear semi-natural but somewhat distorted features. It is also possible that they represent the practitioners of other forms of dramatic entertainment; perhaps the 'mimes' which are known to have been enacted but about which so little is securely known, perhaps musical or acrobatic acts performed at the private entertainments of the wealthy.

The most dignified images of the mentally and physically disabled seem to combine an almost clinical interest in portraying the symptoms of various conditions with a certain sympathy and respect for the afflicted person. In other representations they throw their wasted or distorted limbs about in a grotesque parody of a dance, often with their mouths flung open in song or speech: these figures, it has been suggested, may represent a class of unfortunates who survived by contorting their twisted and shrunken bodies for the amusement of the rich. The popularly represented dwarfs, sometimes dancing and often endowed

with an enormous phallus, form a particular sub-category here, for some of them, at least in Egypt where they are most numerous, appear to have been employed as cult attendants.

An interest in representing different racial types is a marked feature of many branches of Hellenistic art, undoubtedly the result of the greatly expanded geographical and racial boundaries of the Hellenistic world. In large-scale sculpture, images of native Egyptians or north Africans are generally sympathetic and respectfully observed renderings of non-Greek individuals. This is the case, for example, with the so-called 'Berber Head' from Cyrene in present-day Libya, now in the British Museum, a life-sized bronze head of a man whose features seem to blend native north African realism with Classical idealism (fig. 38). The date of this piece is uncertain, and as the find-context seems to offer little help the head has been placed at various periods between the fourth and (most recently) the second century BC.[20] Indisputable, however, is the dignified treatment of the subject and the accepting inclusion of non-Greek characteristics, notably the set of the eyes, the full mouth and the slight beard: this may result from the identity of the subject, who may well have been a king or prince, or at very least a famously successful athlete, rather than just an 'ordinary' person. There are, too, some sentimental but relatively sympathetic portrayals of non-Greek children. But in general the treatment of non-Greeks in small-scale bronzes and terracottas is rather different, with a tendency to produce exaggerated caricatures of racial types, especially of black Africans or native Egyptians. So we find the majority of them most unflatteringly endowed with over-large ears, thick and twisted lips, severely flattened noses and woolly mops of hair. As some of these people are shown dancing, juggling or declaiming, and some have recognizable disabilities,

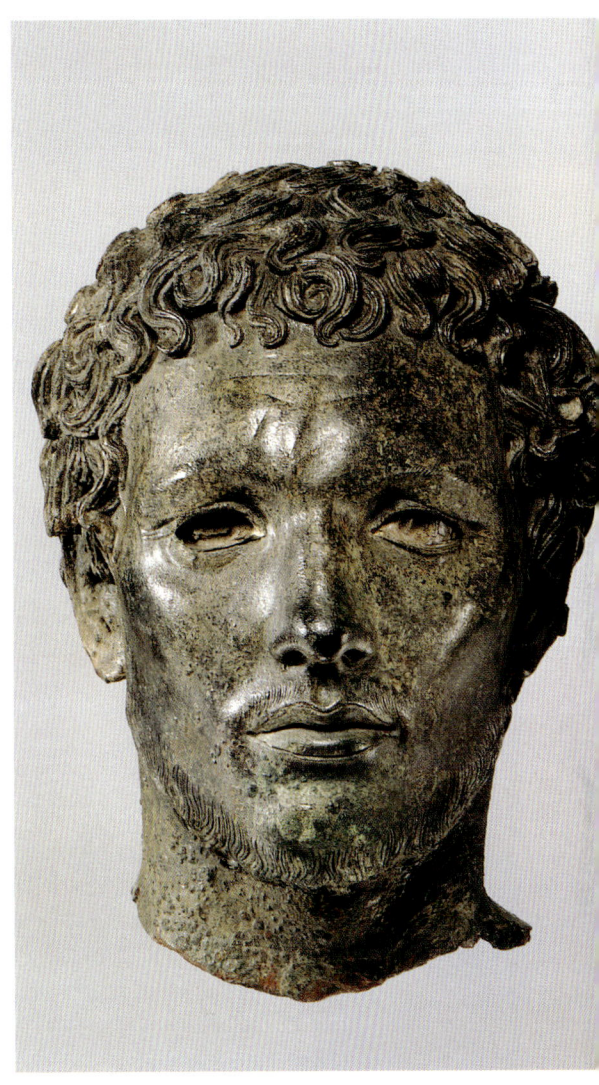

38 The so-called 'Berber Head', a bronze portrait of a young man of African descent, probably either a prince or an athlete. A wide range of dates in the Hellenistic period has been proposed for this piece. From the temple of Apollo at Cyrene in Libya. Height 30.5 cm.

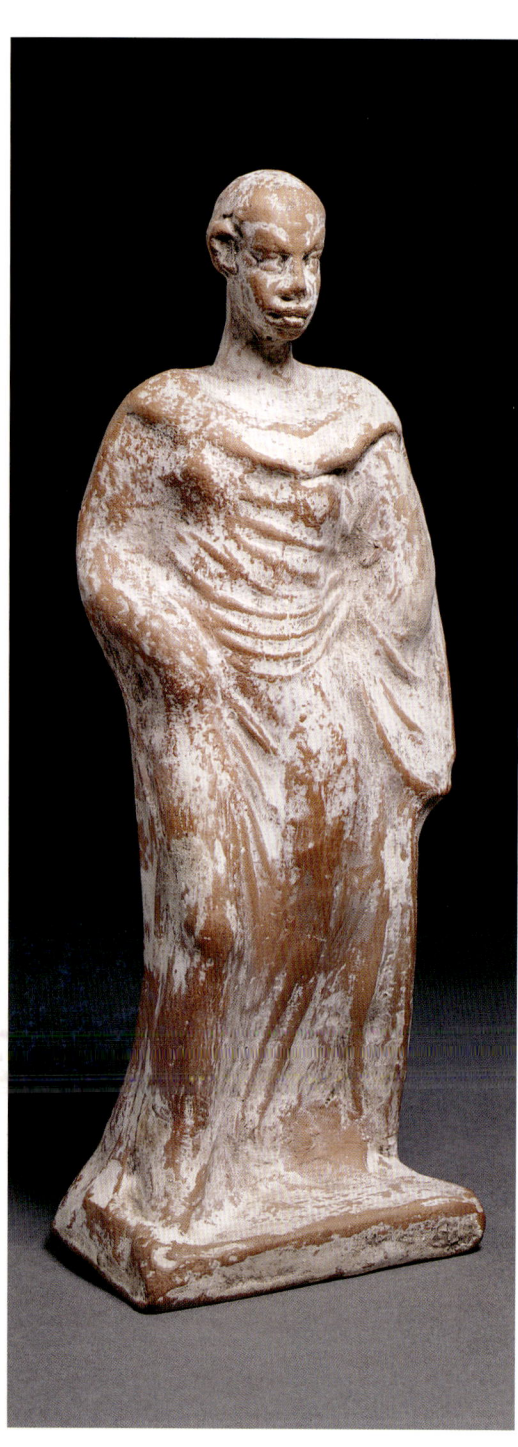

they can fall into two or even three categories at once – non-Greeks, actors and the disabled.

Since these potentially separate categories can so often overlap, when the heads survive in isolation from the bodies to which they were once attached, as often happens, it is not always possible to decide with any certainty to what sort of body any given head originally belonged. And in any case, the technique of manufacture, whereby the heads were made separately from the bodies, could easily have permitted the attachment of identical or similar heads to quite different types of torso. An interesting case is provided by a rare example of a full-length figure in the British Museum (fig. 39): had the figure's head survived in isolation, it would surely have been identified as an unflattering image of a shaven-headed, male, black African; no-one could possibly have predicted the seemingly female body to which it is quite securely joined! Although the significance of this figure is as yet uncertain, one likely explanation is that it represents a eunuch priest, an interpretation based on its similarity to more securely identifiable contemporary Egyptian statuettes and later Roman figures who play this role in narrative scenes.[21] However, some of our best clues as to the identities of such figures and their significance, or how they were perceived in antiquity, must lie in the careful interpretation of the contexts in which they were found.

Because they are relatively small and cheap, many of these terracotta figurines have traditionally made their way on to the antiquities market quite divorced from any information about their findspots. Terracotta figurines are intrinsically fragile, so if a terracotta is well preserved, like the 'eunuch priest', the likelihood is that it was found in a tomb; domestic and sanctuary sites, where the terracottas have enjoyed less favourable conditions of deposit, generally yield many more fragments than complete

figures. We might therefore suppose that some of the more complete examples may derive from tombs, but that many of the isolated heads found in museums could come from other contexts too: such figures may then have fulfilled various different functions. As so few Hellenistic cemeteries have been properly and recently excavated, opportunities for linking grave goods of any type with individuals of known sex or age or status are of necessity pretty limited. Any discussion of the role such figures played in the tomb is of course part of the wider discussion about the purpose of terracottas as grave goods. It may be suggested that one of their functions was to play a part in funerary ritual, providing comfort or company to the dead person, and, in a related manner, perhaps to serve as propitiatory gifts to the gods of the Underworld and thus smooth the dead person's path into life after death.

If we ask why these 'non-ideal' figures were thought suitable for these functions, rather than more obviously beautiful or straightforwardly attractive figures, perhaps the consideration that similar figures were quite frequently dedicated in sanctuaries of the Underworld deities Hades, Demeter and Persephone may be of relevance here. One frequently advanced theory for this practice is that there were obscene elements in the cults of these deities and that these are reflected in the figurines and masks. If such objects were suitable gifts for the Underworld gods in sanctuaries, they could also have been offered to these same gods in the tomb.

If there are apparently logical and interrelated reasons for placing such figures in tombs and sanctuaries, their presence in domestic contexts is less easy to comprehend. Yet many such figures have been found in Hellenistic houses, including some of those excavated at Priene. Here, the terracottas are generally said to have fulfilled the same function as small-scale sculpture in bronze or marble, that is, a decorative or ornamental one. In the case of non-decorative, positively repulsive terracottas, however, this might seem less likely, although there is possibly an element of voyeurism. This is part of the reasoning behind one theory for the popularity of such figures in a domestic context: that, like the real-life outcasts and 'under-classes' that they represented, their presence in a house was a sign of the contrastingly privileged social status of the occupants.[22] There may also, however, have been some element of domestic cult involved; and their inclusion in either a domestic or a funerary setting may at the same time have been apotropaic, the aim being to draw away from the occupants of the house or tomb the ill-fortune that they personified.

Beautiful, divine, royal, realistic, visionary, ideal, schematic, accursed: the sheer variety of types of 'portrait' that the Hellenistic world achieved can

OPPOSITE:
39 Terracotta figure consisting of a male African head set on an apparently female body – possibly a eunuch priest? Probably made at Smyrna, Asia Minor, in the second or first century BC. Height 17 cm.

scarcely fail to impress. But more importantly, each type opens a window onto a different segment of contemporary society – perhaps a different geographical area of the Hellenistic world, perhaps a new social division, or an unexpected preoccupation. Rarely can we be sure that we understand quite what, or whom, in each case, we are seeing. But even cautious awareness of the multiplicity of options and uncertainties can help to edge our understanding of Hellenistic society a little further on its way.

Chapter 3

Public Life: Hellenistic cities and sanctuaries

'The city as a whole is intersected by streets practicable for horse-riding and chariot-driving, and by two that are very wide, extending to more than a plethrum in breadth, which cut one another into two sections at right angles. And the city contains most beautiful public precincts and also the royal palaces … for just as each of the kings, from love of splendour, was in the habit of adding some adornment to the public monuments, so also he would invest himself at his own expense with a residence.… The Museum too is part of the royal palaces; it has a public walk, an exedra with seats, and a large house, in which is the communal dining room of the men of learning who share the Museum.' (Strabo, *Geography*, 17.1.10)

Cities and city plans

Strabo's admiring description of the ancient city of Alexandria conjures up an image of a spacious, attractive and thoughtfully laid out city, its broad, boulevard-style avenues lined with beautiful buildings, its shady porticoes and walkways frequented by a cultivated populace. So little of Alexandria has so far been excavated that it is difficult to decide how accurate this picture is – though other literary sources and the existing archaeological evidence suggest that it was indeed carefully planned and thoughtfully sited so as to catch the breezes from the sea. But was this characteristic of Hellenistic cities in general? And can we identify any other distinguishing features that Hellenistic cities had in common with each other, which at the same time mark them out from their predecessors

of the Classical period? Outside cities, the other main areas where people would assemble in public were the extra-urban sanctuaries; so were there ways in which these too differed or had developed from those of the Classical period?

In terms of the number of cities and their geographical extent there were certainly some very significant developments. In the Hellenistic period overall well over one hundred new cities were founded in Asia Minor, Syria, Palestine and Mesopotamia, and to a lesser extent further east and south.[1] Some of these cities were new foundations on the sites of former native settlements, but all were 'Greek' in the sense that they contained sizeable proportions of Greek settlers who expected to live in cities that would offer them the full range of 'normal' Greek social, cultural and legal institutions. To fulfil these expectations there would be a concomitant need for numerous characteristically Greek types of building or public spaces with specific and well-defined functions. Though the Hellenistic way of life in these new cities would naturally be coloured and enriched by elements of the foreign cultures that surrounded them, in many ways it would remain essentially Greek. In this determination many of the cities were assisted by their impressive size, another key area that saw significant changes between Classical and Hellenistic times. Although population statistics are notoriously difficult to secure for the ancient world, it seems clear that the largest Hellenistic cities, including Alexandria in Egypt, Seleucia on the Tigris and Antioch on the Orontes, were on a substantially larger scale than all but the largest of their Classical counterparts. Cities with more than a hundred thousand inhabitants were no longer a rarity, and many people would now live within relatively easy travelling distance of one: in other words there was probably more 'urbanism', in that far more people would have been able to experience life in a big city than ever before.

Obviously there were some aspects of civic life and the appearance of the city that remained constant from the Classical to the Hellenistic period. Grid plan designs for cities are traditionally associated with Hippodamas of Miletus, believed to have been born about 500 BC; although he probably did not invent the concept, he is likely to have developed it and put it into practice, and certainly evidence of grid-pattern layouts appears in various parts of the Greek world from the mid-fifth century BC. Grid designs continued to be favoured in the Hellenistic period; what was new now about town planning, however, was the care taken to integrate public buildings into key parts of the grid where they would both be convenient for access and make the best impression on citizens and visitors alike. At the same time, many of these public buildings were more monumentally planned, built and adorned than their Classical predecessors.

And in those cities that were built or rebuilt basically from scratch, far greater attempts were made to unite groups of buildings to create appropriate vistas, and much more thought was put into planning the approaches, the organization of spaces and the linking of one group of buildings with another. Such deliberate planning had both practical and aesthetic results: it made the city more workable for its inhabitants while simultaneously creating a pleasing and impressive appearance from afar.

Defining the boundaries of open spaces and linking one group of buildings to another was largely achieved by the clever and prolific use of the stoa,[2] a form of building that had originated in the Classical period but played its most popular and useful role in the Hellenistic age (figs 40 and 41). The basic shape of a stoa has been compared to that of a traditional lean-to bicycle shed: it was essentially a long, rectangular building with a solid back wall, a colonnaded front side and a pitched roof. A stoa was usually divided along its length into two or three aisles, and it could be constructed to provide between one and

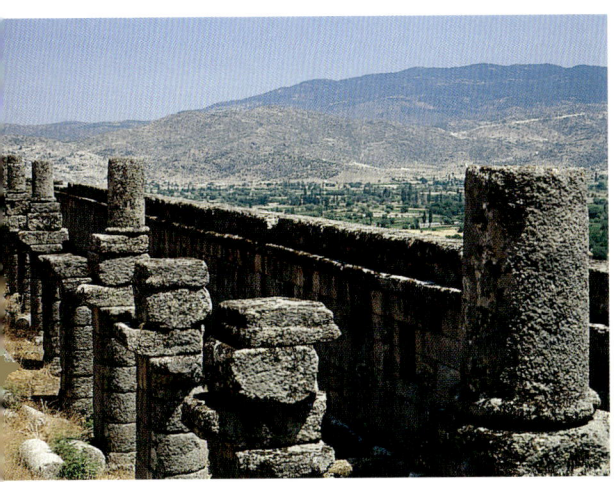 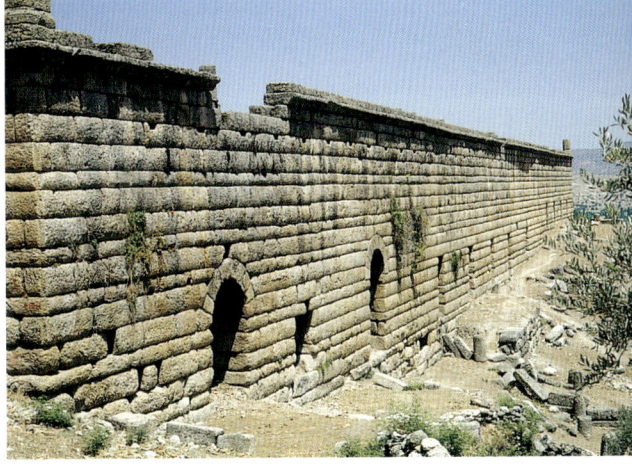

three storeys of accommodation. Stoas were highly adaptable, multipurpose buildings that could provide useful facilities for everything from public dining to shopping, storage of goods, shelter for pilgrims or room for philosophical conversations. Along with their practical uses, stoas helped to create a 'planned' look in Hellenistic cities by marking the boundaries of open spaces such as agoras, or by linking one group of buildings with another. They were constructed in large numbers in virtually all Hellenistic cities – it is recorded that in fourth-century AD Alexandria there were no fewer than 456 of them! The

40 and 41 Inner and outer sides of one of the stoas in the Hellenistic city of Alinda in Caria, Asia Minor, probably dating to the second century BC.

original appearance of a large stoa is easily appreciated from that of the Stoa of Attalos at Athens, reconstructed on its original site and to its original plan in the Agora by American archaeologists and architects for use as an excavation base and museum between 1953 and 1956 (see also fig. 97 and pp. 167–8).

A supreme example of the use of the stoa, and of careful and deliberate planning in general, is provided by the city of Pergamon.[3] Here in the second century BC the city's Attalid rulers created a showpiece of contemporary architectural design (fig. 42). As the city lies on a steep hill that rises suddenly from the surrounding plain, terracing was needed to accommodate the monumental new buildings and enclosures, and here it was employed to astonishingly brilliant effect. The main view of the city is from the west, dominated by the huge theatre sunk into the side of the hill. The arc of the theatre seems to rest upon the giant stoa set below it that both served the practical function of a retaining balustrade and provided a panoramic walkway for strolling theatre-goers. The main terraces on which lay the other main public buildings of the city – the temples, the library and the altar of Zeus – radiated outwards from the theatre, and many of these structures too are defined and linked by stoas.

These changes in the concept of spatial management and planning radically altered the appearance of many cities. In detail, too, as well as in overall plan, the appearance of many Hellenistic cities and sanctuaries was much more splendid, in many ways more noticeably opulent, than that of their Classical predecessors. A city council (*boule*), for example, had been part of the government structure of many cities in the Classical period. But only in the Hellenistic period did it become the norm for the council to have its own dedicated building, a *bouleuterion*. At Miletus, for example, a *bouleuterion* was presented to the city by the Seleucid king Antiochos IV (175–164 BC). It takes the form of a small indoor theatre, accessed through a colonnaded courtyard, which was itself approached from the street by a columned gateway.[4] The remains of a similar, though more modest structure, can also be seen at Priene. Again, many Classical cities had had their own theatres, but most of the ruins that we can see today, such as the well-preserved examples at Epidauros, Syracuse or Ephesus (fig. 43), actually date to the Hellenistic period.[5] The circular *orchestra* of the Classical theatre remained unchanged, but the rough, grassy slopes where Classical audiences had assembled were utterly transformed in the Hellenistic age through the supply of regular rows of marble bench seats arranged in tiers and sections, with special comfortable chairs for the dignitaries in the front rows and elaborate, permanent stage buildings at the back of the *orchestra*.

PUBLIC LIFE

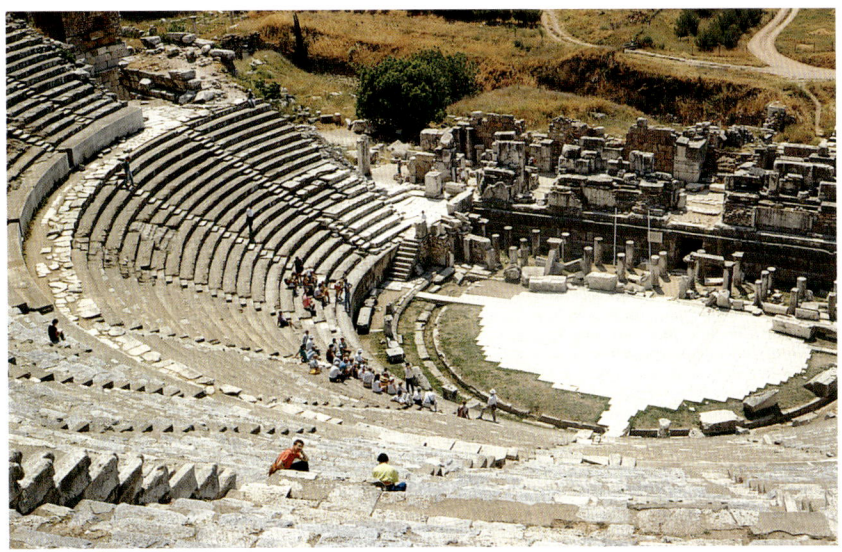

42 Model of the Acropolis (upper city) of Pergamon, Asia Minor, showing how the various buildings, complexes and levels are grouped and linked one with the next.

43 View of the theatre of Ephesus, Asia Minor. The stage-building is Roman in date, but the overall plan and the lower two of the three tiers of seating are Hellenistic. In its expanded Roman form the theatre could seat 24,000 people.

Temples, sanctuaries and public sculpture

In terms of general architectural principles, the inclination already observed in fourth-century Macedon to pay less than strict attention to the Classical forms and canons was carried further. Taking advantage of this tendency there developed an interest in and an ability to use both architecture and sculpture to create feelings not just of awe and admiration but also of surprise, drama and excitement. The great Hellenistic temple of Apollo at Didyma in Asia Minor, for example, probably the largest temple project of the early Hellenistic period, was a building full of unexpected features and architectural novelties (figs 44 and 45).[6] Built to house a cult statue, a sacred laurel tree and an oracular spring, it looked from the outside more or less like a normal peristyle temple, albeit on

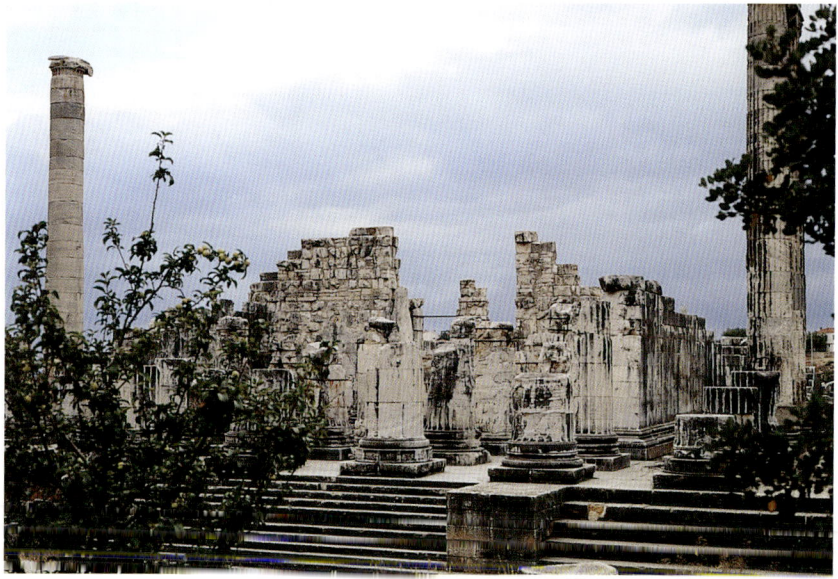

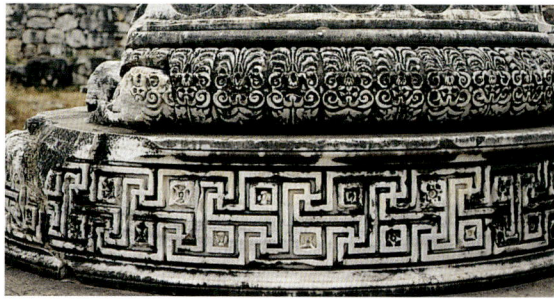

44 and 45 View of the interior court of the temple of Apollo at Didyma, Asia Minor, and a characteristically ornate detail from the base of one of its columns. The building of this temple started c. 300 BC but continued into the Roman period.

a massive scale, and with unusually varied and richly elaborate decoration on the base pedestals of its 20 m-high Ionic columns. However, the porch at the 'front' end of the temple did not lead to a normal-sized cella or inner chamber. The apparent 'door' in its back wall was really rather a high, stage-like window at which a priest might appear to address a crowd of worshippers. The central area of the temple was a massive courtyard sunk below the level of the porch and open to the sky. Access was restricted to two narrow, sloping, barrel-vaulted corridors leading down from the front colonnade. Once inside the court, a staircase of monumental proportions led back up from ground level to the small room behind the porch. Present-day visitors to the site can readily re-create something of the dramatic experience of those worshippers who were allowed to enter the inner court: crowded into the unnervingly dark passages, they would hasten down the sloping pavements of slippery marble to emerge into the extraordinarily vast outdoor space of the courtyard, a place quite secret from the world outside the temple walls; and as they got used to this they might turn to find themselves dwarfed by the unexpectedly monumental staircase behind them. The idiosyncratic design is likely to have resulted from the special needs of the cult and ritual that went on there: it must have provided a series of spectacular, theatrical settings in which to impress the worshippers and it is hard to resist the supposition that the ritual involved some impressive performance by the priests, elevated high above the crowds.

The cult statue of Apollo from the great temple of Didyma is lost, but whether it was of bronze or marble, the chances are that it was monumental in scale, and probably positioned so that viewers would look up at it from below. A modest reconstruction of this sort of elevated position has been contrived in the British Museum for a rather later cult statue of Apollo, found shattered into 121 pieces on the floor of a temple at Cyrene in North Africa (fig. 46).[7] Although it probably dates to the second century AD, this colossal marble figure suggests one possible form that the Didyma figure could have taken. Seen from a distance, the size, striking pose and wealth of attributes of the Cyrene Apollo create an imposing effect. Close up, however, the god is less powerful-looking, with a sweet, rather feminine face and long, curling hair that falls onto his shoulders. The *himation*, slipping below his hips, reveals a soft, rather fleshy physique and shows off the exaggerated curve of his torso. His lost right arm was originally raised; his missing left hand would loosely have supported the large lyre that proclaims his role as god of music, while the snake that twists round a tree-trunk below the lyre recalls the legendary serpent of Delphi that the god had once fought and defeated.

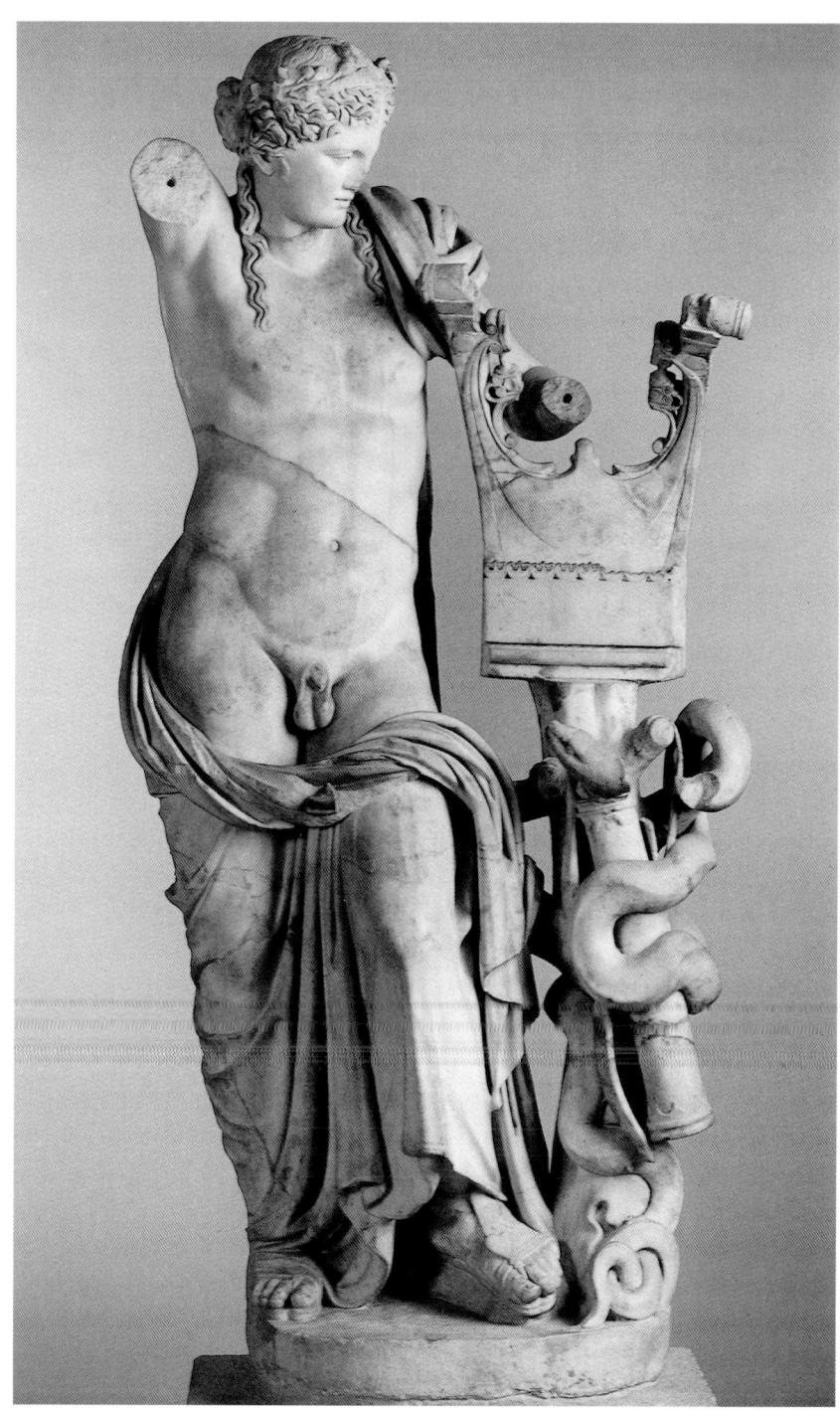

46 The 'Cyrene Apollo', a rather languorous, Dionysian version of the god: this statue dates to the Roman period but is likely to be based on a Hellenistic work of the third or second century BC. From the temple of Apollo at Cyrene, Libya. Height 2.9 m.

PUBLIC LIFE

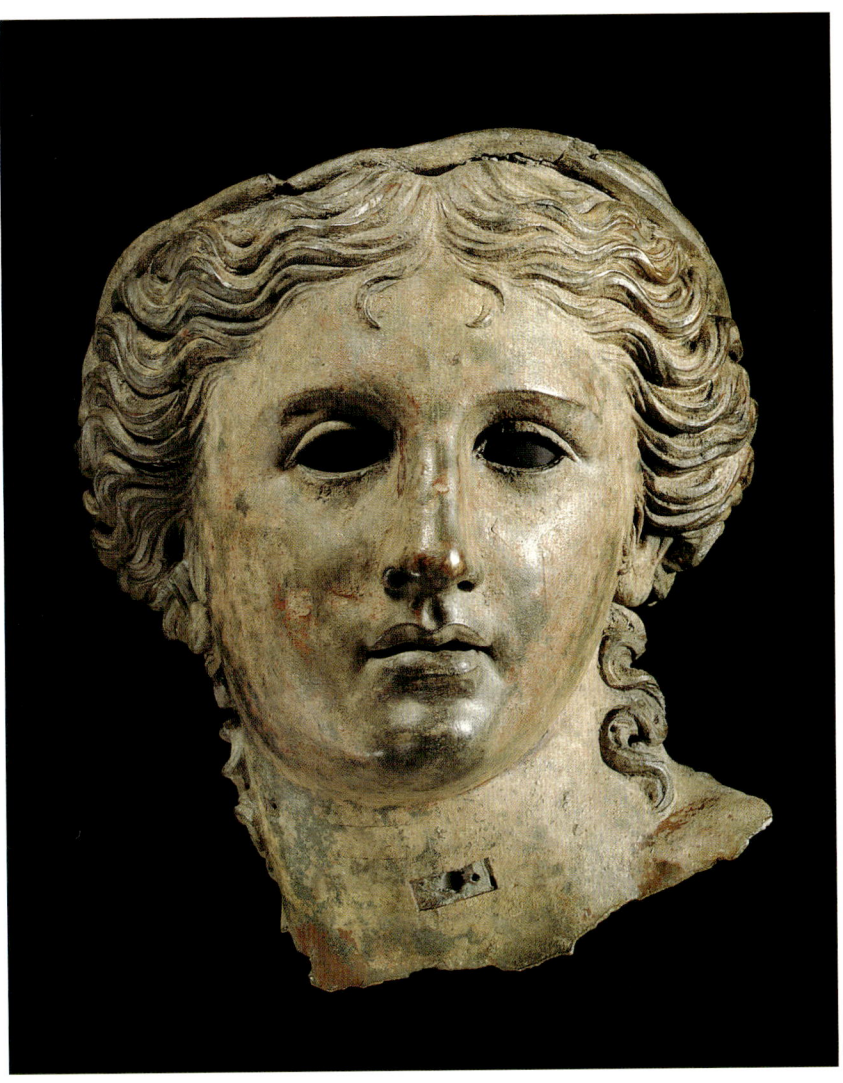

A bronze cult statue would not have needed the rather clumsy tree-trunk and system of struts that this marble version requires to support its weight. Few colossal bronze statues survive from any period of antiquity, because of the propensity for them to be melted down and reused. The British Museum is, therefore, fortunate to preserve one bronze head that comes almost certainly from a late Hellenistic cult statue (fig. 47). This head was discovered in the early 1870s by a man digging in a field on the site of the ancient city of Satala (modern Sadak) in north-east Turkey, in antiquity part of the kingdom of

47 The bronze 'Satala Aphrodite', probably the head of an original Hellenistic cult statue. From Satala (modern Sadak) in north-east Asia Minor. Height 38.1 cm.

Armenia.[8] The head travelled via Constantinople to Italy, where it came into the hands of an Italian dealer and collector who sold it to the British Museum in 1873. Shortly afterwards a bronze hand, almost certainly from the same statue, was presented to the Museum. No more of the statue has ever surfaced. The head has been identified as that of the goddess Aphrodite from its resemblance to other heads on complete Aphrodite statues: it has been suggested that the statue was probably of the 'Cnidian Aphrodite' type, which showed the goddess naked, pulling drapery from a support by her side. The findspot however, has also suggested that the statue may alternatively represent the Iranian goddess Anahita, who was later assimilated with the Greek goddesses Aphrodite and Athena. The features of the full, rather heavy face are very regular, the modelling of the cheeks and chin subtle and rounded. The hair is extremely finely worked, its waves, curls and ringlets, including the wisps in the centre of the forehead, contrasting with and setting off the smoothness of the skin. The eyes, now empty sockets, would originally have been inlaid with either precious stones or glass paste, and the lips may have been coated with a copper veneer. A late Hellenistic date, perhaps in the first century BC, is suggested by the thin walls of the casting. Since no traces of a temple were ever found when the alleged site was excavated, the original setting of this statue remains a mystery; the exceptional quality of the surviving elements, however, suggest that it must have formed a highly impressive figure.

The Nike of Samothrace

The most dramatic of all known public settings for a piece of sculpture is surely that contrived for the most impressive free-standing sculpture of the Hellenistic age to have survived, the huge (3.28 m high) and magnificent figure of the Nike (Victory) of Samothrace (fig. 48).[9] Now in the Louvre, the Nike originally stood in an open-fronted building at the top of the theatre in the Sanctuary of the Great Gods on Samothrace (fig. 49). She is shown alighting on a base in the form of a ship's prow; it is possible, though not certain, that this was originally set in a rock-surrounded basin of water – in other words, a miniature seascape of cliffs and waves. The Nike looks best when seen in left three-quarter view, the angle from which most viewers would originally have approached her. The figure was carved from one principal block of marble, extending from below the breasts to the feet, with a number of subsidiary blocks for the bust, head, wings and elements of the drapery: all these separate pieces were skilfully pieced

PUBLIC LIFE

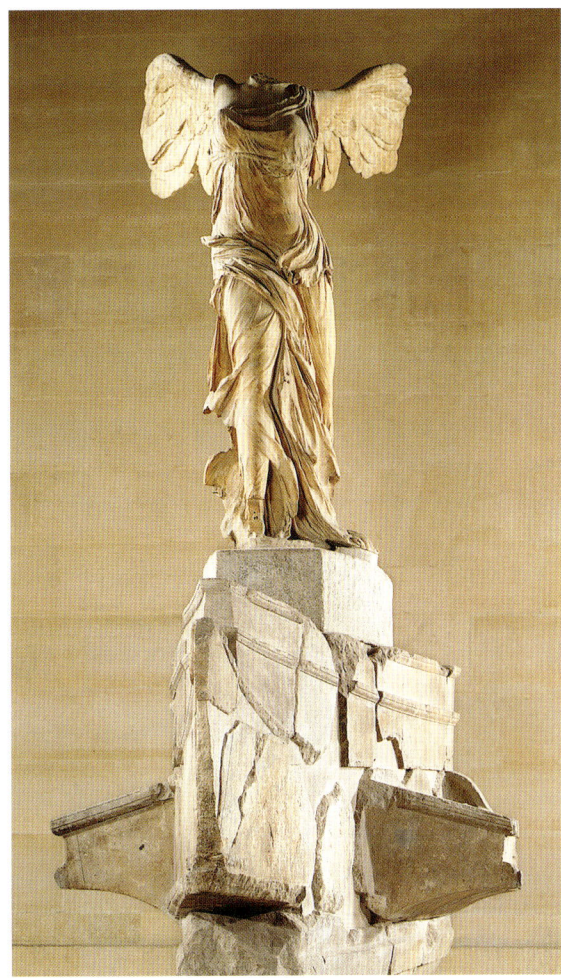

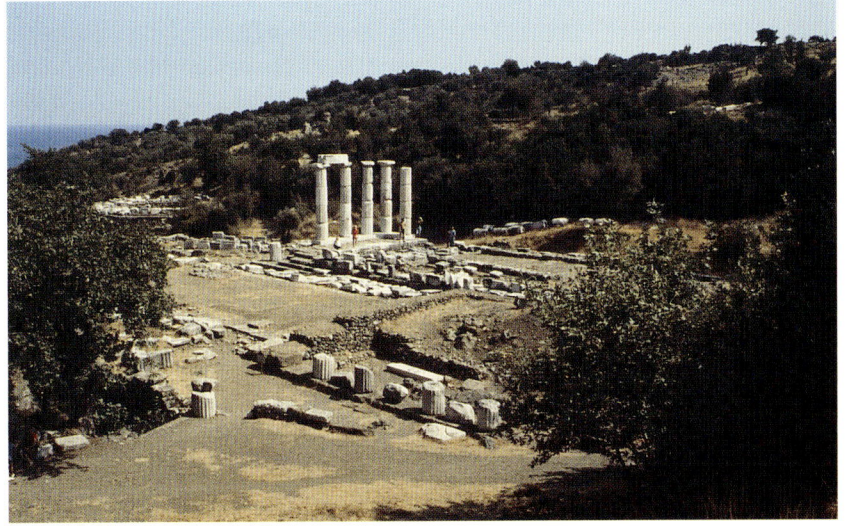

48 The Nike (Winged Victory) of Samothrace, alighting on the deck of a ship. Various dates within the Hellenistic period have been proposed for this figure, which is likely to have been a thank-offering for some great naval victory. Height of the Nike herself c. 2.45 m.

49 This is the spectacular view over which the Nike of Samothrace looked, across the Sanctuary of the Great Gods to the sea.

together. The Nike is a massive, muscular and powerful figure. With her huge, meticulously feathered wings outspread, she strides energetically forward, her torso twisted in one direction, her hips in the other, producing a boldly contorted effect as she battles against the wind to land on the deck of the ship. The full curves of her body are visible through her finely pleated *chiton* as it presses against and moulds her body and thighs, while her wind-blown cloak wraps itself around and between her legs in deeper, thicker folds. The circumstances of this figure's dedication are unknown. It is likely to have commemorated an important naval victory, but we do not know for certain whose, or even roughly when. Samothrace was a major sanctuary in the Hellenistic period, and as such it was controlled and patronized by various Hellenistic rulers in turn, including the Ptolemies (who built an unusual rotunda, the Arsinoeion, to house the cult of Queen Arsinoe) and the Antigonids of Macedonia. Some scholars argue that the Nike is most likely to have been dedicated by Antigonos Gonatas after his naval victory over the Ptolemies at Kos in the 250s BC. Another, perhaps rather over-ingeniously crafted hypothesis (which tries to link together a fragmentary sculptor's name, the supposedly Rhodian type of ship portrayed and the possibly but not as yet demonstrably Rhodian origin of the grey stone used for it) suggests that instead the Nike commemorated the victory of the Roman fleet, assisted by that of Rhodes, over Antiochos III of Syria in 190 BC. This debate, very typical for the major monuments of the Hellenistic period, seems set to continue. Incontrovertible, however, is not just the magnificent quality of the sculpture but also the theatricality of the setting. The prominence of the chosen site, the thought that has gone into the effect of the figure on her viewers, the miniature seascape setting that would only be appreciated close at hand and the larger desire to use the landscape to enhance the sculpture and vice versa, are all typical of the grand planning tendencies of Hellenistic sculptors and architects, here realized to maximum effect.

Pergamon and the Great Altar

To appreciate Hellenistic civic architecture to the full, it is of course desirable to visit some of the sites of the Hellenistic cities and sanctuaries. To glimpse something of the original grandeur of Pergamon – and of Hellenistic public architectural sculpture in its most developed form – it is also advisable to view the Great Altar as reconstructed in the splendour of the Pergamon Museum in Berlin (fig. 50).[10] Here, however, divorced and isolated from its original city and

sanctuary setting, it has acquired a rather different aura, one that is perhaps even more imposing than that of its original context. The architectural form of the Great Altar is in itself a Hellenistic development, a good example of the tendency of Hellenistic architects to adopt Classical forms but convert them into something rather different. Monumental altars on stepped platforms, though found in various East Greek sites in the Archaic period, were not favoured in Classical times. The preference then was for a relatively small altar placed in front of a temple: it was the temple itself, complete with columns and various forms of sculpture, that dominated most sanctuary precincts. The Pergamon Altar, however, was an independent structure in its own precinct. It consists of a large platform set on a massive podium: on the front side the podium splits to create two projecting wings framing a monumental staircase. The platform

50 General view through the colonnade of the Great Altar of Pergamon, as reconstructed in Berlin, showing the location of the gigantomachy frieze.

bears a colonnade and passing through this at the top of the staircase, the visitor would reach a courtyard that housed the real altar where sacrifices would be made. With its stepped podium, its colonnades, its enclosed inner courtyard and the elaborate sculptural ornament that is its most important and indeed its dominant feature, the Altar completely replaces a traditional temple building. The architectural form of the Altar seems to have been largely determined by the needs of the sculptural frieze; 2.3 m high and 110 m long, this represented the epic story of the battle between the gods and the giants. It ran straight round the outside of the podium on three sides, while on the fourth it turned in to flank each side of the stairs. A second frieze ran round the three inner walls of the courtyard: its central subject was the life and adventures of a relatively obscure hero, Telephos, the legendary founder of Pergamon.

Both these friezes would have been visible to the viewer in a way that earlier temple sculpture, located high up on a building, had never been. On the Pergamon Altar, the bottom of the gigantomachy frieze on the three unbroken sides of the monument was only about 2.5 m from the ground. Walking up the great staircase, some of the figures from the frieze surge alongside you: some even spill over onto the actual steps. The quieter Telephos frieze, too, was comfortably placed at eye level; this would have been seen by most people as a series of scenes framed through the columns of the inner colonnade, and its composition is suitably pictorial and episodic for such a setting.

This concern for visibility and display is a defining feature of Hellenistic public art, and for the sculpture of the Pergamon Altar it had important implications. It was possible to leave some of the sculptured friezes that ran high up above the architraves of Classical temples relatively roughly or slightly finished – think, for example, of the slightly rushed or blurred-seeming cavalcades from the south frieze of the Parthenon. But every detail of the Altar sculpture had to be able to stand up to intimate scrutiny and so every detail had to be completely finished (fig. 51). The surface detail of the figures is indeed amazing – the scales of the snake coils of the giants, feathers, hair, the texture of garments – all are intricately realized in marble in a manner more usually found only in bronze. The overall planning and design of the full length of the frieze, with its ebb and flow of battle, is both complex and masterful; it has been argued very plausibly that a contemporary epic account of the battle, perhaps one composed specially for the Attalid court, lies behind its arrangement and choice of themes. And above all, there is a terrific feeling of passion, of vigour and energy, despair and elation, with some figures so powerfully carved that they seem almost to burst out of the relief. This emotional style of carving is sometimes described as

'Hellenistic baroque': the Pergamon Altar reliefs are its most extreme and characteristic expression.

In many ways the gigantomachy frieze is the surviving *tour de force* of Hellenistic public sculpture. Typically, as with the Nike of Samothrace, there is uncertainty over the date and circumstances of the Altar's dedication. There was a long tradition in Greek art of using the theme of the gigantomachy to express the triumph of civilization over the barbarian. In Classical Athens the gigantomachy, along with the centaur- or amazonomachy, had been a popular metaphor (on the Parthenon metopes, for example) for the Athenian-led victory over the Persians in the earlier fifth century BC. The Great Altar frieze incorporated artistic quotations from the Parthenon (for example, the Athena and Zeus from the east frieze are adapted from the figures of Athena and Poseidon in the Parthenon's west pediment), a visual expression of Pergamon's claim to be the new Athens, the new centre for and leader of Greek culture and civilization. But the gigantomachy theme itself would have enjoyed a special resonance in Pergamon, whose forces enjoyed successive victories over the Gauls in the second century BC. For this reason, and also because of the fairly secure dating of various distinctive fragments of pottery found in the foundations of the Altar, some scholars think it should be dated after the Gallic war of

51 Detail from the east frieze of the Great Altar of Pergamon, with Athena vanquishing a giant and being greeted by Nike (Winged Victory): Ge, the Earth and mother of the giants, looks on in despair in the lower part of the scene.

168–166 BC. Others, however, prefer a date rather earlier in the reign of the Pergamene king Eumenes II (197–159 BC), suggesting the Altar could have been a votive dedication after the Peace of Apamea in 188 BC, which put Attalid power on a secure footing and inspired a rush of building projects in the Attalid capital city.

Priene and Knidos

The British Museum cannot present Hellenistic public sculpture or architecture on the scale of the Great Altar of Pergamon. Its rich collections do, however, allow us to view characteristic elements of the public landscape of Hellenistic cities and sanctuaries in the sculpture and other items that it houses from two other significant Hellenistic sites, the city of Priene and the sanctuary of Demeter at Knidos.

Priene is – and was in antiquity – on a much more manageable scale than Pergamon. It was established on its present site, a steeply sloping, south-facing hillside, in the later fourth century BC (see fig. 2). Here the grid-pattern of the streets was sensitively adapted to the terrain, with broad streets running east to west across the slope, crossed by narrower, sometimes stepped, alleyways climbing up and down the hill. The public buildings were few in number compared to those of Pergamon, and relatively small in scale, yet no less well placed and integrated into the overall plan. The dedication of the temple of Athena Polias at Priene by Alexander the Great has already been mentioned. The architect of this temple was Pytheos, whose name is also associated with the design of the Mausoleum of Halicarnassus. The temple was built in the Ionic order, and the ceiling of the colonnade was decorated with coffers bearing figures carved in high relief. The site was first investigated in 1868–9 on behalf of the Society of Dilettanti, with the support and encouragement of the British Museum, by a British architect, R.P. Pullan. Numerous fragments of the ceiling coffers, and other pieces of sculpture from the site, are now in the British Museum. The site was subsequently re-excavated more extensively by German archaeologists in 1895–9, and German research still continues there today. In the later twentieth century the coffer fragments were painstakingly examined by an American scholar, J.C. Carter, who was able to reconstruct around twenty-six separate compositions, mainly composed of figures of a gigantomachy. Difficult as these are to appreciate in their current fragmentary state, they should not be overlooked as examples of early Hellenistic sculpture, and some of the fully

developed figures and groups appear to prefigure the more famous gigantomachy groups of the Great Altar of Pergamon.[11]

In the Hellenistic age the temple precinct, situated near the centre of the city, would have been crowded with dedications including fine pieces of sculpture. Part of one such dedication is preserved in the British Museum: the elegantly elongated figure of a charioteer, dressed in the long robe associated with his role (fig. 52). As was often the case with Hellenistic sculpture, the arms and head were made separately and are now missing. It is clear, however, that the arms would originally have reached forward to grasp the reins. The charioteer wears a very full *chiton*, fastened at each shoulder and pulled and folded into numerous fine pleats by a high girdle – the holes that survive on this are probably the result of the attachment of a belt in gold or bronze. The garment and the dignified, columnar effect of the figure are not unlike those of the famous earlier Classical bronze charioteer from Delphi. The Priene figure would originally have stood in either a two- or a four-horse chariot group, and was probably a dedication offered by someone who had won a major chariot race victory.[12]

Those who could not afford large-scale bronze or marble gifts for the goddess would leave more modest offerings. These might take the form of bronze or pottery vessels, or smaller figurines in marble, bronze or terracotta. Many such figures were found in the German excavations, and a large female terracotta figure in the British Museum, also found on the site of the temple, is likely to have formed an offering of this type (fig. 53).[13] Her head-dress and her finely detailed costume with its dotted border decoration indicate she is a queen or goddess. Excavations in various sanctuaries around the Hellenistic world have suggested that in many places there

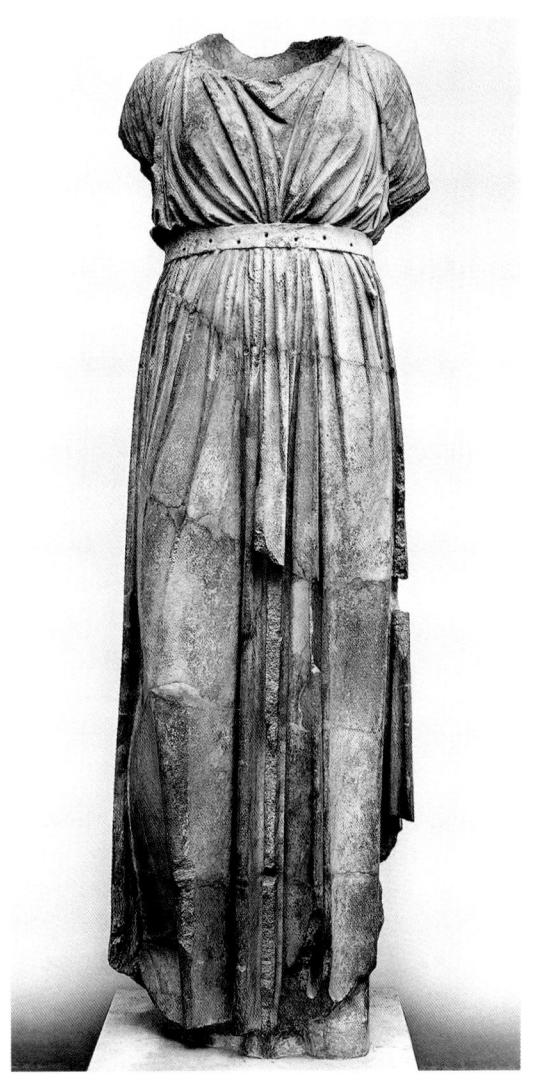

52 Fragmentary figure of a charioteer, part of a chariot group that would have formed a dedication in the precinct of the temple of Athena Polias at Priene. The lack of head and the formal, perhaps slightly archaizing style make the date difficult to determine. Height 1.28 m.

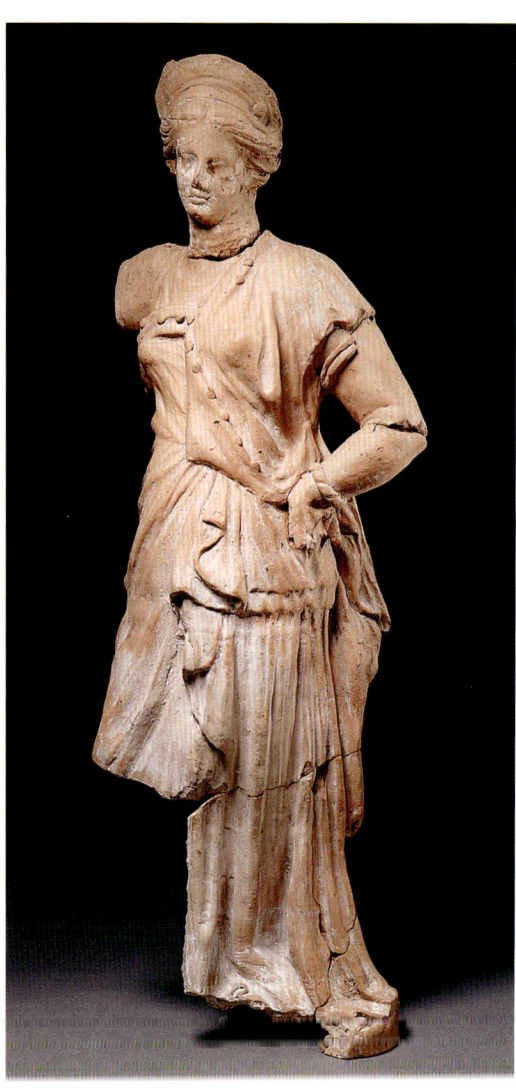

53 Large-scale terracotta figure, a dedication made in the precinct of the temple of Athena Polias at Priene in the third or second century BC: her diadem suggests she should be either a queen or a goddess. Height 48 cm.

would have been areas set aside for small-scale dedications such as terracotta figures, perhaps equipped with tables or benches where the gifts could be deposited. In some sanctuaries at least, it seems to have been the custom from time to time, perhaps at the end of one festival 'season' or in preparation for a new one, to sweep up the old dedications and bury them in pits, sometimes described as 'ritual deposits'. Such deposits were certainly a feature of the sanctuary of Demeter and the Underworld gods at Knidos, in south-west Asia Minor (modern Turkey), excavated by Sir Charles Newton in 1857–8.[14] This sanctuary appears to have been laid out at much the same time that the city of Knidos was re-founded on a new site around 360–350 BC. This new site, at the head of a long peninsula, was strategically and commercially advantageous, besides enjoying wonderful views out over the Gulf of Kos. Substantial remains of the city have continued to be excavated at various times since Newton's explorations, up to the present day.[15] The buildings found include a Hellenistic house, a stoa, and a round building that may be the temple of Aphrodite, in addition to later Roman structures. The sanctuary of Demeter and the others, who comprised Hades, god of the Underworld, Demeter's own daughter Persephone and the messenger god Hermes, lay on a long platform set into the side of the acropolis hill, high above the city (fig. 54). The gods worshipped there are named in an inscription, and the well-known seated marble figure of Demeter that Newton found there has been identified as a cult statue of the goddess (fig. 55).[16]

Spanning the transition between the Classical and Hellenistic periods, the Demeter of Knidos was probably carved and dedicated in the early years of the sanctuary in the mid-fourth century BC. She sits in a calm and peaceful attitude, her head turned slightly to her left, one foot tucked behind the other.

She rests upon a cushioned throne, the back and arm-rests of which are now missing. Probably in one of her (now missing) hands she originally held a libation bowl or torch. Her head was carved separately from the rest of the figure (and was indeed found in a different part of the sanctuary). The smoothly polished surface of her face forms a strong contrast both to her roughly waving hair and to the deeply chiselled, rather restless drapery that crosses and re-crosses her body in an elaborate series of pleats and folds.

Newton's excavations revealed that for much of its existence the sanctuary must have been crowded with votive statues. Many of these survive only as fragments, presumably because of the regular clearance of the votive areas – hands holding staffs, for example, are found in enormous quantities. But there are also many substantially complete pieces that do convey an impression of what such a sanctuary would have looked like. Among these are numerous animal statues, principally calves and pigs, enduring stone images of the real young animals that would have been sacrificed to Demeter, goddess of fertility, and the others. We do not know how these marble votives would have been arranged in the sanctuary or how many would have been on display at any one time, but the quantities that survive and the homogeneity in the style of carving of quite a number of the more intact pieces suggests that considerable flocks or herds would have been visible at once. Among the more intact of the surviving statues is that of an elderly woman, identified as a priestess by her garments and veil;[17] such a figure might have been dedicated posthumously by the woman's family in memory of her service to the goddess, or by suppliants hoping for a favourable answer to their prayers.

54 View of the Sanctuary of Demeter and the Underworld Deities at Knidos, as it was when excavated by Charles Newton in 1857–8.

As at Priene, many cheaper, smaller-scale offerings were also left in this sanctuary. Newton's excavations uncovered several small rectangular subterranean chambers, some walled with rough masonry and roofed with tiles. These were packed with objects, carefully arranged in rows. It is uncertain whether these pits were constructed to form temporary shelter for votive offerings after the destruction of a proper treasury building; alternatively they might have been built in anticipation of an attack on the sanctuary, or else more simply may represent clearing deposits, the ritual burial places of previous seasons' offerings. Spanning the late Classical, Hellenistic and early Roman periods, the deposited objects included glass

 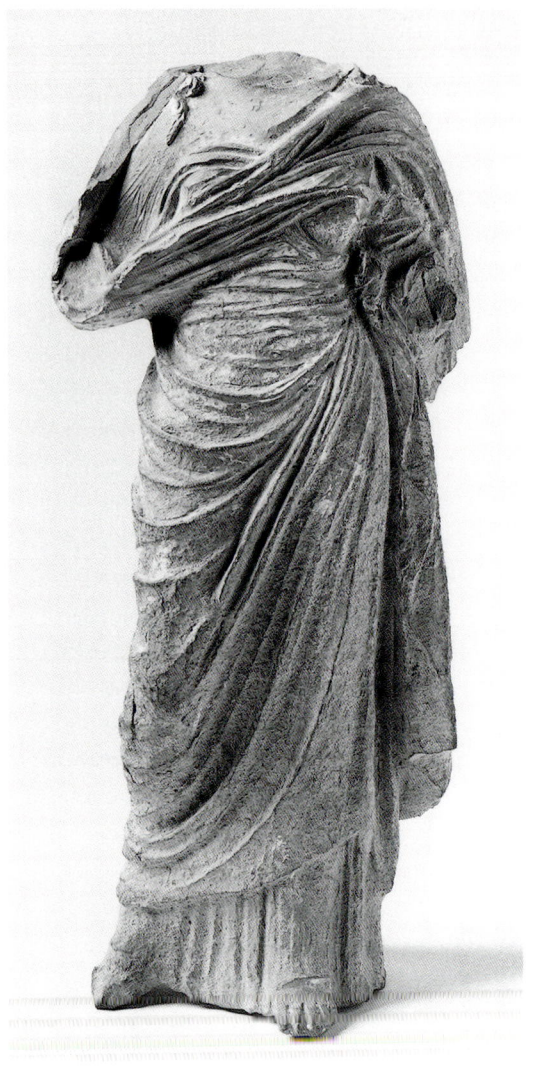

ABOVE LEFT:
55 Seated marble figure of the goddess Demeter, excavated (the head at some distance from the body) in her sanctuary at Knidos. c. 340 BC. Height 1.47 m.

ABOVE RIGHT:
56 Large-scale terracotta figure excavated in the Sanctuary of Demeter and the Underworld Deities at Knidos; parts of this exceptionally fine figure have been built up by hand, and the drapery is very similar to that of the marble cult statue of Demeter. Probably late fourth or early third century BC. Height 23.5 cm.

bottles, stone weights, pottery, terracotta figures and hundreds of clay lamps that made appropriate offerings for lightening the darkness of the Underworld. The lamps, pottery and terracottas were all made locally. Many of the lamps are distinctive, multi-nozzled types, made in a fine, hard, metallic-grey fabric. The terracotta figures are of especial interest. Terracotta figures of *hydrophoroi*, young women who carry pitchers on their heads, were popular dedications in Demeter sanctuaries all around the Mediterranean, and were found in considerable numbers at Knidos.[18] They most probably served a dual function, acting as images both of the votaries themselves and of the mythical daughters of Keleos, king of Eleusis: according to legend these met Demeter, mourning the loss of her daughter Persephone, at a well where they had gone to draw water, and took her back with them to the shelter of their home. In addition to the *hydrophoroi*, the Knidian terracottas in the British Museum include the head of an old woman with a ritual cylindrical basket or *cista* on her head, a comic actor, and a pig.[19] There are also some very fine, if fragmentary, draped female figures, the largest and best of which is a true sculpture in miniature of a type known on a larger scale to represent the goddess Persephone (fig. 56).[20] The drapery of this terracotta, substantial elements of which have been built up and finished by hand, strongly resembles that of the seated marble statue of Demeter, and it has been suggested that it forms a small-scale version of a full-sized cult statue of Persephone that would originally have stood beside the statue of her mother.

The public areas of Hellenistic cities and sanctuaries played key roles in Hellenistic life. For the rulers they provided conspicuous opportunities to flaunt their wealth, culture and power. Many ordinary people must have appreciated the facilities offered in these public areas: they were places where the traditional ways of life, both sacred and secular, might go on as before. At the same time many would have enjoyed the sightseeing possibilities that the splendid new precincts offered. At all events a fragment of dialogue attributed to the mime-writer Herodas gives a vivid impression of two women happily engaged in this sort of activity, admiring the works of art displayed in a sanctuary of Asklepios:

> 'Don't you see, dear Kynno, what works are here? You would say that Athene carved these lovely things.… If I scratch this naked boy, won't he be wounded, Kynno? … and the silver fire tongs, if Myellos or Pataikiskos, son of Lampion, were to see them, wouldn't they think they were really silver? … And the ox … if I didn't think it would be behaving too boldly for a woman I would have cried out, in case the ox should harm me.…' (Herodas 4.56–71)

Chapter 4

Private Life: the Hellenistic house and tomb

'Next one comes to the area of the Necropolis [city of the dead], in which are many gardens and graves and resting-places fitted up for the embalming of corpses.' (Strabo, *Geography*, 17.1.10)

Archaeological evidence can help us to visualize the physical settings in which the people of the Hellenistic world lived, died and were buried. It can help us to reconstruct their domestic surroundings from wall- and floor-coverings to furniture, silverware, glass, pots, pans and lighting equipment. Many Hellenistic tombs and cemeteries have been fully or partially excavated, and from these we can learn about burial practices and even, to some extent, religious beliefs.

Architecture: scale and plan

Hellenistic houses are known from several sites, including those of Pella already referred to in Chapter 1 (pp 44–6), Priene, and Delos. Many of the later Delos houses are particularly splendid, reflecting the great prosperity of the island in the period from 166 BC onwards when, under Athenian control, it became a free port, a major centre for the lucrative Mediterranean trade in slaves, and attracted a cosmopolitan assortment of rich merchants and bankers from all over the Mediterranean, especially from Italy and the Hellenized east. This period of prosperity was, however, short-lived, as the island was sacked by pirates in 88 and 69 BC and never regained its former greatness.

The essential plan and construction of many Hellenistic houses did not differ greatly from those of the houses of the Classical period: the principal

changes lay in the increased scale and more elaborate decoration of the houses of the wealthier sections of society. In many places house walls were built of rubble or sun-dried bricks bonded together with clay; only the most opulent would have an outer finish of dressed masonry blocks. Like Classical houses, Hellenistic dwellings remained essentially inward-looking: few would have appeared particularly striking from the street, although many Delian houses had an upper storey and the three-storey 'House of the Hermes' on Delos, terraced against a hillside, must have impressed even from the outside through its unusual height and prominence. The only source of natural light and air for most houses would be the inner courtyard, which was approached by a narrow passage leading from the street. The courtyard was sometimes, but not always, surrounded on one or more sides by columns (see, for example, fig. 57); set around it and entered from it were the rooms in which the women of the household worked and rested, the bed-chambers, the slaves' quarters, and, most important, the rooms in which the men of the family lived and entertained their guests, the so-called *androns*. Below ground some houses might have their own private supplies of water, essential for so many domestic activities, from drinking to cooking, washing and cleaning. On the dry, rocky island of Delos there is only one river, which often runs dry, but there is a good supply of

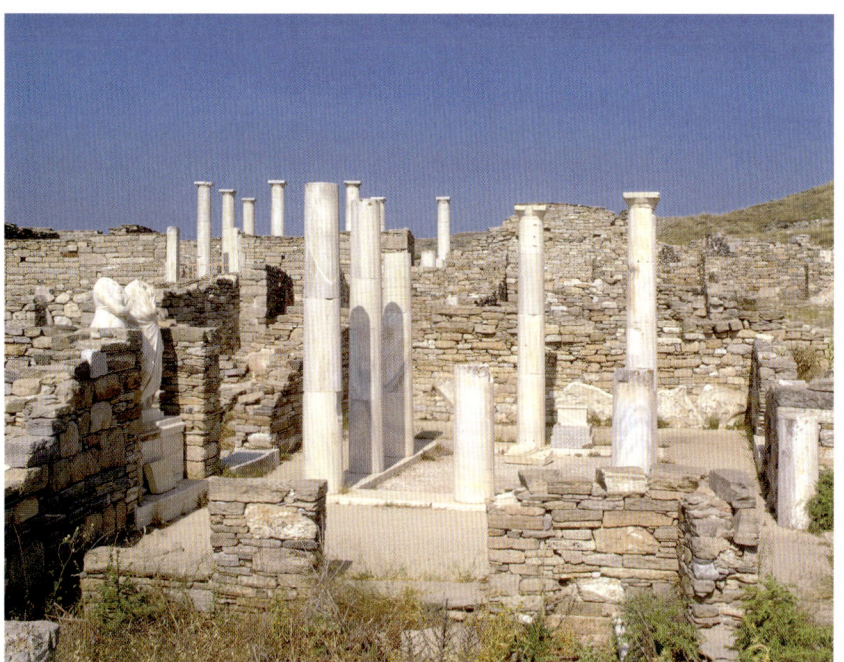

57 View of the 'House of Cleopatra' on Delos, giving an idea of the characteristic arrangement of wealthier houses, with rooms around a colonnaded courtyard. The thickness of the walls suggests that there was originally an upper storey. Second century BC.

underground water on the island, accessible in antiquity as today through wells, and provision was also made for the collection of rain water. Several Delian houses had private wells in the courtyard, sometimes with decorative well-heads in white or bluish marble. Large marble basins on stands were often placed nearby to hold the water as it was drawn up. Other houses had underground cisterns, kept filled up partly from rain water; one house had a curved staircase leading down into its vaulted cistern.

The *andrones* were the most lavishly appointed rooms in any Hellenistic house. Often approached through a columned vestibule leading off the court, they were usually more generously proportioned than the other rooms. They can be identified not merely by their position, size and often superior decoration in the form of mosaic floors or painted walls, but also by various design elements that show they were intended to accommodate the long couches on which banqueters were accustomed to recline. Thus the doors in these rooms are generally not placed centrally on a wall, and if the floors are covered in mosaic, their margins may bear up to four '*kline* bands'. These we encountered in the 'palatial' houses of late fourth-century Macedon: they could either take the form of plain stripes in a contrasting colour or they could be lines of pattern, typically of a wave design, which mark the position of the couches (*klinai*). Dining rooms may also preserve open drains, which were used to dispose of water or dregs of wine during the banquet. Wealthy homes such as the 'palatial houses' of Pella and several examples on Delos, following the lead of the royal palaces, had several dining rooms; which one or ones were used on particular occasions might depend on a number of factors, including the numbers and status of the guests or the season of the year.

Decor: mosaics and wall paintings

The extent and elaboration of the decoration in a private house would reflect the wealth of its occupants; and in many houses superior decoration was found only in the public rooms, where visitors were entertained. At Priene, for example, where most of the houses were relatively modest in their decor, only a few of the public rooms had pebble mosaic floors, while the majority were of beaten earth. To supply the desires of those who could afford it, however, the technique and practice of mosaic-making expanded and developed considerably in the course of the Hellenistic period. The early Hellenistic pebble mosaics of Pella and Vergina have already been discussed. From the third century BC onwards,

pebble mosaics continued to be produced, but there was also considerable experimentation in other mosaic techniques.[1] Occasionally small pieces of marble, either cut into small, regular cubes (*tesserae*) or irregular in shape, are found set in alongside the pebbles; there are also pavements made up solely of irregular marble chips, a form of flooring that remained popular throughout the Hellenistic period; and from about 250 BC onwards whole panels of regularly cut *tesserae* appear. It does not seem possible to identify one particular centre or even one area where the practice of using neatly cut cubes of stone and other materials developed. Rather, the new techniques, including the use of regular-shaped *tesserae*, seem to have emerged more or less contemporaneously in various parts of the Hellenistic world; doubtless the mobility of craftsmen at this period encouraged the rapid geographical spread of new skills and techniques.

Sometimes mosaics made in different techniques appear in one house, even combined on one floor; in the 'House of Ganymede' at Morgantina in Sicily, for example, the three surviving mosaic floors provide examples of irregular chips, carefully squared *tesserae* and pieces cut to a special shape to fit particular parts of the design. Even late on in the Hellenistic period it is common to find irregular chip borders surrounding panels worked in regular *tesserae*. As new designs evolved, including complex geometric patterns such as borders of seemingly three-dimensional meander patterns, the advantages of using regular *tesserae* must have become clear – they could provide a far greater range of colours and shades than pebbles, and could be fitted closely together to form a smooth and continuous surface.

It was in Hellenistic Pergamon that Sosos, the only mosaicist whose name is recorded in the literary tradition, is said to have worked: according to Pliny, he 'laid at Pergamon what is called the *asarotos oikos* or "unswept room", because on the pavement was represented the debris of a meal, and those things which are normally swept away, as if they had been left there, made of small *tesserae* of many colours' (*NH* 36.184). Several Roman mosaics resembling this description have been found, with assorted objects such as leaves, nuts, fish skeletons and snail-shells lying scattered on a background of plain *tesserae*. Pliny's account goes on to suggest that Sosos's example may have been the border to a scene with doves drinking from a bowl and preening, similar to a surviving mosaic from Hadrian's villa at Tivoli. No mosaics that can be securely attributed to Sosos have been found at Pergamon, but the city was clearly a centre of mosaic production in the mid- to late second century BC. This is suggested by the discovery in the royal palace there of a few mosaics of very high quality, made of extremely tiny *tesserae* in an enormous variety of colours and materials,

including glass: this technique of using very tiny *tesserae* is known as *opus vermiculatum*.[2] Several other sites have yielded examples of Hellenistic mosaics worked in various techniques. Alexandria, for example, was clearly one important centre of production. A floor excavated in the Shatby district, bearing a scene of Erotes hunting stags, demonstrates developments similar to those observable at Morgantina: mostly executed in square-cut *tesserae*, pebbles are used to create a rougher texture for details such as hair, manes and bristles. One of the finest of all Alexandrian mosaics found so far decorated a floor discovered in the course of the excavations for the foundations of the new Alexandrian Library, in the area of the palace of the Ptolemies: beautifully fitted into a circular medallion is a large and rather melancholy-looking brown, black and white dog with a red collar, seated with his tail wrapped round his back legs beside an overturned bronze pitcher (fig. 58). The dog is posed and depicted with an extraordinary degree of naturalism and also much sophistication in the rendering of the effect of light and shade. The date is uncertain but the quality of the workmanship, with its tiny, immaculately cut and placed *tesserae*, suggests the likelihood of a fairly late date, perhaps in the first century BC.

For the late Hellenistic period of the late second and first centuries BC, however, it is Delos that has so far yielded the largest numbers of mosaic floors of all kinds, the great majority found in private houses.[3] Not surprisingly, the finest mosaics tend to be located in the more public areas of the houses, especially in the dining rooms. Very often a central, carpet-like rectangle made up from squared *tesserae*, either standard size or *opus vermiculatum*, is surrounded by an edging band in a coarser technique; occasionally circular medallions are also found. Geometric designs are the most common, including bands of guilloche, or bead and reel; also popular are complex meanders shown as though in perspective, and groups of lozenges of three different colours, placed to create the illusion of three-dimensional cubes. These two last designs show the Hellenistic mosaicists' fondness for playing with spatial illusion, however inappropriate this might be in the context of a level floor! Some of the finest floors have as centrepieces separately made panels, known as *emblemata*, constructed off-site in mosaicists' workshops on backing panels that could then be transported and fitted into the floor as required. Two exceptionally fine mosaics from the 'House of Dionysos' on Delos were made like this. One shows Dionysos riding on a panther, the other a winged Dionysiac figure mounted on a tiger. Both are executed in *opus vermiculatum*, the tiny squares often less than a millimetre across, neatly cut from a huge range of colours and materials, including glass and faience alongside stone and terracotta, all set against a black

background. The scene with the winged figure riding a tiger in particular exploits the technique to the full, with subtly graded colours used to suggest texture, contour and the effects of light.

It is also on Delos that some of the best-preserved remains of Hellenistic wall decorations are to be found. The style used in private houses appears essentially to consist of stucco, modelled in relief to imitate courses of masonry and painted to suggest different types of stone: this is the Hellenistic precursor of the decorative system that becomes known in the Roman context as the First Style. The lowest course, set on a shallow plinth, generally consists of large panels (orthostates); above these are one or two narrow friezes (string courses); and above these again is set a series of regular courses imitating carefully cut and drafted blocks of stone; an alternative for the upper part of the wall would be an architectural design with engaged columns providing strong vertical accents across the wall.[4] A stucco satyr mask found in a house at Priene is likely to have been set between the columns of such a scheme; from a late Hellenistic house on the slope at Ephesus come fragments of terracotta masks that may have been similarly used.[5] The top of the wall would be marked by a frieze with a projecting cornice. The string course friezes, which were set roughly at eye level, were often singled out for special treatment; sometimes they were painted to resemble richly veined marble or alabaster, but alternatively they might be

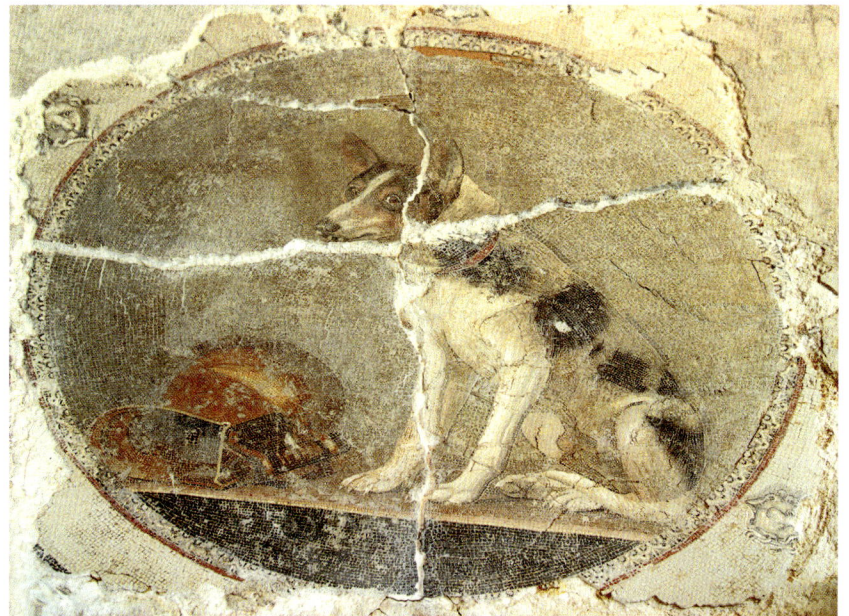

58 Mosaic floor: a melancholy-seeming dog sits beside an upturned pitcher. From Alexandria, excavated on the site of the new Alexandria Library, in the area of the palace of the Ptolemies, probably dating to the first century BC. Diam. of roundel 2.4 m.

decorated with illusionistic meanders, floral scrolls, or even figures, including Erotes, mythological battles, masks or theatrical characters. The larger blocks above and below were often painted to give a rich, polychromatic effect: popular shades were yellow, red and black, and sometimes the drafted margins of the blocks might be painted in a contrasting colour.

Domestic sculpture

In the Hellenistic period, as in the Classical, most sculpture was designed for a public setting, whether a sanctuary, a gymnasium, or some other communal space. But at the same time, although the evidence is limited, in some cities at least there arose a parallel demand for small-scale sculpture, suitable for a domestic context. The material in which such sculpture was made, and the quality of its execution, would obviously depend upon the wealth of the household and to some extent on what was produced locally, but bronze, marble and terracotta would have been the most popular materials. Small marble and terracotta statuettes were certainly found in the rooms of several of the private houses in Priene, for example; we do not know how they were displayed, although either on tables, or in wall niches seems likely; the smaller pieces may perhaps have provided an alternative to painted string courses, if set on a shelf projecting from the wall roughly at eye level. Among the marble statuettes found at Priene were two seated figures of Aphrodite or a nymph;[6] similar in type is the small marble figure of Aphrodite in the British Museum, said to be from the Roman baths in the Peiraeus, Athens, but likely to date to the second or first century BC (fig. 59). Similarly, in the late Hellenistic house at Ephesus already mentioned, terracotta figures of Aphrodite are thought to have been arranged on a table.[7] Many of the Priene terracottas lack bases and cannot stand without support; holes or loops on their backs suggest they were either attached to the walls with nails and cords or perhaps even suspended from the ceiling: this would clearly have been most effective in the case of the flying figures. Terracotta figures formed a cheap alternative to sculpture in marble or bronze, but at the same time many of these examples are of outstanding quality and very attractive in their own right. In one house were found the remains of ten marble statuettes and thirty-five figured terracottas, suggesting that the owner could choose his materials and had put together his collection with some care.[8] When compared with contemporary terracotta figures from a votive deposit in the sanctuary of Demeter at Priene, it is clear that much higher standards were

OPPOSITE.
59 Marble statuette of Aphrodite, seated on a rock. Said to have been found in the women's baths at the Peiraeus, this is the sort of small-scale figure that would have formed a desirable and highly decorative ornament for an affluent Hellenistic home. Height 21.5 cm.

PRIVATE LIFE

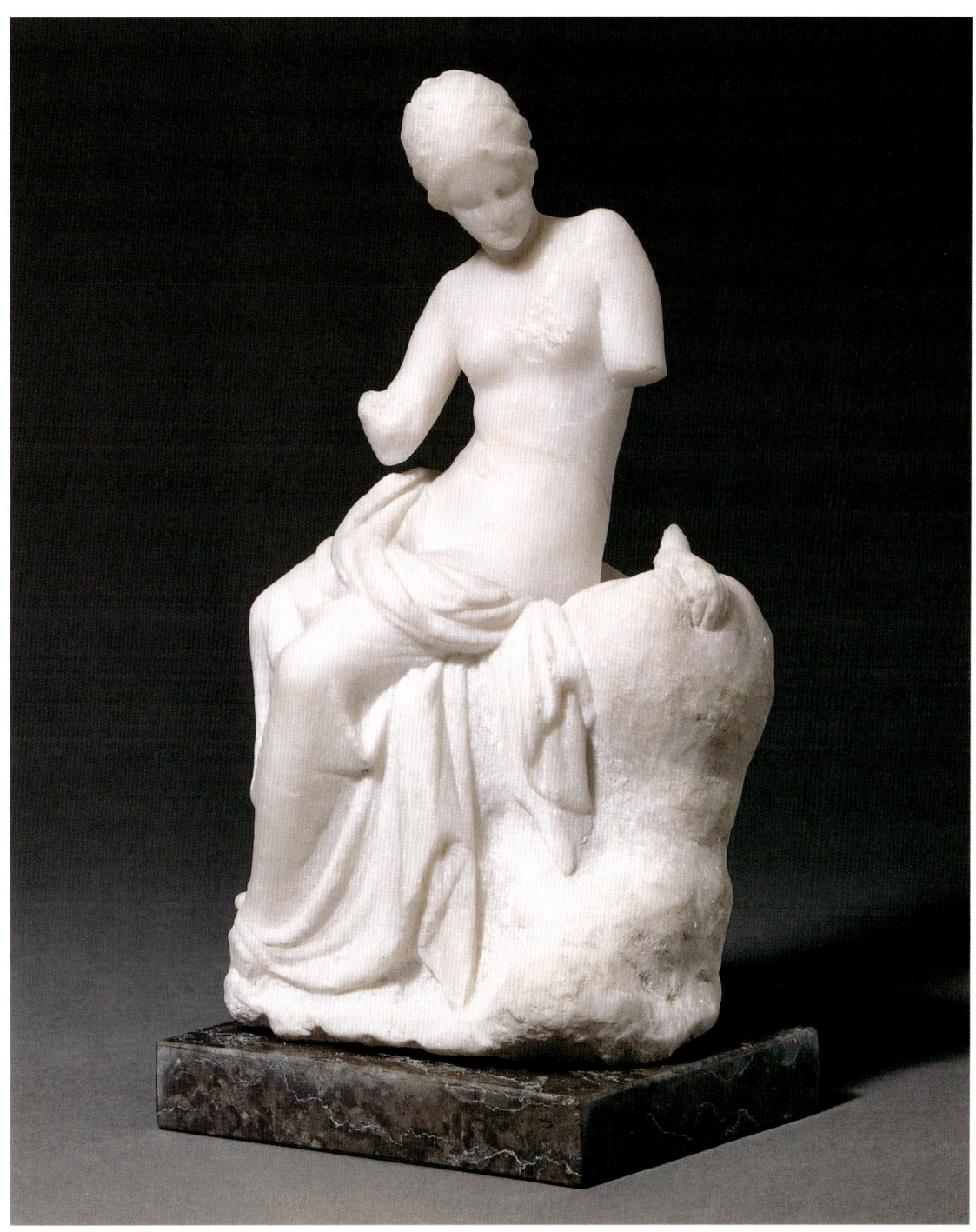

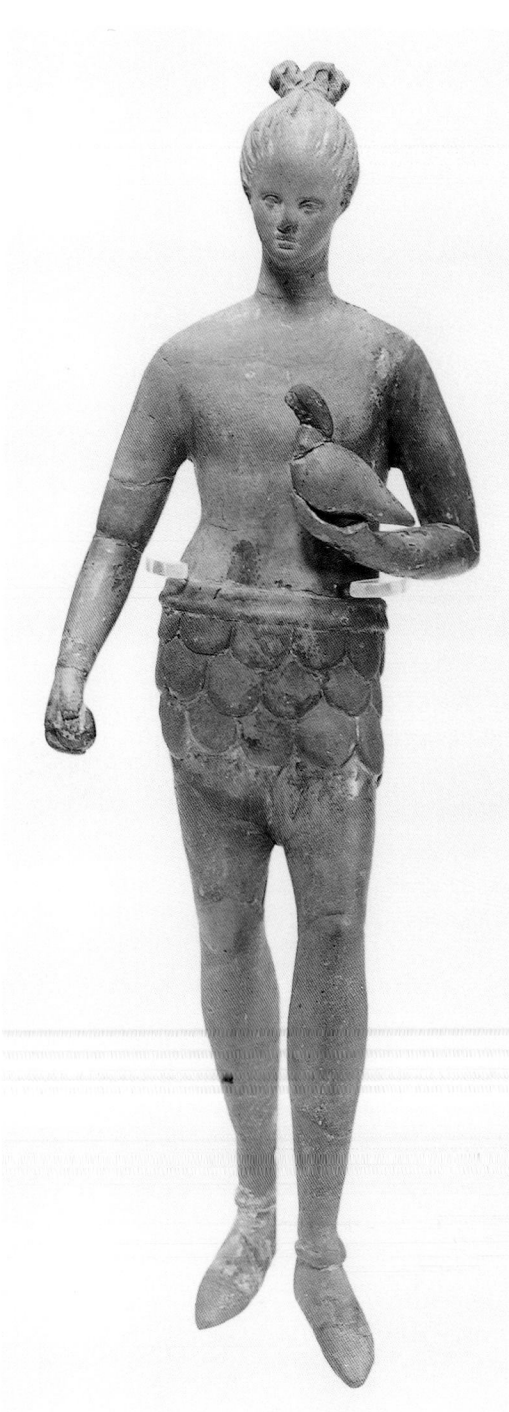

employed for figures thought suitable to decorate an affluent house. Like most terracottas of the period they were made in moulds, but the clay is very fine and considerable care has been taken in retouching them – that is, in going back over and improving the precision of the modelling with a sharp tool. Many of them still preserve traces of colour – pink or pale orange for the flesh, red on the hair, and blue, pink and gold for drapery or details of the wings. Most of them are standing, draped female figures, but there are also dancers, figures from mythology such as satyrs, Eros and Atthis, and theatrical masks.[9] Comparable terracotta figures in the British Museum, found not in domestic contexts but in tombs in Tanagra and Cyrenaica, are similar in type and in the quality of their finish to some of the Priene examples, and would perhaps have been equally suitable for the decoration of private homes. A pair of Priene figures identified as Atthis and Eros, for example,[10] the latter distinguished by a fawn-skin cloak that lends him a Dionysian quality, are paralleled in the British Museum by two large figures of Eros (fig. 60). Like the Priene couple these were clearly made as a complementary pair: almost identical in size and attitude, one wears a short, pouched *chiton* and a Phrygian cap, and the other, who carries a ball and a bird, is distinguished by a curious skirt made up of overlapping rows of leaves (paralleled on the figure of a satyr from Priene); their effeminate-looking heads may be from the same mould, though differently finished. Similarly, the Priene dancers[11] are equalled by two in the British Museum from Cyrenaica, both twisting and twirling, the long folds of their drapery swirling and billowing in response to their rapid movements (fig. 61). These in turn recall the exquisite bronze 'Baker Dancer' now in the Metropolitan Museum of Art, New York, and it is easy to imagine that she too might once have adorned a table in a wealthy

Hellenistic home (although it has also been suggested that she may originally have stood on top of a large bronze vessel).[12]

Banqueting equipment

In an affluent Hellenistic house dining and feasting was carried out with elegance, luxury and style. Here the boundaries between private and public space are blurred, as one of the most important functions of the house was to serve as a setting for the entertainment of guests from outside the family; taking their lead from the kings in their palaces, wealthy citizens would use the occasion of a banquet to impress and influence their contemporaries. Here we shall look in detail at the furniture and tableware needed for such parties.

As in the Classical Greek and Roman periods, Hellenistic banqueters reclined on couches, which, until the middle of the fourth century BC, seem to have been constructed exclusively of wood, with occasionally an ivory veneer. In the Hellenistic period couches which had bronze legs and decorative, bracket-like edges to the head-rests were in use in more affluent households. These bronze couch fittings were doubtless produced in several centres, but the discovery on Delos of both actual couch elements and plaster moulds used for the production of the finely shaped couch legs shows that this was certainly one place where such luxury items were manufactured.[13] Pliny actually tells us that 'bronze first acquired renown there [at Delos] in the manufacture of the feet and head-boards of dining couches' (*NH* 34.9); and it has been very convincingly argued that the several couch elements rescued from the Mahdia shipwreck (see Chapter 6, pp. 174–5) were also made there. High-quality dining couches might

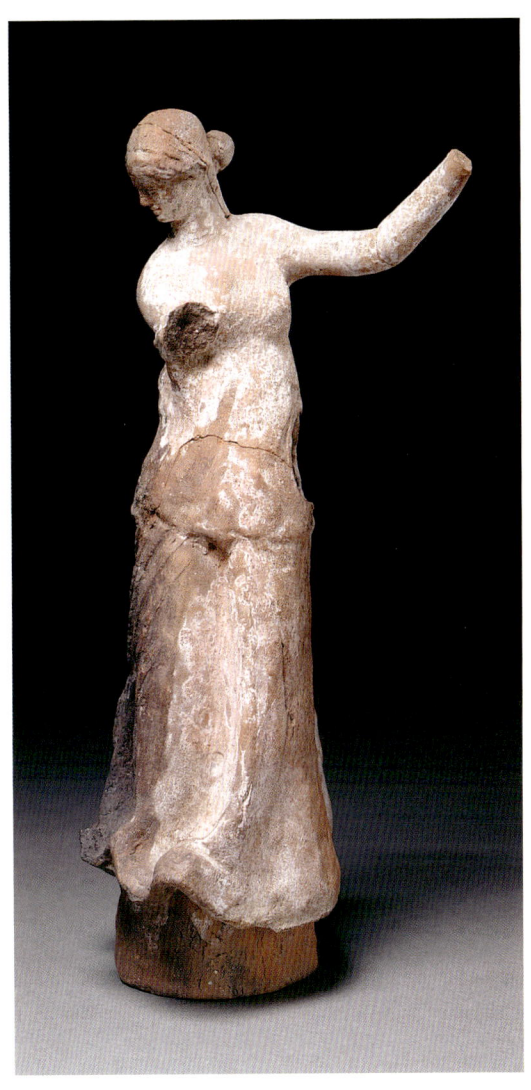

OPPOSITE AND ABOVE:
60 Terracotta figure of Eros wearing a leafy skirt: this large and unusual figure is one of a pair. Probably made at Tanagra in the third century BC. Height 29.5 cm.

61 Terracotta dancer: the figure's swirling drapery invites the viewer to turn her round and admire her from all angles. From Benghazi, Cyrenaica (present-day Libya), c. 200 BC. Height 29.5 cm.

be quite complex in their construction. The hollow-cast bronze legs were made in sections: these were held together and attached to the horizontal wooden frame with long, iron clamps; the legs might be further strengthened by being packed out with a wooden core. The horizontal frame could also be made stronger by the addition of strips of iron. Finally, leather webbing would provide a comfortable base for the mattress or cushions on which the banqueter lay. Mattresses are shown on many of the extensive series of East Greek grave reliefs on which the dead person reclines at his own funerary banquet (see below, pp. 121–2): they can be quite thick, and sometimes a valance-like hanging is fastened beneath them, hiding the legs of the couch. Many banqueters on these reliefs rest their left elbow on a pile of three or four little cushions; occasionally a larger one is shown folded over to give extra height.

The parts of the couches that survive most often are the decorative bronze elements of the head-rests, known as *fulcra* (fig. 62). These consist of a scroll-shaped frame surmounted by a three-dimensionally modelled protome, often in the form of a human or animal head, and finished at the lower edge with a round medallion, bearing a bust cast in high relief; some fittings terminate instead with a medallion at either end; and the central area can be filled with either a plain sheet of bronze or one decorated with silver inlay or with bronze relief decoration. The subjects of the busts on the *fulcra* are quite often suitable for the context of a banquet, as Dionysos, Ariadne, satyrs and maenads are all popular types; other gods and goddesses also appear, notably Apollo, Athena, Artemis and Eros, along with various mythological characters including Scylla or an Amazon.

In addition to couches, low tables would clearly be required for banquets, as well as for occasional use around the house. Round tables with three animal legs are commonly shown on funerary reliefs, set beside the couch and holding food and drink; rectangular examples are also seen. Surviving on Delos are fragments of many actual marble tables, both table tops and legs, sometimes in the form of animal legs or with feet in the shape of animal paws. Table tops in slate, a material that could be easily and decoratively incised, have also been found there, including an example decorated with incised concentric circles of geometric and floral designs, from a house in the theatre quarter.[14] Other furniture was probably minimal: on the funerary reliefs a wife may sometimes sit on a high-backed chair beside the couch, and quite often a slave is busy beside a chest with slatted sides, the top of which is used for the preparation of food and drink.

Warmth and a means of cooking might be provided by a portable terracotta stove: these generally survive in extremely fragmentary form, and often it

PRIVATE LIFE

is only the lugs, or handle plaques, frequently decorated with wildly grinning satyr heads or Medusa masks, that are preserved. From Delos again, though, there is a highly decorative and relatively complete example of the type. This stove, reconstructed from fragments, stands to a height of about 88 cm and is likely to have been on show and in use in one of the public areas of the house. A fire would have been lit in the basin-shaped upper part, which stood on a flaring, cylindrical pedestal. Holes pierced in the fire basin allowed ash to fall through into the lower chamber, and this was fitted with an arched doorway to promote a draught and also allow access for clearing out the ashes. Three lugs or handles decorated with Medusa masks are attached to the rim, where they could have been used to support a vessel over the fire. The entire stove is richly

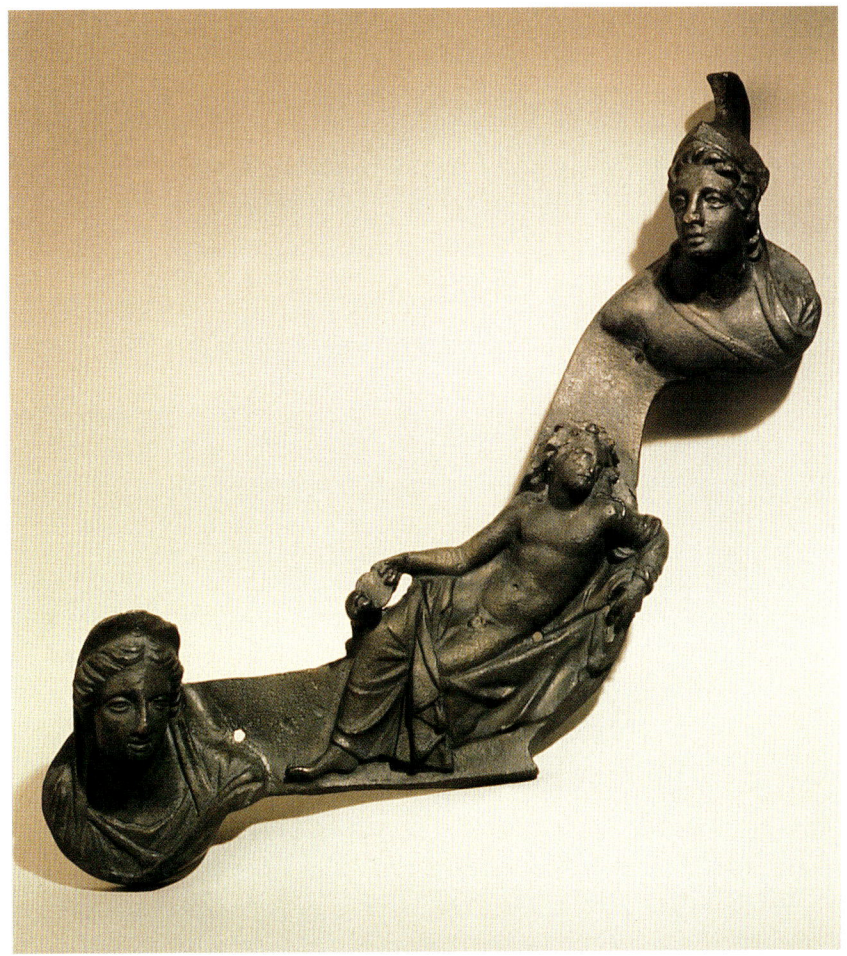

62 Bronze couch fulcrum with Dionysos reclining between busts of Ares (?) and Hera or Aphrodite. Length 43 cm.

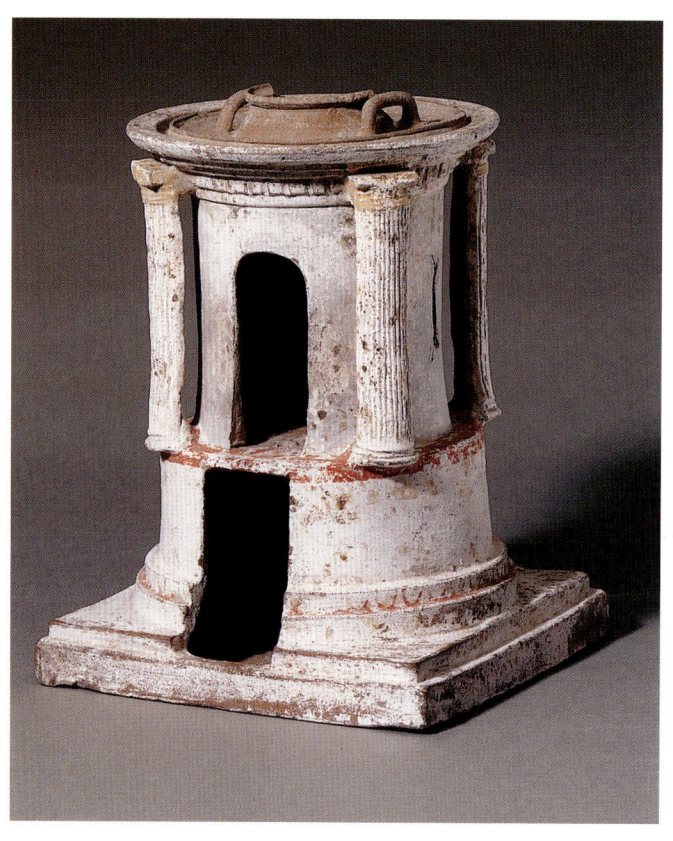

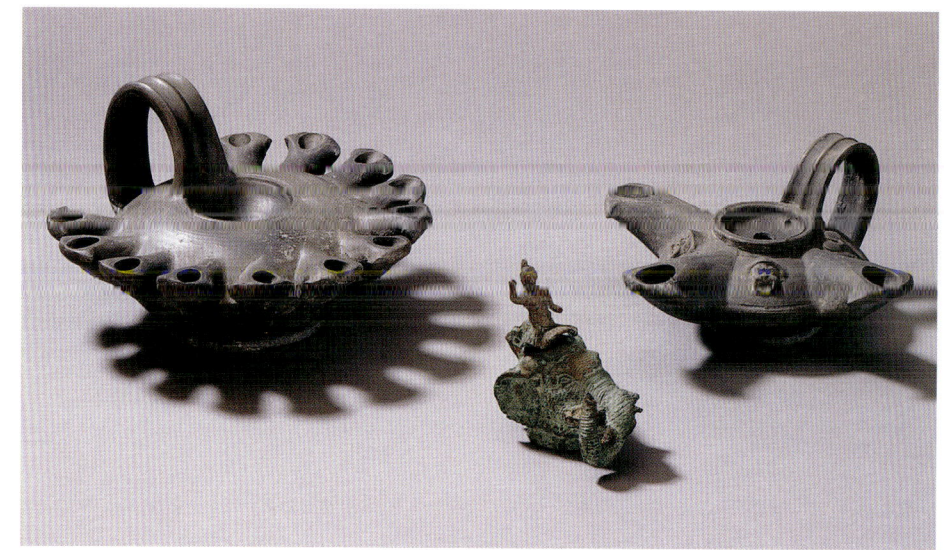

63 Terracotta brazier in the form of a miniature, shrine-like building. Said to be from Olbia, Crimea. Height 29.4 cm.

64 Hellenistic oil lamp in clay and bronze. Some of these would have been placed on top of high candelabra to spread a wider light. Third to first centuries BC. Width of largest lamp 20.7 cm.

decorated in relief, with architectural elements, swags and, in the uppermost register, a representation of the battle between the Greeks and the Amazons.[15] A more modest, yet also very decorative form of brazier is represented by a curious terracotta object in the British Museum (fig. 63). This takes the form of a model building, perhaps a small, circular shrine, with a small coarse-ware dish fitted into the top (the roof): one likely explanation of its design is that charcoal could have been burnt in the lower chamber to warm whatever was placed in the dish above.

As in the Classical period, lighting for the banquet or for any other domestic purpose was provided by oil lamps, usually made from either clay or bronze (fig. 64). In the most elegant households, one or more lamps might be set on a plate on top of a tall, bronze candelabrum, perhaps in the form of an elongated column. Both bronze and pottery lamps come in a wide variety of shapes, sizes and styles. Where Classical lamps were often fairly shallow and open, their Hellenistic counterparts are generally deeper and closed except for the filling aperture. Nozzles tend to be longer and mould-made lamps start to appear alongside the traditional wheel-made examples. For bronze lamps, handle attachments in the form of vine or ivy leaves are relatively common; the lids of two bronze examples in the British Museum are further embellished with small figures of mice, crouching to eat. The Hellenistic period also sees the beginning of the production of bronze lamps plastically modelled in the shape of people, plants and animals. An example in the British Museum in the form of an elephant's head, the hinged lid modelled as a rider in military dress, is said to come from Memphis and was probably made in Egypt in the third or second century BC. The elephant's forehead is realistically wrinkled, while its trunk, now incomplete, waves in a lifelike fashion to its right; the separately made tusks, now lost, appear to have been made of iron.

Tableware

The poet Theocritus provides an elaborate account[16] of an ornately wrought and highly polished ivy-wood bowl that a goatherd offers the object of his affections, Thyrsis. The detailed description of the bowl, with its carved figure scenes and rustic landscapes, its border of twisting ivy fruits and flowers, and (perhaps on the outside) its lushly spreading acanthus leaves, reflects amongst other considerations the pleasure taken by the poet's contemporaries in the appearance and also the tactile qualities of elegant tableware of all varieties. As in the

Classical period, the quality and materials used for banqueting equipment would depend to a large extent on the wealth of the host. It does appear, however, from the amounts of silver that survive, that the Hellenistic period saw an increase in the use of silver in private life, both for daily use and for display as an indication of wealth and status. In more affluent households, vessels of silver and bronze would have been fairly plentiful. In many respects, the shapes and forms of vessels that are known from later fourth-century Macedonian burials continued in production throughout the Hellenistic period. Wine would have been mixed with water in large *kraters*; some *kraters* are fitted with integral strainers, presumably used to filter out any solid dregs accumulated in the wine during storage. Separate strainers are also found. Jugs or ladles would be dipped into the *kraters* by the slaves whose task it was to move among the couches, filling and re-filling the drinking cups. The techniques developed for working silver in the Classical period continued to be used: most vessels were cast, but there was also an increasing use of the repoussé technique, which involved laying the piece to be worked face down on a bed of soft pitch or bitumen, and

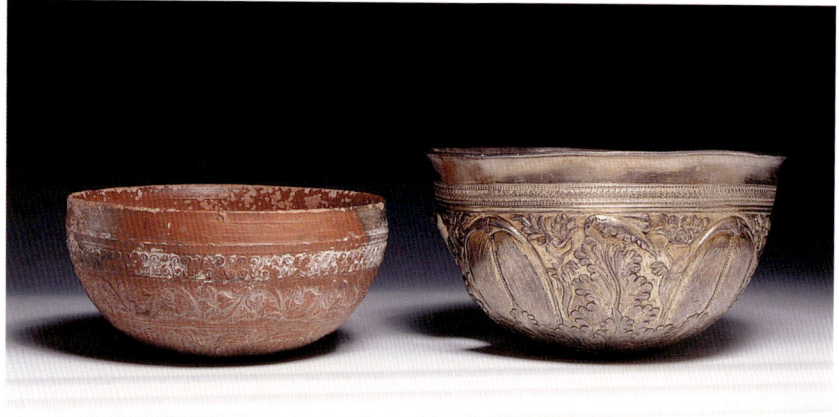

65 Silver bowl with gilded details, and mould-made pottery 'Megarian' bowl, both dating to the third or second centuries BC. The silver bowl is said to be from Bulgaria, while the clay version was made in the eastern part of the Hellenistic world. Diam. of silver vessel 15 cm.

punching and hammering the designs out from the inside: the patterns would then appear raised in relief on the outer surface. The silver bowl illustrated (fig. 65) was made in this way: the elegance and intricacy of its decoration is worth describing in some detail. The lower part of the bowl is decorated with alternating acanthus leaves and lotus (*Nymphaea nelumbo*) petals, separated by flowers on curving tendrils. The leaves and petals are shown in a style that combines apparently realistic details with highly structured, formal patterning. The waving, wind-blown effect of the acanthus leaves and flowers, the delicately

veined texture of the lotus petals and the way the leaves and petals curl over at the top seems naturalistic. This curling over, however, is also a carefully contrived artistic device: without it too much background would be left unfilled at the top of the field. The calyx from which the leaves and petals rise is a formally patterned double rosette medallion, the exact repetition of the design around the bowl is formal rather than derived from nature, and the lines of punched-out circles that mark the central ribs of leaves and petals are highly stylized. The leaves, petals and flowers are embellished with gilding, and the lower part of the deep, slightly out-curved rim is ringed by a finely executed guilloche band between lines of neatly punched circles (echoing the central rib of the leaves). Prominently placed on the upper, undecorated part of the rim, directly above one of the lotus leaves, are the dotted ligamented letters M and P, an indication of the vessel's weight. To modern eyes such inscriptions seem unsightly, but similar and longer graffiti are found on many pieces of Hellenistic and Roman silver, suggesting that their ancient owners found them inoffensive: perhaps they were considered actually to enhance an item's status. The repoussé technique leaves the interior of the vessel with slight concavities where the design has been pressed out, and some bowls of this type are fitted with a separately made lining which rises to form the rim, the junction with the outer decorative shell concealed beneath a decorative moulding: this practice continued into the Roman period.[17]

Silver bowls of this shape, and variations of it, have been found in many parts of the Hellenistic world. In their basic form they clearly recall and probably derive from the rather deeper silver bowls of Persian (Achaemenid) shape that became popular in Greece in the wake of Alexander's conquests; several examples of these are among the finds from the tombs at Derveni and Vergina. It seems likely, however, that this shallower, essentially hemispherical shape, with its many variations of leaf and petal decoration, originated or was at least most fully developed in Ptolemaic Egypt. The greatest number of silver bowls of this shape with variations on this type of decoration have been found here, as have numerous fragments of similarly shaped and decorated faience bowls. Moreover, it was in Egypt that the *Nymphaea nelumbo* was a native species, along with other types of plant that also appear on such bowls, including the pointed *Nymphaea caerulea* leaves. The *Nymphaea nelumbo* is also found on two fragments of mould-made pottery bowls of the type generally known as 'Megarian' found in the excavations of the Athenian Agora; and in general terms the silver bowls bear an obvious resemblance to this type of bowl.[18] 'Megarian' bowls (see fig. 65) bear a variety of designs, including narrative scenes, but

many of the popular leaf and petal arrangements very clearly resemble the silver forms. 'Megarian' bowls are thought to have originated at Athens, where they seem to have come into production quite suddenly in the late third century. It has been very plausibly suggested that it was in response to a very specific political and cultural event – the institution at Athens, probably in 224/3 BC, of the Ptolemaia, an athletic festival held at Athens in honour of Ptolemy III Euergetes – that such bowls started to be made. Perhaps a group of fine silver examples was imported from Alexandria for the occasion and promoted the production of cheaper versions.

Whatever the initial impetus, from the late third century onwards pottery mould-made bowls of this type were produced in numerous centres of mainland Greece, the islands and Asia Minor: this was an important development as it entailed a dramatic change in manufacturing processes, and the inception of a technique that was to endure throughout the Roman period. Occasionally a mould for a pottery bowl might be taken from a metal example. Usually, however, clay moulds were purpose-made on the wheel, often left fairly rough on the outside but smoothly finished within. Decoration was applied to the interior while the clay was still soft: grooves might be cut while the mould was spinning on the wheel, and small, individual stamps could be applied. In the case of bowls decorated with leaves or flowers, some designs were drawn freehand in the mould. As well as floral designs, figured subjects are found: dramatic masks, goats and Pans clustered around large wine bowls, satyrs, ships and hunting scenes are all part of the repertoire. After firing, the moulds were ready for use. The potter would press soft clay into his chosen mould, working it into all the hollows with his fingers. He would then centre the mould on the wheel and spin it while he smoothed the interior of the bowl. The bowl would have to be left in the mould for several days until it was sufficiently dry to be removed without damage. A potter wishing to specialize in the production of such bowls would therefore need a large supply of moulds if he were to produce a sufficiently large number of bowls at a reasonable speed. That this was indeed the case is suggested by the excavation of a workshop at Pella dating to the decades around 100 BC, where more than three hundred complete or fragmentary moulds were found together.[19] Once the potter had successfully removed the bowl from the mould, he would coat it in black slip, and, in Athens at any rate, finish it off by scraping grooves around below the lip and around the base medallion, and then filling these with a decorative slip of clay mixed with red ochre (*miltos*). For firing they would be stacked in the kiln one inside the other, separated by thick clay rings.

In addition to 'Megarian' bowls, a wide range of other types of pottery tablewares, mainly wheel-made, was produced throughout the Hellenistic period.[20] Especially widespread and long-lived in its production was the so-called 'West Slope' ware, named after the west slope of the Athenian Acropolis, where large quantities of it have been found (fig. 66). 'West Slope' vessels are essentially black-glazed, with decoration applied partly in added white and yellow and partly by the use of incision. They were produced not just in Athens but in many other centres too, including Corinth, Macedonia, Crete, Cyrenaica, Pergamon and Egypt. Sometimes they might be additionally embellished with moulded elements, such as plaques or masks, occasionally even entire moulded figures; ribbing was also popular. Other types of pottery display 'dark

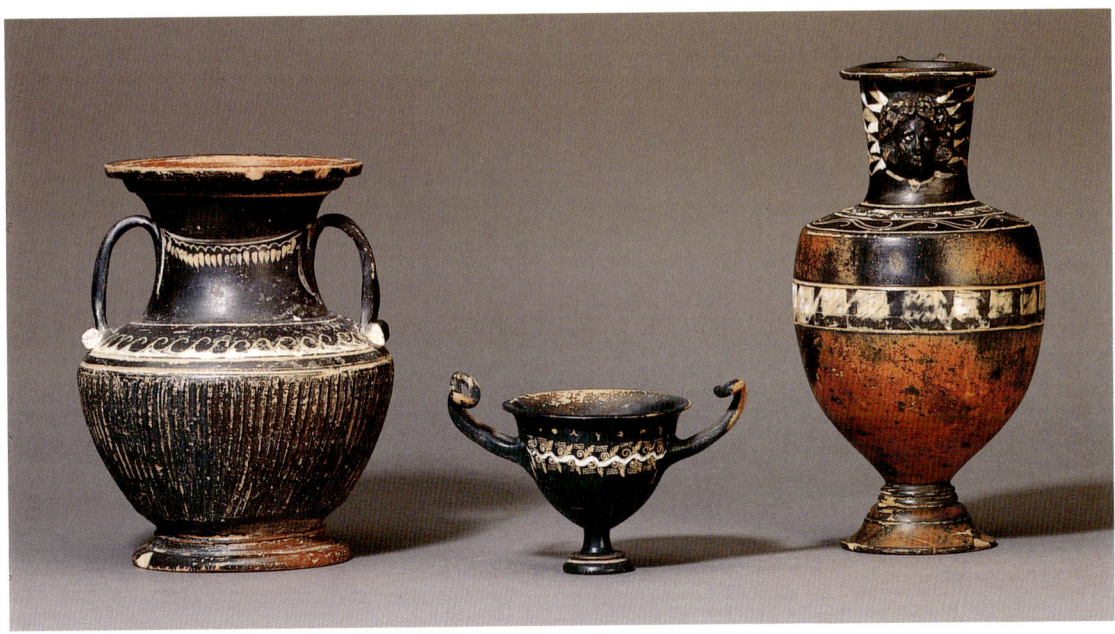

on light' decoration, in other words the decoration is executed in brown glaze against either the natural background colour of the clay or a whitish slip. Good examples of this sort of decorative scheme are the squat jugs (*lagynoi*) of the so-called 'Lagynos Group', produced near Pergamon and elsewhere in the eastern Mediterranean: coated in thick white slip, they typically carry small vignettes, including wreaths and other articles connected with feasting, and even actual *lagynoi*. A different kind of visual joke is played by a small class of little jugs and pots made to resemble leather balls, sewn together from patches of leather in the

66 Characteristic shapes and decorative schemes of 'West Slope' pottery from various parts of the Hellenistic world, third and second century BC. Height of vessel on right 28 cm.

shape of pentagons or hexagons, the seams suggested on the pottery versions by simple incised lines. The production centre of these is not clear – they are mainly found in the eastern Mediterranean, at sites such as Knidos, but they have also been excavated in mainland Greece, including Athens.

Affluent Hellenistic diners in search of novelty and variety could, alternatively, from the mid-third century onwards opt for a whole new range of colour

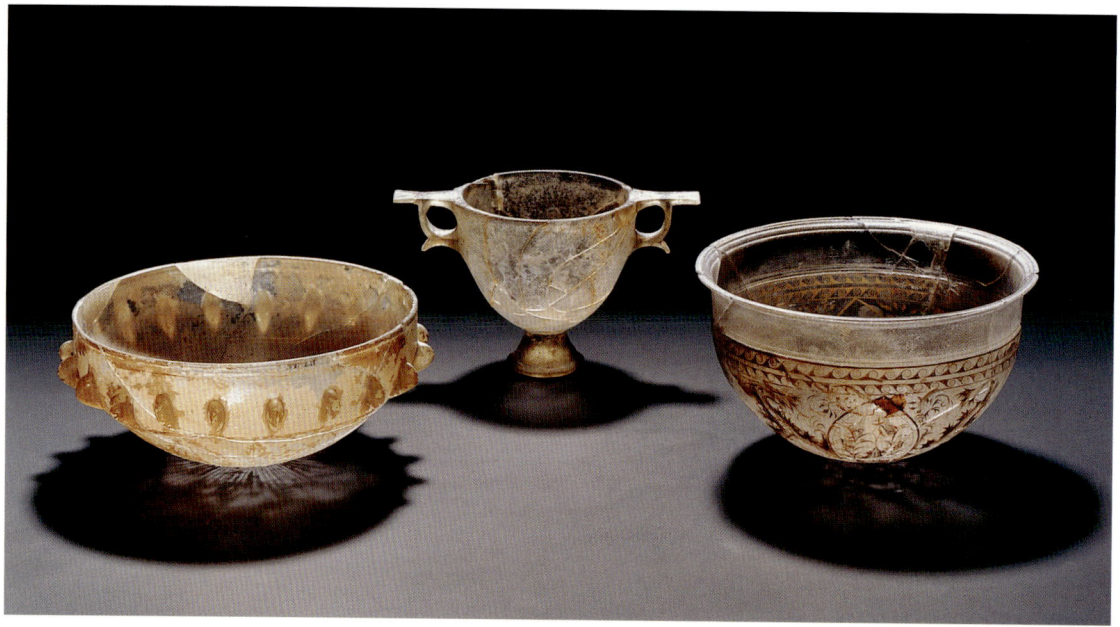

67 Three clear glass vessels from a tomb at Canosa, southern Italy, that contained ten high-quality pieces of glass. Shown here are a shallow bowl decorated with raised bosses and with a finely cut rosette inside, an elegant chalice on a tall stem, and a 'sandwich' gold bowl (one of a pair) with intricate designs of gold leaves and flowers pressed between two layers of glass. Height of chalice 11.1 cm.

and brilliance in the form of glass tableware, by this time being worked in a variety of techniques.[21] There is no consensus on where most advances in glass-making took place: the credit often goes to Alexandria, but the finds come from areas as far-flung as southern Italy and the Black Sea. Most spectacular, perhaps, are the plates and bowls of mosaic glass: to make these, large numbers of evenly sized sections or slices of multicoloured glass canes would be laid in a circle on a tray, then heated in a furnace until they slid and fused together in a large, pancake-like mass, which would then be 'slumped' over a form of the desired shape and size and left to cool and harden. Often sections of 'sandwich gold' glass canes, made by pressing gold leaf between two colourless layers, would be included to add sparkle and brilliance to the range of colours. A variation on this basic mosaic technique was that of so-called 'lacework' or 'network' glass, made from canes of spirally twisted threads of different coloured glass laid side

by side. Complete dinner services, consisting of vessels for both serving food and drinking, were sometimes cast in monochrome glass, often intentionally decolourized to pale or yellowish-green. After cooling these would be carefully ground and polished and decorated with fine, linear cutting in the form of flutes, grooves, rosettes and other patterns. Finest of all, perhaps, are the hemispherical bowls made from two layers of almost colourless glass with floral designs in intricately cut gold leaf pressed in between. Two of these were found, with other mosaic and cast glass vessels, in a tomb at Canosa in southern Italy (fig. 67). Clearly made as a pair, and with matching designs of flowers and leaves, even in their current fragmentary state they afford a stunning glimpse of the craftsmanship, beauty and luxury available at the time. It is also interesting to note that both in their shape, with their plain, slightly out-turned rims rising above hemispherical bowls, and in their decorative schemes of leaves and flowers they recall the silver and the Megarian bowls discussed above and thus form an interesting example of the way shapes and decorative motifs could cross materials, workshops and areas of production.

We have so far concentrated on the use of the home as a place for dining and entertaining, but for some Hellenistic people their home was also their place of work or their office. The excavations of the 'Coroplast's House' at Halos in Thessaly, a relatively simple house that was destroyed or abandoned in about 260 BC, discovered evidence for the production of terracotta figures in a room that seems to have served as a workshop.[22] In the much more opulent 'House of Seals' on Delos, on the other hand, a house in the northern quarter of the town which was destroyed by fire probably in the first century BC, one of the upper rooms appears to have been used as an archive or safe-deposit room. In it were found about 25,000 clay sealings, which carry on one side one or more seal impressions, and on the other traces of papyrus fibres, showing that they were once attached to documents.[23] A number of bronze and iron nails found in the debris, and the bronze leg of a chest, suggest that the documents were stored in chests. All the sealings are pierced lengthwise by a channel produced by the passage of a cord that attached them to the surface leaf of the papyrus. The seals provide a fascinating glimpse of the wide variety of types in use over the period between about 170 and 69 BC: they are also suggestive of the way they might have been used, perhaps in place of signatures, to identify the individuals whose dealings were thus recorded and preserved by the owner of the house, who may have been a merchant, a banker, or perhaps the ancient equivalent of a solicitor or notary.

Funerary practices and monuments

Tombs and their contents survive in much greater numbers than do houses, for the simple reason that most were constructed at least in part underground, and most were sealed once their occupants had been laid in place. Although they primarily offer evidence for funeral customs and beliefs, tombs are at the same time an invaluable source of evidence for the types of material goods which people used in life: there seems to have been a feeling widespread in the Hellenistic world that life continued after death, with an ongoing requirement for the same sorts of furniture and equipment that were needed in life. Like Hellenistic houses, Hellenistic tombs cross the boundaries of public and private life: though privately organized, funerals were often very public affairs, and could certainly provide opportunities for displays of wealth and taste.

Funerary practices did of course vary in the Hellenistic world, both according to national, regional and local laws and fashions, customs and beliefs, and depending on the degree of wealth of the individual family to which the dead person belonged. They can be reconstructed in part from literary and epigraphic evidence, and in part from what can be deduced from the archaeological record, the excavations of tombs and burials. In Athens, and elsewhere too, many of the traditions that had been established in the Archaic period continued to be observed – the laying out of the body for all to see that the person was truly dead, the procession before dawn of the family and other mourners to the place of burial, the deposition of the body in the tomb, or its cremation, followed by the collection of the ashes in a vase. A funeral banquet might be held and food offerings might be made above the grave, involving burning the food complete with its containers. At a set interval after the burial, the length of which would vary from one place to another, the family would return to the grave for more rituals, then there would also be annual rites to be fulfilled at the tomb.

In Athens the great series of funerary *stelai*, many in the form of small shrines framing family groups, that had stretched from the last decades of the fifth century BC on through most of the fourth, came to an end in the late fourth century, probably as a result of an embargo placed on sumptuous grave markers by the pro-Macedonian tyrant Demetrios of Phaleron (317–307 BC): from now on in Athens grave mounds could be topped only by 'a small column no more than three cubits in height, or else a table or small basin' (Cicero, *Laws*, 2.26.66). Elsewhere in the Hellenistic world, however, especially in Asia Minor and the eastern Aegean, a new, smaller type of sculptured grave *stele* developed

in the third century BC and continued to be made into the Roman period. These *stelai* were generally made in one piece, with the figure or figures carved in relief, standing inside a shrine (*naiskos*) edged with columns or pilasters, set on a high podium base and surmounted by a moulded entablature and a pediment finished off with floral acroteria. These sorts of architectural details echo the monumental tombs of the wealthy. Sometimes an 'attic' zone is inserted beneath the pediment, bearing honorific wreaths or an inscription; more usually the lettering, which sometimes consists of a lengthy epigram extolling the virtues of the deceased, is found on the podium. Many *stelai* bear a single figure, standing in the same formal pose that was used for honorific statues. Very often

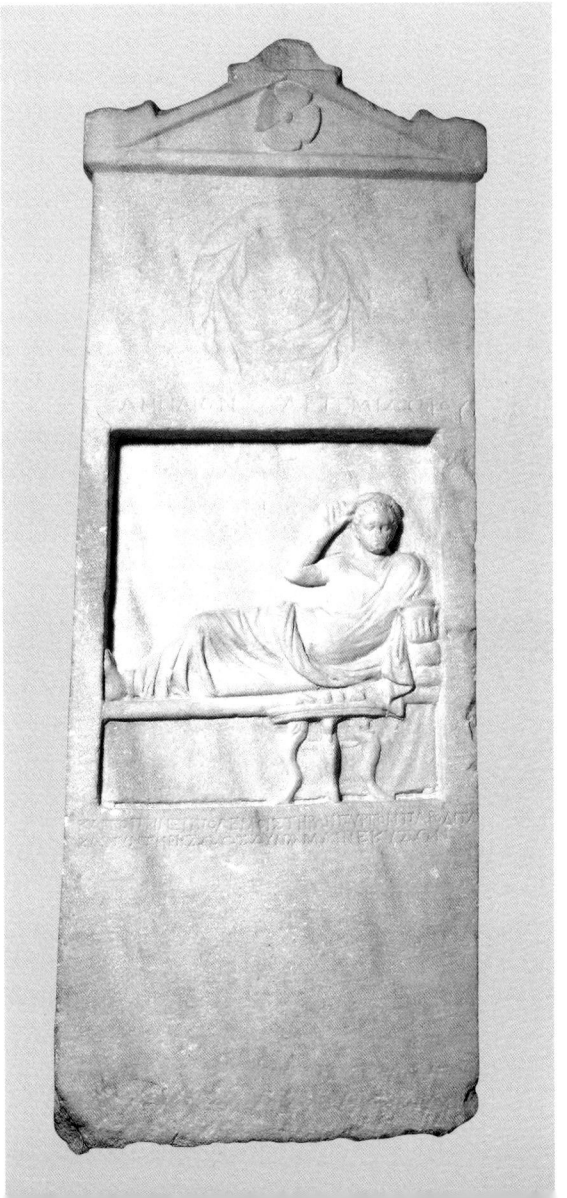

68 East Greek grave-marker, on which the dead man is shown as a banqueter, reclining on a couch with a low table before him. The inscription names him as Lenaios, son of Artemidoros, and his epitaph suggests he had been a valiant soldier: 'As I guarded the tower in battle, o passer-by, so now shall I defend it in death'. c. 150–100 BC. Height 120.5 cm.

69 View of a tomb complex under excavation in the Gabbari necropolis of Alexandria. Each of the rock-cut niches contained one or more burials.

articles symbolic of the dead person's character and particular strengths are carved as though resting on projecting ledges or pillars in the field – writing tablets indicate erudition, a wool-basket feminine industry, a cuirass represents martial prowess, and so on. Sometimes the written epigram carefully explains the meaning of the symbols in case the viewer needs to be told. Two series of *stelai* continue subjects already popular in the fourth century. In one group the dead man is heroically naked and appears along with his horse at a tree, around which twines a snake. In the second series, already referred to in connection with banqueting equipment, the dead man reclines on a couch, enjoying a funerary banquet either alone or with members of his family (fig. 68). His wife generally sits on the couch at his feet, but occasionally she has her own high-backed chair; small-scale servants prepare the food and drink, and sometimes a dog scavenges for scraps: the whole scene can present a vivid image of the feasts that took place at funerals and on certain days thereafter. In various parts of the Hellenistic world, including northern Greece, Egypt and parts of the Black Sea, painted *stelai* are found; some of the best known of these preserve poignant scenes of women dying in childbirth.

Pressure of space might sometimes result in communal burial. This was the case for many who died in Hellenistic Alexandria. they were placed sometimes in stone sarcophagi but more commonly in the niches (known to archaeologists as *loculi*) that honeycombed the walls of specially designed rock-cut chambers in the exceptionally well-preserved and distinctive tomb complexes of the several remarkable necropoleis of the city (fig. 69).[24] The Alexandrian cemeteries – among them Shatby, Hadra and Eleusis to the west of the ancient city walls and Gabbari, Wardian and Mex to the east – are extraordinary

both in their extent and in their design. They are so extensive simply because Alexandria was in ancient terms an extremely large city – the largest of the Hellenistic world – only to be overtaken in ancient times by imperial Rome. It is estimated that at the height of its growth its population is likely to have numbered 400,000, and during the roughly three centuries of the Hellenistic period several million Alexandrians must have died and required burial. When the geographer Strabo visited the city in 25 BC, he described one of the necropoleis, identified as that of Gabbari, as one of the sights of Alexandria: it is in fact he who uses the word necropolis, which means literally 'city of the dead', very probably for the first time, to describe this vast area of tombs, gardens and embalmers' establishments. In many respects the underground burial complexes resemble contemporary Greek houses, with the dead and their visitors provided with facilities similar to those they had enjoyed in life.

There are two main types of tomb complex: one, like the *peristyle* house, with rooms set around a central courtyard, one side of which may sometimes be furnished with a colonnade; the other, like the simpler *oikos* house, characteristic of many Classical and later settlements, consisting of a series of communicating rooms set on a single axis. Sometimes the tomb complex would include a dining room where, according to Greek tradition, mourners would feast on the day of the funeral, forty days after the death and on its anniversaries and certain other feast days when the dead were honoured. These dining rooms may be identified by their rock-cut couches; and banqueting equipment including drinking cups and wine amphorae has been found in some of them. Staircases led down to the tombs from ground level, usually into the central courtyard, which was open to the sky, with a parapet wall to prevent visitors, stray animals or drifting sand from falling in. Above ground the tombs were sometimes marked by tall pillars bearing lions, sirens or sphinxes.

The *loculi* were on average about 2 m long and no more than about 80 cm^2 in section. Grave goods were often placed with the dead; although precious items have generally been removed by tomb-robbers, numerous small pots, lamps and terracotta figures have still been preserved. Each *loculus* was closed with a plaster slab painted to resemble double doors, sometimes with a window above. Painted ribbons sometimes hung from the doors, and in one case there was a painted key, perhaps symbolizing the reopening of the doors when the inhabitant of the *loculus* was reborn into a new life.[25] Sometimes the name of the dead person was painted above the doorway. Some free walls were decorated with wall paintings: most of these are dated to the Roman period, but their iconography, which sometimes demonstrates the dual belief systems – Greek

and Egyptian – of many of the inhabitants of this cosmopolitan city, may well have had Hellenistic origins. Pressure of space often resulted in the reuse of the niches, and there are examples where as many as ten skeletons have been found crammed in together.

Some Alexandrian tombs are supplied with shallow niches in which were set vases containing cremated remains. A black-glazed hydria used for this purpose was excavated in the Ibrahimieh cemetery in 1906. Its ribbed surface is punctuated and articulated with plain bands bearing wreaths of incised and white-painted leaves and flowers, and further embellished with moulded plaques showing female figures, perhaps dancing, alternating with masks of a helmeted head, perhaps that of the goddess Athena. The mouth of the jar is still sealed with the plaster bung inserted when the ashes were placed inside it. The most remarkable feature of the pot, however, is the fact that set into the plaster is a terracotta figure of a standing, draped woman, not coloured in the shades of white, blue and pink normal for such figures but instead coated in black glaze similar to that used on the body of the pot. The vase itself was probably made on Crete: the terracotta figure may also have been imported from there, but might alternatively be a local production.[26]

More commonly found as the containers of cremated remains in Alexandria are the so called Hadra *hydriai*, a type of ware named after the Hadra necropolis where many examples have been found, but also used elsewhere in Alexandria (fig. 70). The more carefully potted and decorated of these vases were made on Crete: they are distinctive for their standard decorative scheme, which consists of floral, linear and occasionally figured designs, rendered in brownish glaze in a mixture of outline, silhouette and incision that shows up well against the natural yellowish colour of the clay. Popular decorative

70 A 'Hadra' *hydria*: vases of this type appear to have been specially made on Crete to contain the ashes of foreigners resident in Alexandria. The scratched inscription on this example reads 'Dorotheou', 'of Dorotheos'. c. 200 BC. Height 35 cm.

motifs include bulls' heads, birds, swags and garlands, and friezes of plunging dolphins: one recently excavated example shows a hunting scene, with hunting dogs cowering before a magnificent stag.[27] Some of the vases bear inscriptions that show that the ashes they contain are those of Greeks from other parts of the world who had died during official visits to Alexandria and been cremated at the expense of the magistrates: the inscriptions also record the magistrates'

names and the date of death. Other funerary *hydriai* were made locally in Alexandria of coarse, dark Egyptian clay (so-called 'Nile silt'), coated in thick white slip on top of which polychrome decoration was applied, generally in the form of floral swags or animal heads.

In complete and striking contrast with the subterranean dwellings of the Alexandrian dead are various over-ground monumental tombs of Asia Minor that seem to derive at least part of their inspiration from the mid-fourth-century Mausoleum of Halikarnassos. One such is the so-called Lion Tomb

71 Colossal recumbent marble lion from the so-called 'Lion Tomb' at Knidos, Asia Minor. Probably late fourth or early third century BC. Height 2 m.

from Knidos in Asia Minor, named from the colossal lion that originally reclined on its summit and now rests in the Great Court of the British Museum (fig. 71).[28] The Lion Tomb was a square structure on a stepped podium, with four engaged Doric columns adorning the main section of the outer wall on each side. Supported on this was a stepped pyramid, built to carry the massive lion that lay on a hollowed-out, rectangular pedestal. The outer courses of the masonry were marble, while the inner core was of rougher limestone. The interior room of the tomb, the funerary chamber itself, was reached through a door on one side. It consisted of a circular, beehive-shaped chamber, the lower walls of which were pierced by eleven radiating *loculi*, cut right through the limestone walls as far as the marble facing. The lion itself is also made of marble, in this case Pentelic from Attica, across the Aegean. The sculptor has paid particular attention to the lion's mane, realistically rendered as a series of shaggy, overlapping ruffs. The lion's eyes are now deep, empty sockets; perhaps they were originally fitted with discs of precious or semi-precious, light-reflecting stone. In the absence of inscriptions or grave goods the tomb is hard to date, but on grounds both of its architectural resemblance to the Mausoleum and of the style of the lion, it seems likely to belong in the late fourth or early third century BC. Originally standing to a total height of around 20 m and set on a platform levelled out on the tip of a promontory looking out to sea, the Lion Tomb must have formed a prominent memorial to the dead whose remains it contained, and also a notable landmark for sailors out at sea. A later variation on such funerary monuments as this is the Scylla monument from Bargylia in Caria, probably datable to the second century BC: the remains of the sculptural parts of this, too, are now in the British Museum. Monumental tombs like these were occasionally imitated on a small scale: the small, stepped pyramidal tomb markers found in the necropolis at Abacaenum and elsewhere in Sicily seem to echo these larger structures.[29]

In other parts of the Hellenistic Greek world, it is not uncommon to find tombs that in architectural terms are extremely modest – sometimes no more than shallow pits dug into the ground, sometimes lined with plaster or just field stones, the body and the grave goods covered perhaps with large tiles and earth then heaped over the top – but that are yet equipped with an extensive range of grave goods. This is certainly the case in many of the cemeteries of the Greek cities of southern Italy. A child's grave excavated in 1982 in the crowded cemetery at Heraclea, for example, was a simple pit, measuring 120 x 60 cm, found just 60 cm below the surface of the ground. In it, however, were found twelve female terracotta figures of various types, one a dancer, others standing, or

PRIVATE LIFE

seated beside unusual conical containers. Also found were a drinking cup on a tall stem, a smaller beaker and a child's feeding cup with an incised dedication to Hygieia, goddess of health, who may have been seen as a protectress in Heraclea.[30] Other tombs in and around Taranto have yielded similar assemblages,[31] as have graves in many other parts of the Greek world (fig. 72).

Though many grave goods were relatively cheap, in some parts of the Hellenistic world those who could afford to might lay rich and costly gold jewellery in the tomb: this practice would bring honour to the dead and also reflect the wealth and status of the surviving family. Jewellery was certainly found in the tombs at Myrina, a small city lying midway between Smyrna and Pergamon in Asia Minor. Excavated in the early 1890s, the tomb-groups here were not well recorded, so that in only half a dozen cases is it now possible to establish which grave goods come from which tomb. Alongside the spectacular

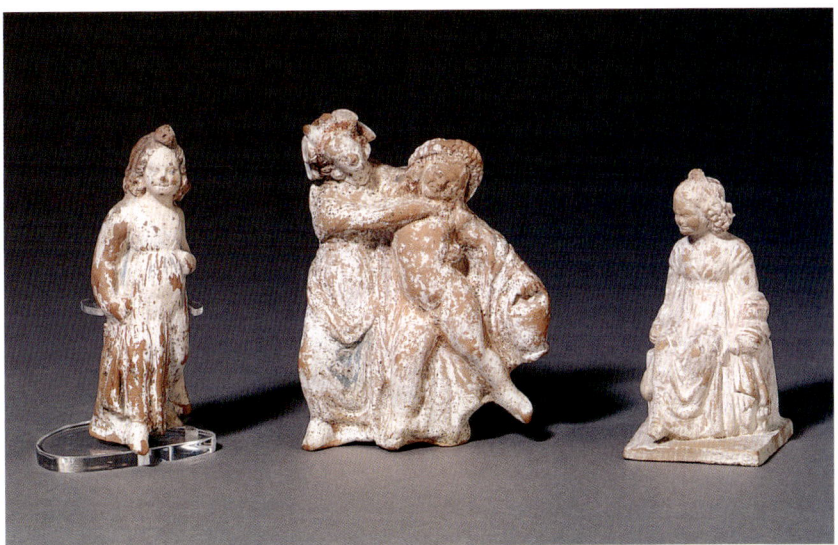

72 Terracotta children; made in Athens or Tanagra in the late fourth or third century BC, and said to be from Aigina and Tanagra. Such figures were frequently placed in graves, especially those of children and young women: they offer vivid and apparently informal glimpses of everyday life. Height of boy and girl in centre 12.1 cm.

gold jewellery found at Myrina were large numbers of terracotta figures, which are, in technical and artistic terms, the finest that survive from anywhere in the Hellenistic world; it is as yet unclear whether they were made locally at Myrina or at some other centre nearby, either Pergamon or Kyme.

Two types of figure were exceptionally popular: draped, mainly standing, female figures that seem to reflect in their virtuoso drapery the contemporary large-scale marble sculpture of nearby Pergamon, and flying figures of Nike, Winged Victory, and Eros (fig. 73). Unlike the standing female figures, generally

made in two principal moulds, front and back, with separately made heads inserted on long tangs, the complex poses and attributes of the flying figures, with their great wings and outspread limbs and, in the case of the Nikai, their windswept drapery, meant that they had to be built up from many separate elements that were pieced together before firing. Most are extremely fragile and cannot easily be laid down: some are equipped with clay loops or extra holes that seem designed to hold cords for suspension, but it is hard to see how this would have been achieved in the tombs where they ended up. The possible significance of the two main types of figure has recently been discussed, and it has been suggested that the female figures may have accompanied the body as substitutes for the women of the family, who would tend the grave in the future. While this seems plausible, the idea that the flying figures are suggestive of the 'otherness' and pleasantness of life after death has perhaps less to recommend it.[32] Terracotta actors and replicas of theatrical masks are also found in many tombs, both at Myrina and elsewhere in Asia Minor and the wider Hellenistic world, from southern Italy to Cyprus: in the case of the latter it was perhaps the link between the theatre and its patron deity Dionysos, and his other role as the mystery god whose initiates were assured of life after death, that encouraged the deposition of such items in the grave.[33]

In addition to terracotta figures, metal and clay vessels of many kinds are commonly found in graves. For the most part vessels of the same types that were used in life were provided for the use of the dead. But in certain areas and at certain times special sorts of vessels were made exclusively for use in the tomb. Practically ubiquitous are the small oil flasks known as *unguentaria*, or sometimes 'tear-flasks'. These change in shape over the period, starting off fairly plump and gradually elongating; in Athens at least they were originally glazed, but in most places by the end of the period they are unglazed. Other funerary vases included gilded wares that would from a distance have resembled gold plate. These are found in various places at various times: in some late fourth and early third-century Macedonian tombs black-glazed pottery coated in a thin layer of gold leaf has been found; in third and second-century Apulia, too, gilding is sometimes applied to unglazed vessels. In neither case was it easy to get the gold to adhere to large areas, so that the technique is mostly confined to small pots, such as cups and jugs; and it is unlikely to have worn very well in daily use. It is hard to avoid the conclusion that this effect was designed simply to impress at funerals.[34]

At Canosa in eastern Apulia, in the late fourth and early third century BC, monumental underground tombs (*hypogea*) were sometimes furnished with

OPPOSITE:
73 Terracotta figure of Nike (Winged Victory), made at Myrina in the early second century BC. Creating such a complex figure, which is composed of numerous separately made parts joined together before firing, was a highly skilled and complex job. Height 25 cm.

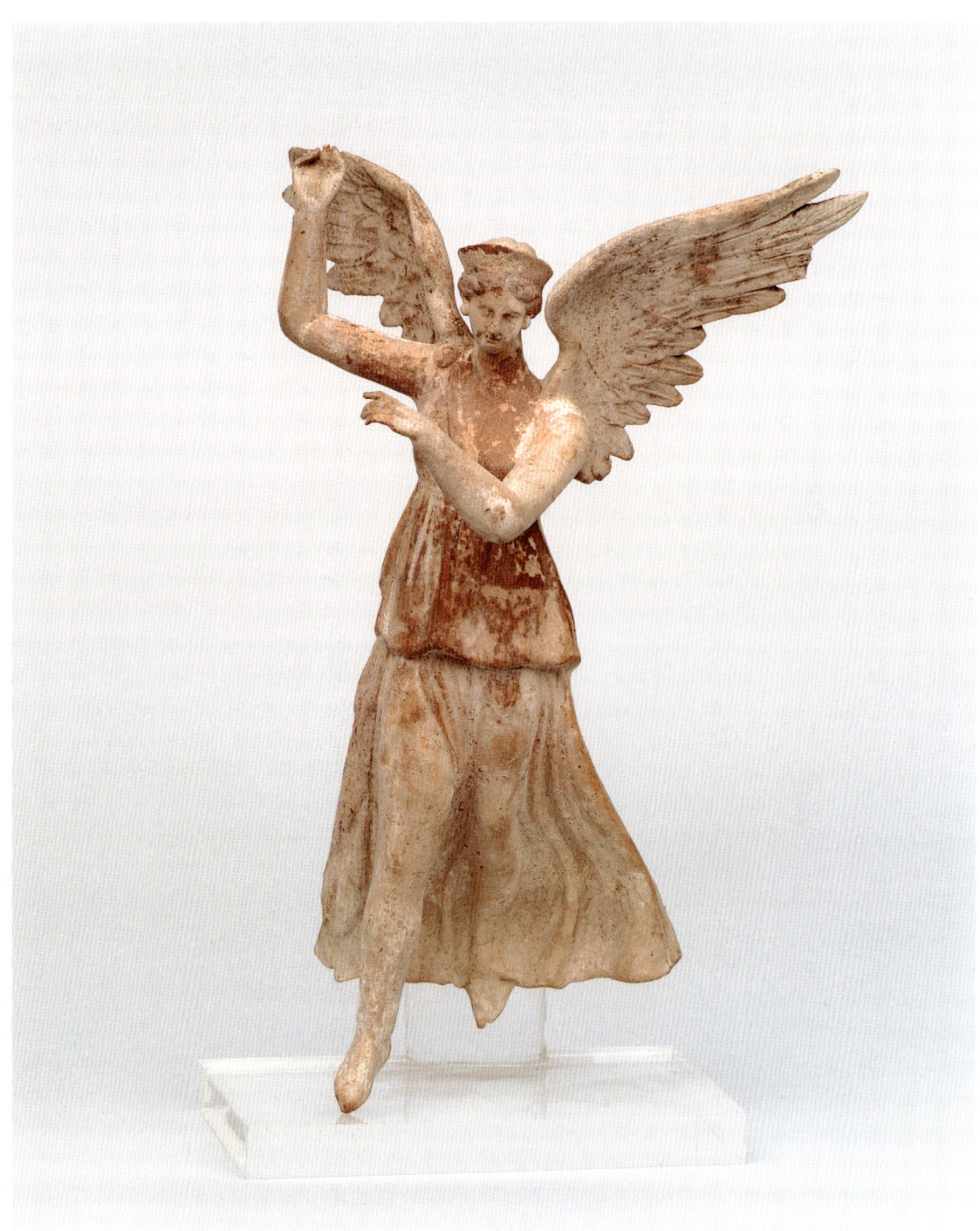

pairs or even sets of four vases on a monumental scale. Their large size and generally swelling, bulbous shapes are mainly adopted from native Italian, principally Daunian, wares. However, their decoration is purely Greek in style, a later development of the white ground style popular for grave vases in fifth-century Athens, with polychrome scenes painted over white ground. Shades of blue, yellow and bright pink, the same pigments used for the decoration of contemporary terracotta figures, are the most popular colours. Although these often do not survive very well, they and the artists' attempts to suggest the effects of light and shadow can sometimes give an impression of the likely appearance of contemporary large-scale wall and panel painting. Popular subjects are sea-monsters and large Medusa masks. Greek in influence too are the moulded attachments lavishly applied to these vases, including the foreparts of horses, Medusa masks, and snake-bodied Scyllas; standing female figures were also attached, sometimes with their hands raised in a gesture which may suggest either mourning or the veneration of a deity. Large-scale, free-standing versions of these figures, often nearly a metre high, have also been found in Canosan tombs, and the links between the pots and the terracotta elements strongly suggest that the same workshops were producing both. A similar style of painted polychrome pottery with extensive moulded additions developed in late third- and second-century Sicily, centring around the small town of Centuripe in the eastern part of the island.[35] Some Centuripe vases are so clearly designed to be decorative rather than functional that only the front of the vase is decorated, and the lids, fired onto the bodies, are not removable. Sometimes elements of their elaborate relief decoration can echo details of contemporary architecture, an interesting example of the typically Hellenistic practice of transferring motifs from their proper or traditional medium into another where they played a purely decorative and sometimes inappropriate role.

Chapter 5

Themes in Hellenistic Art

'Questioner: "Who are you?" Statue: "Opportunity, the all-conqueror."
Q: "Why do you stride on the tips of your toes?" S: "I am always running." Q: "Why do you have pairs of wings on your feet?"
S: "I fly like the wind." Q: "Why do you carry a razor in your right hand?" S: "To show people that my appearance is more abrupt than any blade." Q: "And what about your hair – why does it hang down over your face?" S: "So that anyone who meets me may grab it."
Q: "By Zeus, and why is the back of your head bald?"
S: "Because nobody, once I have run past him on my winged feet, can ever catch me from behind, even though he longs to."
Q: "Why did the artist fashion you?" S: "For your sake, stranger...."'
(*Anth. Graec.* 2.49.13, *Anth. Pal.* 16.275)

As Hellenistic artists shared in the varied preoccupations – intellectual, social or political – of their age, it is not surprising that sometimes they attempted to express them in their art. It is not always easy to estimate the success of these endeavours. A work that seems obscurely convoluted to our eyes might have been much more successful in its own day and its original setting. However, the rather laborious question-and-answer epigram quoted above, in which the sculptor Lysippos's statue of Kairos, Chance or Opportunity, explains the subtleties of its own iconography to a passer-by, does rather suggest the possibility that ancient viewers no less than we ourselves might have found some of the more complex works were not immediately self-explanatory. Many of the themes and stylistic trends of Hellenistic art have been touched upon in previous chapters. It is not possible to give a comprehensive overview here: the intention of this discussion is, rather, to focus on particular examples of a few dominant and typical themes and to examine their appearance, their treatment and their function.

Art and learning, personification and allegory

An interest in (sometimes quite obscure) literary history and scholarship is one theme that can be detected in some forms of Hellenistic art. We have already noted the interest in illustrating previously obscure myths on major monuments – the Telephos frieze on the Great Altar of Pergamon is a case in point (see p. 92). On that occasion there were good local and dynastic reasons for this choice of myth. At other times, however, it can appear as though the desire to show – or cater for – erudition outweighs all other considerations, as is the case, for example, with the so-called 'Homeric bowls' (fig. 74).[1] These are a group of the mould-made 'Megarian bowls' already mentioned (see pp. 115–16). About sixty of them are known, and they are believed to have been made in Boeotia in mainland Greece in the second century BC. The bowls are decorated in relief with scenes taken not just from the Homeric epics of the *Iliad* and *Odyssey*, but also from other epic poems now lost, and from some of the Classical tragedies. What is most immediately striking – and indeed peculiar – about these bowls is the fact that the groups of figures are framed by and punctuated with long quotations from the poems themselves. Although the lettering is usually quite neat, the lines of verse are squeezed in pretty densely and with rather irregular spacing between the figures in a manner that does little to enhance the overall visual effect, and can indeed result in an odd, almost strip-cartoon-like effect. It is of course true that Archaic and Classical black- and red-figure vase-painters, and also the Classical painters of large-scale wall and panel paintings, sometimes named characters, places or even events in their scenes. Perhaps to some extent the producers of the Homeric bowls were conscious Archaizers (or Classicizers), proudly demonstrating their sense of history by alluding to the productions of their predecessors of three or four hundred years ago. But the overall impression given by the bowls is that they attempt (without perfect success) to combine the functions of a wine cup and a manuscript: it has indeed been suggested that they may derive their layout from that of an illustrated

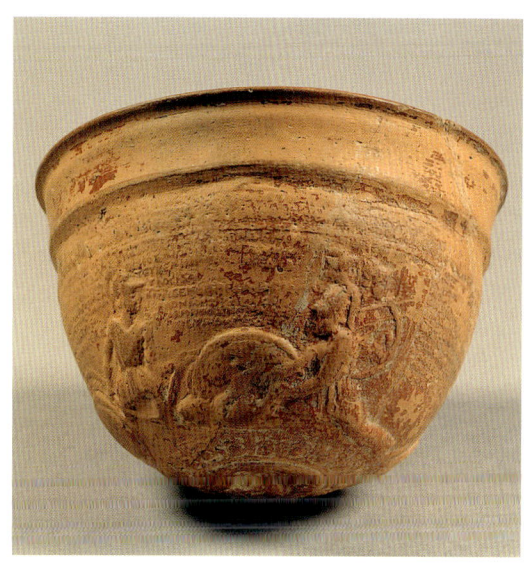

74 An example of a mould-made 'Homeric bowl', illustrating Odysseus slaying the suitors of his wife, Penelope. Quotations from the *Odyssey* appear in among the figures.
c. 175–125 BC.
Height 7.3 cm.

book-scroll. While to our eyes the bowls may not really please in purely visual terms, they may in their day have had a more complex appeal. They demonstrate the scholarly learning of their producers and suggest the existence of an equally scholarly clientele who may, perhaps, have enjoyed the bowls at literary symposia, turning them in their hands and taking it in turns to recite the stories shown.

A further and possibly related manifestation of literary preoccupations is the group of small marble reliefs known as the *Tabulae Iliacae* or the 'Trojan Tablets' (fig. 75).[2] The date and production place of these is uncertain; they may be as late as the first century AD, but they could equally well belong in the late Hellenistic period, possibly the first century BC. Like the Homeric bowls they show scenes from epic, and they too resemble strip-cartoons in that the field is usually divided into narrow, frieze-like bands on which the same characters or groups recur from one episode to the next as the plot progresses. Again, the

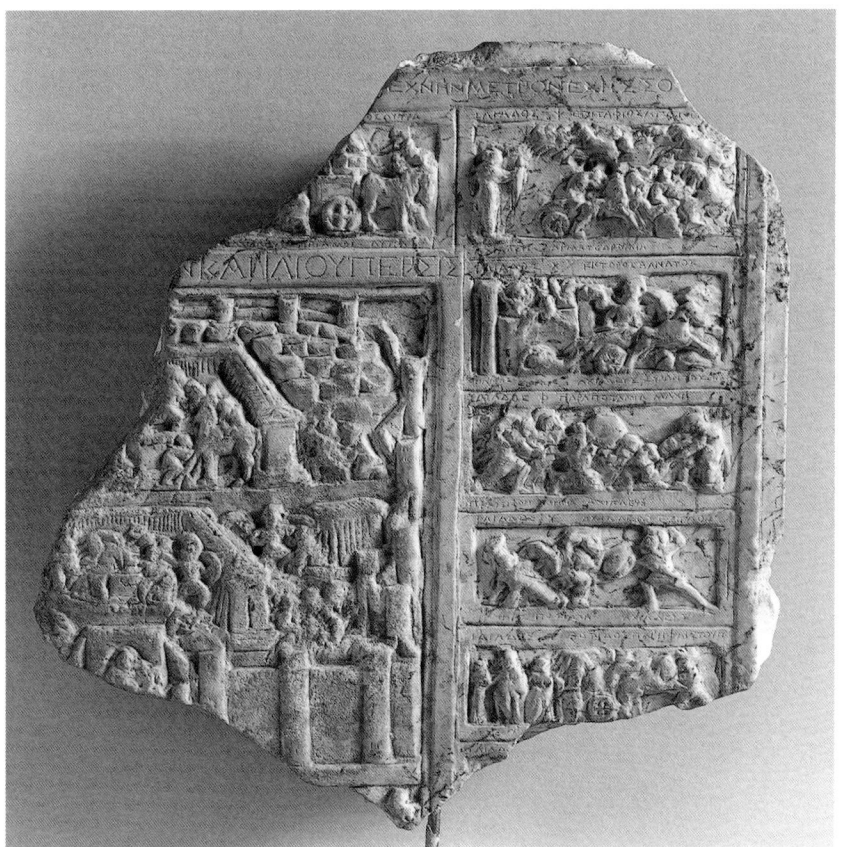

75 A fragment of a *Tabula Iliaca* ('Trojan Tablet') with minuscule scenes from the Trojan War. It is signed on the reverse by a Greek artist named Theodoros, to whose workshop all the surviving examples can be attributed. The *Tabulae Iliacae* are usually dated to the early first century AD, but seem likely to derive from the same Hellenistic artistic–literary tradition as the 'Homeric bowls'. At the left-hand side, in the centre, stands the wooden horse of Troy. Height 17.6 cm.

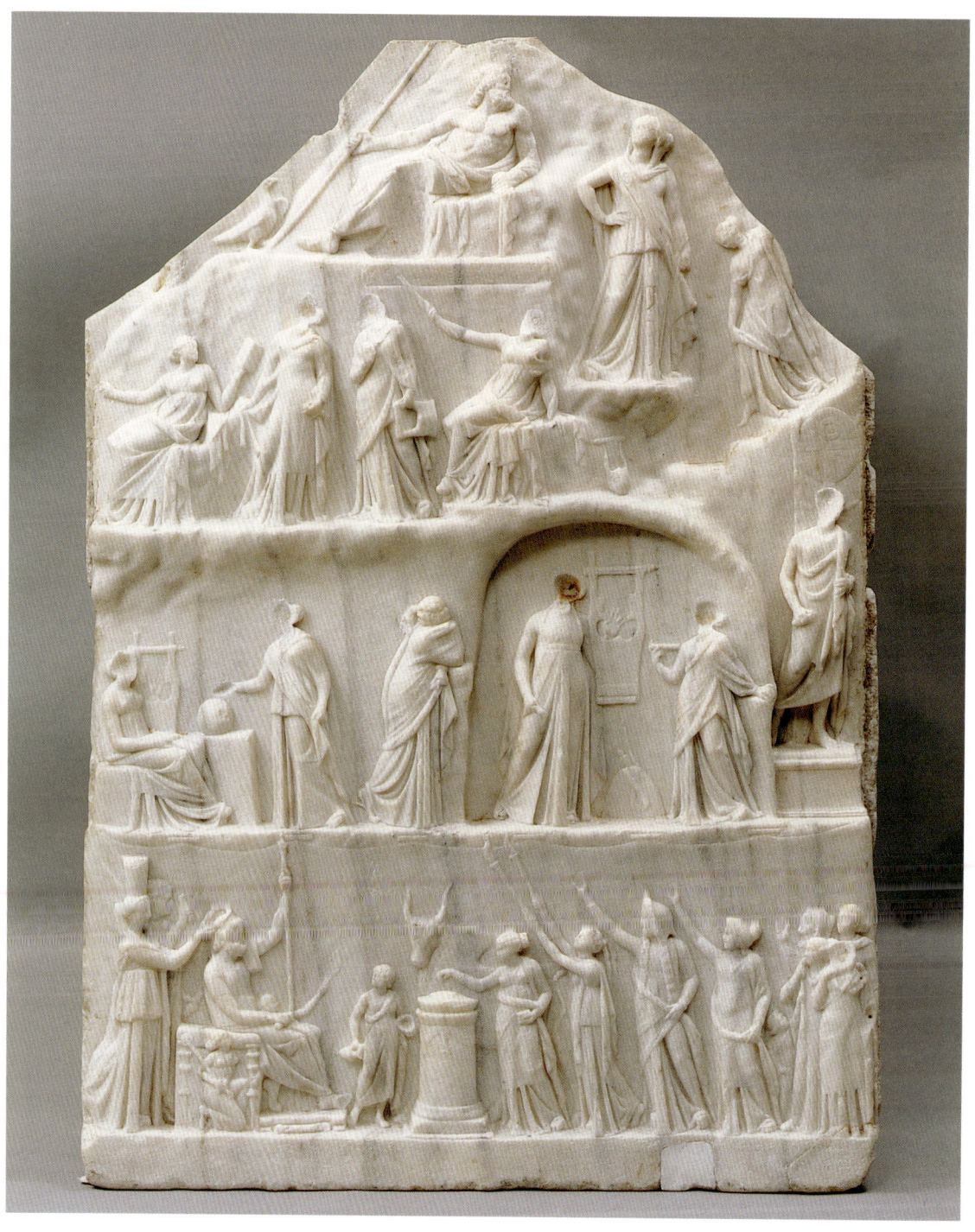

figured scenes are accompanied by texts, both verse excerpts from the actual poems and lists of books. The purpose of these reliefs is unknown and disputed – were they memory aids for scholars and their teachers, or perhaps, as is more likely, symbols of erudition, kept for display and amusement in the houses of the wealthy and cultivated? The attempts of the makers of the *Tabulae Iliacae* to represent portions of complete epic cycles are remarkably ambitious. In several respects these reliefs, with their continuous narratives unwinding through bands of densely packed figures in their land- or city-scapes, seem like small-scale forerunners of such later Roman epic monuments as Trajan's column. In a Hellenistic context, they offer further evidence for the tendency of some artists and craftsmen to blur the boundaries between the visual arts and literary learning.

Alexandria, where the Ptolemies were early and exemplary patrons of many forms of art and literature, has provided at least its fair share of examples of 'erudite art'. One large-scale, elaborate and very dramatic example of this is the allegorical marble relief known as the 'Apotheosis of Homer', found at Bovillae in Italy and signed by the sculptor Archelaos of Priene, but almost certainly made to celebrate the victory in a poetry competition of an Alexandrian poet (fig. 76).[3] Although it does not represent a narrative in the same way as the *Tabulae Iliacae*, the relief is divided into three horizontal registers by ledges on which its many figures are disposed, and the identity of the figures is secured by the (now very worn) inscriptions naming each. The lowest register shows a couple whose features suggest they should be a Ptolemaic king and queen, probably Ptolemy IV Philopator and his wife Arsinoe III, but whose names show they are seen here as 'Chronos' (Time) and 'Oikoumene' (the 'inhabited world'). The queen lays a wreath on the head of a venerable seated figure, identified as Homer by the named personifications of his two epic poems, the *Iliad* and the *Odyssey*, kneeling on either side of his throne. In front of Homer is a cylindrical altar, behind which looms the head of a sacrificial bull. Curtains form a backdrop to this register of the relief, suggesting the scene may be set in an enclosed area, perhaps a special part of a sanctuary. On either side of the altar stand the personifications of Myth and History. Beyond are Poetry, Tragedy and Comedy, all with arms uplifted in honour of the sacrifice; on the far right a child-figure named Human Nature reaches up towards the personifications of Excellence, Mindfulness, Trustworthiness and Wisdom. The marginal-seeming figure standing on a pedestal at the right-hand end of the second register up is probably to be thought of as the victorious poet in whose honour this sacrifice is taking place. Beyond him in an arching cave Apollo, leader of the Muses, stands beside the wool-bound Delphic *omphalos* (the stone that marked the

OPPOSITE:
76 The 'Apotheosis of Homer', a marble votive relief, found at Bovillae in Italy but likely to have been made in Alexandria in the later third century BC; signed by the sculptor Archelaos of Priene. Height 1.18 m.

centre of the world), holding his kithara and attended by a Muse; outside the cave are three more Muses with the various tools of their trade. Zeus sits at the very top of the relief where the background has been carved to suggest the rocks and gullies of a mountain, presumably Helicon, the mountain of the Muses. Looking up at him is Mnemosyne, Memory, and grouped below her on the slopes are five more Muses, making up the full complement of nine.

The literary, allegorical 'meaning' of the relief is made clear by the arrangement of the figures and by their identities, as revealed through the inscriptions. Poetic inspiration comes from Zeus (who in some Hellenistic philosophies was equated with 'the universe') and is sent down, via Memory and the nine Muses, to mankind. The universal and everlasting poet will always be Homer – hence his crowning by the Inhabited World and Time – and at his altar all other forms of Poetry must sacrifice; through poetry Mankind (or Human Nature) acquires all its most noble qualities. In poetic terms Homer is both a god and the guiding ancestor of the victorious poet.

The Apotheosis of Homer is thus the expression of a universal view in which the art of poetry takes centre stage. It is also a compliment to the Ptolemaic royal couple, who were great patrons of the arts and indeed founded a temple to Homer in Alexandria, the Homereion.[4] Although it is an artist's view of this poetry-centred philosophy, the artist has, in a manner of speaking, put his own art in second place, at the disposal of that of the poets. His own medium, the visual art of sculpture, is here combined with words and concepts borrowed from contemporary and earlier poets and philosophers. The hierarchical arrangement of the figures on the relief, and the choice of subject and of the individual characters, may be the sculptor's own, but the complex patterning of the allegory and the relationship of the figures to each other make sense only when the names are read and understood.

The personification of Tyche, Chance or Fortune, and the influence for good or evil that it played in people's lives, was a dominant obsession of the Hellenistic Age.[5] Although the notion of Fortune had already been acknowledged in the Archaic and Classical periods, it seems to have been only from the fourth century onwards that Fortune was taken more seriously both as a philosophical concept and, in popular thought, as a goddess to be propitiated. Different philosophies coped with the idea in different ways: while the Epicureans saw the workings of Fortune in terms of purely random collisions and conjunctions of atoms, others, including the Stoics, viewed it as the dominant, conscious and deliberate guiding force in the universe. The popular view is perhaps represented in contemporary Hellenistic drama, notably that of

Menander, who seems to have been especially keen to point out how drastic and unpredictable an influence for success or failure, riches or poverty, happiness or disaster, Fortune could exercise over people's lives. So far as can be judged from various extant fragments of his plays, Menander brought Fortune onto the stage as a goddess in her own right and this was probably how many people thought of her. In addition to the 'universal' role of Fortune, concepts of personal and also of civic Fortune began to develop from the early Hellenistic period onwards. Alexander, for example, was believed to be blessed with a 'fortunate' form of the goddess that travelled with him through life and might also rub off on his associates if they were lucky; cities, too, might have their own version of the goddess with whom they would do their best to keep on favourable terms.

In terms of artistic representations of Tyche, the first reported cult statue dates to the early fourth century BC; no longer in existence, it was made by the sculptor Praxiteles for a temple of the goddess in Megara. The most famous and influential ancient image of Tyche, however, was created by the aptly named Eutychides ('Blessed by Fortune'), perhaps a son and certainly a pupil of Lysippos, for the Seleucid city of Antioch on the River Orontes (fig. 77). The statue was completed in about 296 BC, shortly after the foundation of the city by Seleukos. Seleukos may have recognized a special debt to the goddess, for it was to the notably dramatic reversals in the fortune of the Antigonid Demetrios Poliorketes, initially one of the most energetic and successful protagonists in the wars of the successors that followed the death of Alexander, that he owed his own rise to fame. The statue showed the goddess seated on a rock above the River Orontes, which was personified as an athletic male swimmer. The goddess herself sat in a seemingly casual but actually elaborately

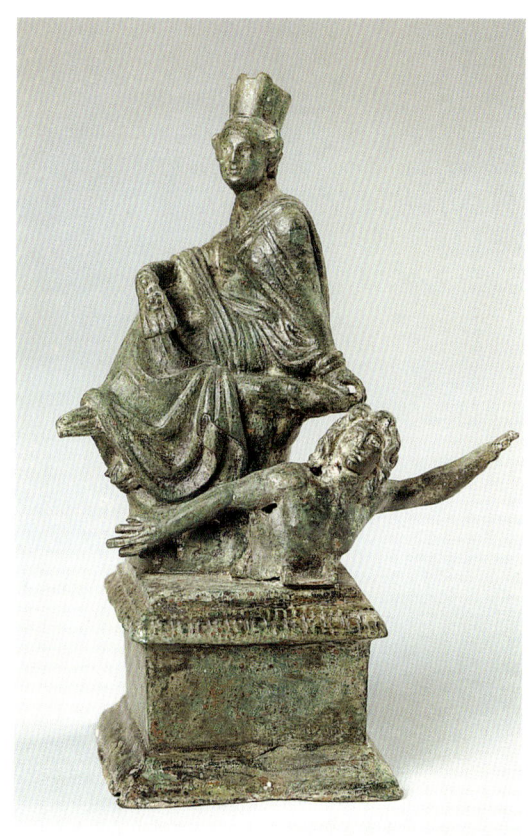

77 Miniature bronze version of the Tyche of Antioch: the athletic male swimmer beneath the Tyche is the personification of the River Orontes. Probably Roman, first century AD. Height (without base) 11.5 cm.

contrived and twisted pose that produced a strongly three-dimensional effect and enabled her to be seen to good advantage from several different angles. She was tightly wrapped in a long garment that was pulled in various directions in a series of long, dramatically opposed diagonal folds, and in her hand she held a sheaf of grain, a sign of the prosperity she brought to the city. On her head she wore a 'mural' crown in the form of the city walls, complete with projecting buttresses or towers – a type of crown that entered Greek iconography from Near Eastern art. Although Eutychides' statue no longer survives, ancient descriptions, along with replicas and reproductions in many different media and sizes, including, by Roman times, the coins of over forty eastern cities, can provide us with a very good idea of what it looked like.

Landscape and nature: the rural idyll

A rather self-conscious interest in nature, and in man's place in the natural world, is another mode of thought that is reflected to some extent in both the art and the poetry of the Hellenistic world. The poetic strain most probably has its roots in the sophisticated urban society of Alexandria: the Alexandrian poets and their audiences had little or no personal experience of the hardship and often grinding poverty of rural life, and so were free to concentrate instead on its picturesque qualities. Callimachus, for example, while ostensibly telling the epic tale of *Hecale*, dwells in loving detail on the practical aspects of his heroine's rustic hut and diet; and most of the *Idylls* of Theocritus are set in a fantasy world of shepherds and shepherdesses whose love-sick lives are idled away in beautiful landscapes, making music, dancing and feasting on simple but deliciously satisfying fare.[6]

A kindred attitude to the natural world, in terms of both landscape and animals, may on occasion be detected in the visual arts, especially in the later Hellenistic period. With some artists the interest in nature finds expression in the inclusion of renderings, either highly naturalistic or boldly stylized, of trees or other landscape elements in scenes that had previously been occupied exclusively by people. On a votive relief in Munich,[7] for example, a family is shown sacrificing to a male and female deity at an altar (fig. 78). But in addition to these, the principal actors in the scene, a major role in the composition is played by a large and curiously shaped tree. Its trunk is massive and gnarled, covered in a series of stylized swellings; fillets or sashes are wrapped and tied around it. At two-thirds of the tree's full height the trunk divides; the left-hand branch is

sawn off, with the cut surface patterned like a star, while the right-hand branch surges across horizontally to loom above the altar, sprouting curved and coiling branches and a thicket of large, again rather stylized, but essentially maple-like leaves; the life and dynamism of this branch is such that it strongly resembles a shaggy-maned lion springing forward in the sky! Partially suspended from the leafy branches is a large cloth that forms a backdrop to the scene at the altar and to the gods beyond. A further interest in landscape is suggested by a column next to the tree, but so positioned as to seem set slightly behind it, with two archaizing figures, presumably to be read as 'ancient statues', standing on its top. And clustered around the foot of the tree are four more figures, two women (one dressed just like a 'Tanagra' figurine, complete with pointed sun-hat) and two small, child-like figures; the four appear to have no real role in the offering scene, but seem rather to be set there simply as background, to enhance the landscape feel of the setting. This relief is one of several that seem to demonstrate a notable interest in nature and its importance in human affairs; the life that the sculptor has poured into the leafy branch may also express the idea that nature is as animate as human life.

Sometimes, as in poetry, the artistic interest in nature can seem sentimentally romanticized; at other times the artists can appear overwhelmed by the

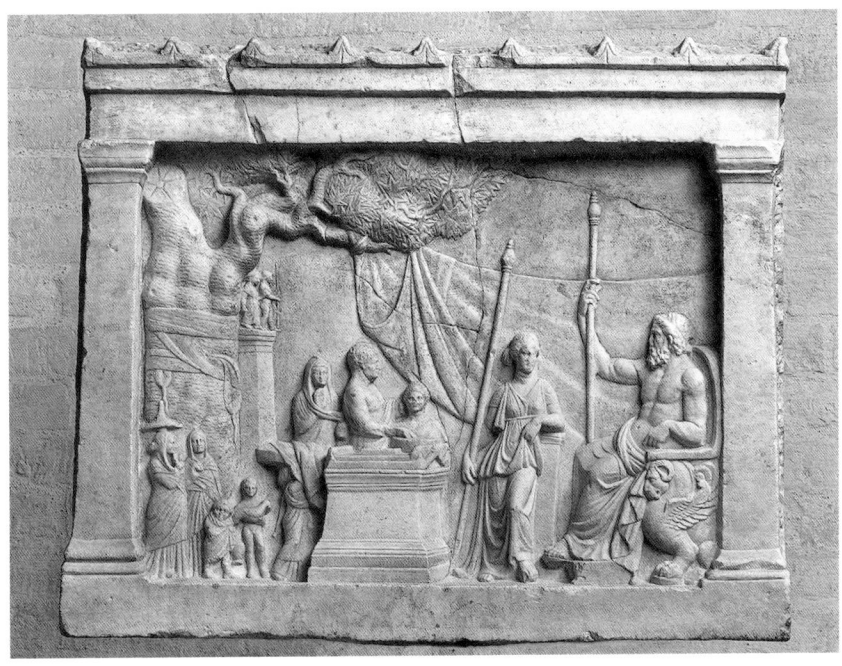

78 Marble votive relief with a scene of sacrifice. Second century BC. Height 79 cm.

vastness and power of nature, as is the case with the 'Odyssey Landscapes', a cycle of what were originally eleven paintings found in a house on the Esquiline Hill at Rome, dating to the first century BC.[8] Their ostensible subjects are episodes in the wanderings of Odysseus, but in reality the misty, rather impressionistic landscapes themselves take centre stage, with the tiny human figures dwarfed and rendered insignificant by the soaring cliffs, looming skies or towering waves of the sea. Here too, the landscapes respond to and reflect on a giant, cosmic scale the human struggles that they frame and contain; as Odysseus battles with and finally escapes from the clutches of the Laestrygonians, trees bend and toss their branches, storm clouds gather, and gigantic seas threaten to overwhelm the hero's ship. The exact status of these paintings is a matter of some dispute, but regardless of whether they are copies of an earlier series of paintings or original compositions, their presence in this opulent domestic setting testifies to the interest of urban Romans of the late Hellenistic period in contemplating the awesome magnificence of nature.

Few surviving paintings can be dated with any security to the Hellenistic period. A beautifully painted tomb in the Wardian necropolis at Alexandria, named the 'Saqiya Tomb' after its unique depiction of a 'saqiya' or waterwheel, turned by a pair of oxen, has been placed as late as the third century AD by some scholars (fig. 79).[9] However, a cogent argument, based on the architecture of the tomb, in addition to the style, subject and iconography of the painting

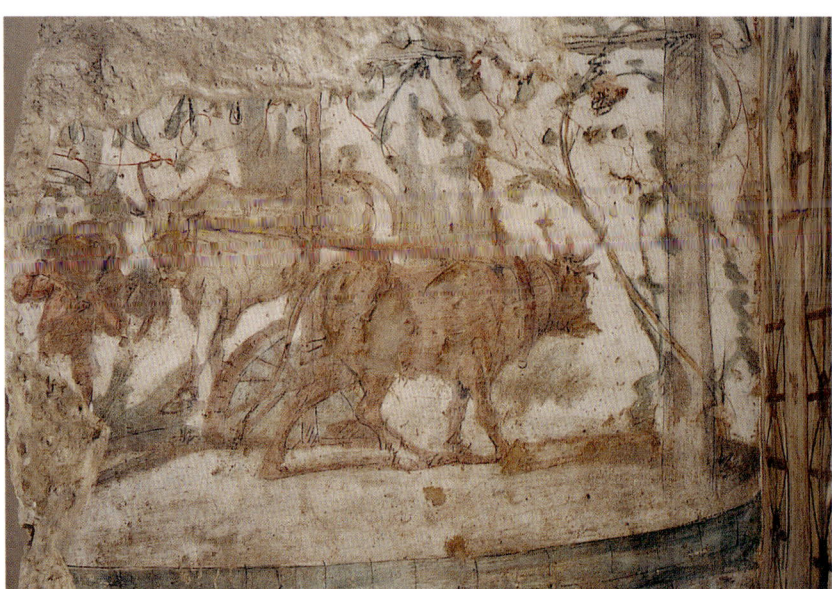

79 Painting of oxen turning a waterwheel ('saqiya') from the so-called 'Saqiya Tomb' at Alexandria. The date is uncertain but may be as early as the second century BC.

(including archaeological evidence for the likely date of the type of waterwheel depicted here), has recently been put forward in support of a date in the second century BC. Three painted scenes survive. The first shows the oxen, plodding round at their wheel, which is placed under a trellised arbour, canopied by a spreading, leafy vine. To the left is a small boy playing the pipes. In the foreground is a pond with marsh plants and various types of duck. At right angles to this scene, on a projecting piece of wall, the second scene centres on a herm of the god Pan, set in a small, fenced-off enclosure. At right angles again to the herm, a herdsman and his flock decorate the third section of wall. The three scenes thus portray three types of rural landscape, and three aspects of man's relationship with nature: the saqiya scene demonstrates how cultivated land can be harnessed and brought under fruitful control by man; the herm of Pan, representing the wild and unpredictable power of nature that man should fear, placate and venerate, stands in a rustic, untended grove; and the shepherd with his flock suggests man's pastoral role in the countryside. The paintings are frescoes, applied directly onto damp plaster; the most successful scene is that of the saqiya, where the painting covers a greater area and the larger forms of the oxen and the wheel are bold enough to accommodate the broad strokes of the brush. The colours are a subtle range of blues, greens, red and yellow ochres and soft purples. As has been pointed out, the subjects of the three paintings are mirrored in the thematic structure of Theocritus's first *Idyll*, which moves from a pastoral setting to one of human cultivation and then to the wilder regions of myth and imagination. No-one would suggest that the tomb paintings are a deliberate illustration of the poem; the point is, rather, that the poem and the paintings can be read as products of the same cultural milieu and express similar ideas about man's relationship to nature.

The great 'Nile Mosaic' from the Etruscan city of Palestrina (not far to the east of Rome) dates to the second century BC, but is thought likely to reflect an earlier painting from Hellenistic Egypt (fig. 80).[10] It is a most remarkable and detailed scene, and as such provides invaluable evidence for artists' observation of and interest in the countryside – its geographical features, its flora, fauna and human inhabitants, ranging in class and status from members of the royal court to soldiers, temple priests and peasants. This interest seems to combine a scientific approach to both nature and the social and cultural complexities of Ptolemaic Egypt, as demonstrated by the variety of elements shown and the accuracy with which they are depicted, with traces of the same romantic, elegiac view of nature already noted. The mosaic is also unusually ambitious in its style and composition, perhaps combining elements of contemporary map-making

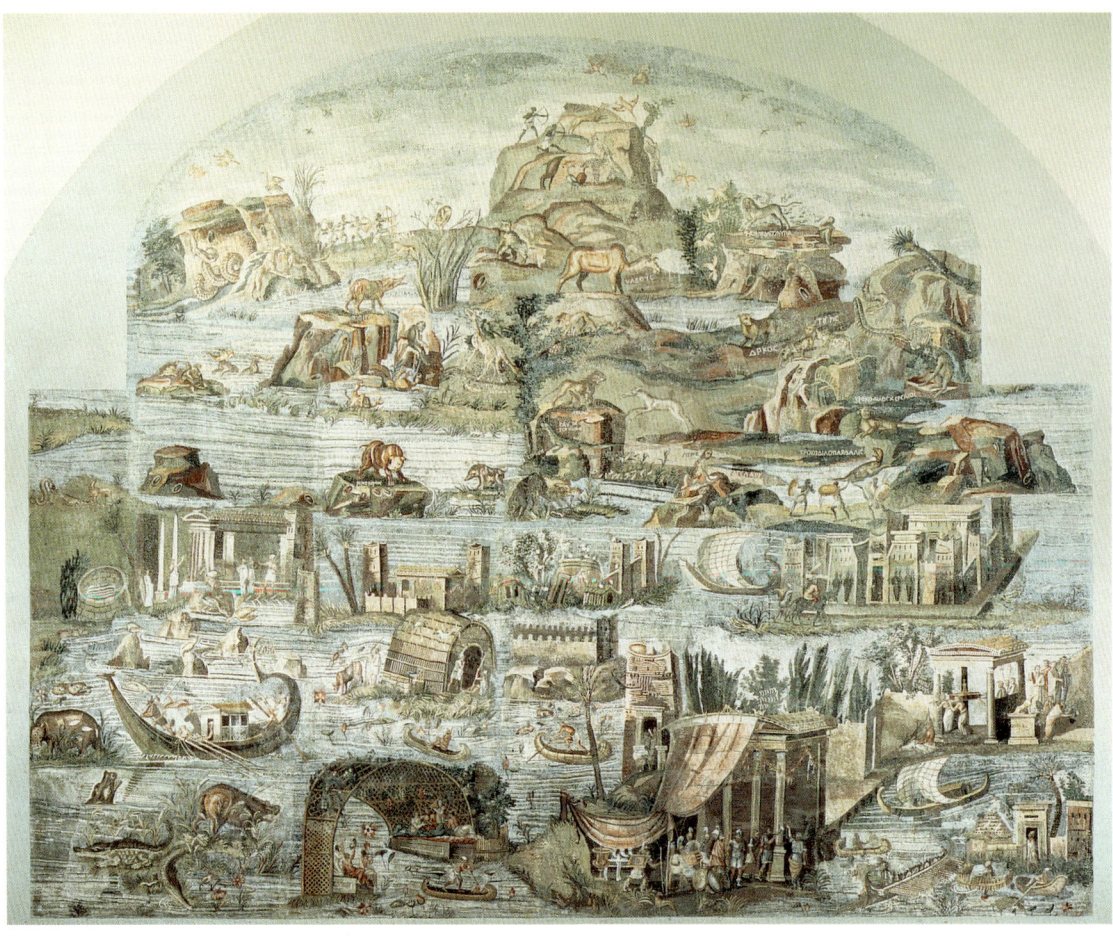

80 The 'Nile Mosaic' from Palestrina, Italy, second century BC. It shows the land of the Nile from an experimental perspective, and with many vivid details of human and animal activity: it may reflect an earlier Ptolemaic painting.

techniques with a bird's eye perspective that enables the scene successfully to be viewed as a whole. The three horizontal registers of the mosaic are generally taken to represent Upper Egypt, Middle Egypt and the Delta, with the River Nile running through from south to north. In the upper part of the picture, wild and exotic animals are being hunted in hilly country: here, the scientific, classificatory interest is shown by the way each of the hunted animals is labelled with its name in Greek beside it. The middle zone of the mosaic illustrates a monumental Pharaonic temple complex, walled cities and a country estate. In the foreground are vivid glimpses of life in the Delta, with romantically idealized reed-built peasant huts, fishing scenes, a variety of types of boat being rowed, sailed or punted, a group of Greek-looking soldiers beneath a canopy at the entrance to a Greek-style temple, and a leisured picnic party of people

reclining, drinking and generally taking their ease beneath a woven bower. Leaving aside the human activities, the detail of the flora and fauna is quite extraordinary, with literally scores of animals and birds, flowers, plants and trees each represented in its appropriate natural setting, and each detail contributing to the ideally realized vision of a landscape.

The Nile Mosaic betrays elements of what seems to have been a slightly patronizing and romanticizing interest on the part of town-dwellers in 'peasants', those who made a living in the country. The real lives of the fishermen who inhabited the swampy waters of the Nile Delta were without doubt tough and squalid, yet on the Nile Mosaic they appear as happily and restfully occupied as the members of the picnic parties or the landowners on their estates. Other artists, however, did stress the effects of a life of toil and hardship, and aged, ravaged-looking fishermen were to prove a particularly popular 'genre' theme for Hellenistic sculpture. Among the most famous is the impressive black marble figure in the Louvre (fig. 81),[11] with his expression of utter exhaustion and his muscular, sinewy limbs: once interpreted as an image of the dying Seneca, this is now generally thought to show an aged, toil-worn fisherman wading after his catch; another type portrays a weaker, more emaciated figure carrying a basket of fish, presumably to market. Statues of fishermen may have been dedicated in sanctuaries; some could also have been placed in urban gardens where, as in later Roman gardens, they might both fulfil a desire to mark the superior social status of the owners of the house and at the same time evoke a rural illusion in a city setting.

Animals and birds, even insects, are sympathetically treated by both poets and artists in the Hellenistic period; they now become subjects in their own right rather than just adjuncts or accessories to

81 Black marble figure of an aged fisherman: the veins and sinews of his arms and legs stand out in the polished surface. c. 200–100 BC. Height (without the magnificent Renaissance marble basin) 1.22 m.

82 Life-sized marble figure of a ferocious mastiff, known as the 'Jennings dog' after an eighteenth-century owner, Mr Henry Constantine Jennings. Roman marble copy of a lost Greek original of the second century BC. Height 1.05 m.

the human figures. Epigrams from the Greek Anthology demonstrate a degree of anthropomorphism – animals speak or are endowed with human qualities and talents.[12] In the visual arts, the sensitively mournful dog of the Alexandrian mosaic discussed in Chapter 4 (fig. 58, p. 104) finds free-standing counterparts in marble sculptures of 'Molossian hounds', of which the 'Jennings Dog' is a descendant (fig. 82). As already mentioned in reference to mosaics, an image that was to become a favourite motif for Roman painters and mosaicists – a highly realistic group of doves at a bowl of water – is said by Pliny to have been

the invention of a Pergamene mosaicist named Sosus, likely to have been at work in the second century BC: 'A marvellous feature in that place [i.e. one of the houses at Pergamon] is a dove drinking water and casting the shadow of its head upon it, while other doves sun and preen themselves on the rim of a large drinking vessel' (*NH* 36.184).[13]

The erotic and the macabre

The Hellenistic period saw the exploration in many media of new aspects of human relationships and sexuality. Groups of nymphs repelling the advances of satyrs portray the violence of human lust at one remove from reality, by projecting it onto the semi-bestial satyr. A variation on this theme shows the sexually ambiguous figure of a hermaphrodite repelling an over-amorous satyr.[14] The vigorously intertwined couple form an ambitiously complicated sculptural composition that asks to be viewed from all angles, and indeed requires full exploration of all viewpoints for its true subject to become apparent. From the satyr's point of view his intended victim looks like a beautiful young girl. For the viewer the subject offers a sophisticated sort of erotic joke: if we walk round we can see better than the satyr that even were he successful in his attack, he would still be disappointed, while the hermaphrodite's gesture, pressing his/her hand against the satyr's eyes, serves both physically to fend off the attack and to make him still more blind to the dual nature of his victim. Another statue of a hermaphrodite, again known only from Roman copies but very likely to derive from a Hellenistic original, shows the figure reclining on a mattress.[15] From the main angle, the rear, the proportions of the figure, along with the head and face, are those of a beautiful young girl. The viewer might expect this to be a sleeping maenad, or perhaps the sleeping Ariadne; the 'truth' will be revealed only when he goes round the other side, sees the male sexual organs and so appreciates the ambiguity of the figure, the sculptor's clever joke.

The general popularity of satyrs and centaurs in the Hellenistic period is clearly vast. They appear dancing or playing pipes to accompany the dances of the wood-nymphs into whom their traditional Archaic and Classical companions, the maenads, have been transformed. Sometimes they are drunken; sometimes they are transporting their infant lord, the wine-god Dionysos. The enthusiasm for these subjects must arise in part from the interest in the countryside, of which they are the mythical inhabitants. At the same time it may relate to a slightly macabre obsession with the mildly repulsive or grotesque, as

83 Small-scale marble figure of Aphrodite found at Knossos, her right hand lowered towards her raised left ankle. Known as the 'Spratt Aphrodite' after a former owner, Captain Thomas Abel Brimage Spratt. Height 54.3 cm.

discussed in Chapter 2 (pp. 72–4). Satyrs and centaurs had originally evolved in specific narrative situations, but from the Classical period onwards they had also proved themselves to be useful vehicles for expressing the darkly bestial side of human nature, as seen in such conditions as lust and drunkenness. In the Hellenistic period they extend their capacity as bearers of allegory and metaphor, and at the same time they develop a tendency to become subjects in their own right. A pair of centaurs, one young and the other old, combine their bestial natures with an element of eroticism, as they are shown each carrying the little figure of an Eros on his back. The younger centaur is smiling and carefree, upright of carriage, snapping his fingers as he looks happily round at his passenger; but his elderly brother, teased by the little Eros who rides on his back and tugs at his hair, can do nothing to resist his tormentor as his arms are tied behind his back: thus the idea of the pitiful enslavement of elderly human lovers is mercilessly caricatured.

Another aspect of eroticism is the very obvious emergence, after centuries of more or less decorously draped female figures, of the female nude in the person of Aphrodite, goddess of sex and sexual love.[16] A wide range of naked Aphrodite types is known, mainly through Roman copies. Although naked or partially clothed female figures had occasionally appeared in Classical art, their nudity was generally related to their function. On Athenian red-figured vases, for example, the boyishly proportioned naked *hetairai* in symposium scenes, the dishevelled maenads or the dying Niobids could all justify their nude or semi-nude state by virtue of the social or narrative context in which they were portrayed. But the naked cult figure of a goddess, an object that exists in isolation, simply to be viewed and venerated, is something different: in this case her nudity

must be intended as an explicit embodiment of her nature, or in other words a physical expression of her allure. Quite clearly the idea was to suggest sexual allure and, in a voyeuristic way, to arouse the sexual desires of her (male) viewers. Amongst the earliest of the naked Aphrodites was Praxiteles' Aphrodite of Knidos, famously reported to have been so desirable that she was sexually assaulted by a man who contrived to get himself locked in her temple overnight. Roman coins of Knidos enable us to identify the Knidian Aphrodite type quite clearly: the heavily proportioned goddess whose face, in the finest versions, appears to modern taste more beautiful than her rather fleshy body, is shown undressing or dressing before or after her bath. Her right hand bends modestly to rest between her thighs; her left grasps the garment that lies tumbled over the water jar that stands beside her.

Many other Aphrodite types were developed in the Hellenistic period; many of them share the Knidia's ineffectual attempts to conceal her nakedness, with gestures that merely serve to emphasize it. Another popular type, for example, was the 'Crouching Aphrodite', probably intended as a votive rather than an actual cult statue: this captures the goddess in a momentary twisting, squatting pose that, once again, seems to ask for all-round viewing. Here, too, the goddess is heavily proportioned, with emphasis laid on the softness of her flesh and the rolls of fat beneath her breasts and across her stomach. Other Aphrodite types show the goddess stretching up both arms to tie a sash or fillet round her head, or with one foot raised to fasten or unloose her sandal. It is difficult now to imagine the original appearance of what is probably the most famous of these Hellenistic Aphrodite types, the Louvre's armless 'Venus de Milo', but the likelihood is that she rested her left arm on a support of some kind, and perhaps it encircled her infant son Eros. Much of the sensuous appeal of the Venus de Milo derives from the contrast between the smoothness of her flesh and the rough, impressionistically carved drapery that slips from her lower body to the ground. Such Aphrodite figures were made in all materials and a range of sizes; many of the smaller-scale figures, such as the British Museum's 'Spratt Aphrodite' (fig. 83), may have been designed to be used either as votives, offered by individuals in sanctuaries of the goddess, or else as domestic ornaments, for the private enjoyment of the house-owner and his friends or guests. Aphrodite was also a popular figure for the decoration of small, intricate toilet articles or tablewares, such as the gilded silver medallion from a silver bowl or cosmetic box in the British Museum (fig. 84).

A combination of an increased interest in the erotic and also in personifi-

84 Silver medallion with gilded details: Aphrodite is attended by a young girl and Eros; in the background are musical instruments, a bird and a cicada. The medallion may originally have adorned a bowl or a cosmetic box. Made at Taranto, southern Italy, third century BC. Diam. 9.3 cm.

cation led to Aphrodite's son Eros, the god or harbinger of Love, himself becoming a popular independent subject for small- and large-scale sculpture in marble, bronze and terracotta in the Hellenistic period. The god is variously shown as a plump little child or an adolescent youth, either completely naked or scantily draped; his attributes vary from his traditional bow and arrows to balls or birds or flowers. A practically life-sized bronze figure of a sleeping Eros-child in the Metropolitan Museum of Art may date to either the Hellenistic or the Roman period (fig. 85); the excellent quality of the casting and the subject (of which several other less accomplished versions are known) would be equally at home at either date. The pudgy, tousle-haired child lies relaxed in sleep, his mouth slightly open, recovering from his exhausting work of arousing passion.[17] A perceived link between Sleep and Love or erotic desire is clearly visible in the slumbering figure of the 'Barberini Faun', a relaxed and drunken satyr, likely to represent a Roman copy (with Renaissance modifications) of a statue type that developed first in the Hellenistic period. The Faun – or rather satyr – combines erotic appeal with bestiality as he lies sprawled in an abandoned pose upon a rock (once more, the insistence on the rural theme). It is not immediately obvious from his physique that he *is* a satyr – only careful observation reveals a small tuft of hair on his forehead and a pointed ear; but the panther-skin thrown over the rock and one of his arms affords another clue, while his immodest position, too, would not be appropriate for a respectable youth.

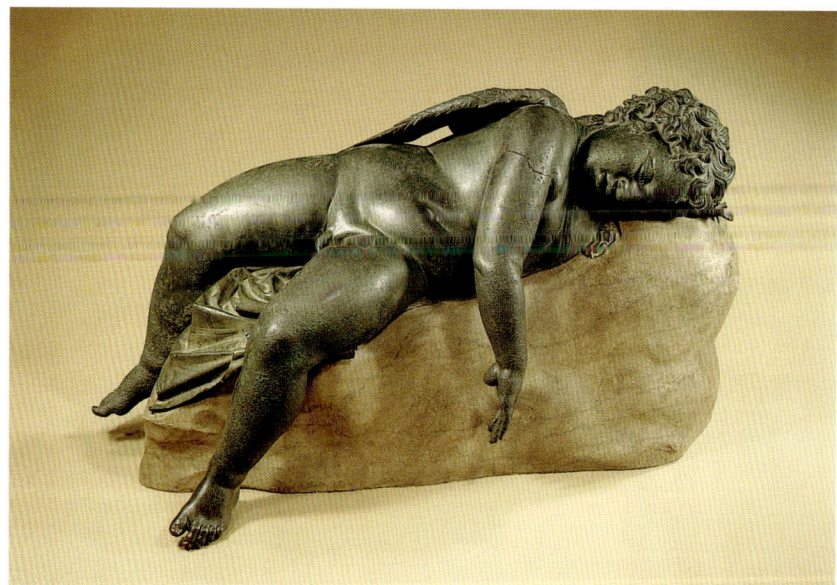

85 Bronze figure of a sleeping Eros: the plumpness of the figure and the extremely relaxed and child-like pose are beautifully realized. Third or second century BC. Length 78.1 cm.

Sleep (Hypnos) himself appears in person in the Hellenistic period. In Archaic and Classical Greek art and thought Hypnos and Thanatos, Death, had been seen as rather grim and sinister figures, the winged twin sons of Night whose principal role was to bear the bodies of warriors off the battlefield or towards their tombs. In the Hellenistic period, although Hypnos retained his association with Death, he seems to have taken on a more benevolent persona. His wings enabled him to travel swiftly over land and sea; his son, Morpheus, was the personification of dreams. Like Eros, Hypnos was portrayed as a child or, more often, a youth. The British Museum's fine head of Hypnos (fig. 86), with its elaborately curled and knotted hair, may derive part of its appeal from the fact that only one of the wings that sprouts from the sides of the god's head is preserved; had both survived, the more symmetrical appearance of the god would have been less immediately dream-like. The similarity the head bears to those of other more completely preserved examples shows that it originally belonged to a full-length figure of the god running forward, holding a bunch of poppies in his right hand and in his left a drinking horn, from which he may have poured a sleeping potion. Although the head is almost certainly Roman in date, on the grounds both of the existence of many versions of the same type and the style and subject it is thought likely to reflect an original work of the Hellenistic period.[18]

The sentimental and erotic story of Eros and Psyche is very probably a Hellenistic invention, and although the main literary sources are of Roman date

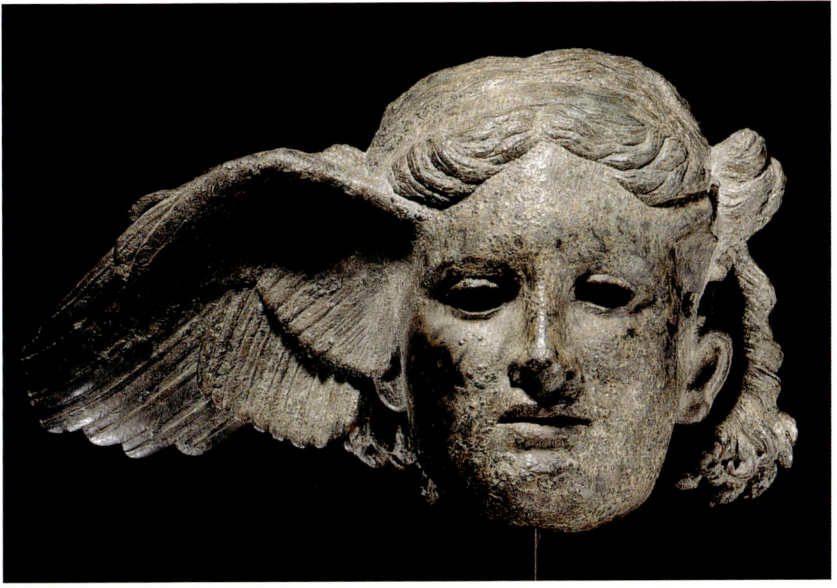

86 Winged bronze head of Hypnos (Sleep), from a full-length statue showing the god running forward with a bunch of poppies in one hand and a drinking horn (presumably containing a drinking potion) in the other. Probably a Roman copy of a Hellenistic original. Found at Civitella d'Arno, near Perugia, Italy. Height 21 cm.

it certainly seems to be in the Hellenistic period that it becomes popular in art.¹⁹ Psyche was a young girl (with butterfly wings) whose beauty provoked the jealousy of Aphrodite. The goddess sent her son Eros to take revenge on her behalf but the plan misfired when he himself fell deeply in love and the pair were secretly married. Their happiness, however, depended on Psyche never attempting to see her beloved's face, and when she succumbed to temptation their bliss was shattered and she was forced to undergo numerous trials before the pair were eventually reunited. In the Hellenistic period there are many extant images showing Psyche alone, an adolescent girl with butterfly wings sprouting from her shoulders, and there are also larger- and smaller-scale sculptural groups of Eros and Psyche locked in a fond embrace. In both Hellenistic and Roman art there are also scenes in which Eros is shown torturing his beloved, either by tearing her wings or, as in the terracotta shown here, holding her (in the form of a butterfly) in a flame (fig. 87). These images seem to reflect a version of the story in which Eros is impelled – perhaps by childish cruelty or powerful outside forces – wilfully to destroy Psyche, the person whom he most loves.²⁰ Such images may therefore reflect, amongst other things, ideas of the cruelty of love and lovers, the transience of passion, so instantly consumed in the flames, or even the brevity of life itself.

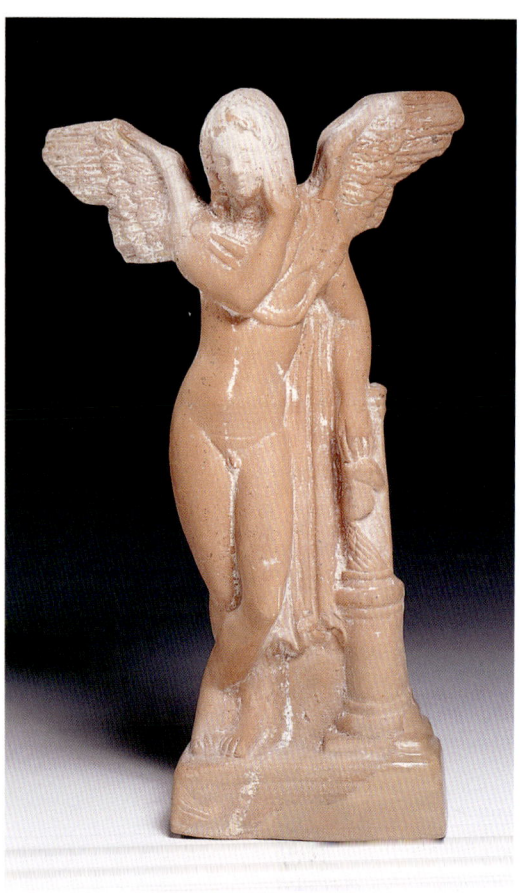

87 Terracotta figure of Eros burning a butterfly, perhaps a reference to the myth of Eros and his beloved Psyche, or even to the brevity of life. Made at Myrina, Asia Minor, in the first century BC or AD. Height 20.5 cm.

Gods and heroes: emotion and experience

We have already observed that the Alexandrian poet Callimachus promised his readers that his wagon would roll on 'untrodden paths'. Similarly, while many of the traditional gods and heroes continued to feature quite strongly in Hellenistic art, there were

significant changes in the portrayal of some figures, and this tendency was accompanied by a perceptible interest in drawing out some of the hitherto rather obscure characters of mythology, and even in introducing new gods and novel types of contemporary 'hero'. And while many of the same types of statues, such as athletes, continued to be produced and dedicated in large numbers, they underwent significant changes in keeping with the new concerns of the new age.

The development of new iconographies for such gods as Tyche and the proliferation of new types of Aphrodite and Eros, probably the most popular goddess of the period, has already been observed. Another 'traditional' deity who was restyled in the early Hellenistic period was the sun-god Helios, patron deity of the city of Rhodes. A marble head of Helios from Rhodes[21] appears to embody an early Hellenistic move to make the gods 'live' in their portraits. The god's lips are parted, his head sits at an angle on his neck, and his hair is wavy and tousled: the seemingly all-pervasive influence of images of Alexander has here resulted in a more dynamic, much less static image of the god than is seen in his (rare) Classical images. Zeus, too, might be given a more dramatic and powerful image in the Hellenistic period: an acrolithic head from Aegeira in the northern Peloponnese, for example,[22] gives the king of the gods a striking upward-sweep to his hair and a forcefully bulging brow. If Zeus and Helios become more powerful and dynamic seeming in the Hellenistic period, the opposite is true for Apollo and Dionysos, both of whom become increasingly languid and effeminate at this time. In Apollo's case this is the result of the stress now laid on his connections with art, music and literature.

In Hellenistic Egypt the political astuteness of the Ptolemaic rulers and their genuine enthusiasm for Egyptian culture led to their promotion of the composite deity Serapis, a god who combined in Hellenized form the attributes of Osiris, king-god of the Underworld, and the living Apis bull. As Osiris-Apis, this deity had already been encountered by Alexander, on the site of the city that was to bear his name, and Alexander had commissioned a temple to him. Gradually Serapis grew in popularity throughout the Hellenized world. He developed into a god of many parts, linked to such Greek deities as Hades, Dionysos, Asklepios, Helios and even Zeus. His iconography, which portrays him as a mature, bearded figure, is based on that of these other gods, but he is clearly distinguished from them by the corn-measure (*kalathos*), the symbol of Osiris, that he always wears on his head (fig. 88). Alexander's successor in Egypt, Ptolemy I, is said to have dreamed that he would import a statue of the new god from Sinope to Alexandria. This, or another statue of the god set up in Alexandria,

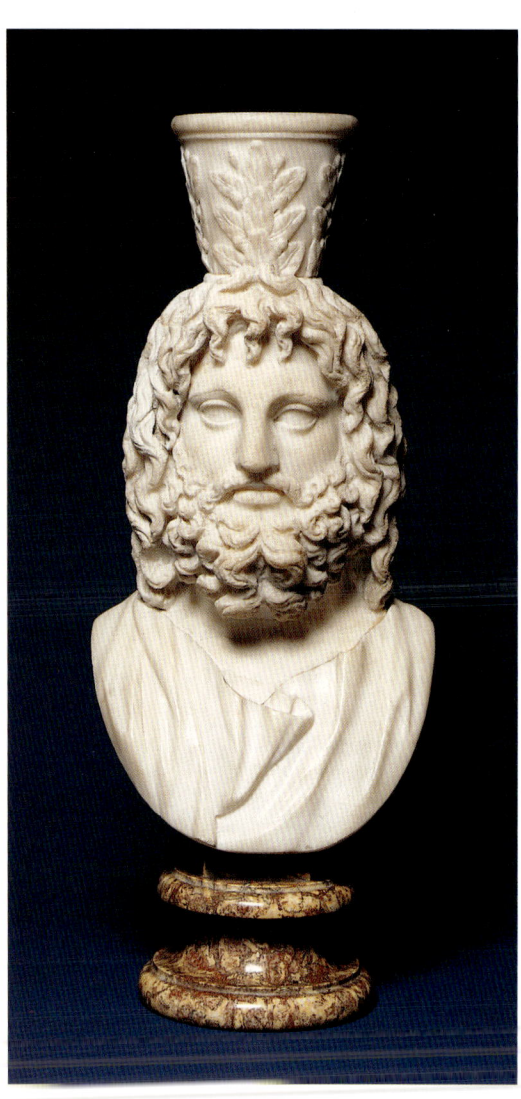

88 Marble bust of the composite deity Serapis. Probably Roman, of the second century AD, but reflecting earlier Hellenistic images of the god. Acquired in Rome. Height 22 cm.

has traditionally been attributed to the Greek sculptor Bryaxis. Bryaxis's full-length cult-statue is likely to have shown Serapis as a mature, bearded male figure, seated on a throne, with the triple-headed hell-hound Cerberus beside him at his feet.

The Greek-style presentation of foreign, in this case Egyptian, deities is not as common a Hellenistic phenomenon as might be expected. Instances of 'conflation' or 'assimilation' of Greek and indigenous deities can indeed be found: in various parts of Anatolia, for example, the worship of the goddess Aphrodite appears to have been conflated with that of the Mesopotamian Anahita. At the Bactrian city of Ai Khanoun beside the River Oxus in what is now north-eastern Afghanistan, Artemis was worshipped under a local name that translates as 'Lady Moon'. The single most dramatic instance of blending or assimilation is that presented by some of the statues in the mountain-top sanctuary of Nemrud Dagh in Commagene, near Lake Van in eastern Anatolia.[23] Here in the first century BC Antiochos I of Commagene built himself a monumental tomb and sanctuary where he could be worshipped as a god. Surrounding the tomb mound, on three great terraces cut out of the mountainside, he set two rows of colossal stone seated statues, each nearly 10 m tall (see fig. 93). Along with images of Antiochos himself and of the Tyche of Commagene, were gods representing amalgamations of Classical Greek and Eastern deities. One blended Zeus with the Persian god Ahuramazda, and another combined elements of Herakles, Ares and a local god, Artagnes. The kings of Commagene claimed descent from both Alexander and the Great King of Persia, and were conspicuously proud of their mixed tradition. However, in most of the non-Greek areas of the Hellenistic world, including Egypt, what evidence we have tends to suggest that the Greeks and the indigenous

peoples maintained religious traditions that ran on the whole in separate and parallel tracks: mixing or integration was not particularly common. But the evidence is not always easy to interpret. At Ai Khanoum, again, a vast temple has been excavated: its scale and plan suggest the influence of Mesopotamian models, but most of the sculpture found there (including fragments of a large, possibly acrolithic Zeus) is purely Greek in style and subject; among the finds, however, are small bone figurines of a local fertility goddess, along with other objects that relate to the cults of older civilizations including those of Assyria and Urartu. This might suggest that local people continued to worship their own gods on the same site, but recently it has been suggested that the indigenous or 'foreign' material represents rather a chronological development, the gradual decline of Classical religion and the ascendancy of local cults.[24]

Like the gods, many of the traditional heroes retained their perennial appeal, but changed with the times to appear in new guises that might stress different aspects of their character or new attributes. The 'Herakles Farnese', for example, the best-known Roman version of a statue believed on the grounds of its subject and style to derive from an early Hellenistic work by the sculptor Lysippos, is a twice-life-sized image of the well-known hero, showing him standing leaning on his lion-skin-covered club. The viewer's initial impression is one of awe at the enormous scale of the figure, his powerful proportions, the size and solidity of his muscles and sinews, and the dynamism of his wildly curling hair and beard. But a longer glance reveals the toll taken by the hero's struggle to overcome the repeated challenges flung at him by Eurystheus, the taskmaster of the hero's well-known Labours. The brow of the Herakles Farnese is furrowed and his gaze downcast, the whole attitude of his body expressing not triumph, elation or even happy relaxation but instead extreme exhaustion. The subject is generally taken to show the hero resting from his labours, but the emphasis is not, as in the Archaic or Classical periods, on triumph, but rather on the draining and debilitating effects of physical and mental struggle. Indeed it seems as though there is much less interest in Herakles himself, and much more in the abstract conception of what his life and labours represent: a paradigm, perhaps, of the universal human lifetime struggle.

Some of the same ideas may be seen in the portrayals of an entirely novel class of hero, the Gauls, who became a subject of great artistic interest after they had been defeated in a series of campaigns by the Attalids of Pergamon. In the 220s BC the Attalids set up at least two great victory monuments on their acropolis; inscribed bases from these dedications have survived, and the subjects have been recognized in a number of later copies. These include the group of a Gaul

who has killed his wife and now turns his sword upon himself, in order to avoid the ignominy and disgrace of capture; and a 'Dying Gaul', who sits bleeding to death, his head drooping onto his chest, his life-force ebbing away. Both the male Gauls are tall, strong and handsome; they are naked, with roughly curling hair, moustaches but no beards, and torques around their necks. The idea of representing vanquished enemies as noble heroes is new, and reflects the respect and admiration that the Greeks felt for these new adversaries. Literary sources report that they were greatly impressed by the Gauls' physique and bravery. At the same time, this new sympathy may reflect changes in people's outlook in the Hellenistic period: geographers and historians alike were beginning to develop a broader interest in and understanding of foreign, non-Greek, peoples, and their work was both symptomatic of and contributing to the generally more cosmopolitan outlook of the age.[25]

The same interest in portraying experience and emotion is evident in some of the athlete statues of the Hellenistic period. These are another type of subject that survives the transition from the Classical to the Hellenistic periods, while undergoing slight but significant transformations. The typical athlete dedications of the Classical period had shown athletes of fairly generalized type, muscular young men who could have turned their hand to any kind of sporting activity. In the Hellenistic period there continued to be a demand for athlete statues to set up in sanctuaries, but many of them are much more specific in terms of representing an individual branch of athletics or indeed an individual's experience of his sport. This may in part reflect an increasing specialization and professionalism among athletes in the later period, but it also seems to arise from the typically Hellenistic urge to portray the experience and specific destiny of individuals, as well as the ideal. One well-known bronze statue, now in Rome,[26] represents an elderly, seated boxer, his hands and wrists bound with protective thongs. His face is battered, and as he turns it up towards us, we can see that it is lined with slashes and scars, vividly inlaid in copper. At the other end of the age spectrum comes the young boy-jockey in the National Archaeological Museum of Athens, found in the sea of Cape Artemisium, a tiny, lively figure with a dishevelled mop of hair, dwarfed by his huge bronze horse.[27]

Hellenistic iconography thus blends continuity with innovation. It draws on the traditions of the Classical era while at the same time laying the foundations for the subjects of Roman art. The legacy of Hellenistic art to Rome will be one of the principal themes of our final chapter.

Chapter 6

Artists, Patrons and Collectors, and the Hellenistic Legacy to Rome

'His [Apelles'] politeness of manner made him all the more agreeable to Alexander the Great, who often visited his studio … but in the studio Alexander would talk a great deal without much understanding, and so Apelles persuaded him tactfully to keep his mouth shut, saying he was being laughed at by the boys who ground the pigments.…' (Pliny, *NH* 35.85).

We value quotations such as this because of the insights they seem to offer us into the characters and personalities of historical figures, the 'fly-on-the-wall' feeling they can give us of eavesdropping on the real conversations of the past. Pliny tells an equally vivid story about the painter Protogenes of Rhodes, whose humble suburban cottage, where he had spent many years perfecting a single painting, was in the way of Demetrios Poliorketes' siege operations in 305–304 BC. Summoned before the king and asked to explain why he was confidently carrying on with his work, he replied that he had understood the war was between Demetrios and the Rhodians, not Demetrios and the arts. The king was so taken with this reply that he assigned guards to protect Protogenes; and so that he could enjoy the painter's company without interrupting the progress of his work in future he visited the studio himself rather than calling the painter to his presence (*NH* 35.85). Several sources add that the distraction offered by Protogenes was one reason why the siege of Rhodes was ultimately unsuccessful. It is tempting to use such stories as 'evidence' for the status of artists and for the way in which they behaved towards or were treated by their powerful and wealthy

clients. However, as they invariably show the artists treating their patrons as equals or even inferiors, putting them in their place, as it were, their suspiciously apocryphal message suggests they should be treated with some caution. In order to understand how patrons, artists and craftsmen really functioned in the Hellenistic period, how supply and demand might be controlled by the wealthy and the powerful, and how the market operated, we need to review as many different types of evidence as possible, even though, or indeed especially as, these can often be in conflict.

The literary sources, combined with the historical record, can help us to understand the political importance of art and the way it might be used by rival Hellenistic dynasties to enhance their reputations and thus their power; we have seen this in reference to the rulers' fondness for conspicuous display in the public areas of their cities (Chapter 3). Sometimes the literary sources can also provide glimpses of people's attitudes or responses to art. And with the emergence of Roman intellectuals and aesthetes as a major factor on the art scene, authors such as Cicero and Pliny can offer valuable insights into the activities and passions of contemporary collectors. At the other end of the spectrum, we have the archaeological record, which can be difficult to read but may on occasion provide evidence for workshops and workshop practices, and also for the sorts of contexts for which the objects were designed, or in which they ended up. We have epigraphic evidence, largely in the form of inscriptions on statue bases, some of which can provide information about the mobility of sculptors from one area of the ancient world to another, and for family relationships between different generations of artists. And finally we have the objects themselves. Many of these can offer valuable internal evidence for craft and manufacturing processes; and in terms of the Hellenistic legacy to Rome, it is the objects that must provide the strongest proof of Rome's artistic debt to the Hellenistic Greek world.

The first question that this chapter seeks to answer is what do we really know about the working lives and practices of the creators of Hellenistic art? And how did patronage work? The chapter ends with a consideration of the impact of Rome on Hellenistic art, and of Hellenistic art on Rome.

Workshops, tools and technology

In some respects the life of Hellenistic artists was not very different from that of their Archaic and Classical Greek predecessors. The tools of their various

ARTISTS, PATRONS AND COLLECTORS

trades, and the technologies involved, were not radically different,[1] and because of this for most practitioners of most arts, fairly basic and small-scale organization of workshops seems to have continued to be the norm. We deduce this partly because the workshops so rarely leave their traces. Where they do, as in the case of an example at Troy which seems to have been used for the production of terracotta figurines, the tools and equipment involved were modest in the extreme: all that survive are eight fragmentary moulds, a few patches of a very fine, pure clay, and, perhaps for pressing the clay into the mould or for incising details on the surface of the figurines, one small bone spoon and two bone styli.[2] A marble workshop in the Athenian Agora was similarly modest in its equipment: essentially a room in a private house, tools, pots and a few pieces of unfinished sculpture suggest that it was in use for about 150 years, from about 450 to 300 BC.[3] Where remains of furnaces and casting pits provide evidence for bronze-working, these often look more like fairly temporary structures than any sort of long-term or permanent arrangements.[4]

Occasionally there is evidence for the likelihood of collaborative or workshop practices as opposed to individual production. Sometimes this evidence derives from the actual objects: the blocks of the cornice above the frieze of the Great Altar of Pergamon, for example, bore positioning marks in the form of letters of the alphabet, apparently a precaution taken so that the sequence in which they were ultimately erected, perhaps by a team who were not the same people who had carved them, would be clear.[5] A similar procedure appears to have been followed by the makers of the bronze couches found in the Mahdia wreck (see below, p. 174): each couch was constructed out of more than sixty individual elements, and the construction sequence of, for example, the separate parts of each couch leg, was indicated through a series of letters engraved on each.[6] Again, the wings of some of the flying terracotta figures of Nike or Eros made in Myrina are incised with a letter that may have enabled the coroplast or an assistant to mass-produce a stock of these intricate pieces in advance and then apply the appropriate set to the particular figure he had in hand (fig. 89).

89 Back of a wing of a terracotta Victory or Eros from Myrina: the incised mark is either that of the terracotta maker or a key that would enable him to attach the correct wing to the matching body.

For bronze-casting, inscriptions on marble bases from Hellenistic Rhodes that once held bronze statues provide evidence of collaboration between two or more craftsmen and artists; a few seem specifically to refer to a division of

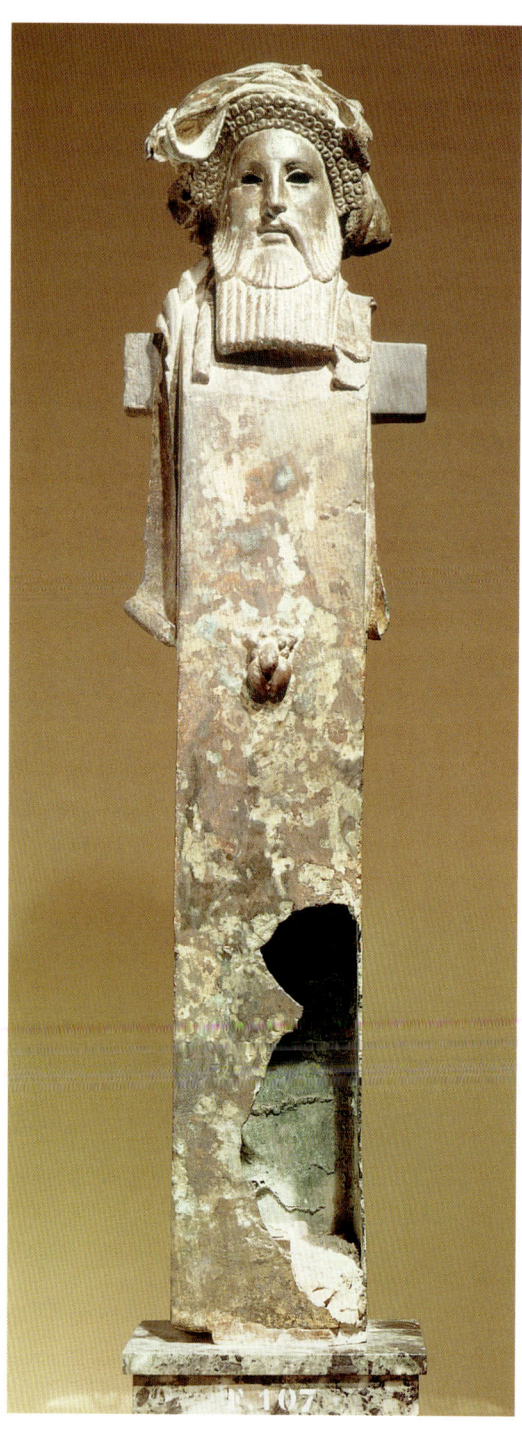

labour in which one man 'made' (the Greek word is *epoiesen*), meaning perhaps 'sculpted', and another 'cast in bronze' (Greek *echalkiourgesen*).[7] A bronze herm, with a finely modelled head of the god Dionysos (fig. 90), also part of the Mahdia wreck cargo, bears the maker signature ('made') of Boethos of Calchedon, cast in the surface of the bronze and thus clearly the result of its having been incised in the surface of the wax model. This rare survival is interesting, partly because someone of this name is mentioned by Pliny (*NH* 34.84) as a sculptor best known for his work in metal; Pliny adds that he had also made a sculpture of a baby strangling a goose, a subject known in two different versions. Two further inscriptions, one from Delos associated with a portrait of the Seleucid ruler Antiochos IV (175–164 BC), the other on a statue base from Lindos on Rhodes apparently of similar date, seem to confirm that an artist named Boethos, from Calchedon, was active at this period, and because of this the Mahdia herm allows us plausibly to link a surviving work with a name known from literary sources. The inscription on the herm has other implications, too, because the Getty Museum owns the 'twin' of the Mahdia herm: a bronze of exactly the same dimensions and subject, cast from a virtually identical alloy, but made with much less surface detail, and without a signature. Careful comparison of the two herms has led to the conclusion that each was cast from a wax working model made from piece-moulds taken from the same clay original. So perhaps in this case at least, the title of 'maker' was claimed by the person who re-touched and elaborated the wax working model, rather than the creator of the original clay prototype. At least seven other variations on this very distinctive Dionysos herm are known, in a variety of scales and media, from engraved gems and cameos to marble tondi: few have secure findspots but most are

probably from Italy, and the likely dates range from the second century BC to the mid-first century AD. Among the versions are two large-scale terracotta herm busts in the British Museum (fig. 91), part of an intriguing group of large-scale terracotta figures found near the Porta Latina at Rome in 1767. The longevity of the type is difficult to explain, but it seems to suggest that casts could be replicated, kept and reused over a considerable period of time.[8]

The interchangeability of media for a single subject could have been fostered by the fact that the practitioners of various different crafts might at times have either shared premises or worked in close proximity to each other. The Dionysos heads are not an isolated case: many other motifs including gorgon or maenad heads can turn up in a wide range of materials or scales, from couch *fulcra* to architectural ornaments or engraved gems. This process of transferral suggests the close contacts between craftsmen and artists, as well as a common awareness of current fashions and an entrepreneurial ability to turn them to good advantage! There were also practical and commercial reasons for inter-craft contact. Potters, bronze-casters and terracotta-makers all worked with clay, though in different ways and to different ends, and so it would have been logical and economical for some of them to have shared premises and facilities. Certainly potters and terracotta-producers appear to have shared a workshop at Panticapaion on the Black Sea,[9] while elsewhere there is evidence to suggest that some terracotta-makers incorporated the by-products of metallurgical operations in the white coatings that were commonly applied to their figures after firing.[10]

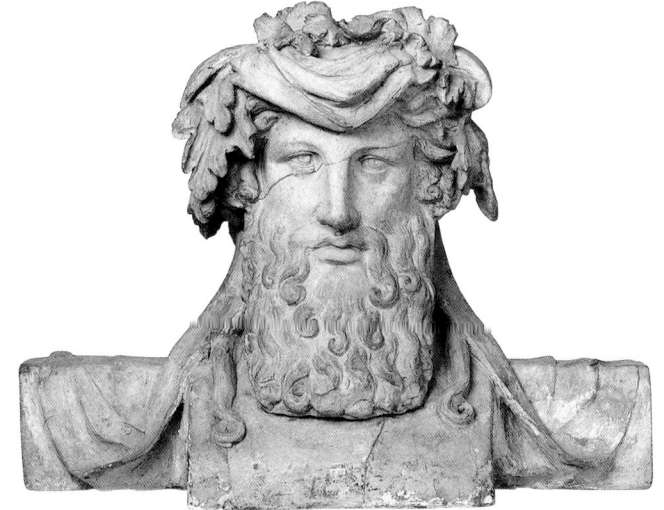

OPPOSITE AND RIGHT:
90 Bronze herm with the head of the wine-god Dionysos, signed by Boethos, found in the Mahdia shipwreck and probably dating to the second century BC. Height 103 cm.

91 Terracotta herm with the head of Dionysos, part of a group of large-scale terracotta figures found near the Porta Latina at Rome in 1767. Probably first century AD. Height 40.6 cm.

There was little true innovation in bronze technology in the Hellenistic period, although in some cases the lead content of the alloy was increased to improve the flow and so pick up more of the details of the original wax or clay model and obviate the need for later chasing.[11] There was, however, a marked surge in confidence and competence in the general processes of bronze-casting, and this is manifested very strongly in the well-attested ability of Hellenistic bronze-casters to construct colossal statues. Colossal statues of the Classical period, such as Pheidias's chryselephantine images of Athena and Zeus at Athens and Olympia, appear to have been about 10–12 m tall, roughly six or seven times the height of a tallish man. But these Classical colossi were dwarfed by several famous Hellenistic bronze figures. Taranto in southern Italy, for example, could boast two colossal bronze statues by the sculptor Lysippos, an 18 m high standing figure of Zeus, looming over the city's market-place, and on the acropolis an equally massive seated Herakles (taken to Rome by Fabius Maximus when he captured the city in 209 BC).[12] But the largest and most famous of all colossi was the statue of Apollo at Rhodes, the work of Lysippos's Rhodian pupil Chares, 31 or 32 m tall and one of the Seven Wonders of the Ancient World.[13] We have little hard evidence as to what the 'Colossus of Rhodes' really looked like, as the surviving images are all late in date and more or less imaginary: the head is likely to have resembled some of the Helios heads perennially popular on Rhodian coins (fig. 92). We know that it was erected about 280 BC, on a mole beside the entrance to the harbour at Rhodes where it stood until it was destroyed by an earthquake in 224 BC. No-one, however, has as yet come up with an entirely convincing explanation of how it was made. Ancient accounts of its construction say that it was raised in stages like a building, and as each successive stage was cast onto the one below, the mound of earth on which the casters worked grew higher and higher. The internal armature was constructed of strong iron bars, reinforced with great blocks of stone. It took twelve years to build and cost an enormous 300 talents, money said to have been gained by the sale of the siege equipment abandoned by Demetrios Poliorketes when he gave up his attempt to capture Rhodes; and doubtless money that the Rhodians considered well spent on so daring and conspicuous a symbol of their triumphant independence. Even after its downfall the Colossus was a terrific tourist attraction and possibly it was even easier to appreciate its huge size as its shattered fragments lay on the ground. As Pliny described it: 'Few people can make their arms meet around its thumb; the fingers are larger than most complete statues. Huge caverns

92 Silver tetradrachm of Rhodes, third century BC, showing a head of the sun-god Apollo believed to reflect that of the head of the Colossus.

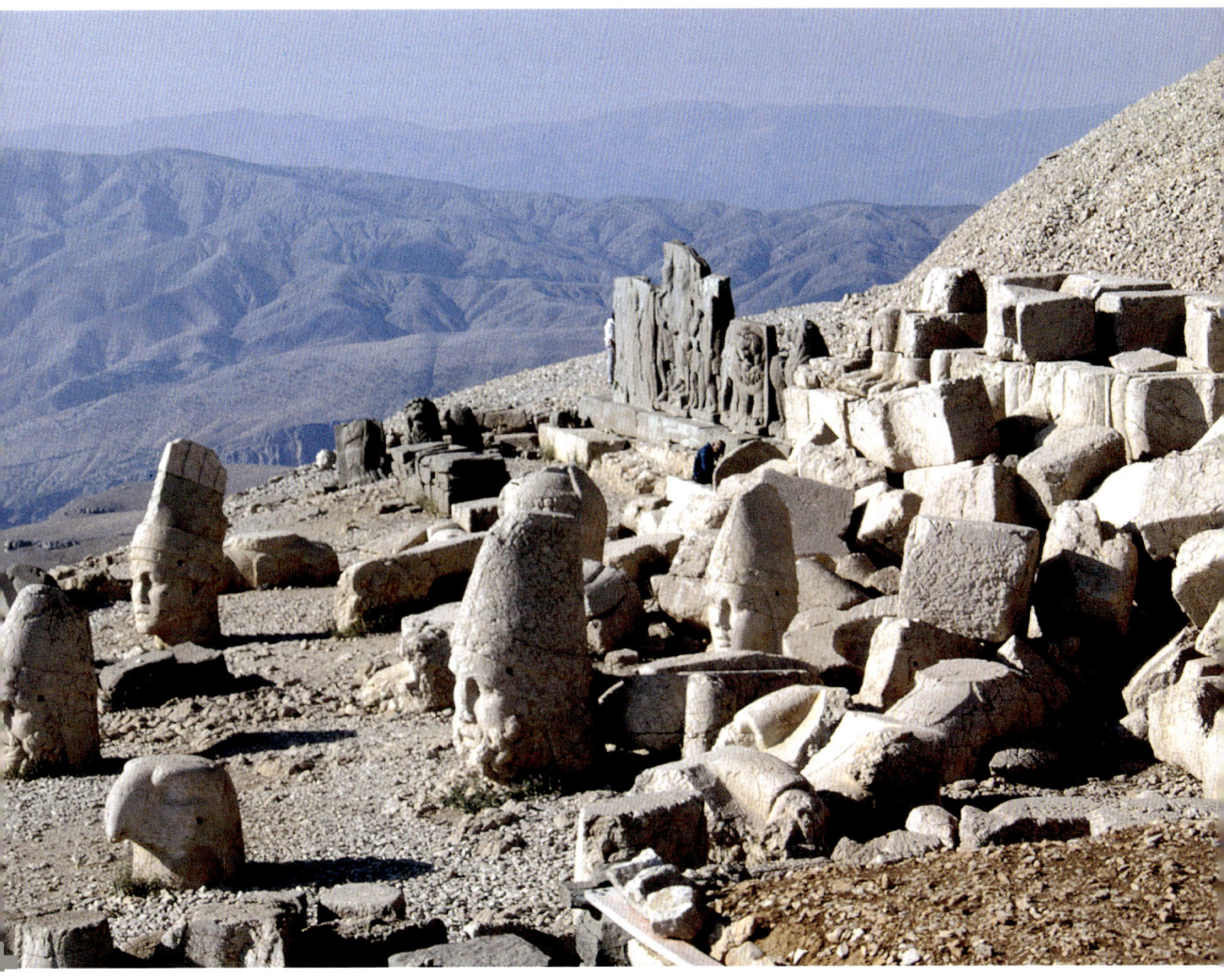

93 General view of the mountain-top tomb sanctuary of Nemrud Dagh in Kommagene. The bearded heads with conical cap are those of the composite deity Zeus-Ahuramazda. c. 64–38 BC.

gape where the limbs are broken; inside one sees rocks of massive size, with the weight of which the artist stabilized it during the erection process ...' (*NH* 34.41). The fact that the Colossus of Rhodes was constructed at all and stood for even fifty years speaks volumes for the skill of contemporary bronze-casters.

There were also stone colossi: although few Hellenistic kings chose to have themselves portrayed on so grandiose a scale, the Ptolemaic rulers of Egypt, where colossal ruler statues were a well-established phenomenon, were certainly the subject of gigantic, Egyptian-style portraits. The colossi of Nemrud Dagh in eastern Turkey (fig. 93), the mountain-top tomb sanctuary of Antiochos I of

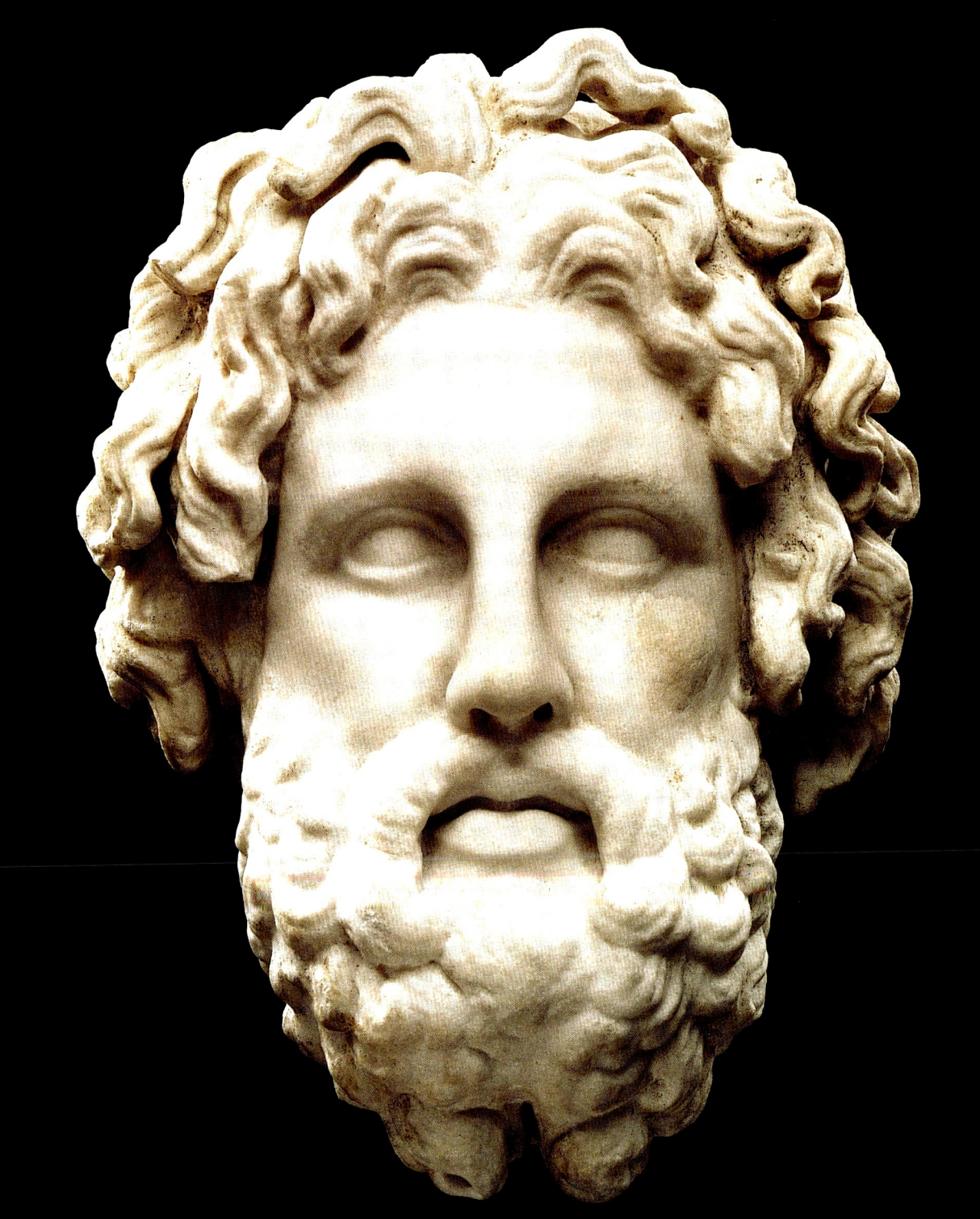

Commagene, have already been mentioned: some were originally as much as 10 m high, built up from uneven courses of large blocks of limestone. Some impression of the giant scale of such colossal stone figures may be gained from the appearance of the British Museum's head of Asklepios from Melos (fig. 94), a medium-sized colossus, but one still large enough to give a powerful glimpse of the impressive dwarfing powers full-length figures on this scale would have possessed.

Moving on from sculpture in bronze and stone to the other arts, there were some artists, such as goldsmiths and gem-engravers, who seem to have continued to use traditional techniques, while taking advantage of new materials such as the wider range of coloured and banded gemstones available after Alexander's eastern conquests. Some precious or semi-precious stones, such as rubies and emeralds, appear for the first time, as do the first cameos (fig. 95). The cutters of these intricately made gemstones exploited the special qualities of banded sardonyx by cutting its separate layers to different depths, so that, for example, a light-coloured portrait head could stand out against a darker background. In painting and mosaic production there was gradual change and refinement rather than a revolution in technique. But in a few areas there were significant technological developments: the chief of these were the new ways of working glass already discussed (see pp. 118–19), but evidence for experiments with plaster moulds (instead of the traditional clay versions) for clay lamps or figurines show that not all the practitioners of these crafts were simply repeating the same old techniques that they had inherited from their predecessors.

Social status and mobility

It would be unwise to generalize about the status or lifestyle of artists and craftsmen in the Hellenistic world: what evidence we have points to huge variety. In the Hellenistic period, as earlier, the literary sources suggest that there were great dynasties of artists and craftsmen: the sons of Lysippos, for example, were all important sculptors; the family of Menodotos of Tyre can be traced through six generations in the second and first centuries BC; and the family to which the Classical sculptor Praxiteles belonged produced sculptors for over 400 years. The literary sources suggest that there was certainly a hierarchy of status within the arts: painters occupied the top rung of the ladder, with

OPPOSITE AND ABOVE:
94 Larger-than-life-size marble head of Asklepios, god of healing, probably from a cult statue. The god's furrowed brow and serious gaze seem to convey his concern for the sick. From Melos, third or second century BC. Height 53 cm.

95 Onyx cameo, the upper white layer cut from the lower, translucent brown, to show a female figure, either a Muse or a maenad, playing a lyre. The fluttering, swirling drapery suggests a date in the first century BC. Height 2.3 cm.

sculptors below them and the practitioners of such minor arts as terracotta figurine or pottery production right at the bottom. But beyond this there was variation within each art or craft: inscriptions show that a few Hellenistic sculptors in Athens, Delos or Rhodes were men of standing in their own communities, elected to magistracies or priesthoods or accorded other honours. It was probably early in the early third century BC, for example, that the sculptor Telesinos, by origin an Athenian, became the subject of an inscription in Delos that offered him various civic honours in return for his generous donation of time, labour and materials to the Asklepieion there.[14] This shows that Telesinos was in a position to be a public benefactor – a man not just of considerable wealth but also of civic standing. There were doubtless others like him – but at the lower end of the scale it is equally certain that numerous artists and craftsmen enjoyed much less wealth and fame.

Being an artist or craftsman in the ancient world was probably never a very settled or secure way of making a living, but it seems likely that there was even more mobility of craftsmen in the Hellenistic period than at earlier times. Telesinos was in the advance guard of a great migration of sculptors from Athens to Delos, attracted by the booming prosperity of the island in the Hellenistic age. Many more were to follow in the second century when Delos became a free port and its merchants had money to spend on adorning both the public spaces of the city and their own private houses. Earlier in the third century, after the defeat of Athens by Antigonos Gonatas, many Athenian sculptors seem to have emigrated to Rhodes. Here they were joined by emigrants from elsewhere in the Aegean, and signed portrait bases record the activities of no fewer than 150 portraitists working on Rhodes before it was sacked by the Roman general Cassius in 43 BC. Most people believe that there was a similar influx of skilled Rhodian marble-workers to Pergamon when the Attalids began to spend their accumulated wealth and declare their status through monumental sculpture and architecture. Doubtless artists and craftsmen had always been to some extent itinerant, but in the Hellenistic period they travelled greater distances and in greater numbers than ever before. The evidence for such migrations comes partly from the literary accounts of sculptors working in various places, and partly from inscribed statue bases, from some of which, when sculptors named their cities, it is apparent that Athenians or Rhodians, for example, were working far from their countries of origin.

The common artistic style of the Hellenistic world, the artistic *koine* (common language), both resulted from and provides evidence for the great mobility of Hellenistic craftsmen. For instance, the fact that locally made

ARTISTS, PATRONS AND COLLECTORS

sculptures of identical type and style can turn up in such far-flung sites as Cyrene and Pergamon suggests a strong likelihood that many sculptors travelled, and replicated either their own work or that of others in distant places. The Roman names of some makers of terracotta figures, too, from such sites as Myrina or Ephesus (fig. 96), suggests that even these relatively low-status craftsmen might sometimes travel from one side of the Hellenistic world to the other to set up in business.[15] There were, however, other routes for the artistic *koine* to develop. The phenomenon of the production of absolutely identical terracotta figures in, say, Tanagra in mainland Greece and Alexandria in Egypt – and indeed the discovery of identical moulds in these places – has been explained in various ways. One likely hypothesis suggests that the original mould – a so-called 'mould-mother' – was made at Tanagra; from this a series of prototype figures were made, and from these in turn moulds were taken and exported as required.[16]

The wealth of artists' names that have come down to us from the Hellenistic period, among them painters, gem-engravers, and terracotta-makers, but overwhelmingly sculptors, can make it tempting to think that through them we can get close to the real people who created art. Indeed, the attempt to connect names of known sculptors with extant pieces of sculpture, or to identify and define artistic personalities, is as valid a form of study as any other and can be a productive way of furthering our understanding of how people worked and how art was made – the example of Boethos, cited above, is a case in point. Sometimes, however, it can seem that scholars try to pursue rather hazily defined artists further than can sensibly be justified. About the work of Telesinos, for instance, mentioned above as an example of an Athenian sculptor on Delos, we know nothing outside the evidence of one inscription. 'Epigonos' provides

96 Signature in Greek letters 'MASIMOU', a Greek version of the Latin name 'Maximus', on the back of a late Hellenistic figure of Artemis of Ephesus, perhaps made at Smyrna. Although many Greek artists and craftsmen travelled to Italy in the late Hellenistic period, signatures like this suggest there was also traffic in the opposite direction. Height 16.5 cm.

another case in point: Pliny mentions (*NH* 34.84) a sculptor named 'Isogonos' as one of those who worked at Pergamon on the battle groups showing the triumph of the Pergamene monarchs over the Gauls. A little later on (34.88) he refers to 'Epigonos' as a second-rank sculptor in bronze and a master imitator in almost all subjects, who 'excelled with his Trumpeter and Weeping Child pitifully caressing its murdered mother'. Because of the famous statue of the dying trumpeter from Pergamon and because the name 'Epigonos' appears on eight signed statue bases from the citadel of Pergamon, two of which have a fairly firm association with Attalid victory monuments, several scholars have 'deduced' that Pliny made a mistake and wrote 'Isogonos' for 'Epigonos' and so they have gone on to attribute many of the extant victory monuments to Epigonos and cast him as a major force in the development of the so-called 'Hellenistic baroque' style, a key arbiter of taste and style in second-century Pergamon and beyond. Clearly a balance needs to be struck between sensibly combining as many types of evidence as possible and building up over-fragile hypotheses that can all too easily come to be seen as fact.[17]

Patrons and customers of the arts

In the Classical period, while individual citizens might commission a set of silver plate or an occasional painting for their private use, orders for major 'art' in the form of monumental architecture or sculpture were handed out by the state. Wealthy individuals would usually end up paying the bill, but in many places only after a collective decision had been made as to the nature of the work required and the craftsman to whom the commission would be entrusted. In the Hellenistic period, such public commissions were to a large extent replaced by individual orders placed by the kings. The kings in turn were emulated by wealthy private individuals, and for both types of customer the commissioning, possession and conspicuous display of 'art', both contemporary and Classical, became an increasingly important status symbol, a sign not just of their wealth, superior taste and culture but also, through these, of their power.

The Hellenistic rulers tended to commission monumental sculpture and architecture: portraits of themselves and their families, votive monuments to commemorate victories, cult statues for new temples, and palaces and public buildings to adorn their cities. There was plenty of conspicuous consumption of luxury items, too, which must have provided lucrative employment for many types of artist and craftsman. The literary sources tell us, for example, of an elaborately

adorned pleasure boat built for Hieron II of Syracuse but later given by him to one of the third-century Ptolemies: the lavish fittings of the *Syracusia* included paintings, statues and a shrine to the goddess Aphrodite, with a floor made of agate and other beautiful stones, cypress wood walls and ceilings, and doors of ivory and fragrant wood; even the crew's quarters were fitted out with mosaic floors bearing scenes from the *Iliad*.[18] The same sources describe a festival pavilion erected, probably in about 276 BC, by Ptolemy II Philadelphos. This was fitted out with paintings, statues, shields, soldiers' cloaks with portraits of kings or mythological scenes woven into them, and dramatic tableaux consisting of sets of statues dressed as various types of comic or tragic actor arranged in groups as though for drinking parties, with golden vessels set beside them.[19] On the same occasion, a great procession or parade was staged, with floats bearing enormous statues of Dionysos, along with other gods, Ptolemy himself and his relatives and ancestors, including Alexander. One float carried a massive statue of Dionysos on an elephant, wearing a purple cloak and a crown of golden ivy and grape leaves. In his hands he held a gold thyrsos and his shoes were bound with gold lace. Even the elephant had gold trappings, and around his neck was a gold garland of ivy.[20]

As the story of the *Syracusia* shows, gift-giving was an important aspect of Hellenistic patronage. Historical sources describe the Hellenistic rulers from Alexander onwards bestowing gifts on loyal troops or allies. Gift-giving could also be on a civic scale. Many Hellenistic rulers, but most especially the Attalids of Pergamon, sent gifts of statues of themselves to numerous cities throughout mainland Greece and Asia Minor, a decorative but insistent reminder of their power and influence. Favour could also be bestowed through gifts of buildings, whether temples or sanctuary refurbishments or secular constructions such as theatres, council buildings or stoas (see Chapter 3, pp. 82 and 90). Stoas appear to have been an especially popular choice of gift-building, and doubtless their recipients found them very useful. The appearance of the stoa that Attalos II bestowed on the Agora of the city of Athens in the later second century BC can still be appreciated today in its reconstructed form (fig. 97): 116.38 m long, the elegant double columns of its façade form a solid and very noticeable border to the east side of the Agora, and in antiquity, too, the stoa would have provided a conspicuous reminder of Attalid power. Gifts of buildings could also give concrete expression to the competitive nature of Hellenistic monarchy. In Delos, for example, Attalos I of Pergamon erected a stoa in the southern part of the sanctuary of Apollo, looking towards the sea; not long afterwards Philip V of Macedon trumped this with a second stoa to the west that effectively cut off Attalos I's sea view.

There are close parallels between the visual arts and poetry in terms of both these changes in the commissioning agents (from the state to the private, often royal, individual) and the new importance of patronage; so it seems legitimate to use some of the explicit references to patronage in Hellenistic poetry to suggest what sort of a relationship a painter or sculptor might hope to foster with his patron. Some poets were certainly quite frank about their expectations. Theocritus, for example, in his sixteenth *Idyll*, addressed to Hieron II of Syracuse, comes straight out with his need for a patron. 'I am seeking to whom of mortals I may come as a welcome guest in company of the Muses', he declares, and he goes on to point out that if modern heroes (like Hieron) want to become as famous as those of old, they need poets to sing their praises; only thus will their deeds live on. In his fourteenth *Idyll* Theocritus is lavish in his

97 View of the Stoa of Attalos in the Agora at Athens, originally built in the late second century BC and reconstructed by the American School of Classical Studies in the mid-twentieth century AD.

praise of Ptolemy II Philadelphos, his ideal of a beneficent patron – 'giving much to many, not refusing when asked, as befits a king: but you mustn't always ask!' (line 62). In *Idyll* 17, Ptolemy's virtues are sung again, and the poet's part in the bargain is made quite clear: 'And never comes for the sacred contests of Dionysos one skilled to raise his clear-voiced song but he receives the gift his art deserves, and those mouthpieces of the Muses sing of Ptolemy for his benefactions. And for a prosperous man what finer aim is there than to win goodly fame on earth?' (*Idyll* 17, lines 112 ff)

Theocritus sees patronage in terms of a contract or business arrangement between the artist and his patron, and it seems likely that similar terms could apply in cases of artistic patronage. The patron provides material rewards in return for art that in one way or another extols his character, wealth and taste. This enhances his reputation, augments people's views of his importance, and ultimately extends his power and influence. This was undoubtedly an important motive for the way the Attalid rulers of Pergamon, for example, patronized the visual arts: the great public buildings of their splendid city formed a conspicuous symbol of their power. There are also significant parallels between some of the specific varieties of literary and artistic activity promoted by Hellenistic monarchs. One major endeavour of the scholars who laboured in the Library at Alexandria was the collection and transcription of 'Classical' texts, that is, those of the Archaic and Classical periods of Greek civilization. It has been argued that one reason why this was considered so important was the sense of fragmentation and upheaval brought about by the constant political shifting of the Hellenistic world. Securing the survival of the 'classics', such as Homer, Hesiod, or the fifth-century Athenian tragedians, was a way of ensuring and affirming cultural identity. The Attalids of Pergamon were operating in a similar way in the visual arts by forming an extensive collection of Archaic and Classical Greek sculpture, and also in starting the fashion for copies of Classical works such as the one-third life-sized Athena Parthenos that adorned the Library of Pergamon. In these sorts of ways Attalos I and Eumenes II were trying to build some form of continuity between their own period and the past: Pergamon, they wanted people to believe, was a new, eastern Athens, its rulers and its people the true heirs of Pericles.

Similar retrospective tendencies mark the first books on art history and criticism, another Hellenistic innovation. None of the books themselves survive intact, but as they were heavily used and quoted by later Roman writers on art, notably Pliny and Pausanias, we know the names of some authors and have a partial idea of the content.[21] It seems clear that the Hellenistic works had a strong historical perspective and were highly nostalgic, stressing the skill and achievements of the artists of the past as compared with those of the present day. The parallel emergence of conscious 'art-collecting' clearly reflected a similar focus of interest, with collectors prizing Archaic and Classical works far more highly than contemporary pieces.

Royal patronage, however important in general terms, can never have been available to more than a relatively small proportion of the vast numbers of artists and craftsmen operating in the Hellenistic world. The rest were able to

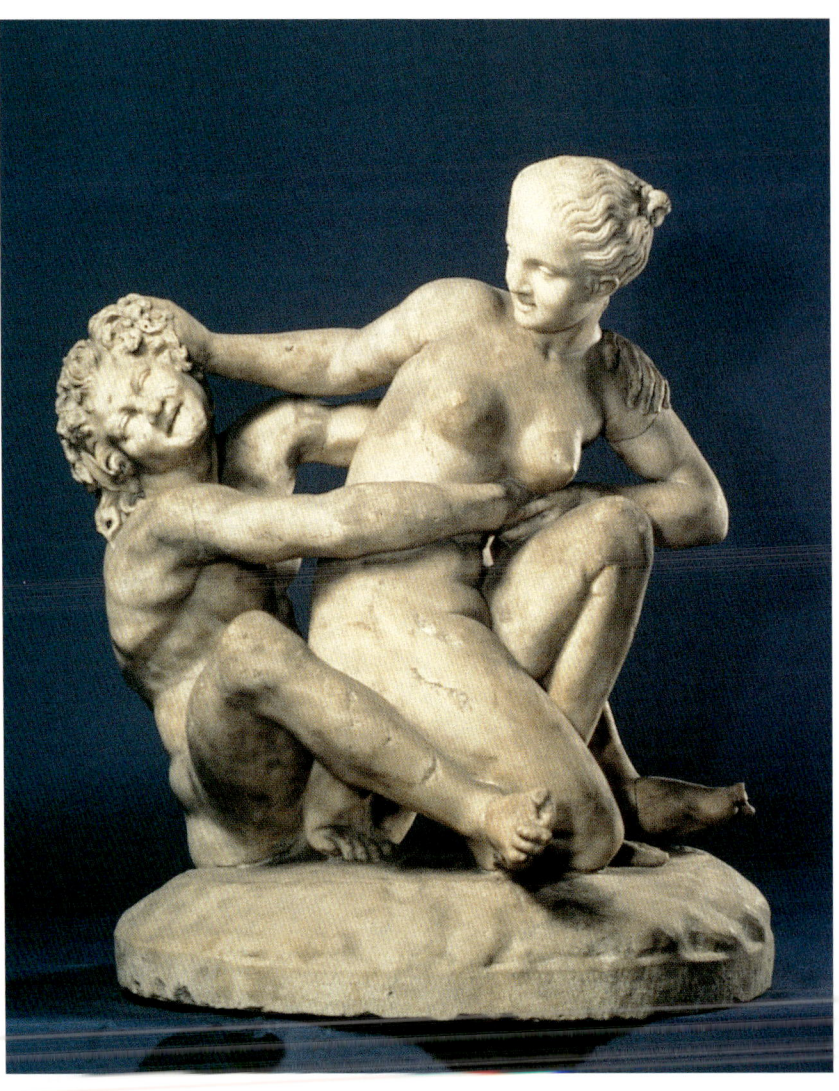

98 Marble group of a nymph struggling to free herself from a satyr. Roman version of a theme popular in the Hellenistic period. Height 76.5 cm.

make a living because private individuals or groups took their lead from their sovereigns and also became patrons of the arts, if on a smaller scale. We have seen how wealthy individuals acquired art and valuable artefacts for both use and display in their homes and tombs; they also commissioned funerary statues and reliefs, as well as statues of various sizes and materials to offer as dedications to the gods. The period also saw the emergence of new types of social group such as clubs or schools of philosophy, many of which might purchase art to decorate their communal premises. Considerable quantities of sculpture were found,

for example, in a Delian house of the late second century belonging to a merchants' association, the Poseidoniasts of Berytos (modern Beirut). The basement rooms of the house were apparently used for the storage of goods in transit. On the ground floor of the house were cult rooms with statues of the patron deities of the association, including Poseidon and Aphrodite-Astarte; at a late stage an extra room was added to house the image of the newly popular goddess Roma. Beyond the sanctuary area were rooms with more 'decorative', generally small-scale sculpture, such as a Herakles Epitrapezios, or a nymph attacked by a satyr (compare fig. 98); in one courtyard was found the well-known group of Aphrodite, assisted by Eros, using a slipper to fend off the advances of Pan.[22]

The impact of Rome

The establishment of a cult room for the goddess Roma in the Delos club-house is symptomatic of the growing influence that Rome began to assert across the Mediterranean world from the second century BC onwards. Rome's accidental or opportunistic rise to a position of political and military dominance was swift and thorough. In brief, the Romans initially entered the Greek world not as conquerors or usurpers but to make common cause with Pergamon against the threat of Hannibal and the Carthaginians, with whom Philip V of Macedon had contracted an ill-fated alliance. In 148 BC, however, the Romans were sufficiently exasperated by Philip's successors and the machinations of the Aetolian League (dominated by Pergamon) first to make Macedonia a Roman province, and, two years later, to repeat the operation with the southern part of Greece, which thereby became the Roman province of Achaea. In 133 BC the last king of Pergamon, Attalos III, bequeathed his kingdom to Rome. Gradually the other Hellenistic kingdoms succumbed, in one way or another, to Roman rule, until the last of the old dynasties, that of the Ptolemies of Egypt, was extinguished at the battle of Actium in 31 BC. More complicated to explain than the political situation is both the Roman reaction to Greek culture, and especially to Greek art, and in its turn the active influence that Rome had on that art's later phases.

The Romans first encountered Greek art in the form of plunder or triumphal booty. As major cities and areas of the Greek world were sacked by Roman commanders – Syracuse in 211 BC, Taranto in 209, Macedon in 168, Corinth in 146 – booty in the form of statues, paintings, gold and silver plate flooded into Rome to be paraded, along with living prisoners, in triumphal

processions through the streets. Literary sources report that reactions to such sights were mixed. The older, austerely traditional Roman, such as Cato the Elder, was disapproving, alarmed by the sight of so much luxury and beauty, which he believed would have a bad effect on people's morals. Others, however, welcomed it without reservation, and in the end it was, inevitably, this very positive attitude that came to prevail among the ruling Roman élite. In the last century of the Roman Republic, many wealthy Romans became eager collectors of Greek art; and so a whole new type of market opened up, both for the artists themselves and for the entrepreneurs who, like today's interior designers, found new career opportunities in sourcing works of art and shipping them back to Rome and Italy for clients too important or too wealthy to do it for themselves.

One of the earliest Roman collectors of ancient art for whom we have much evidence is the writer and orator Cicero, who lived and worked in Rome in the first century BC. His letters to his friend and agent Atticus, who lived in Athens, offer vivid insights into the excitement with which he and others anticipated the arrival of shipments of Greek art:

> '… as for those Hermes figures of yours in Pentelic marble with heads of bronze, about which you wrote me, they are already providing me in advance with considerable delight. And so I beg that you send them to me as soon as possible and also as many other statues and objects as seem to you appropriate…. If there is no ship belonging to Lentulus, have them loaded at any port you like….' (*Ad Atticum* 1.8.2)

Like any collector forced to operate from a distance things did not always work out quite as Cicero intended. The exasperated tone of some of his other letters to agents show that not all the goods he received were of the type and quality he had specified ('… everything would have been fine … if you had bought only those statues I wanted and at the price which I was willing to pay …' *Ad Fam.* 7.23.1). The letters also suggest that Cicero had a carefully thought-out master-plan (or plans) for the arrangement of his acquisitions; it is clear, for example, that he felt some sorts of sculpture were suitable for a library, others for an exercise yard.

From a slightly later date, in the first century AD, we have material evidence for this sort of careful staging of Greek or Greek-style sculpture in a highly dramatic setting. The controversial 'Grotto of Tiberius' is a sea cavern in the cliffs near the village of Sperlonga, on the coast between Rome and Naples. Its association with Tiberius derives from the report of the Roman historian

Tacitus that in AD 26 the emperor was dining in a natural grotto at his villa 'The Cave' (*Spelunca*) when a sudden rockfall blocked the mouth of the cave, crushing several attendants: Tiberius himself was only saved from danger by the brave and daring action of an ambitious friend. The status of the sculpture recovered from the grotto is controversial because much of it is extremely fragmentary, some of the reconstructions have been questioned, and despite the apparent 'evidence' of an inscription, it is not easily datable and in fact most probably covers a considerable period of time, spanning several centuries of use. However, some kind of link with Tiberius remains plausible, and it is probably fair to suppose that at least some of the sculpture was in place in Tiberius's day. The style of the sculpture, moreover, makes it likely that it was produced either by Greek sculptors or that it includes early imperial Roman copies of late Hellenistic Greek work: this very difficulty in distinguishing the two possibilities is in itself a significant example of the sometimes seamless continuum between Greece and Rome.

The sculptural groups include a tableau of the sea-monster Scylla snatching members of Odysseus's crew from his ship, and Odysseus and his men driving a stake through the eye of the Cyclops Polyphemus. These bloodthirsty episodes from Greek mythology would have formed a highly dramatic backdrop to a feast, the white marble sculpture, lit by torches, throwing shadows onto the surrounding rocks and casting reflections into the pools beneath. A marble head in the British Museum is extremely close to that of one of the companions of Odysseus from the Sperlonga Polyphemus Group (fig. 99). It was found in the excavations of the second-century villa of Hadrian at Tivoli, where there may well have been another version of the group. The figure to which this head belongs is fleeing from the Cyclops:

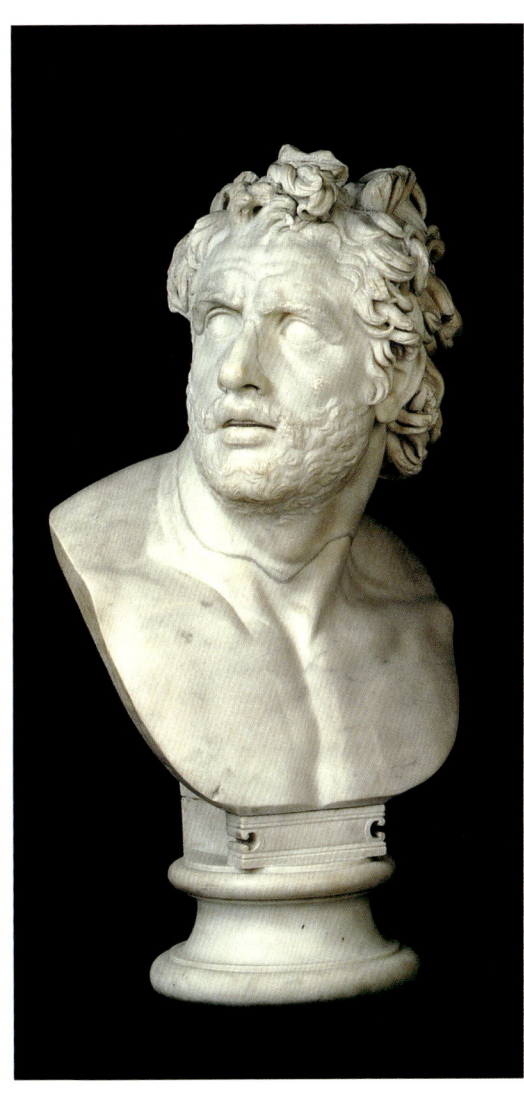

99 Marble head of one of the 'Companions of Odysseus': a virtually identical head was found in the 'Grotto of Tiberius' at Sperlonga, belonging to a hero fleeing in anguish from the sight of the blinding of the giant Polyphemus. Roman, but probably a copy of a Hellenistic original; from Hadrian's villa at Tivoli. Height 54.5 cm.

in his left hand he carries the wineskin that had contained the strong draught that had put the giant to sleep. As he runs away he turns back for a last look at the giant and at the terrible mutilation taking place: his features are twisted into an expressive, anguished blend of fear and horror.

Cicero's letters and the Sperlonga grotto alike provide good evidence for the Roman appetite for and use of Hellenistic sculpture, whether in the form of original works or copies, in the first centuries BC and AD. Shipwrecks, on the other hand, such as the Antikythera wreck with its cargo of sculpture or the Mahdia wreck, with its rather more intriguingly mixed cargo, can provide vivid glimpses of what might have happened at the other end of the art market transaction: the production, assemblage and shipping on from Greece towards Rome of a desirable cargo of works of art. The Mahdia wreck was discovered in 1907 off the east coast of Tunisia. Its extensive and dramatically varied contents are now in the Bardo Museum in Tunis, and their careful examination and analysis has produced a general consensus that the ship had sailed from Athens, most likely soon after that city's sack by Sulla in 80 BC, bound either for Rome or for the Bay of Naples. The main cargo the ship had carried was of marble columns and column capitals. But also on board was a wide range of artistic and decorative artefacts, from marble figures, reliefs, *kraters* and candelabra to ivory inlays and bronze statues and statuettes, couches, vessels and utensils. Taken as a whole, the shipment would have gone a long way towards the tasteful, opulent and indeed luxurious furnishing of the sort of villa that a cultivated and well-to-do Roman such as Cicero would have wanted. What is interesting about the collection as a whole is that some of the items, such as the marble candelabra, for example, had been newly made in a single workshop. They had not been fully assembled before shipping, and so they create a strong impression of being a 'special order' requested by a client. The marble *kraters* form a similar case. Both these types of object have been found in considerable numbers in central Italy: they were a special class of object made in late Hellenistic Athens exclusively for the Roman market. Other parts of the cargo, however, such as the complex and beautifully made bronze couches, are thought more likely to have originated in Delos. And there were other items that could be classed as antique or at least second-hand, including, for example, four mid-fourth-century Athenian relief sculptures; many of the bronze items too, including Boethos's herm, have been dated to the second century BC rather than any earlier, so that if the date of 80 BC is correct, they would hardly have been brand new when they left Greece.

In artistic terms, the transition from Greece to Rome was a gradual one.

ARTISTS, PATRONS AND COLLECTORS

As the contents of the Mahdia wreck suggest, Roman taste and lifestyle to some extent influenced late Hellenistic artistic production, directing it into channels (such as the production of marble vases or candelabra, for example) (figs 100 and 101) where, left to its own devices, it might not otherwise have flowed. Over time, Roman character, aspirations and artistic talent did forge many new and distinctive forms of art: new types of monument, for instance, such as richly sculpted triumphal arches or columns, would lay an increasing and distinctively Roman stress on the glorification both of the emperor himself, and

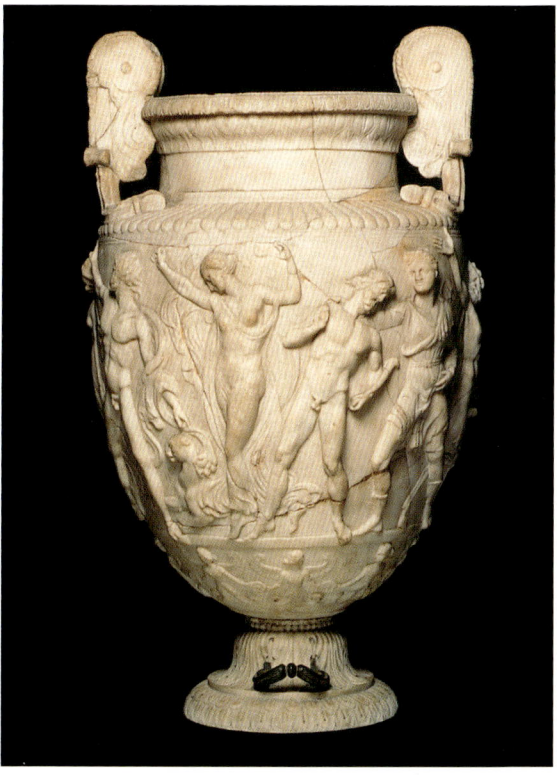

100 Marble vase, known as the 'Townley Vase' after its eighteenth-century owner, Charles Townley. The vase is decorated in high relief with a Bacchic scene of Pan, satyrs and maenads. This vase may date to the second century AD, but its iconography goes back to the Hellenistic period. Vases of similar shape were found on the Mahdia shipwreck of the first century BC. Height 93 cm.

101 Marble candelabrum: several candelabra of this type were found on the Mahdia shipwreck: like the marble vases, they are thought to have been made in Greece by late Hellenistic artists specially for the Roman market. Height 122 cm.

of the military and political power of Rome. However, in the last years of the Roman Republic and the first century of the Empire, it was Greek artists and craftsmen who flocked to Rome and Italy to meet the growing demand for decorative and luxury goods, Greek skill and style that painted and furnished Roman houses and laid affluent Roman tables with sparkling glass and silver vessels. The surviving art of this period, when Roman political power was balanced in cultural terms by that of Greece, does not always lend itself to easy classification as either 'Greek' or 'Roman'. On which side, after all, would we

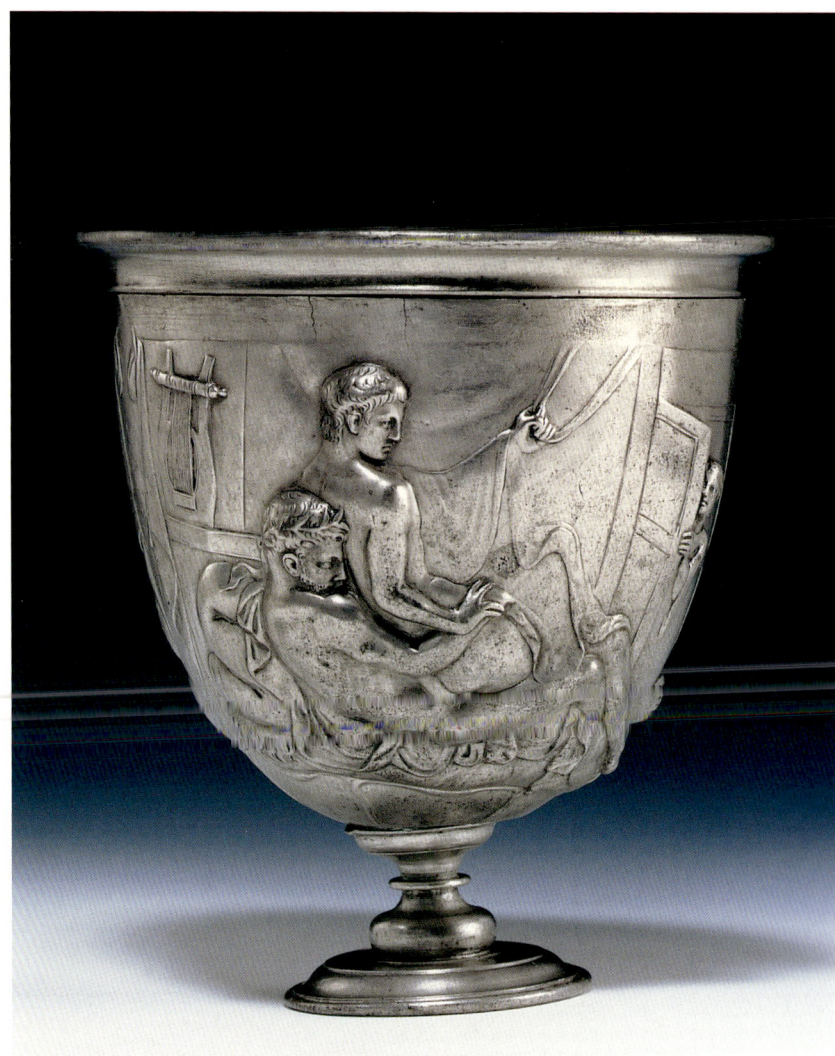

102 The 'Warren Cup', so-named after its first modern owner, Edward Perry Warren. The style and homosexual subject matter of this silver cup are a vivid illustration of the way Greek culture lived on into, informed and infiltrated Roman taste and society. Said to be from Bittir (ancient Bethner), near Jerusalem, c. AD 50. Height 11 cm.

want to assign much of the Sperlonga sculpture? Or the Warren Cup, so elegantly and allusively Greek in both subject matter and style (fig. 102)? The Portland Vase, too, with its learned and certainly allegorical–political iconography, looks back to Ptolemaic Alexandria as much as it points forward to the political and dynastic complexities of the early empire (fig. 103). The Romans themselves acknowledged their debt to Greek culture – 'Captive Greece led her proud conqueror captive' wrote the Augustan poet Horace. As late as the second century AD we still find the Emperor Hadrian both collecting Greek sculpture

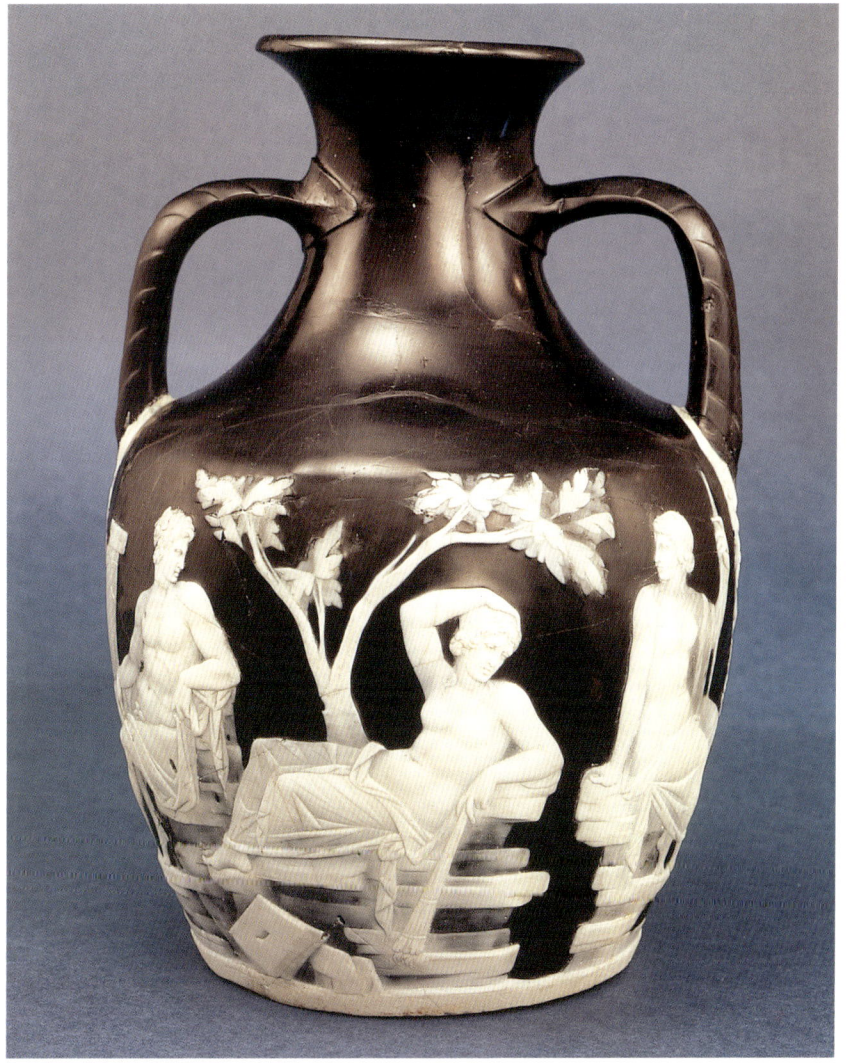

103 The Portland Vase, an early Roman *tour de force* of the glass-blowing and cameo-cutting arts developed in the Hellenistic period. Its complex visual imagery may derive some of its inspiration from such scholarly Ptolemaic works as the 'Apotheosis of Homer', updated to reflect the social and dynastic complexities of the late Republic and early Empire. Said to be from Rome, C. AD 5–25. Height 24 cm.

and playing at Alexander the Great as he came close to losing his ill-fated young friend Antinous in a near-disastrous lion-hunt. Perhaps in artistic terms it is premature to 'close' the Hellenistic period with the emergence of Augustus as the first Roman emperor: instead we might think of Hellenistic art, in all its glorious diversity, as a force that lives on even into the later imperial period, quietly continuing to inform the visual language and landscape of the new, Roman, masters of the Mediterranean world.

Bibliography and Abbreviations

Agora
The Athenian Agora. Results of excavations conducted by the American School of Classical Studies at Athens (Princeton 1953–)

Beard and Henderson
Beard, M. and Henderson, J., *Classical Art: from Greece to Rome* (Oxford 2001)

BM Catalogue of Terracottas III
Burn, L.M. and Higgins, R.A., *A Catalogue of Greek Terracottas in the British Museum* III (London, 2001)

Das Wrack
Hellenkemperer Salies, G. and others (eds), *Das Wrack: Der antike Schiffsfund von Mahdia* (Cologne 1994)

Délos
Exploration archéologique de Délos faite par l'École Française d'Athènes (Paris 1909)

Erskine, A. (ed.), *A Companion to the Hellenistic World* (Oxford 2003)

Fowler, *Hellenistic Aesthetic*
Fowler, B.H., The Hellenistic Aesthetic (Madison, Wisconsin, 1989)

Ling, *Making Classical Art*
Ling, R. (ed.), *Making Classical Art, Process and Practice* (Stroud, Gloucestershire, 2000)

Macedonia and Greece
Barr-Sharrar, B. and Borza, E. (eds), *Macedonia and Greece in late Classical and early Hellenistic times* (Washington DC 1982)

Mattusch, *Classical Bronzes*
Mattusch, C., *Classical Bronzes: the art and craft of Greek and Roman statuary* (Ithaca, Cornell, 1996)

Mattusch, *Greek Bronze Statuary*
Mattusch, C., *Greek Bronze Statuary: from the beginnings through the fifth century* BC (Ithaca, Cornell, 1988)

Musée du Louvre, Les Sculptures Grecques
Hamiaux, M., *Musée du Louvre, Les Sculptures Grecques* (Paris 1998)

Palagia and Coulson, *Regional Schools*
Palagia, O. and Coulson, W. (eds), *Regional Schools in Hellenistic Sculpture; proceedings of an international conference held at the American School of Classical Studies at Athens, March 15–17, 1996* (Oxford 1998)

Pollitt, *Hellenistic Age*
Pollitt, J.J., *Art in the Hellenistic Age* (Cambridge 1986)

Raeder, *Priene*
Raeder, J., *Priene. Funde aus einer griechischen Stadt* (Berlin 1984)

Smith, *Hellenistic Royal Portraits*
Smith, R.R.R., *Hellenistic Royal Portraits* (Oxford 1988)

Smith, *Hellenistic Sculpture*
Smith, R.R.R., *Hellenistic Sculpture: A handbook* (London 1991)

Stewart, *Greek Sculpture*
Stewart, A., *Greek Sculpture: An exploration* (New Haven 1990)

The Cambridge Ancient History
Ling, R. (ed.), *The Cambridge Ancient History. Plates to Vol. VII, Part 1. The Hellenistic World to the Coming of the Romans* (new edn, Cambridge 1984).

The Coroplast's Art
Uhlenbrock, J.P., (ed.), *The Coroplast's Art: Greek terracottas of the Hellenistic world* (New York 1990)

The Oxford History of Classical Art
Boardman, J. (ed.), *The Oxford History of Classical Art* (Oxford 1993)

The Western Greeks
Carratelli, J.P. (ed.), *The Western Greeks* (Venice 1991)

Walker and Higgs, *Cleopatra*
Walker, S. and Higgs, P. (eds), *Cleopatra of Egypt: from History to Myth* (London 2001)

Wiegand and Schrader, *Priene*
Wiegand, T. and Schrader, H., *Priene. Ergebnisse der Ausgrabungen und Untersuchungen in den Jahren 1895–1898* (Berlin 1904)

Notes

Introduction

1 'Sculpture defines Greek and Roman art and will take the lion's share of attention in the rest of this book', Beard and Henderson, 83.

2 J.G. Droysen, *Geschichte des Hellenismus*, vols I and II (Hamburg 1836).

3 See S. Hornblower in *The Oxford Classical Dictionary* (3rd edn, Oxford 1996), sv 'Hellenism, Hellenization'.

4 C. Havelock, *Hellenistic Art: The art of the Classical world from the death of Alexander the Great to the battle of Actium* (Greenwich, Conn., 1970), 16.

5 J. Onians, *Art and Thought in the Hellenistic Age: The Greek world view, 350–50 BC* (London 1979).

6 Pollitt, *Hellenistic Age*.

7 E.D. Reeder (ed.), *Hellenistic Art in the Walters Art Gallery* (Baltimore 1988).

8 Smith, *Hellenistic Sculpture*, 7, 8.

9 Stewart, *Greek Sculpture*, 313.

10 C.M. Robertson in P. Green (ed.), *Hellenistic History and Culture* (Berkeley 1993), 86.

Chapter 1

1 On this see E. Badian, 'Greeks and Macedonians' in *Macedonia and Greece*, 33–51; also G. Shipley, *The Greek World after Alexander, 323–30 BC* (London 2000), 111.

2 For Sindos see J. Vokotopoulou and others, *Sindos* (exhibition catalogue, Thessaloniki 1985).

3 For a full publication of the Derveni tombs see P. Themelis and G. Touratsoglou, *Hoi Taphoi tou Derbeniou* (Athens 1997) (in Greek with useful English summary and excellent photos).

4 Themelis and Touratsoglou, *op. cit.* (n. 3), 220.

5 See S. Miller, 'Macedonian Tombs: Their architecture and architectural decoration' in *Macedonia and Greece*, 153–72.

6 See M. Andronikos, *Vergina: The royal tombs and the ancient city* (Athens 1984); also *The Oxford History of Classical Art*, figs 148–50.

7 For the Palermo mosaic, found in the Villa Bonanno in the Piazza Vittoria, Palermo, see A. Cohen, *The Alexander Mosaic: Stories of victory and defeat* (Cambridge 1997), 77, fig. 48.

8 For the Alexander and other Sidon sarcophagi see Smith, *Hellenistic Sculpture*, 190–92; C. Houser, 'The "Alexander Sarcophagus" of Abdalonymus, a Hellenistic monument from Sidon' in Palagia and Coulson, *Regional Schools*, 281–91.

9 O. Palagia, 'Hephaestion's Pyre and the Royal Hunt of Alexander' in A. Bosworth and

E. Baynham (eds), *Alexander the Great in Fact and Fiction* (Oxford 2000), 167–206.

10 For Macedonian and other Hellenistic palaces see I. Nielsen, *Hellenistic Palaces* (Aarhus 1994), 81–99 and *passim*.

11 For pebble mosaics, their origin and development, see K. Dunbabin, *Mosaics of the Greek and Roman World* (Cambridge 1999), 5–17. For the theory of the Sikyonian school see M. Robertson, 'Early Greek Mosaic' in *Macedonia and Greece*, 241–50.

Chapter 2

1 For an introduction to ancient portraiture see S. Walker, *Greek and Roman Portraits* (London 1995). For a comprehensive overview of Greek portraits see G.M.A. Richter, *Portraits of the Greeks* (revised and abridged by R.R.R. Smith, Oxford 1984). For specifically Hellenistic portraits see Smith, *Hellenistic Royal Portraits*; Pollit, *Hellenistic Age*, 59–78; Smith, *Hellenistic Sculpture*, 19–62.

2 For the 'Villa of the Papyri' and its sculpture see Walker, *op. cit.* (n. 1), 44–6; Smith, *Hellenistic Royal Portraits*, 70–78.

3 For the Via Appia portrait group, *BM Catalogue of Sculpture*, nos 1830, 1838, 1843, 1845, 1854, see Walker, *op. cit.* (n. 1), 43–4.

4 For a brief discussion and illustrations of 'orator' portraits see Smith, *Hellenistic Sculpture*, 37–8, figs 38–41.

5 For the portraits of Menander see Richter, *op. cit.* (n. 1), 159–64.

6 For Delos see Pollit, *Hellenistic Age*, 1–6; Stewart, *Greek Sculpture*, 227–8.

7 For the statue from the 'House of the Diadoumenos' on Delos, Athens, National Museum 1828, see Smith, *Hellenistic Sculpture*, fig. 315; Stewart, *Greek Sculpture*, fig. 840.

8 Demosthenes, *Against Meidias* XXII (522).

9 For Hellenistic seals see D. Plantzos, *Hellenistic Engraved Gems* (Oxford 1999); for a brief summary see J. Boardman in D. Collon (ed.), *7000 Years of Seals* (London 1997), 78.

10 For an example of a gold-plated bronze bracelet from Taranto see *The Western Greeks*, 651.

11 For an example of a terracotta wreath, made up from pierced conical beads, from a tomb at Taranto, see *The Western Greeks*, 734, no. 306.

12 For a brief introduction to the image of Alexander see Smith, *Hellenistic Sculpture*, 21–2; Smith, *Hellenistic Royal Portraits*, 57–69, and for an in-depth study A. Stewart, *Faces of Power* (Los Angeles and Oxford 1993).

13 For ruler portraits of the various dynasties see Smith, *Hellenistic Royal Portraits*.

14 For Hellenistic ruler portraits on coins see Smith, *Hellenistic Royal Portraits*; for good illustrations of examples of Ptolemaic issues see Walker and Higgs, *Cleopatra*, 82–7.

15 For these faience 'queen jugs' see D.B. Thompson, *Hellenistic Oinochoai and Portraits in Faience: Aspects of the ruler cult* (Oxford 1973).

16 See S.-A. Ashton, *Ptolemaic Royal Sculpture from Egypt: The interaction between Greek and Egyptian traditions* (Oxford 2001).

17 This idea is voiced by Pollit in his discussion of the 'theatrical mentality' that he identifies as a characteristic of the Hellenistic age: see Pollit, *Hellenistic Age*, 4–7.

18 For the best illustrations of theatre masks see L. Bernabó Brea in collaboration with M. Cavalier, *Maschere e Personaggi del Teatro Greco nelle Terracotta Liparesi* (Rome 2001), with numerous colour illustrations and useful English summary (281–91).

19 See Beard and Henderson, 141–2.

20 For the Berber head see most recently D.W. Roller, 'A Note on the Berber Head in London', *Journal of Hellenic Studies* 122 (2002), 144–6.

21 See *BM Catalogue of Terracottas* III, 146–7, no. 2382.

22 For this theory see L. Giuliani, 'Die Seligen Krüppel', *Archäologischer Anzeiger* 1987, 701ff.

Chapter 3

1 For the development of cities in the Hellenistic period see R. Billows, 'Cities' in A. Erskine (ed.), *A Companion to the Hellenistic World* (Oxford 2003), 196–215.

2 For the stoa see especially J.J. Coulton, *The Architectural Development of the Greek Stoa* (Oxford 1976).

3 For the city of Pergamon see Billows, *op. cit.* (n. 1), 206–9; or, for a convenient summary, *The Oxford History of Classical Art*, 159–60, no. 150.

4 For the *bouleuterion* at Miletus see *The Oxford History of Classical Art*, 169–70, no. 159.

5 For the architectural development of the theatre in the Hellenistic period see Billows, *op. cit.* (n. 1); for its social and cultural development see J.R. Green, *Theatre in Ancient Greek Society* (London 1994), 105–41.

6 For the temple of Apollo at Didyma see J. Chamoux, *Hellenistic Civilisation* (1981, trans. M. Round, 2003), 282.

7 For the Cyrene Apollo, GR 1861.7-25.1 (Sculpture 1380), see Smith, *Hellenistic Sculpture*, 65.

8 For the Satala Aphrodite, GR 1873.8-20.1 (Bronze 266), see Stewart, *Greek Sculpture*, 224.

9 For the Victory of Samothrace see *Musée du Louvre, Les Sculptures Grecques* II, 27–41; Stewart, *Greek Sculpture*, 215; I.S. Mark, 'The Victory of Samothrace' in Palagia and Coulson, *Regional Schools*, 157–65; Smith, *Hellenistic Sculpture*, 77–9.

10 For the Pergamon Altar see *The Oxford History of Classical Art*, 164–5, no. 155; Smith, *Hellenistic Sculpture*, 155–80; Stewart, *Greek Sculpture*, 210–13.

11 See J.C. Carter, *The Sculpture from the Sanctuary of Athena Polias at Priene* (London 1983).

12 For the Priene charioteer, GR 1870.3-20.203 (Sculpture 1154), see Carter, *op. cit.* (n. 11), 268–71. For the Delphi charioteer see Stewart, *Greek Sculpture*, figs 301–2.

13 See *BM Catalogue of Terracottas* III, no. 2416.

14 The best accounts of Newton's excavations are his own: see C.T. Newton, *Travels and Discoveries in the Levant* (London 1865), 176–200 and *History of Discoveries at Halicarnassus, Cnidus and Branchidae* (London 1862), 375–425.

15 For a brief summary see *BM Catalogue of Terracottas* III, 176, with references.

16 For the Demeter of Knidos see B. Ashmole, 'Demeter of Cnidus', *Journal of Hellenic Studies* 71 (1951), 13–28; *The Oxford History of Classical Art* 139, no. 132.

17 GR 1859.12-26.25 (Sculpture 1301).

18 See *BM Catalogue of Terracottas* III, nos 2513–32.

19 See *BM Catalogue of Terracottas* III, nos 2533, 2542, 2544.

20 See *BM Catalogue of Terracottas* III, no. 2496, with further references. The sculptural nature of many Knidian terracottas is discussed by L. Burn, 'Sculpture in Terracotta from Cnidus and Halicarnassus' in I. Jenkins and G. Waywell (eds), *Sculptors and Sculpture of Caria and the Dodecanese* (London 1998), 84–90.

Chapter 4

1 For the development of mosaic techniques in the Hellenistic period see K. Dunbabin, *Mosaics of the Greek and Roman World* (Cambridge 1999), 5–52.

2 For Sosos and Pergamene mosaics see Dunbabin, *op. cit.* (n. 1), 26–8.

3 For the Delos mosaics see Dunbabin, *op. cit.* (n. 1), 30–35.

4 For an example of stucco wall decoration in the 'House of the Tridents' at Delos see *The Cambridge Ancient History*, plates to vol. VII, part I, 111, fig. 138; for a reconstruction drawing of this same wall see R. Ling, *Roman Painting* (Cambridge 1991), 12, fig. 7. For a coloured reconstruction of a section of wall decoration from House 23 at Priene see Raeder, *Priene*, col. pl. I.

5 For the Priene stucco mask see Raeder, *Priene*, 69, fig. 7b; for the terracotta masks from Hanghaus 1 at Ephesus see C. Lang-Avinger, 'Masken aus Ton und Masken in der Wandmalerei – eine Gegenuberstellung', *Jahreshefte des Österreichischen Archäologisches Instituts in Wien* 67 (1998), 117–31.

6 For these figures see Wiegand and Schrader, *Priene*, 373, figs 468–9.

7 See above, n. 4.

8 This is the house to the east of House 33: see Raeder, *Priene*, 22.

9 For a general overview of the Priene terracottas see in addition to Raeder, *Priene*, J.P. Uhlenbrock in *The Coroplast's Art*, 78–9.

10 See Raeder, *Priene*, 73, figs 11a, 11b.

11 See Raeder, *Priene*, col. pl. III, and 72, fig. 10c.

12 For the 'Baker Dancer', New York, Metropolitan Museum of Art, Bequest of Walter C. Baker, 1971, 1972.118.95, see A.P. Kozloff (ed.), *The Gods' Delight* (Cleveland, Ohio, 1988), 102–6, with earlier bibliography.

13 For couches and couch fittings see S. Faust, 'Die Klinen', in *Das Wrack*, 573–606; for the *fulcra* and other decorative busts and attachments see B. Barr-Sharrar, *The Hellenistic and Early Imperial Decorative Bust* (Mainz 1987), *ead.*, 'Five Decorative Busts' and 'The Bronze Appliques' in *Das Wrack*, 551–8, 559–72; for the theory of Delian manufacture see B. Barr-Sharrar, 'Some Observations Concerning Late Hellenistic Bronze Production on Delos' in Palagia and Coulson, *Regional Schools*, 185–98.

14 For this table and others see *Delos* XVIII, pl. 188.

15 For this brazier see *The Cambridge Ancient History* plates to vol. VII, part 1, 115, fig. 143.

16 Theocritus, *Idyll* 1; for discussion see Fowler, *Hellenistic Aesthetic*, 5–15.

17 For an example of a similar bowl fitted with a lining, and also a price graffito, see A. Oliver, *Silver for the Gods: 800 years of Greek and Roman silver* (Toledo 1977), 78–9, no. 43.

18 For the relationship between silver and 'Megarian' bowls see S. Rotroff, *Agora* XXII, 6–13.

19 For the Pella bowls see I.M. Akamates, *Pelines Metres Angeion apo ten Pella* (Athens 1993).

20 For a good overview of Hellenistic fine wares see J. Hayes, 'Fine Wares in the Hellenistic World' in T. Rasmussen and N. Spivey (eds), *Looking at Greek Vases* (Cambridge 1991), 183–202.

21 For a general introduction see V. Tatton-Brown in H. Tait (ed.), *Five Thousand Years of Glass* (London 1991), 47–51.

22 See H. Reinder Reinders, *New Halos* (Utrecht 1988), 117–34; for another example of a similar sort of arrangement in a house at Abdera (Thrace) see J.W. Graham in *American Journal of Archaeology* 76 (1972), 295–301.

23 For a summary of the sealings from the 'House of Seals' see D. Plantzos, *Hellenistic Engraved Gems* (Oxford 1999), 32; for a full publication see M.-F. Boussas, *Scéaux Publics, Apollon, Helios, Artemis, Hekate: les séaux de Délos*, 1 (Paris 1992), and N.C. Stambolidis, *O Erotikos Kuklos. Les scéaux de Délos*, 2 (Paris 1992).

24 For a recent overview of recent discoveries in some of these cemeteries, with dramatic photographs, see J.-Y. Empereur, *Alexandria Rediscovered* (London 1998).

25 For this example see Walker and Higgs, *Cleopatra*, 123, no. 150.

26 See Walker and Higgs, *Cleopatra*, 121, no. 147, with further bibliography.

27 For this example see Walker and Higgs, *Cleopatra*, 117–18, no. 142; for a brief discussion of Hadra hydriai in general see *ibid.*, 117, with bibliography; for other examples see *ibid.*, 118–20.

28 For the Lion Tomb see J. Fedak, *Monumental Tombs of the Hellenistic Age* (Toronto 1990), 76–9; also, concentrating on the lion, G.B. Waywell, 'The Lion from the Lion Tomb at Cnidus' in Palagia and Coulson, *Regional Schools*, 235–41.

29 See *The Western Greeks*, 654.

30 For this tomb, Heraclea Tomb 191, see *The Western Greeks*, 649–50.

31 For illustrations of tomb groups at Taranto see D. Graepler, *Tonfiguren im Grab. Fundcontexte Hellenistischer Terrakotten aus der Nekropole von Tarent* (Munich 1997), 105; for a tomb at Egnathia see *The Western Greeks*, 729–30, and for another at Taranto see *ibid.* 731–2.

32 See U. Mrogenda, *Die Terrakottafiguren von Myrina* (Frankfurt 1996).

33 For terracottas in Hellenistic southern Italy see R.M. Ammermann, 'The Religious Context of Hellenistic Terracotta Figurines' and M. Bell III, 'Hellenistic Terracottas of Southern Italy and Sicily' in *The Coroplast's Art*, 37–46 and 64–70.

34 See S. Drougou (ed.), *Hellenistic Pottery from Macedonia* (Thessaloniki 1991), 41–4.

35 For Canosan and Centuripe wares see M.E. Mayo

(ed.), *The Art of South Italy: Vases from Magna Graecia* (Richmond, Virgin., 1982), 298–302 (Canosan), 282–5 (Centuripe).

Chapter 5

1 For the 'Homeric bowls' see Pollitt, *Hellenistic Age*, 196, 200–2.

2 For the *Tabulae Iliacae* see Pollitt, *Hellenistic Age*, 202–3.

3 For discussion of the 'Apotheosis of Homer' relief see Pollitt, *Hellenistic Age*, 16.

4 For Ptolemy IV and Arsinoe III's patronage of the arts and the Homereion see Pollitt, *Hellenistic Age*, 16, with further references.

5 For Tyche see S. Matheson, *An Obsession with Fortune: Tyche in Greek and Roman art* (*Yale University Art Bulletin* 1994).

6 For the rural idyll in poetry see Fowler, *Hellenistic Aesthetic*, 23ff.

7 Munich, Glyptothek, Pollitt, *Hellenistic Age*, 196, fig. 210.

8 For the 'Odyssey Landscapes' see Pollitt, *Hellenistic Age*, 185–6, 209.

9 For the Sakyia tomb see S.M. Venit, *Monumental Tombs of Hellenistic Alexandria* (Cambridge 2002), 101–18.

10 For the Nile mosaic see *The Oxford History of Classical Art*, 180–81, no. 174; Pollitt, *Hellenistic Age*, 205–8.

11 For this figure see most recently Beard and Henderson, 141–2.

12 For a discussion of this phenomenon with references to and quotations of specific examples see Fowler, *Hellenistic Aesthetic*, 123–6.

13 For Hellenistic mosaics see above, Chapter 4.

14 See Beard and Henderson, 135, fig. 94(b).

15 For the 'Sleeping Hermaphrodite' see Beard and Henderson, 133–4; Pollitt, *Hellenistic Age*, 204–5, no. 208.

16 For Hellenistic Aphrodite figures see Smith, *Hellenistic Sculpture*, 79–83; *The Oxford History of Classical Art*, 191–3, nos 190–91.

17 For the Metropolitan Eros, Rogers Fund, 1943 (43.11.4), see Mattusch, *Classical Bronzes*, 160–68.

18 For Hypnos see Mattusch, *Classical Bronzes*, 151–60.

19 For Psyche see N. Icard-Gianolio in *LIMC*, sv 'Psyche'; the images of Eros torturing Psyche are nos 102–9.

20 See H. Sichtermann, 'Eros Glykopikros', *Mitteilung des Deutschen Archäologischen Instituts: Römische Abteilung* 76 (1969), 266–306.

21 For the head of Helios from Rhodes see Smith, *Hellenistic Sculpture*, fig. 303; *The Oxford History of Classical Art*, 190, no. 187.

22 For the Zeus from Aegeira see *The Oxford History of Classical Art*, 190, no. 188.

23 For Nemrud Dagh see Smith, *Hellenistic Sculpture*, 226–8, Pollitt, *Hellenistic Age*, 274–5.

24 For a stimulating assessment of Hellenistic religion, including an analysis of the situation at Ai Khanoum, see D. Potter, 'Hellenistic Religion' in A. Erskine (ed.), *A Companion to the Hellenistic World* (Oxford 2003), 407–30, especially 419–26.

25 For 'cosmopolitanism' see Pollitt, *Hellenistic Age*, 10–13; for the Gauls *ibid.*, 13, 83–97.

26 For the Rome boxer see Stewart, *Greek Sculpture*, fig. 814.

27 For the Cape Artemisium jockey see Stewart, *Greek Sculpture*, figs 815–16.

Chapter 6

1 For tools and workshops see, for example, R. Ling, *Making Classical Art*.

2 For this workshop see *Studia Troica* I (1991), 54–6. For another workshop at Argos, identified as such by the presence of hundreds of moulds and lesser quantities of figurines, but no other 'equipment', see A. Banaka-Dimaki, 'La Coroplathie d'Argos. Données nouvelles sur les ateliers d'époque hellénistique' in A. Muller (ed.), *Le Moulage en Terre Cuite dans l'Antiquité* (Lille 1997), 315–32.

3 For this workshop see *Hesperia* 38 (1969), 383–94.

4 For the evidence that survives for casting pits and furnaces see Mattusch, *Greek Bronze Statuary*, 54–8, 226–34.

5 For the Pergamon Altar positioning marks see Pollitt, *Hellenistic Age*, 102.

6 For the bronze couches and their complicated construction see S. Faust, 'Die Klinen', in *Das Wrack*, 573–606.

7 For a discussion of the 'made/cast' distinction and full references see Mattusch, *Classical Bronzes*, 193–4.

8 For the Mahdia herm and its relations see C. Mattusch, 'Bronze Herm of Dionysos' in *Das Wrack*, 431–50.

9 For the Panticapaion workshop see *The Coroplast's Art*, 15, with references.

10 For this suggestion see A. Middleton in *BM Catalogue of Terracottas* III, 308.

11 This was, for example, the case with the so-called 'Piombino Apollo', an archaizing work which carried inside it a plaque recording its sculptor, Menodotos of Tyre: for its composition, which included 8–10 per cent lead, see Mattusch, *Greek Bronze Statuary*, 15, n. 16.

12 For these colossi see Ling, *Making Classical Art*, 118–19.

13 For the Colossus of Rhodes see Ling, *Making Classical Art*, 119–20.

14 Translated and quoted in full by Stewart, *Greek Sculpture*, 23.

15 For Roman names of terracotta workers from Myrina see D. Kassab, *Statuettes en terre cuite de Myrina. Corpus des signatures, monogrammes, lettres et signes* (Paris 1988).

16 For this theory see D. Kassab Tezgör and A. Abd el Fattah, 'La Diffusion des Tanagrénnes a l'Époque Hellénistique; à propos de quelques moules alexandrins' in A. Muller, *op. cit.* (n. 2), 353–74.

17 For Epigonos as an important character see Stewart, *Greek Sculpture*, 204–7, 301–2; Pollitt, 84; undermining the artificial Epigonos edifice, Beard and Henderson, 159.

18 The ship is described by Athenaios, *Deipnosophistai* V.207.

19 The pavilion is described by Athenaios, *op. cit.* (n. 18), V.197A–C.

20 For the procession see Athenaios, *op. cit.* (n. 18), V.197D–202B, discussed by E.E. Rice, *The Grand Procession of Ptolemy Philadelphus* (Oxford 1983).

21 Stewart, *Greek Sculpture*, T 145–6.

22 For this house see Stewart, *Greek Sculpture*, 58, 226–7.

Photographic Acknowledgements

1. BM GR 1870.3-20.88 (Inscription 399)
2. Photo: L. Burn
3. BM CM 1866.12-1.1008
4. BM GR 1848.10-20.33-258 (Sculpture 850–944)
5. BM GR 1857.12-20.232 (Sculpture 1000)
6. BM GR 1865.1-3.37 (Bronze 1084), 1906.3-10.1 (Terracotta 2275)
7. BM GR 1907.5-19.11 (Terracotta 2367)
8. BM GR 1896.6-30.2
9. BM GR 1877.9-10.16-17 (Jewellery 1672–3)
10. Archaeological Museum, Thessaloniki/TAP
11. Archaeological Museum, Thessaloniki/TAP
12. Vergina, Tomb of Persephone/The Bridgeman Art Library
13. Vergina, Tomb of Philip from the Archaeological Museum, Thessaloniki/The Bridgeman Art Library
14. Vergina, Tomb of Philip, after M. Andronikos, *Vergina: the Royal Tombs* (Athens 1984), 102–3.
15. Museo Nazionale Archaeologico, Naples, 10020 © Photo SCALA, Florence
16. Istanbul Archaeological Museum 68/The Bridgeman Art Library
17. Pella House 1.5/TAP
18. Archaeological Museum, Thessaloniki, after J. Vokotopoulou, *Guide to the Archaeological Museum of Thessaloniki* (Thessaloniki), p. 101
19. BM GR 2000.5-23.1, 2002.9-26.3, 2002.9-26.2, 2002.9-26.1
20. BM GR 1868.5-20.65 (Bronze 1453)
21. BM GR 1865.7-12.1 (Bronze 848)
22. BM GR 1873.8-20.724 (Sculpture 1838)
23. BM GR 1973.3-3.2 (Sculpture 1840)
24. BM GR 1760.9-19.1 (Bronze 847)
25. BM GR 2000.9-7.1
26. National Archaeological Museum, Athens, NM 14612/TAP
27. BM GR 1908.4-14.1 (Jewellery 1628)
28. Fitzwilliam Museum, Cambridge, CG 74 and 75
29. BM GR 1872.5-15.1 (Sculpture 1857)
30. BM CM PGG IV A 16
31. BM GR 1772.3-2.11
32. BM CM 1864-13-3-2
33. BM GR 1873.8-20.389 (Vase K 77)
34. BM GR 1926.4-15.15
35. BM GR 1893.9-15.5 (Terracotta 2301), 1866.4-15.161 (Terracotta 2017), 1906.5-12.4 (Terracotta 2302)
36. Staatliche Antikensammlungen und Glyptothek 437, Munich
37. BM GR 1814.7-4.277, 1928.1-17.13b,c (Terracotta 2386), 1889.11-22.1 (Terracotta 2387)
38. BM GR 1861.11-27.13 (Bronze 268)
39. BM GR 1993.12-11.1 (Terracotta 2382)
40. Photo: L. Burn
41. Photo: L. Burn
42. Preussischer Kulturbesitz, Berlin
43. Photo: L. Burn
44. Photo: L. Burn
45. Photo: L. Burn
46. BM GR 1861.7-25.1 (Sculpture 1380)

47 BM GR 1873.8-20.1 (Bronze 266)
48 Paris, Louvre MA 2369 © Photo RMN – G. Blot/C. Jean
49 Photo: B. Wescoat
50 Staatliche Museen zu Berlin – Preussischer Kulturbesitz, Antikensammlung (photographer unknown)
51 Staatliche Museen zu Berlin – Preussischer Kulturbesitz, Antikensammlung. Photo: Erich Lessing
52 BM GR 1870.3-20.203 (Sculpture 1154)
53 BM GR 1870.3-20.73 (Terracotta 2416)
54 After Charles Newton, *A History of Discoveries at Halicarnassus, Cnidus and Branchidae* (1862), vol. I, pl. LIV lower
55 BM GR 1859.12-26.26 (Sculpture 1300)
56 BM GR 1869.12-26.154 (Terracotta 2496)
57 Photo: Roger Wood/CORBIS
58 Alexandria, Greco-Roman Museum 32044, Stéphane Compoint
59 BM GR 1885.8-4.1 (Sculpture 1713)
60 BM GR 1878-5-4.3 (Terracotta 2148)
61 BM GR 1856.10-1.44 (Terracotta 2724)
62 BM GR 1908.4-10.2
63 BM GR 1907.5-20.79
64 BM GR 1922.7-12.11 (Lamp Q 3574), 1859.12-26.280 (Lamp Q292), 1859.12-26.286 (Lamp Q300)
65 BM GR 1989.7-24.1, 1865.7-20.29
66 BM GR 1994.7-28.1, 1908.4-10.8, 1856.10-1.29
67 BM GR 1871.5-18.7, 1871.5-18.9, 1871.5-18.2
68 BM GR 1835.4-11.2 (Sculpture 723)
69 Photo: Stéphane Compoint
70 BM GR 1995.10-3.1
71 BM GR 1859.12-26.24 (Sculpture 1350)
72 BM GR 1893.11-1.5 (Terracotta 2024), 1893.11-1.9 (Terracotta 2027), 1875.10-12.2 (Terracotta 2099)
73 BM GR 1991.1-31.1 (Terracotta 2285)
74 Staatliche Museen zu Berlin – Preussischer Kulturbesitz, Antikensammlung/V.I.3161n. Photo: Ingrid Geske
75 New York, Metropolitan Museum of Art, Fletcher Fund, 1924, 24.97.11
76 BM GR 1819.8-12.1 (Sculpture 2191)
77 Paris, Louvre Br. 4453, ex-coll. de-Clerq-de Boisgelin
78 Staatliche Antikensammlungen und Glyptothek 206, Munich
79 Alexandria, Greco-Roman Museum. Photo: Sally-Ann Ashton.
80 Palestrina, Archaeological Museum/The Bridgeman Art Library
81 Paris, Louvre MA 1354 © Photo RMN – G. Blot/H. Lewndowski
82 BM GR 2001.10-10.1
83 BM GR 2000.5-22.1
84 GR 1853.3-14.1 (Silver 71)
85 The Metropolitan Museum of Art, Rogers Fund, 1943 (43.11.4) Photograph © The Metropolitan Museum of Art
86 BM GR 1868.6-6.9 (Bronze 267)
87 BM GR 1893.9-15.2 (Terracotta 2292)
88 Fitzwilliam Museum, Cambridge, GR.15.1850
89 Paris, Louvre M 140
90 Tunis, Bardo Museum F 107. Photo: Preussischer Kulturbesitz, Berlin/Felicien Faillet
91 BM GR 1802.7-3.286 (Terracotta D432)
92 BM CM 1841-7-26-459 (BMC Rhodes 120)
93 Photo: C.S. Lightfoot
94 BM GR 1867.5-8.115 (Sculpture 550)
95 Fitzwilliam Museum, Cambridge, CG 520
96 GR 1971.9-24.1 (Terracotta 2309)
97 Photo: C. Pickersgill
98 BM GR 1805.7-3.2 (Sculpture 1658)
99 BM GR 1805.7-3.86 (Sculpture 1860)
100 BM GR 1805.7-3.218 (Sculpture 2500)
101 BM GR 1805.7-3.220 (Sculpture 2508)
102 BM GR 1999.4-26.1
103 GR 1945.9-27.1 (Gems 4036)

Index

Numbers in **bold** are figures.

Abdalonymos 42
Actium, battle of 15, 171
Africans, images of 75–6, **38**
Aigai 44
Ai Khanoum 52–3
Alexander I of Macedon 28
Alexander III of Macedon ('the Great') 10–12, 41–3, 44, 46–9, 62–5, **20**, **29**, **30**
Alexander IV of Macedon 15
Alexander Mosaic 40–41, **15**
Alexander Sarcophagus 42, **16**
Alexandria 79, 122–5, 135–6, **58**, **69**
Alinda 81, **40**, **41**
animals and birds 144–5, **82**
Antiochos III 15
Antisthenes 54, **22**
Aphrodite 22, 87–8, 107, 146–7, **6**, **47**, **59**, **83**
Apollo
 temple of, at Didyma 84–5, **44**, **45**
 cult statue of, from Cyrene 85, **46**
Apotheosis of Homer 135–6, **76**
Archelaos
 of Macedon 28–9, 43
 of Priene 135–6
Ariadne 32
Arsinoe II 67–9, **32**, **33**
Asklepios 163, **94**
Attalids (general) 169
Attalos I 167
Attalos II, Stoa of 82, 167, **97**
Attalos III 15, 171

Berber head 75, **38**
Berenike I **32**
Boethos of Calchedon 158
bronze
 statues 75, **38**, **47**
 working 157–60

Callimachus 20–21, 138, 150
cameos 163, **95**
Caria 20, **5**
centaurs 145–6
Cicero 172
cities, city life, city planning 79–83
Cleopatra VII 13
Colossus of Rhodes 160–61
colossal statues 161–3
couches 46–7, 109–10, 157, **18**, **62**

Cyrene, Apollo from 85, **46**

Delos 57–8, 101–2, 104–6, 110–12, 171
Demeter of Knidos 96–8, **55**
Demetrios Poliorketes 155, 160
Demosthenes 54–6, **23**
Derveni
 tombs 30–33
 krater 31–2, **10**
Didyma, Temple of Apollo at 84–5, **44**, **45**
Dionysos 32
disability, disabled people 73–5, **37**
dress 58–60

Egypt 66–70, 122–3, 141–2, **80**
Epigonos 165–6
Eros 147–50, **85**, **87**
eunuch priest (?) 76, **39**
Eutychides 137–8
faience queen jugs 67–8, **33**
fishermen 143, **81**
funerary practices and monuments 120–30

Gauls 153–4
genre figures 72–4

glass 24, 118–19, **8**, **67**
Gnosis 44–5, **17**
grave reliefs 120–22

Hades 34–6, **12**
Hadra *hydriai* 124, **70**
Halikarnassos 20
Helios 151
Herakles 23, 153, **7**
hermaphrodites 145
Hieron II of Syracuse 166–7
Homer *see* Apotheosis
Homeric bowls 132–3, **74**
houses, design and decoration 44–6, 101–9, **57**
hunting, hunt scenes and images 39, 41–2, 44–6, **14**, **16**, **17**, **20**
Hypnos 148–9, **86**

Isogonos 165–6

Jennings dog 144, **82**
jewellery 26–7, 60–61, **9**, **27**

Kairos 130
Kassander 40, 42
Knidos 96–9, 125–6, **54**, **55**, **56**, **71**
Krateros 44

lamps, lighting 113, **64**
landscape 138–42, **78**, **79**, **80**
Lycia 10–19
Lysippos 63, 160, 163

Macedon 13–14, 26–49
'Macedonian' tombs 32–3
Mahdia wreck 157–8, 174, **90**

masks 70–72, **35**
Mausolos, Mausoleum 20, **5**
'Megarian' bowls 115–16, **65**
Menander 56–7, 136–7, **25**
mosaics 39–40, 44–6, 102–4, 141–2, **7**, **17**, **58**, **80**
Myrina, terracottas from 127–8, 157, **73**, **87**, **89**

Nemrud Dagh 152, 161–2, **93**
New Comedy *see* Menander
Nike
 of Samothrace 88–90, **48**, **49**
 in general 127–8, **73**
Nile Mosaic 141–2, **80**

Octavian 13
old age 72–3, **36**

painting 34–7, 39–42
palaces 43–4
patronage 166–71
Pella 43–6
Pergamon
 city plan 82–3, **42**
 Great Altar 90–94, 157, **50**, **51**
 mosaics from 103–4
Persephone 34–6, **12**
Philip II of Macedon 13–14
Philip V of Macedon 15, 167, 171
Philip Arrhidaios of Macedon 14, 41
philosophers 52–4, **21**, **22**
Portland Vase 177, **103**
portraits 50–78
Potidaea, couch from 46, **18**
pottery 116–18, **65**, **66**, **70**, **74**
Priene 10–11, 95–7, **1**, **2**, **52**, **53**

Protogenes 155
Psyche 149–50, **87**
Ptolemy I **32**
Ptolemy II Philadelphos 166–7, **32**

Rome 171–8

Samothrace, Nike of 88–90, **48**, **49**
satyrs 145–6
saqiya, tomb painting of 140–41, **79**
Satala, Aphrodite from 87–8, **47**
sealstones, seal impressions 61, 119, **8**
Serapis 151–2, **88**
silver vessels 114–16, **65**
Sindos 29
Sophocles 55, 56, **24**
Sperlonga, grotto of Tiberius 172–3, **99**
stoas 81–2, 90, **40–41**, **97**

'Tabula Iliaca' 133–4, **75**
temples 84–5, **2**, **44**, **45**
Telesinos 164
terracotta figures 73–7, 97, 106–8, 126–8, **35**, **37**, **39**, **53**, **56**, **60**, **61**, **72**, **73**
theatre, theatrical figures 56–7, 70–72, 82, **35**, **43**
Theocritus 21, 138, 168–9
Tyche 136–7, **77**

Vergina 29, 33–42, 44 **12**, **13**, **14**

Warren Cup 176, **102**
West Slope pottery 117, **66**
workshops, artists' 156–7

Xanthos 18, 19, **4**